LAS VEGAS

LAS VEGAS

AN UNCONVENTIONAL HISTORY

♠ MICHELLE FERRARI WITH STEPHEN IVES ♥

BULFINCH PRESS

NEW YORK • BOSTON

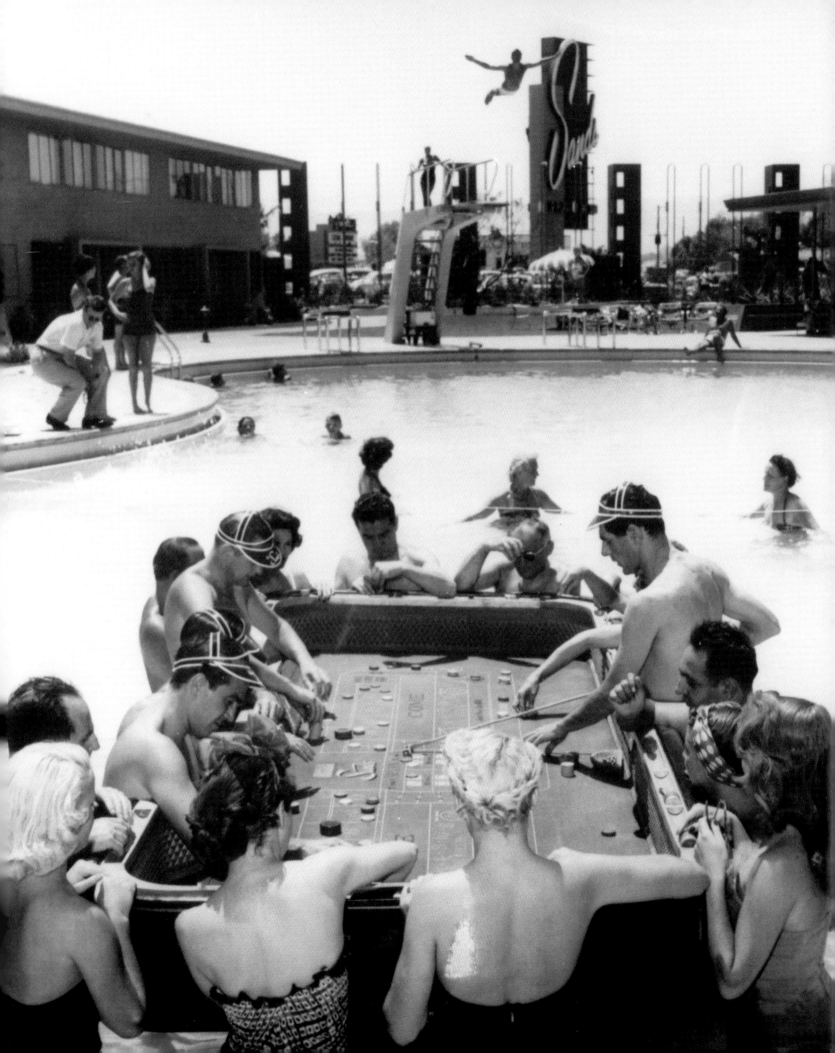

CONTENTS

The famous floating craps table at the Sands, 1954.

INTRODUCTION

My interest in Las Vegas began one night at a dinner party in Manhattan. The hosts were good friends and in many ways typical sophisticated New Yorkers—he, a senior editor at *Newsweek,* and she, a successful film producer and Web designer. They had recently got married, and over a cocktail they related the story of their wedding, which turned out to have occurred at a drive-thru wedding chapel in Las Vegas. After nearly choking on my olive, I asked what these worldly and quintessentially East Coast urbanites were doing in the land of Elvis impersonators, Wheel of Fortune slot machines, and the $9.99 buffet. It didn't make sense. But after a few bottles of wine and a hilarious description of their forty-eight hours in Vegas, my friends' escapade to Sin City seemed not only perfectly natural but appropriate as well. Was Las Vegas, I wondered, becoming a Mecca for the twenty-first-century American zeitgeist? That night I resolved to try and plot the coordinates of Las Vegas on the map of the American psyche, to see just how much Sin City serves as a barometer of our contemporary cultural attitudes and ideals while simultaneously exploring its improbable history over the last hundred years. Luckily the producers at the PBS series *American Experience* at WGBH-TV in Boston were equally intrigued, and that led to the three-hour documentary series for which this book serves as a companion.

This nation has always had a paradoxical, if not downright hypocritical, relationship with Las Vegas. It is a city that America has loved to hate but cannot do without. It is the antithesis of the conventional, the established, and the traditional, and despite our false pretenses, we are drawn to it for precisely those reasons. We are a Puritan nation obsessed with sex, a self-proclaimed meritocracy that idolizes wealth, a hardworking, churchgoing, law-abiding people that can't wait to party all night long. Las Vegas is the necessary dark side of our nature, the skeletons in our collective closet, the orgiastic expression of our own irrepressible id. It is our favorite dirty little secret.

Ironically it has been the nation's perpetual, often spasmodic efforts at reform that have contributed to Las Vegas's continuing growth. Time and again the periodic crackdowns in places like Steubenville, Kentucky, and Santa Monica, California, sent waves of cardsharps, bookmakers, and assorted lowlifes scuttling for sanctuary in the legally sanctioned safe harbor that was Las Vegas. These underworld migrations—what journalist Marc Cooper has called "a gangster diaspora"—would infuse the city with a colorful and often dangerous new element, but they also brought skilled casino managers, veteran blackjack dealers, and back-office men as adept at hiding profits as they were at making them. In short these were just the kinds of professionals best suited to lay the foundation for an economy based on gambling. By demonizing the vice that so many of

their fellow citizens couldn't live without, the reformers inadvertently helped build the most enduring monument to greed, avarice, and licentiousness that the country has ever known.

Central to Las Vegas's hold on our imagination is its geography. Rising up miraculously out of the desert, a testament to American enterprise, ambition, and greed, it is a postmodern expression of one of this nation's oldest and most enduring myths, the regenerative power of the western frontier. The city itself began as a typical boom-and-bust town, its fate dependent, like so many places in the West, on the often cruel serendipity of the climate and the capricious decisions of bureaucrats back East. But unlike so many other western towns, Las Vegas was a gamble that paid off. Although the construction of Hoover Dam was the seminal event in the city's history (and the waters it would bring from the Colorado River would secure the city's long-term viability), it was Las Vegas's position as a social outcast, the most notorious symbol of the godforsaken state of Nevada, that would shape its future and determine its destiny. Time and time again Las Vegans would be forced to survive by offering Americans something they couldn't find at home—legalized gambling, quickie divorces, glittering entertainers, and gangsters, too—a modern-day, twenty-four-hour Sodom and Gomorrah wrapped in neon and glittering lights, a nocturnal oasis of indulgence in the midst of the jet-black desert. Even today, when gambling is no more than a ninety-minute drive from most American cities, Las Vegas's desert kingdom still exerts a visceral magnetism, urging visitors to cross not only a physical, but a psychic, continental divide. It is this potent allure, at least in part, that has made Las Vegas the most visited place on earth.

Few visitors to Las Vegas, especially those who arrive at night, fail to be struck by the dazzling singularity of the Las Vegas Strip. It is a striking creation—whether one is impressed or appalled hardly matters—and in its audacious display of conspicuous consumption, a distinctively American one. In a larger sense it is also a manifestation of the extraordinarily optimistic vision that has distinguished Las Vegas from its earliest times. Only residents of a particularly sanguine disposition could have looked at the dusty outpost of Las Vegas in the 1920s, situated in the middle of the scorching Mojave Desert, and proclaimed it America's newest vacation playground. But unbridled boosterism has always characterized Las Vegas, and when such a raw and unquenchable faith in the future was combined with the city's extraordinary talent for opportunism, one of the great economic engines the world has ever seen was born.

Las Vegas is, after all, primarily, obsessively, unabashedly about money, and whenever its future has been threatened, the cascading river of cash that it generates has, by virtue of its sheer scale and momentum, never been allowed to run dry. To keep itself going the city has always chased two things: customers and capital, and it has pursued both with a single-minded zeal. To keep its customers coming, Las Vegas had to grow,

and whether it was with shoe boxes full of cash from the mob or loans from Teamsters pension funds, whether it came from the personal checkbook of Howard Hughes, the seemingly limitless coffers of junk-bond managers from Wall Street, or from billion-dollar mergers of multinational hotel chains, Las Vegas was too big a game to close down. Over and over again, with each new source of capital, Las Vegas was given a new set of chips and a chance to remake itself. The city always placed a big bet on the future and, more often than not, came out a winner. From its beginnings as a remote frontier way station to its Depression-era incarnation as the "Gateway to the Hoover Dam," from its midcentury florescence as the gangster metropolis known as Sin City to its recent renaissance as the fastest-growing city in the United States, Las Vegas, chameleon-like, has adapted its image to reflect the changing attitudes of the nation. In so doing it has consistently anticipated the needs and desires of Americans and then fulfilled them. It is a city that has understood, better than any other over the last century, what Americans wanted most when they ran away from home.

On the eve of the twenty-first century, if a curious traveler wanted to take in the pyramids, the Eiffel Tower, and the Statue of Liberty, stand on the drawbridge of a medieval castle, glide in a gondola along the Venetian canals, and sip espresso on the banks of Lake Como, he would have to make a trip around the world—or he could spend one afternoon in Las Vegas. From a dusty train depot in the middle of nowhere, the city has become one of the world's premier tourist destinations. A place that was shunned as Sin City and considered beyond the pale of respectable society has now become the epicenter of mainstream leisure. In the course of this remarkable transformation, clearly Las Vegas has become more like the rest of America, but perhaps more importantly, America has, over these past hundred years, become more like Las Vegas. While this latest fact may be enough to send both the cultural elite and social conservatives into crisis counseling, Las Vegas remains refreshingly, characteristically unapologetic. This is a town where the odds have always been posted, and the only currency that really matters is currency. Knowing that each megahotel is really a nation-state, catering with remarkable precision to a specific socioeconomic group—from Asian high rollers, to Midwestern housewives, to NASCAR dads—does little to change the experience Las Vegas offers. You are here to be transported, to explore a new reality, "to dream with your eyes open," as Steve Wynn likes to say, and the artifice and spectacle, the illusion and fantasy (not to mention the cost) are all part of the bargain, a suspension of disbelief in exchange for the ultimate in experience, which is increasingly the goal of Americans at play.

Las Vegas remains, despite its newfound stature in the nation and the world at large, very much an adolescent city, and nowhere is that more visible than in the social problems that afflict it. If it can, on the one hand, boast unprecedented job growth and a burgeoning, unionized, middle class who are realizing a version of the American dream

that is only a distant memory in the cold corners of the nation's old manufacturing towns, it must, on the other hand, acknowledge the plagues of divorce, teen pregnancy, suicide, and gambling addiction that seem to be a persistent malaise. And as much as urban sprawl, traffic congestion, air pollution, and water scarcity may be problems that have afflicted many other young Sunbelt cities, Las Vegas's particular accident of geography, its seemingly unstoppable need to grow ever faster, its determination to remain a libertarian land of hard-edged individualism may yet challenge its goal of becoming a truly mature community. Achieving this goal will require those attributes that have not traditionally been Las Vegas's strong suits—consensus, power sharing, a greater role for government, conservation. One thing is certain: no one who plays the odds would likely bet against Las Vegas over the next hundred years. The city has proved to be the most resilient, creative, and ambitious place in America, and while the rest of the nation continues to seek greater and greater escape from their ordinary lives, Las Vegas will undoubtedly lead the way.

Stephen Ives, Director, *Las Vegas*

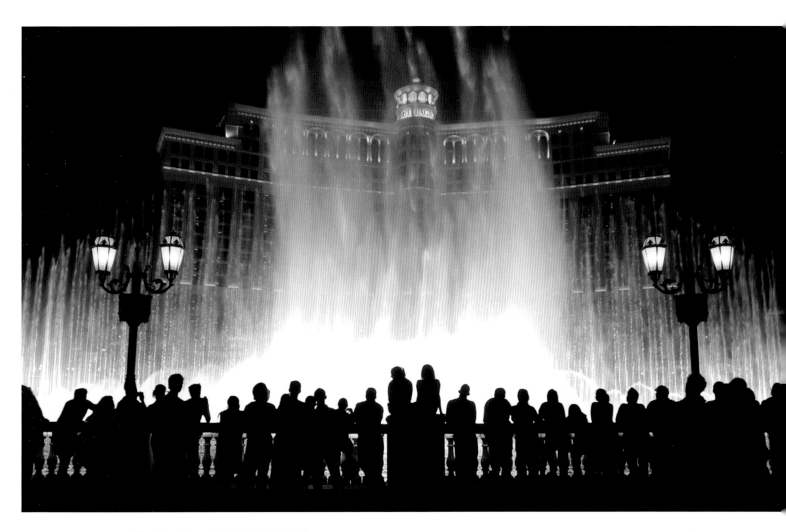

The fountains at the Bellagio hotel.

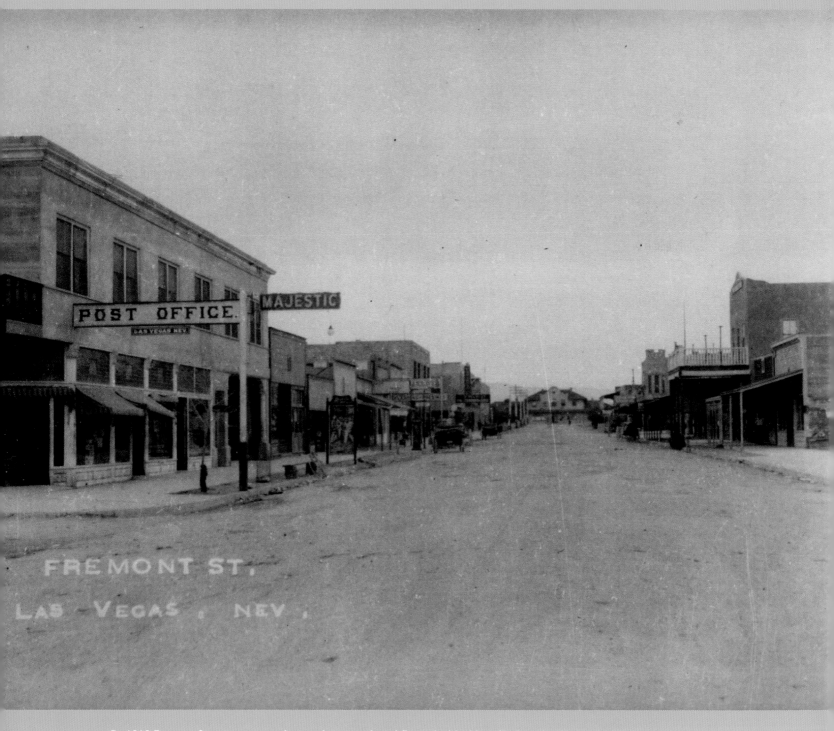

By 1912 Fremont Street was not only paved, guttered, and flagged with sidewalks but also boasted a theater, the Majestic, which regularly presented major motion pictures and top vaudeville acts.

CHAPTER ONE
THE LEAST LIKELY TO SUCCEED

On a bright, blistering afternoon in 1902, an aspiring railroad tycoon and U.S. senator from Montana named William Clark laid eyes on Las Vegas, Nevada, for the very first time.

There was not much to see.

Although the place had been appearing on maps for more than seventy years, America's great westward migration had mostly passed it by. Situated smack in the middle of the Mojave Desert and just 150 miles from Death Valley—one of the hottest places on earth—Las Vegas had so far appealed to only the hardiest of settlers. Not counting the Paiute Indians, who had lived in the region for centuries, the total population was now hovering somewhere around thirty—a number so paltry that the place was not even listed on the 1900 census.

The location's only discernible assets were two large, freshwater springs, the geologic remnants of a two-hundred-foot-wide river that had flowed through the Las Vegas Valley some thirty thousand years before. A ragged band of New Mexican traders first stumbled upon the springs in 1829 and, with just a hint of thirst-induced hyperbole, had called the desert oasis *Las Vegas,* Spanish for "the meadows." Over the decades that followed, the water lured explorers and cross-country mail carriers and prospectors en route to Nevada's famed mines. But apart from a short-lived Mormon settlement, founded by thirty missionaries sent to establish a way station on the road from Utah to California, most who had set foot in Las Vegas found it less hospitable than its name implied.

William Clark, by contrast, thought the place was ideal.

Fabulously wealthy and notoriously corrupt, the spindly, yellow-bearded copper baron turned senator reputedly obtained his political seat with more than a third of a million dollars in outright bribes. So brazen had been his purchase of his office that one Montana newspaper printed a cartoon of a thousand-dollar bill and labeled it "the kind of bill most frequently introduced in the Montana legislature." Not surprisingly, among his more principled peers, the senator was considered something of a reprobate. "If you took away the whiskers and the scandal," Washingtonians supposedly liked to say, "there would be nothing left of him."

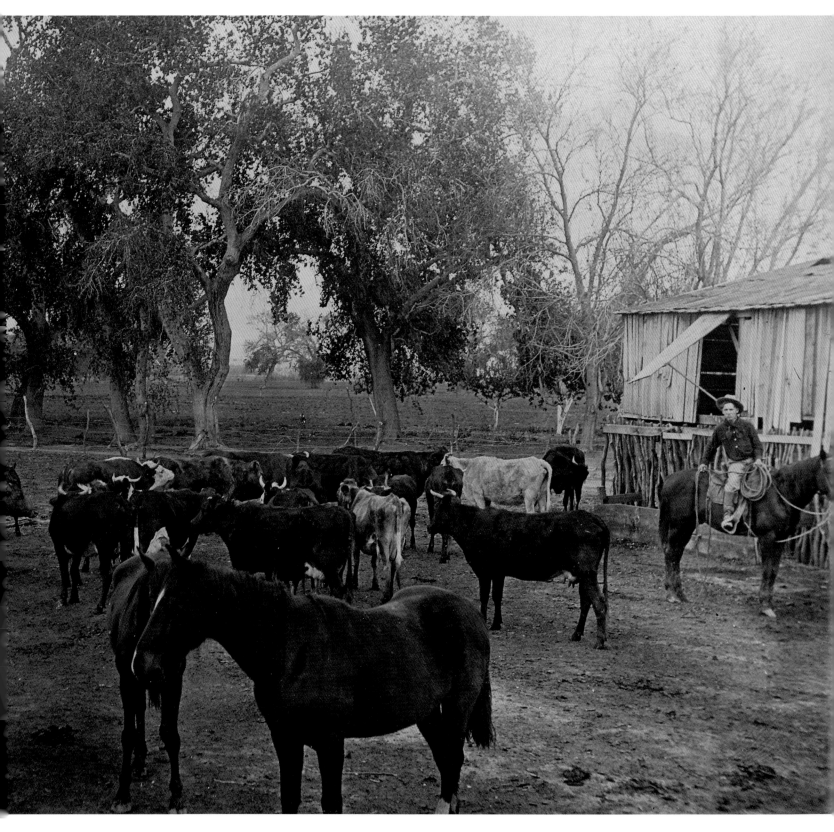

Helen Stewart's cattle ranch, which she operated with the help of Paiute and Hispanic workers, became Senator William Clark's Las Vegas townsite.

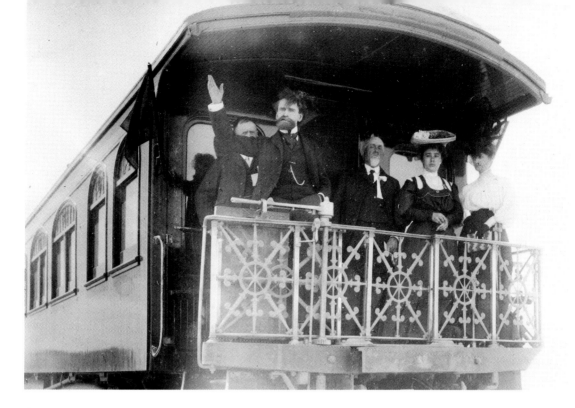

A corrupt copper baron with money to burn, Senator William Clark of Montana (left, waving) campaigned for office aboard his private railcar and was once accused of "purchasing votes like eggs." His San Pedro, Los Angeles & Salt Lake Railroad put Las Vegas on the map.

Looking now to buy something more tangible than influence, Clark decided to build a rail line that would connect the burgeoning markets in Southern California to the Transcontinental Railroad. Linking up with the Union Pacific's main line in Salt Lake City, the new spur—the San Pedro, Los Angeles & Salt Lake—was slated to run some five hundred miles southwest to Los Angeles, with layovers en route for crew changes and service. Largely empty and well-watered Las Vegas, Clark thought, would be the ideal spot for the line's repair shops.

As a sidelight to the railroad, the senator figured to make a killing in real estate. For $55,000 he convinced a local widow, Helen Stewart, to part with her two-thousand-acre ranch and her water rights. Then, as railroad construction crews converged on Las Vegas from both Utah and California, he organized a railroad subsidiary called the Las Vegas Land and Water Company and, in late 1904, began drawing up plans for a town site on the east side of the soon-to-be-laid railroad tracks. While bulldozers leveled the desert and divided the site's forty blocks into thirty-two separate lots, each to be priced between $150 and $750, Clark launched an aggressive advertising campaign, placing notices in newspapers on both coasts that promised to refund train fare to any passenger who bought land.

Railroad spikes left over from the building of the San Pedro, Los Angeles & Salt Lake.

An ad for McWilliams's "Original Las Vegas Townsite," which was built to the west of the railroad tracks. Once early residents recognized the barrier the rail crossing posed to wagon traffic, many abandoned McWilliams's site and pitched their makeshift tent houses and stores on Clark's site instead.

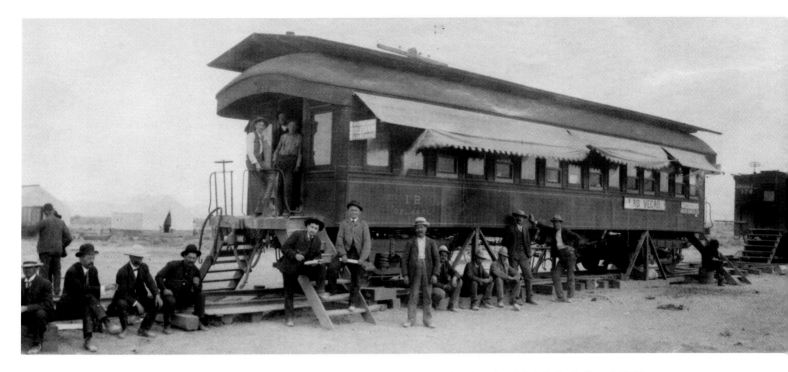

A parlor car serves as the temporary depot for the San Pedro, Los Angeles & Salt Lake Railroad, 1905.

Meanwhile a competing town site was already taking shape on an eighty-acre parcel west of the tracks. There, a railroad surveyor named McWilliams had begun selling lots almost a year earlier, hawking them for as little as $100 each in newspapers throughout Southern California. "Get into line early," the ads had urged. "Buy now, double your money within 60 days."

By the time the railroad was completed, in January 1905, McWilliams's town site already thronged with barbers, grocers, and shopkeepers hoping to make a fresh start—and advance demand for lots on Clark's site was so heavy that his Land and Water Company announced it would be forced to hold an auction sale.

The land fever quickly spread. Bidders poured into the valley by the dozens and pitched tents on the fringes of McWilliams's site or on the banks of the Las Vegas creek. On one afternoon an entire trainload of investors from Los Angeles showed up, lured by the railroad's fully refundable, special round-trip excursion fare of $16. By the eve of the auction, more than three thousand speculators and potential investors were in town—one hundred times as many people as had lived in the valley just three years before.

The auction got under way on the morning of May 15, 1905, in front of the temporary train depot—a parlor car that had been rolled up to the head of Fremont Street, the town's main drag. Throughout that day, under the blazing heat of the desert sun, hysterical bidders drove Clark's advertised prices up and up, until choice inside lots were going for as much as double their listed value. "The auction was a nice clever

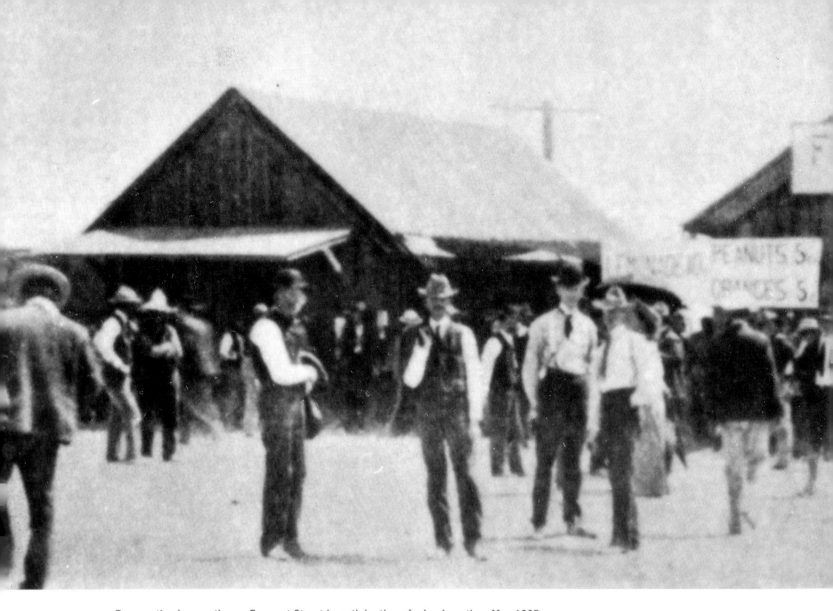

Prospective buyers throng Fremont Street in anticipation of a land auction, May 1905.

scheme," remembered one attendee, "the simplest way of giving everybody a fair shake (down)." Cautious investors who were edged out of the frenzied bidding protested so vehemently that the following day's auction was called off, and the remaining lots were sold for prices within the advertised range.

By the close of the sale's second day, more than six hundred empty lots had been sold for a total of $265,000—almost a 500 percent profit over what had been paid for the land—and Clark had become the first man in history to make a fortune in Las Vegas.

At first the town was nothing more than a collection of tents on a parched desert flat. Aside from the railroad's repair shops and warehouses, the only suggestions of civilization were the makeshift post office and bank, and a smattering of tented hotels, the largest of which was composed of a single bolt of canvas, 126 feet long. Many of the earliest arrivals, including two dozen entrepreneurs who had impulsively snapped up com-

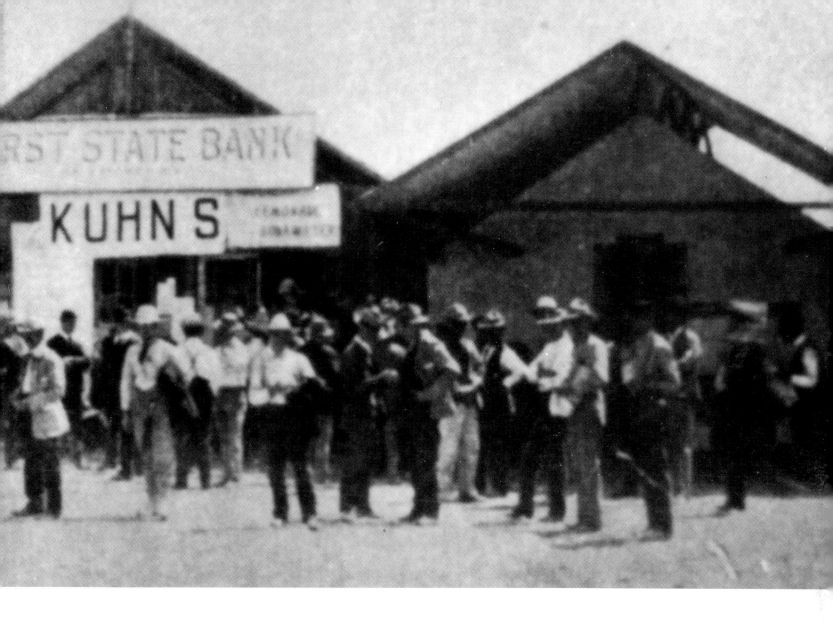

mercial lots during the auction, blew out of town within the first six weeks, convinced the sweltering outpost would never amount to much.

Those who stayed set to hammering and continued more or less unabated for the next decade, banging together dry-goods shops, schoolhouses, pharmacies, and—on Block 16, the zone where the railroad company permitted the sale of liquor—saloon after saloon after saloon. Between catering to the railroad passengers on layover and supplying the mining camps to the north and south, Las Vegas did a brisk business. Before long the once-desolate patch of sand and scrub was just like dozens of other railroad towns in the American West: rowdy, enterprising, and hellishly dusty.

As a company town it was also prone to sudden reversals of fortune. When the First World War ended, in 1917, and the market for Nevada's metals bottomed out, traffic between the mines and Las Vegas slowed to a crawl. In a matter of weeks, the railroad

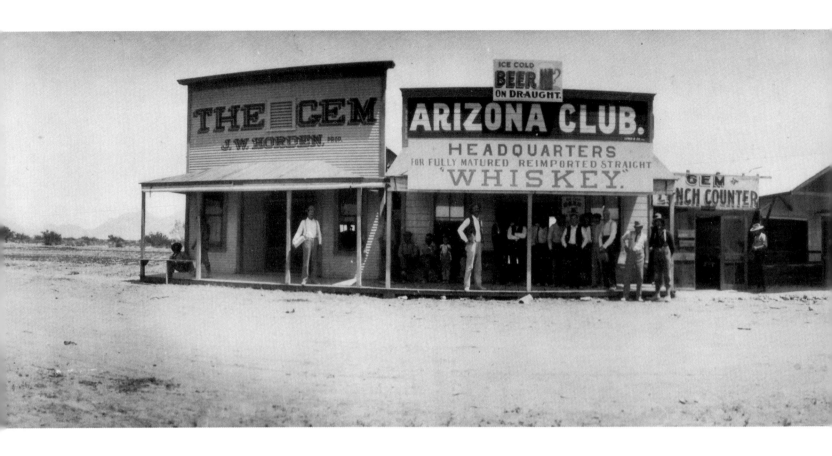

laid off 150 people—more than 10 percent of the town's residents. Four years later, with no sign of a rebound on the horizon, Senator Clark cut his losses and sold out to the Union Pacific, whose management, in turn, promptly laid off another 60 local employees.

Resentment in Las Vegas smoldered; and when 400,000 rail workers across the country went on strike the next year, Las Vegans walked too, idling the line through their town for nearly a month. Meanwhile the city's economy sagged, as freight piled up on sidings, and supplies went unsold. With no way to unload their merchandise, many shopkeepers simply shuttered their doors for good. The resolution of the strike, when it finally came,

Turn-of-the-century roulette accessories, including a brass fitting used to mount the roulette wheel and a couple of handfuls of Bakelite balls.

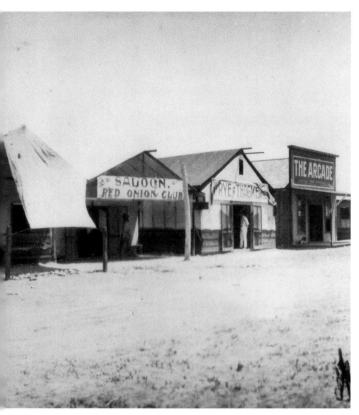

did not improve matters. In a move that many locals regarded as vindictive, the Union Pacific relocated its maintenance shop to Caliente, 125 miles up track toward Utah, adding 300 more people to Las Vegas's already swollen ranks of unemployed.

In the end the only thing that saved the town from utter ruin was that it happened to be in Nevada.

Almost entirely devoid of the natural resources that might have attracted and fostered industry, and so sparsely populated that from time to time its right to representation in Congress was actually challenged, Nevada had long embraced permissiveness as a kind of survival strategy, a lure to snare settlers and their money. When only one state in America allowed prize-fighting, that state was Nevada. While the rest of the nation zealously regulated coupling of all sorts and

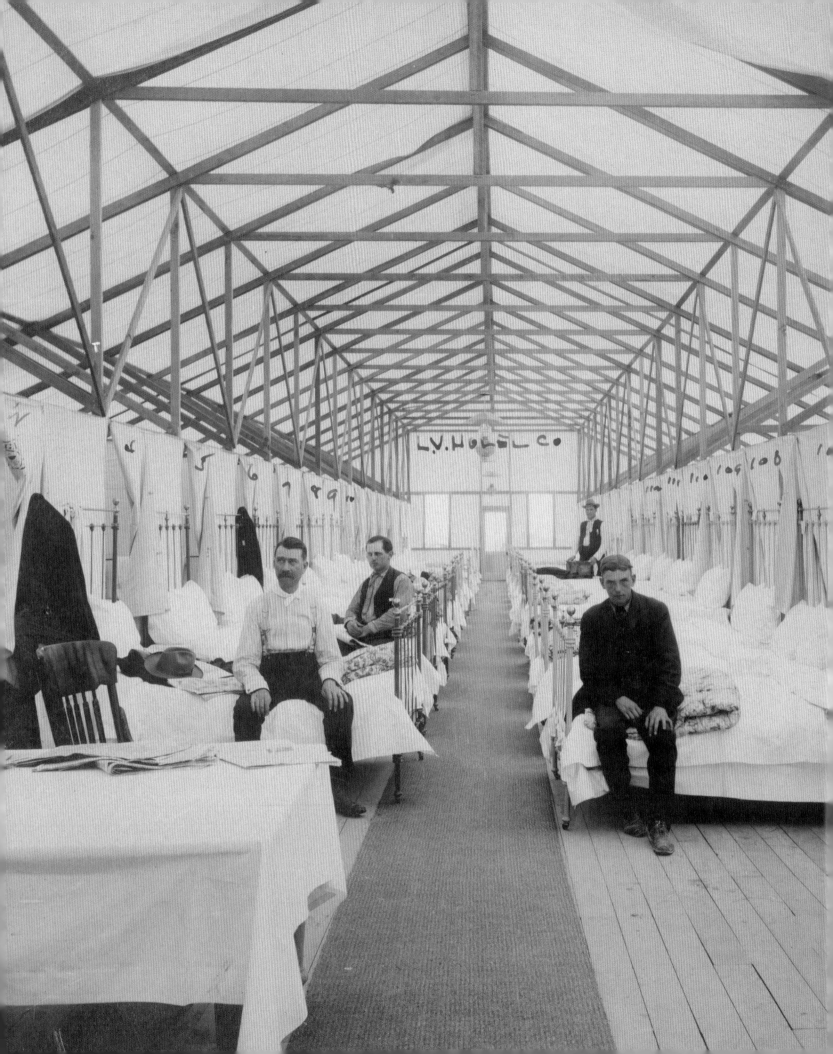

Well into the 1950s Las Vegans would complain about the town's primitive medical services. The first hospital, built around 1905, was certainly no exception.

The Las Vegas Hotel, built in 1905, was a little light on amenities.

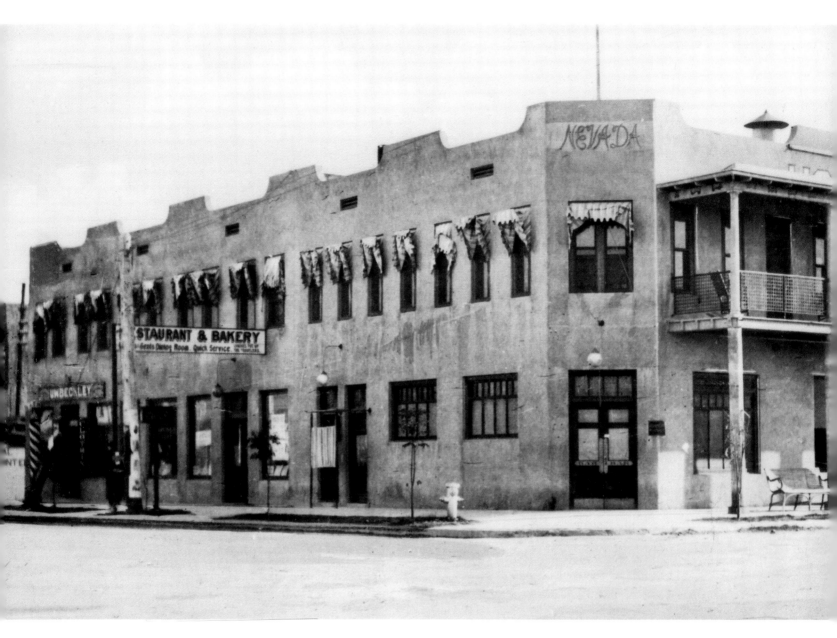

The two-story Hotel Nevada, located near the railroad station on Fremont Street, was one of the first hotels in town to be constructed of something other than canvas.

Opposite: 1920s law enforcement, Las Vegas style: a .45 caliber pistol and "brass" knuckles (actually made of cast iron).

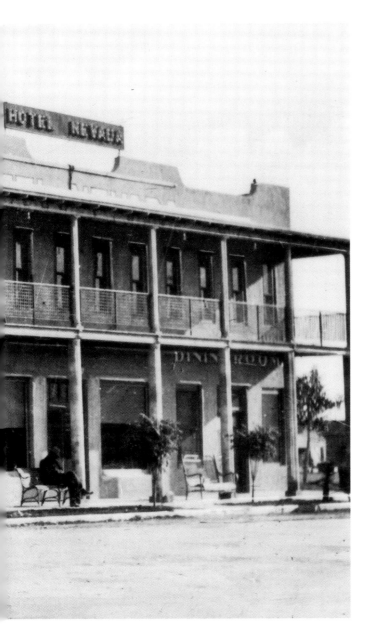

required a church edict to obtain a divorce, Nevada's legislature allowed any man and woman to marry without a blood test, cheerfully dissolved marriages after just a six-month residency, and left the vexing matter of prostitution entirely to the discretion of local governments. Nevada even turned a blind eye to activities that were explicitly forbidden. Unlike other states in the country, where the routine practice of flouting Prohibition involved furtive visits to speakeasies, secret passwords, and periodic raids by the police, Nevada allowed its saloons to operate openly, with little or no interference from local law enforcement. And although legislators had banned wagering under pressure from Progressive reformers back in 1910—albeit grudgingly and only after every other state in the nation had already done so—a poker player was still absolutely free to lose his shirt.

As the humorist Mark Twain once observed during an extended stay in the Silver State: "In Nevada, the lawyer, the editor, the banker, the chief desperado, the chief gambler, and the saloon keeper occupied the same level of society, and it was the highest."

Now that the railroad boom had fizzled, state-sanctioned vice was Las Vegas's primary stock in trade—if not its sole reason for existence. Although the town boasted a variety of enterprises by the mid-1920s, its economic pulse beat mainly in the ramshackle saloons and backroom prostitution "cribs" along Block 16, where cowboys, prospectors, drifters, and weary rail passengers flocked nightly to pay

homage to the unholy trinity of liquor, gambling, and sex. The whole place was so mired in immorality that some Nevadans feared guilt by association. "People in . . . northern Nevada would have been very happy if Las Vegas had seceded from the state," remembered one transplant from Reno. "When I first

came down here, I thought this was the least likely to succeed of any [town] in the United States."

But even as Las Vegas languished, a handful of farsighted residents were plotting a future beyond Block 16. A few miles north of town, an eastern entrepreneur was busy renovating the old Kyle Ranch with the idea of turning it into a dude ranch for vacationers and prospective divorcées. Another recent arrival had begun construction of a full-fledged resort, complete with two man-made lakes for boating and swimming, a dance hall, and a tavern. To the southwest of town, work on Las Vegas's first golf course—nine holes, no grass—was just getting under way.

If their wide-open town could eke out a living as a place to pass through, local leaders reasoned, then surely between its strategic location on the rail line and its year-round sunshine, it could more than prosper as a place to stay. With an optimism that bordered on lunacy, Las Vegas boosters were now determined to promote their isolated desert outpost—where summer temperatures typically soared to 110 degrees—as a new vacation destination, a "resort city" on the order of Arizona's Tucson and California's Palm Springs.

Although it would take another decade and an infusion of federal cash for the scheme to really take off, one of the most unlikely civic enterprises in American history had begun.

The Arizona Club, 1906.

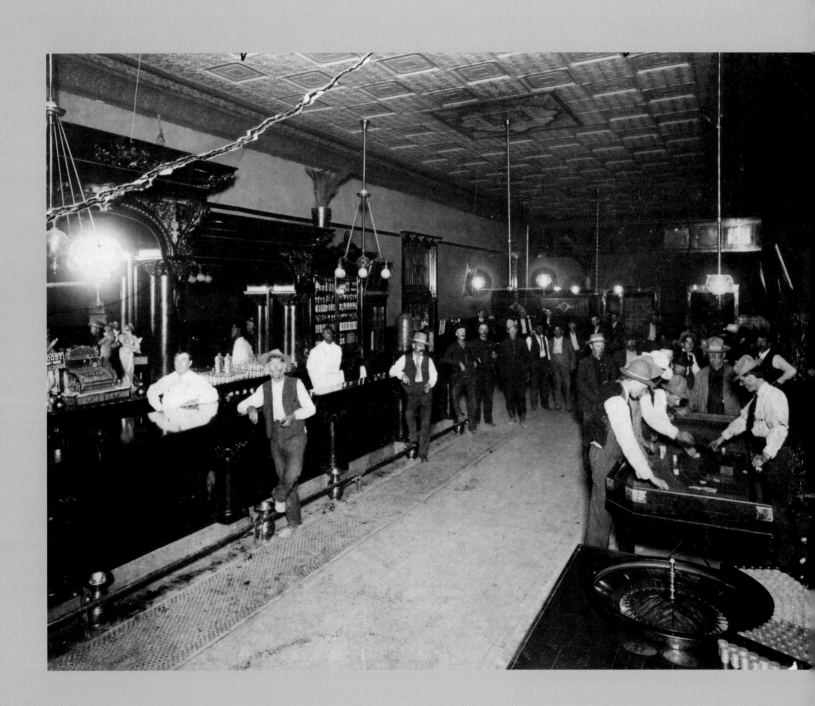

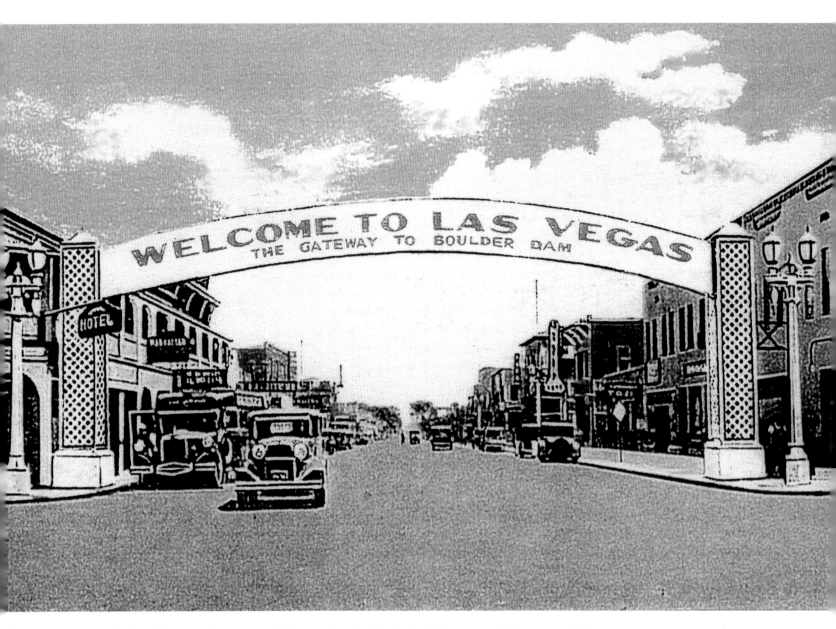

A view of Fremont Street in the 1930s, produced by the Curt Teich Company of Chicago, a well-known manufacturer of picture postcards. Las Vegas wasted no time capitalizing on the tourist potential of the dam. Even before construction got under way, local boosters had dreamed up the tag "Gateway to the Boulder Dam."

CHAPTER TWO
GATEWAY TO THE BOULDER DAM

B y 1928 Las Vegas was hanging on by a thread. A glimmer of hope had flickered the previous year, when the Nevada legislature had passed another round of measures designed to lure those who otherwise might have regarded the state as a wasteland. In addition to shortening the residency requirement for divorce eligibility to a scandalous three months, lawmakers had also taken the radical step of banning sales, income, inheritance, and corporate franchise taxes in the hope of attracting private wealth. But as yet the legislation had done more for the northern town of Reno than it had for Las Vegas. Worse still, the new grass-free golf course had so far failed to attract the resort crowd—and the town's odds of making it as a vacation spot seemed more dismal than ever.

Fortunately Christmas came early that year. Four days before the holiday, President Calvin Coolidge signed a bill authorizing $175 million for the construction of the Boul-

der Dam (later rechristened the Hoover Dam), an ambitious public engineering project that would attempt to harness the raging Colorado River at a spot called Black Canyon, just thirty miles southeast of Las Vegas's train depot. With a single stroke of the pen, the fading railroad town was suddenly back on the map. When the news reached Las Vegas, the locals went wild. "That's when the excitement was," one resident of the time recalled. "People got lit that had never taken a drink before."

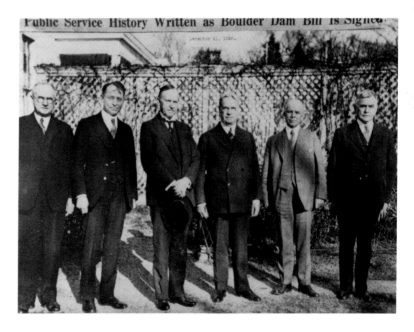

The men who authorized the expenditure of federal funds for the construction of the Boulder Dam and, coincidentally, saved Las Vegas from becoming a ghost town. Left to right: Elwood Mead, Commissioner of Reclamation; California Representative Phil Swing; President Calvin Coolidge; U.S. Senator Hiram Johnson; Addison T. Smith, chairman of the Committee on Reclamation; and W. B. Matthews, general counsel for the Boulder Dam Association.

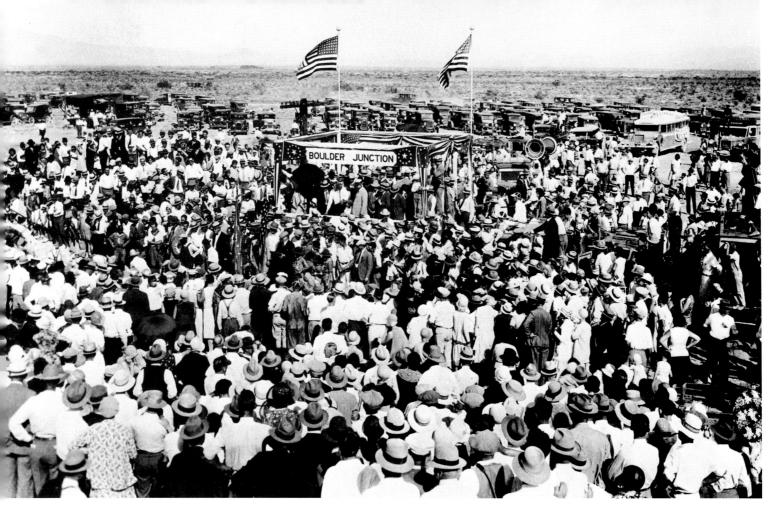

Before dam construction could begin in earnest, a rail line had to be built to the Black Canyon site. Hundreds turned out to witness the ceremonial laying of the first rails and ties at Boulder Junction, in Bracken, Nevada, seven miles south of Las Vegas.

The U.S. government had been contemplating the dam since 1905, the year of Las Vegas's founding, when the Colorado had overflowed its banks and swept through California's Imperial Valley, enlarging the inland Salton Sea from twenty-two square miles to well over five hundred and destroying millions of dollars' worth of crops. Beleaguered farmers had struggled to keep the floodwaters at bay for the better part of the next two years, only to be rewarded with a devastating drought when the river finally receded. In response to their pleas for assistance, the Reclamation Service branch of the U.S. Department of the Interior had begun investigating ways to control the unpredictable menace of the Colorado. Finally, after years of surveys and studies, the federal team of geologists, hydrographers, surveyors, and engineers decided to construct what was slated to be the highest dam in the entire world, a massive concrete wedge rising sixty stories out of the riverbed and spanning nearly a quarter mile between the walls of Black Canyon.

Over the next five and a half years, the government pumped millions of dollars into southern Nevada. The dam not only employed as many as five thousand people at

the peak of construction but also laid the groundwork for all future development in Las Vegas, supplying the water and electricity that enabled the isolated desert town to finally transcend the limitations of its implacable, often downright hostile, environment. "The present time will be looked back upon in future years as the turning point in the history of Las Vegas," the editor of the town's newspaper enthused. "The mills of the gods grind slowly, but they grind exceedingly fine."

Construction of the dam officially began on September 7, 1929, with the ceremonial laying of the first rails for a new spur that would connect the town of Bracken, seven miles south of Las Vegas, to the Black Canyon site. Nevada Governor Fred Balzar declared a state holiday, and special trains were chartered to carry visiting dignitaries from Las Vegas to Bracken for the festivities. Hoping to make a good impression, a handful of sober-minded Las Vegans arranged for a temporary shutdown of every saloon, gambling house, and bordello in town.

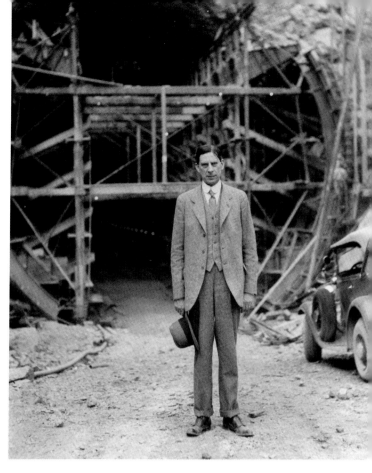

Interior Secretary Dr. Raymond Wilbur pauses for a photo during an inspection tour of the dam site, September 1932. Behind him is a concrete form used to line one of the fifty-foot diversion tunnels.

But their efforts were lost on Interior Secretary Raymond Wilbur. Moments after arriving in Las Vegas, Wilbur's pocket was picked—an episode that only intensified the low opinion he had formed of the town once while on a stopover.

Not long after, the government announced that it would not house the dam workers in Las Vegas but in its own planned community called Boulder City, which would be situated along the new rail line and considerably nearer to the construction site. By federal fiat, gambling would be forbidden, and the town would be drier than desert air.

Badge issued by Six Companies Inc. to those involved in the construction of Hoover Dam.

Las Vegans could afford to shrug off the slight. Even after the stock market crash of 1929 sent the rest of the nation into a tailspin, land values in their town soared. Developers were planning construction of forty new buildings, including a hospital and a combination post office–courthouse. And while the rest of America was scraping through the leanest years of the Depression, Las Vegans could count on a steady stream of federal dollars that would boost the local economy considerably.

Suddenly the trains into town were standing-room only. Between the fall of 1930, when the one-room U.S. Employment Office started processing applications for jobs on the dam, and the spring of 1931, when the work in Black Canyon began, some forty-two thousand of the nation's newly unemployed descended on Las Vegas, desperate to fill

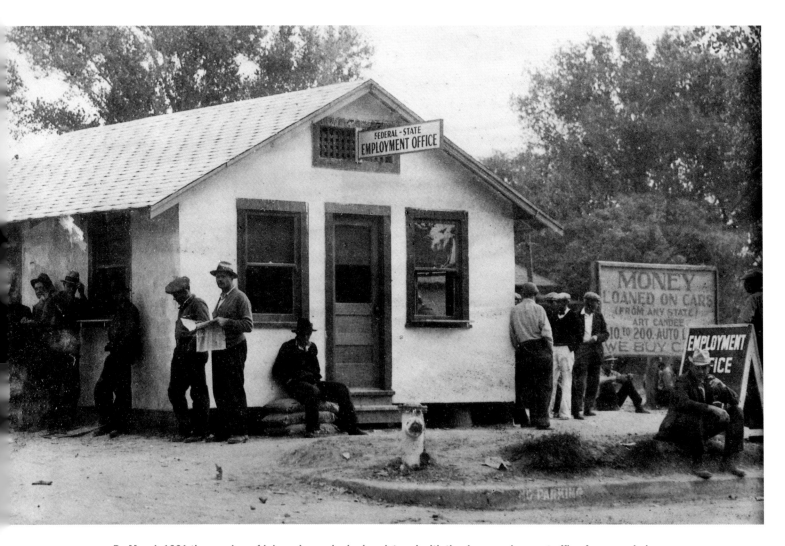

By March 1931 the number of job seekers who had registered with the dam employment office far exceeded available slots on the construction force. "Under existing conditions," a Bureau of Reclamation official warned, "none should go to Las Vegas unless he is assured of employment upon arrival, or is equipped with independent means to carry him over a period of several months."

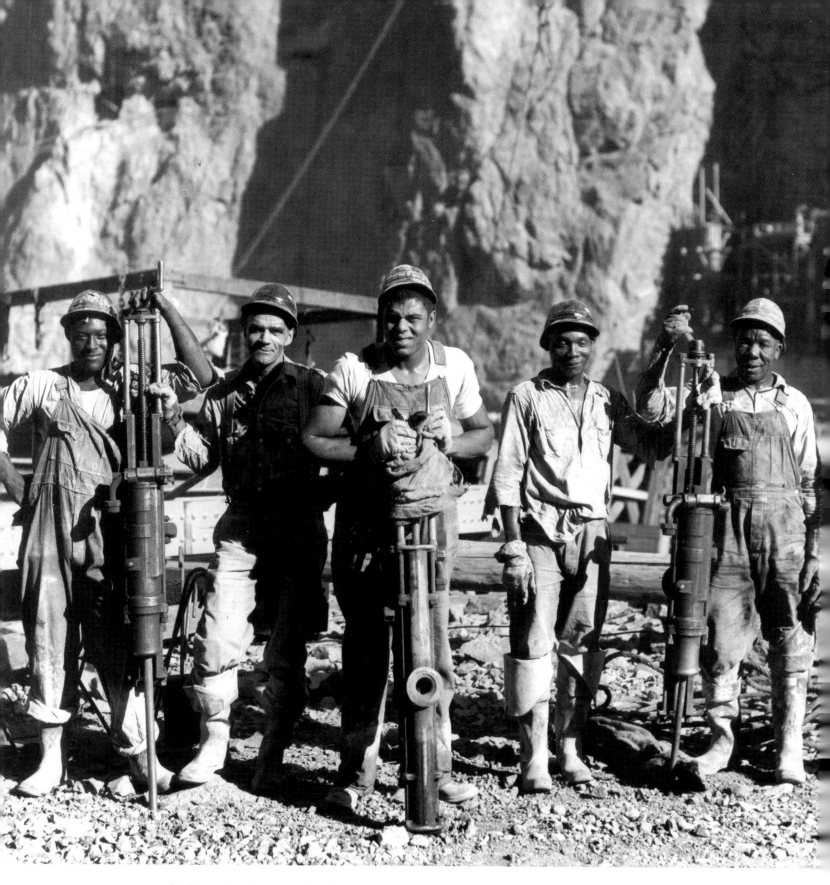

Six Companies, the consortium that managed the construction of the Hoover Dam, quietly but unequivocally excluded African Americans from their workforce. Under pressure from the NAACP, they hired ten black men in July 1932, but it was little more than a token gesture.

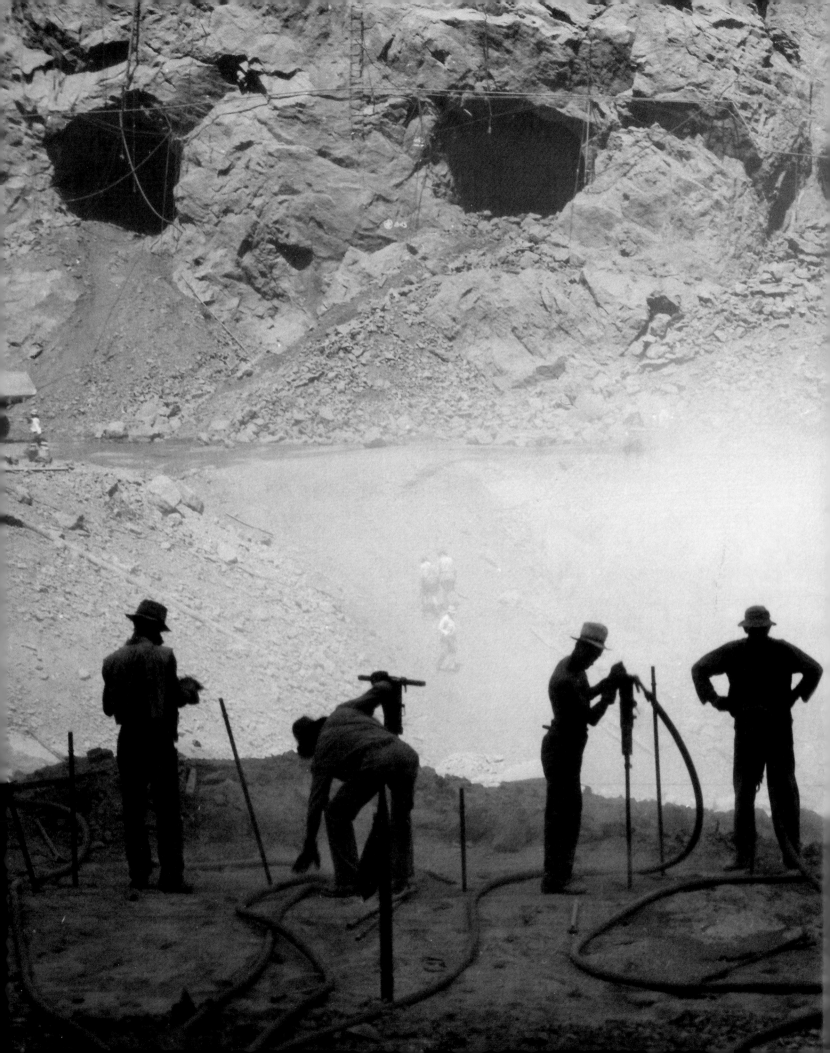

one of the slots at the construction site. Day after day the line of applicants grew longer, until finally it snaked along for so many blocks that one newcomer actually mistook it for a parade. "Everyone was coming," a longtime resident later recalled. "There'd be two hundred people sleeping on the ground or under the benches." In just one year the population of Las Vegas swelled to seventy-five hundred, an increase of more than 50 percent.

Meanwhile, in the state capital of Carson City, lawmakers were looking to build on the federal windfall. By now the bans on wagering that had been passed all over the country at the turn of century had mostly been lifted, and many cash-strapped states had already relegalized horse racing in an effort to generate revenue. Emboldened by the trend and spurred by the hand-to-mouth spirit of the moment, Nevada's ever-permissive legislature opted to trump them all.

At a time when games of chance were illegal everywhere else in the country—and diehard gamblers were forced to play in back alleys and underground clubs and boats anchored off-shore—Nevada lawmakers made their state the only one in the Union with legal, wide-open, casino-style gambling. "Some of those tinhorn cops were collecting fifty bucks a month for allowing gambling," explained the freshman assemblyman who introduced the bill. "Also, the damn state was broke and we needed the money." While they were at it, lawmakers reduced the residency requirement for divorce eligibility once again, this time to an unheard-of six weeks—by far the speediest marriage dissolution time in the country and a mere fraction of the six months necessary to obtain a state license to shoot sage hen.

SIX-WEEKS DIVORCE MADE LAW IN NEVADA

Secret Trial Provided—Governor Also Signs Bill to Legalize Gambling—Reno Prepared.

Not long after the governor signed both bills into law, the first gambling licenses were awarded to the Silver Club, the Tango Club, and the Northern Club near the train depot in downtown Las Vegas. The Meadows Club, a plush roadhouse equipped with a primitive air-conditioning system known as a swamp cooler, opened on Boulder Highway a month later, followed by Las Vegas's first "luxury" hotel, the Apache; the downtown Golden Camel club; and the Pair O' Dice Club, located four miles south of the city limits on Highway 91, the dusty desert road to Los Angeles. Inside of a few years, the town would be loaded with gambling houses, and penny slot machines would be installed in every gas station and grocery store in town.

Previous pages: Drilling holes for explosives on the floor of Black Canyon, 1931. During the summer months the rock in the canyon was literally too hot to touch.

Above: The *New York Times* reports on the Nevada legislature's scandalous move, March 20, 1931.

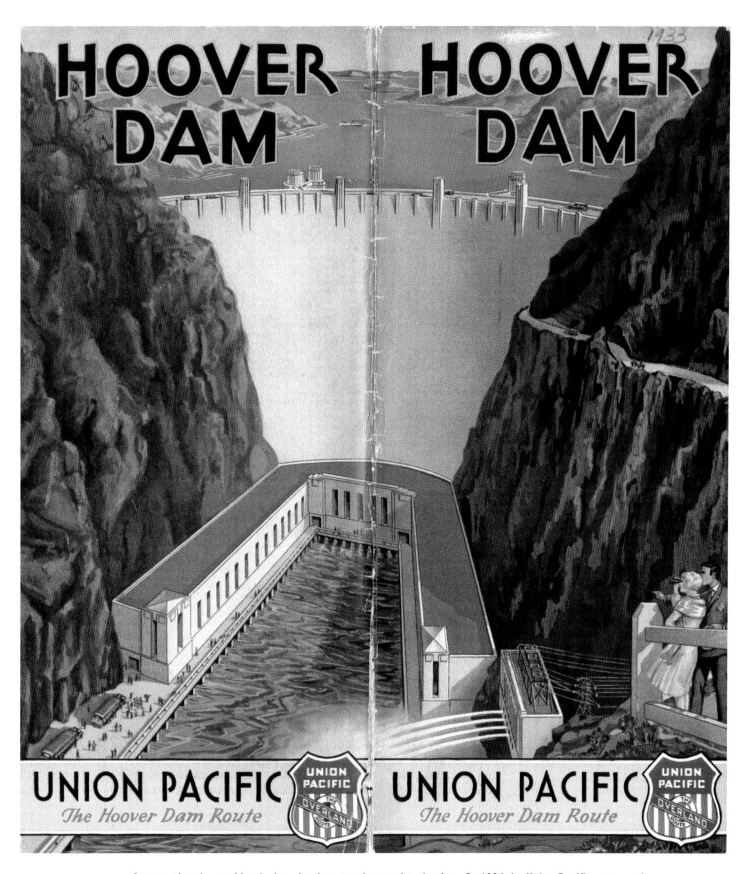

A promotional pamphlet designed to boost train travel to the dam. By 1934 the Union Pacific was running excursion trains to Boulder City almost every week.

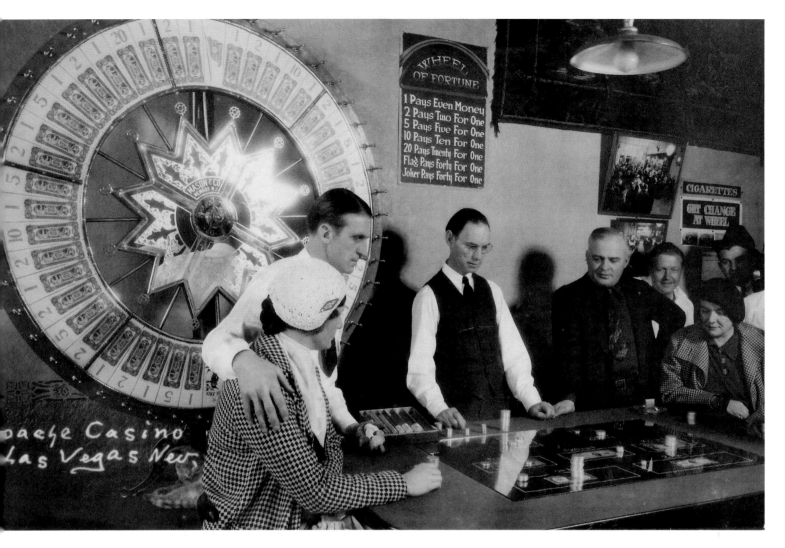

Throughout the early 1930s business was brisk in Las Vegas's clubs and casinos. Tourists en route to the dam often stopped in at places like the Apache Club, on Fremont Street, to try their luck with a one-armed bandit or Wheel of Fortune.

Thanks to the interior secretary's puritanical streak, there were plenty of suckers to go around. To the thousands of young men who spent their days in Black Canyon blasting through stubborn hard rock in 125-degree heat and most of the rest of their time penned up in sweltering barracks on a federal reservation, the prospect of a night on the town in Las Vegas was more welcome than a bucket of ice water. On paydays they bolted out of buttoned-up Boulder City as if it were on fire and headed straight for bawdy, brightly lit Fremont Street or the clubs on the outskirts of town, where they crowded two and three deep around the tables, cheerfully emptying their pockets in exchange for a few hours of sinful release.

Curiosity about the dam boosted business even further. In 1932 some 100,000 people—many enthusiastic new motorists from the neighboring states of Utah, Arizona,

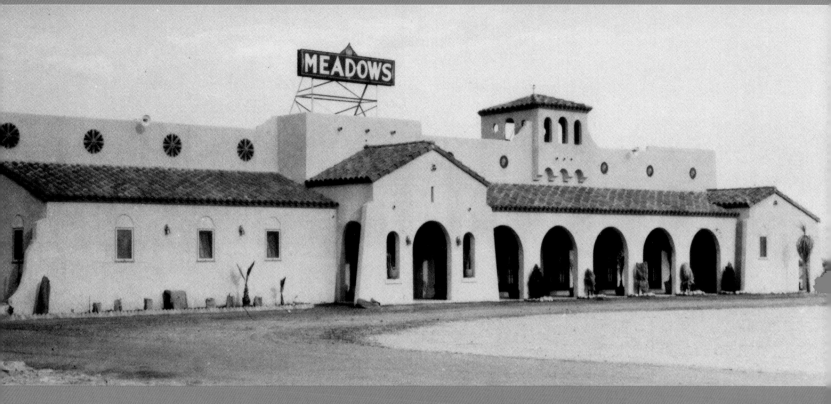

Located just beyond Las Vegas's city limits, on Boulder Highway, the road to Boulder City, the Meadows Club catered mainly to dam workers and locals with cars.

California gambler Tony Cornero (lower left) and his brothers opened the Meadows Club in May 1931. In addition to a variety of casino games, the upscale casino and cabaret boasted an elegant showroom and nightly performances by a Los Angeles band called the Meadow Larks.

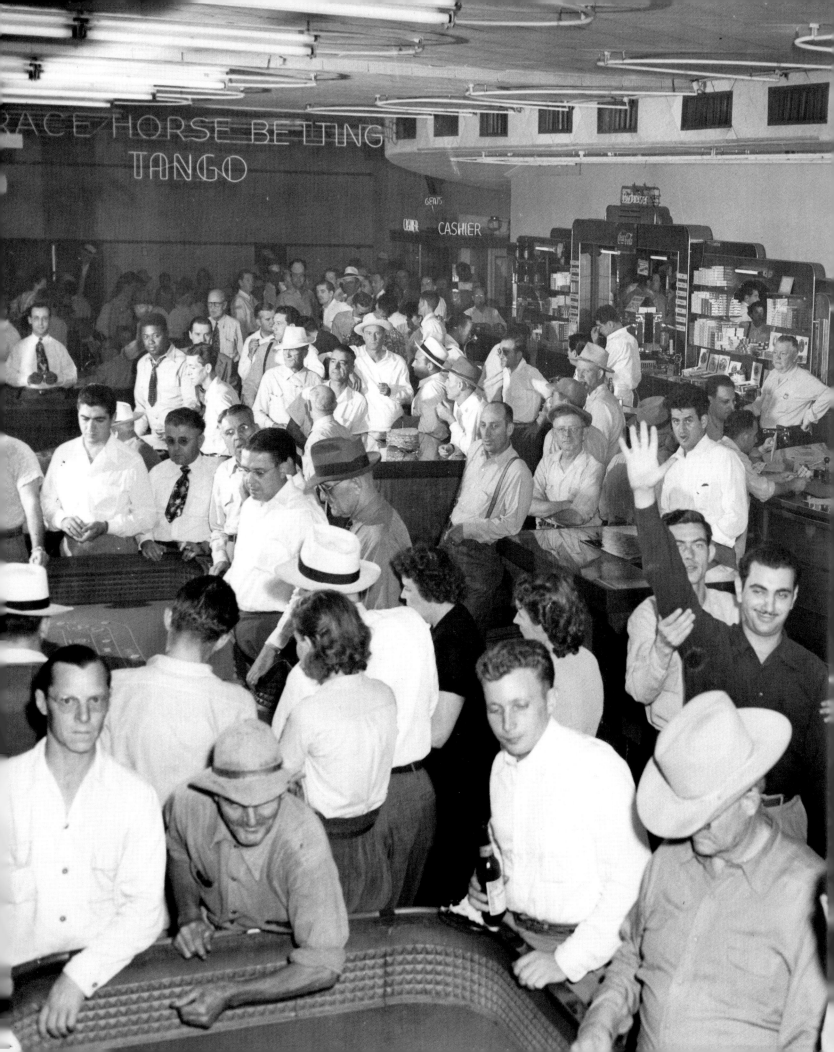

and California—came to gawk at what was fast becoming known as the "eighth wonder of the world," and most paused en route to sample the unique attractions of Las Vegas. By 1933, the year Prohibition was repealed, the town was successfully pulling in more than 250,000 visitors a year, only half of whom ever actually made it out to the dam site at Black Canyon.

Known now as the "Gateway to the Boulder Dam," the town was still only a curiosity on the road from here to there—not yet a destination unto itself. But by capitalizing on its proximity to the dam site and Nevada's embrace of wide-open vice, Las Vegas had inadvertently discovered the immense potential for profit in America's forbidden desires.

Above: The dam's name was a source of persistent confusion. The original bill introduced to Congress for the project had assumed the dam would be built in Boulder Canyon and was, therefore, named the Boulder Canyon Project Act. By the time a government report identified Black Canyon as the better site, the project was already so closely associated with the name Boulder that officials declined to change it. Even after the dam was christened—for Herbert Hoover—in 1930, many Americans continued to refer to it as the Boulder Dam.

Opposite: The Las Vegas Club, one of Fremont Street's major draws.

A crowd assembles in the powerhouse at the Hoover Dam for the inaugural run of the 3,500-horsepower generator, September 1936.

Key pin commemorating the dedication of the Hoover Dam, September 26, 1935. Although the dam had been rechristened "Hoover" years before, the key pin nonetheless reads "Boulder Dam."

Token to commemorate the launch of the Boulder Canyon Project, 1931.

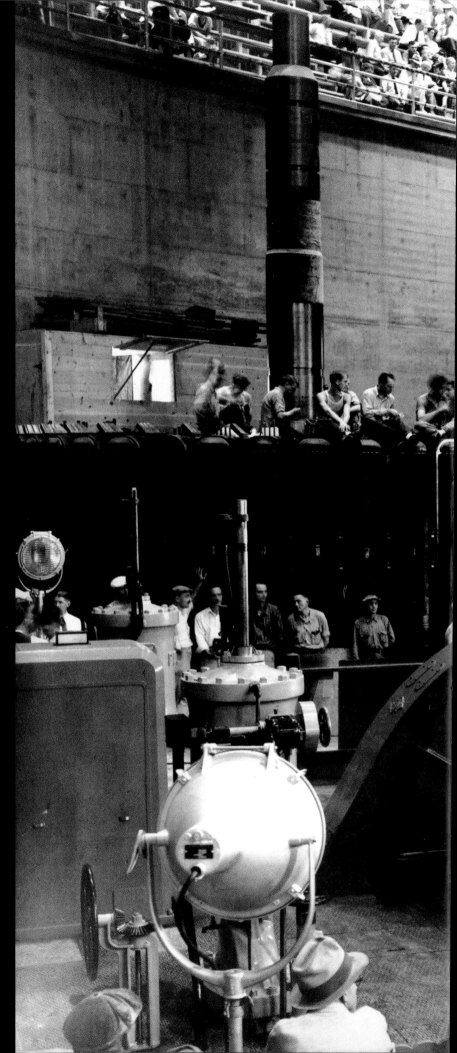

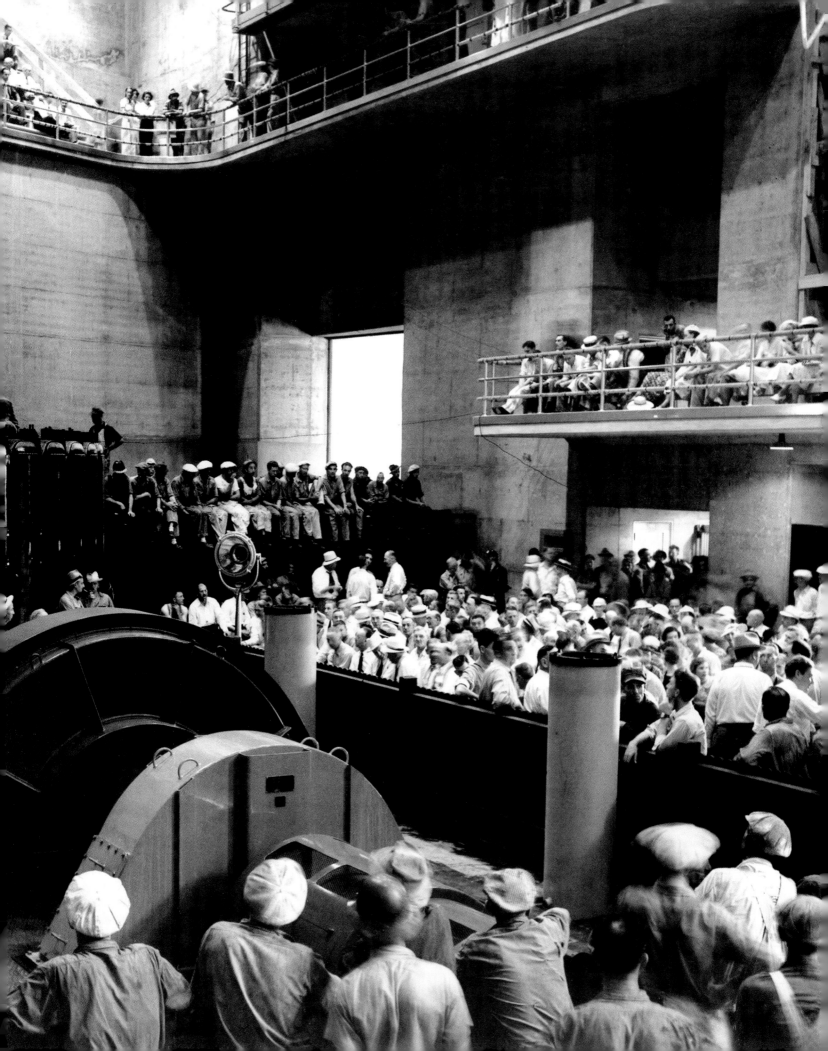

POQAS TO NO-LIMIT HOLD 'EM: A CONCISE HISTORY OF OUR NATIONAL PASTIME

BY JIM McMANUS

In 2003 the *New York Times* declared, "Whoever wants to know the heart and mind of America had better learn poker." The paper was reviewing *Positively Fifth Street*, my book about finishing fifth in the 2000 World Series of Poker. *Harper's* had sent me to Binion's Horseshoe in downtown Las Vegas to cover the progress of women in the tournament, and I somehow managed to secure a $10,000 seat in the Big One and then almost won the damn thing.

Fifth Street also touched on the ways in which Vegas is the natural home of America's pastime, but I now think the history of poker deserves a full-fledged book of its own. The game, after all, has gone hand in hand with pivotal aspects of our national experience for more than two centuries now. The ways we've done business, fought wars, chosen presidents, and explored our vast continent have echoed, and been echoed *by,* its risk-loving acumen. Like legging the spread in a frenzied commodities pit or lighting out for unmapped and perilous territory, poker rewards the skill to manage uncertainty, trade futures with rivals by divining the subtlest gestures and tendencies, and face down assaults from all quarters. Even though women have begun to compete in large numbers, the game still reflects America's sense of manliness, as well as our melting-pot values. In the meantime players such as Jennifer Harman, Annie Duke, and Kathy Liebert have stormed their way close to the top of twenty-first-century pokerdom.

America has never been able to forcibly export our core values. Poker, however, along with much else in our culture, gets the job done more smoothly. With its frontier spirit intact, it's the most popular card game on earth, though the Puritan strain of our heritage remains dreadfully nervous about it. Presidents play it, tournaments are broadcast on Super Bowl Sunday and most other evenings, while the winners get showered with endorsements and take star turns on Letterman. Yet in many states, even dime-quarter games are illegal; if the stakes get too high in most others, you can be

prosecuted for "aggravated gambling." You are breaking the law if you play Texas hold 'em, or any other form of poker, in Texas.

Nevada made poker legal in 1931, and Las Vegas has been the game's capital since the Eisenhower administration, but it arrived in this country through the port of New Orleans a century and a half before Ike. By 1800, French soldiers had introduced a game called *poque* to New Orleans, and well before the Louisiana Purchase, in 1803, sailors from Persia—modern-day Iran and Iraq—were teaching French settlers *As Nas*, Farsi for "My beloved ace!" Eminent pokeratician Al Alvarez believes the game was invented by the French merchants and diplomats "in Persia around the beginning of the nineteenth century [who] adapted their own game of *poque* or *bouilotte* to the local As-Nas deck, then taught it to their Persian hosts." Combining *poque* with *as*, that game was known as *poqas*. After shuffling a twenty-card deck (aces, kings, ladies, soldiers, and dancing girls, one for each suit), five-card hands were dealt to four players, who represented (or misrepresented) the strength of their cards by saying, for example, "I

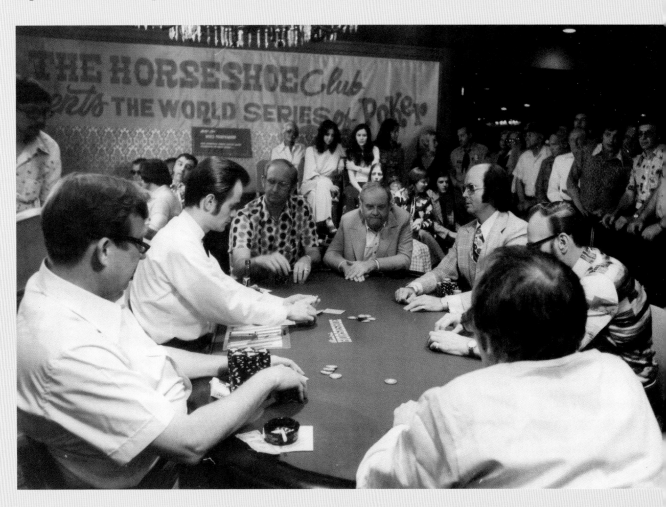

Benny Binion (center), owner of the Horseshoe, waits between hands at the World Series of Poker, the tournament he founded in 1970. By 2004 the world series was drawing so many players that it had to be held at the Rio, a larger venue west of the Strip.

poque against you for six dollars." Four aces, or four kings with an ace, were the only unbeatable hands, but even if you held no pair at all, the look in your eye combined with the size of your wager could force players holding much stronger hands to relinquish the pot, a tactic with a risk-reward quotient very much in the spirit of our wide-open market democracy.

As more and more folks wanted in on the new risqué chancing, it migrated via steamboat up the Mississippi and Ohio rivers. The southern pronunciation was "pokuh," which as the game traveled north became "poker." The rules changed as well. A fifty-two card deck was brought in to accommodate up to ten players and make for more lucrative pots. Flushes and straights were soon introduced, along with the option to draw three new cards, demanding more tactical prowess.

The game's popularity exploded during the Civil War, when soldiers on both sides took it up in the lulls between bloodbaths. Several Confederate victories forced a desperate Lincoln to put the hard-drinking poker player Ulysses S. Grant in command of the Federal army. Unlike his dithering predecessors Grant had a genius for forcing the action—anticipating enemy tactics and countering with devastating ferocity. His ablest lieutenant, William Tecumseh Sherman, found himself in 1864 outside Atlanta facing a Confederate army under John Bell Hood. An officer informed Sherman, "I seed Hood bet $2,500, with nary a pair in his hand." Bluffing such a colossal sum in antebellum dollars confirmed Sherman's read of Hood as brave but impetuous; therefore, he reconfigured his troops defensively and put them on highest alert. As if on cue Hood shattered his army with three suicidal attacks on superior Federal positions.

Civil War survivors brought poker home with them to every state and territory. Since Confederate veterans had fewer prospects, a disproportionate number of them headed West, which helps to explain the modern game's southwestern twang. Back then it was played with the same reckless verve that prospectors, cavalrymen, and wagon-train scouts brought to their day jobs. When their progeny needed time off from building dams, railroads, and highways from Salt Lake City to Los Angeles, a gaming Mecca sprang up to tempt them.

Poker was now fully integrated into the American way of life and had even begun to emigrate. Harry Truman learned to play in Missouri and honed his skills as a doughboy during the Great War in France. On decks issued by the Allies during World War II, Churchill was depicted as the king of spades, Roosevelt the king of diamonds, Stalin the king of hearts, de Gaulle the king of clubs; Hitler, as the useless joker, had a bomb dropping onto his head. Decks smuggled to POWs concealed escape routes out of Germany, revealed when certain pasteboards were separated and dipped in water. During shipboard games in the Pacific, Lt. Richard "Nick" Nixon won enough to finance his first congressional campaign. Farther up the chain of command, President Truman played pot-limit five-card stud with journalists almost twelve hours a day aboard the

U.S.S. *Augusta* while finalizing his decision to drop an atomic bomb on Hiroshima. Secretary of State James Byrnes vigorously opposed using the bomb on any city, and Truman used the daylong poker sessions to reduce Byrnes's access to him. A UP reporter aboard the *Augusta* wrote that Truman "was running a straight stud filibuster against his own Secretary of State."

John Kennedy may have been bluffing with the best hand against Khrushchev during the Cuban Missile Crisis, but the planet was lucky the Soviet premier finally blinked. Gen. David Shoup, Kennedy's trusted adviser, had told his commander in chief: "The commonest mistake in history is underestimating your opponent—happens at the poker table all the time." In Vietnam our military not only underestimated but tried to intimidate the Vietcong by festooning their casualties with the ace of spades as a "calling card." (The Bicycle brand card was favored because many superstitious Vietcong believed that Lady Liberty on the back represented the goddess of death.) Three decades later, in light of his underestimation of Iraqi insurgents, many wonder whether President Bush has effectively countered the bargaining chips in North Korean and Iranian arsenals while playing "Plutonium Poker"—the phrase is Fred Kaplan's, in *Slate*—with Kim Jong Il and the mullahs in Tehran. We will see.

In May 1970, at the corner of Second and Fremont in downtown Las Vegas, sixty miles south of where hydrogen bombs had recently been tested, casino boss Benny Binion created the World Series of Poker. His idea had been germinating since 1949, when Nick "the Greek" Dandalos came looking to play "the biggest game this world has to offer." Having busted every gambler back East—including Arnold Rothstein, who'd fixed baseball's World Series in 1919—Dandalos had won in the neighborhood of $60 million, although he then lost most of it on the Thoroughbreds. Told that Benny Binion was the man to see about no-limit action in Vegas, Dandalos proposed that he match him "against any man around" in a winner-take-all poker marathon. Benny phoned up Johnny Moss, the best poker player he knew. Moss's formal education had ended, like Benny's, in the second grade, but no one could beat Moss at poker or Benny at entrepreneurship. Moss had been playing in Odessa for three days straight, but he got on the first plane to Vegas, took a taxi to Benny's casino, and immediately sat down to face Dandalos.

Benny positioned their table near the entrance, where it was soon hemmed in by audiences of two to three hundred. For the next five months, they played several forms of poker, breaking for sleep only once every four or five days—this, as fresh dealers rotated in every twenty minutes to keep the action brisk and precise. The Greek finally

succumbed with a handshake and the famous line, "Mr. Moss, I have to let you go." Legend has it that the Texan took between $3 and $4 million from the game. Adjusted for inflation, this would be like winning $15 to $20 million today. Moss moved to Vegas and stayed.

It wasn't until 1970, after a stint in Leavenworth for tax evasion, that Benny invited his highest-rolling cronies to compete among themselves in their five favorite games, calling the promotion Binion's World Series of Poker. Moss was sixty-three now, yet he thoroughly outplayed his younger rivals, who voted him champion. The current freeze-out structure, in which everyone sits down with $10,000 and plays no-limit hold 'em till somebody wins every chip, was established the following year, when Moss defeated five challengers. Hold 'em is a variant of seven-card stud, in which each player sets two cards facedown, to be combined with five community cards dealt faceup in the middle of the felt. Originally called hold me, darling, the game was introduced to Las Vegas in 1963 by Texan Felton "Corky" McCorquodale. As *poqas* combined Persian, French, and American ingredients to become poker, hold me, darling, was naturally abbreviated to hold me, and then somehow, via the drawling vicissitudes of cowboy enunciation, to hold 'em. Its rules recommend it, too. Since you share five-sevenths of your cards with opponents, the difference between the best and the second-best hand—all the difference in the world, you might say—is subtler than in seven-card stud. Then too, seven-stud is always played with fixed bet sizes, whereas hold 'em, with four betting rounds instead of five, lends itself more readily to a no-limit format, which gives experts more leverage to win pots without being dealt the best hand.

In 1972 Amarillo Slim Preston got $80,000 for defeating seven opponents. Much more the raconteur than Moss, the tall, rail-thin Preston published a quickie best seller and went on the talk-show circuit. His dozen appearances on the *Tonight Show,* as well as three stints on *60 Minutes* and speeches before the National Press Club and the United States Senate, boosted exponentially the public's interest in Binion's World Series. "This poker game here gets us a lot of attention," Benny told an oral historian, and he wasn't exaggerating. Seven thousand stories had appeared in newspapers and magazines, but Benny was just getting started. "We had seven players last year, and this year we had thirteen. I look to have better than twenty next year. It's even liable to get up to be fifty, might get up to be more than that . . ." He paused, gazing beyond his interviewer for a moment. "It will eventually."

By the time Doyle Brunson became the second repeat champion, in 1977, eighty-five players had entered, with first prize mushrooming to $340,000. Dollars awarded at the WSOP now dwarf the purses of Wimbledon, the Masters, the Kentucky Derby, and

baseball's World Series. Gregory P. Raymer, the latest titleholder, outlasted six thousand contenders and took home $5 million. Money is the language of poker, of course, and nowhere is it spoken more eloquently than in no-limit hold 'em tournaments. So many want to compete in the Big One that the WSOP outgrew the Horseshoe and was moved to the Rio in 2004. Big-money, high-prestige events at the Mirage and Bellagio, over on the Strip, as well as in London, Dublin, Sydney, Paris, Amsterdam, Moscow, and Atlantic City, all closely mimic the WSOP format. Dominated by Texans for almost two decades, the series has lately crowned champions from Brooklyn, the Bronx, Boston, Grand Rapids, Las Vegas, and Stonington, Connecticut, not to mention from Vietnam, China, Ireland, Spain, and two—Mansour Matloubi in 1990 and Hamid Dastmalchi two years later—from Iran, the cradle of card playing.

Since 2003 ESPN and the Travel Channel's hole-card cameras have rounded up millions of new pokeristas. All but a few are well-behaved folks quaffing mineral water in state-sanctioned card rooms, although poker's erotic and outlaw cachets both still enhance its appeal. What used to be called "the cheater's game" is now, for better or worse, at the heart of the world's on-again, off-again romance with market democracy. And more than in politics, warfare, business, or physical sports, poker has become the arena in which men and women compete on the most nearly equal footing. Toned jocks get outplayed every day by people in wheelchairs, while movie stars run over Vegas's flintiest veterans. Evangelical Christians compete with Larry Flynt, CEOs with barmaids and call girls, Persians and Brits with Egyptians and hundreds of rounders named Nguyen. If America is a melting pot, our national card game has become the crucible in which folks from all over the planet find themselves welcome contenders.

Rituals such as poker, says biologist E. O. Wilson, "celebrate the creation myths, propitiate the gods, and resanctify the tribal moral codes." Aces, kings, queens, soldiers, and half-naked dancing girls (chastened into Arabic tens), as well as the eight lower numbers, permutate and combine into untold variations on the theme of what our genes make us do. When we read the community cards and abide by the rules, surrendering a mountainous pot to the grandmother showing down jacks to our tens, we participate in and "resanctify" antediluvian pecking orders. We even accept that, weirdly enough, a deuce is the smallest a thing can get, smaller than even a one; that in tandem, however, deuces overmatch any ace, any face card; but that even three deuces must lose to a straight or a flush—unless, of course, another pair materializes, in which case we have a full house. Straight flushes at the top, then quads, fulls, flushes, straights, sets, two pairs, pairs, highest card, highest kicker: poker's recombinant totem pole, based as it is on money, gender, mathematical scarcity, the Arabic counting scheme, and our status-hungry social order—especially in the cathedrals of Eros and chance that dominate the evolving Strip skyline—feels right in our market-based marrow.

LAS VEGAS GAMBLERS LOSE SOME $5 BILLION A YEAR AT THE SLOT MACHINES ALONE

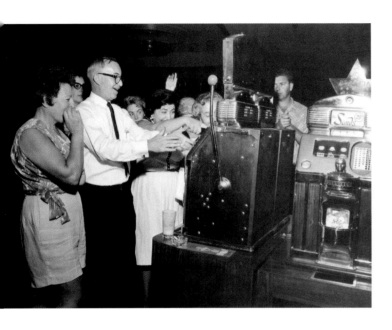

Noël Coward, the English playwright and cabaret star who performed in Las Vegas in the mid-1950s, called them fruit machines—probably in reference to the pictures of lemons and cherries that decorated their whirling reel strips but also quite possibly in affectionate mockery of those who spent hour upon hour pumping nickels into a machine's greedy maw, yanking away at its stiff, black-knobbed lever, and hoping for the clatter of coin on metal that signaled the all-too-rare jackpot. "The sound is fascinating," Coward reported, "the noise of the fruit machines, the clink of silver dollars, quarters, nickels . . . The din is considerable, but you get used to it."

Invented in 1895 by Charles Fey, a Bavarian native turned San Franciscan who had spent his late teens as an apprentice to a scientific-instrument maker, the cacophonous mechanical slot machine—or one-armed bandit—quickly became a staple in San Francisco's Barbary Coast gambling clubs and saloons, hooking hordes of small-time bettors with its promise of a dollar return on a nickel investment. After Nevada legalized gambling,

in 1931, the machines began turning up in Las Vegas, not only in casinos and saloons but also at gas stations, grocery stores, and eventually even the departure lounge at McCarran Airport. In contrast to table games such as blackjack and craps, which require a modicum of both skill and composure, the slots appealed primarily to the inexperienced and easily intimidated player—a quality that casino owners gradually came to associate with healthy profit margins. By the mid-fifties, slot machines had begun to take up ever more space on the casino floor, precisely, as one operator told a journalist, "to keep the women busy while their husbands get trimmed."

The introduction of electrical slots, dollar slots, and, more recently, progressive reel slots such as Quartermania and Megabucks—which link to a statewide network via modem and multiply jackpots into the millions—have boosted the popularity of the so-called sucker's game substantially. With the investment of a dollar, the casino hold can be set at as little as 5 percent without compromising the house advantage. One result has been bigger potential payoffs for players: consider the twenty-something bachelor from Southern California who recently claimed a $39.7 million jackpot from a Megabucks machine at the Excalibur Hotel and Casino. But for every jackpot there are literally millions upon millions of losses, which translate into astronomical profits for the casinos. By 2004 between 60 and 70 percent of all gaming revenue in Las Vegas came from the slots—more than all the table games combined.

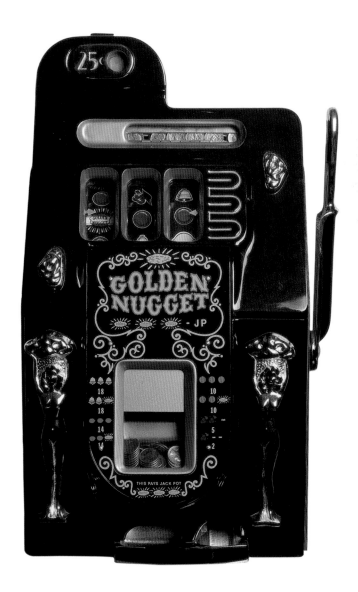

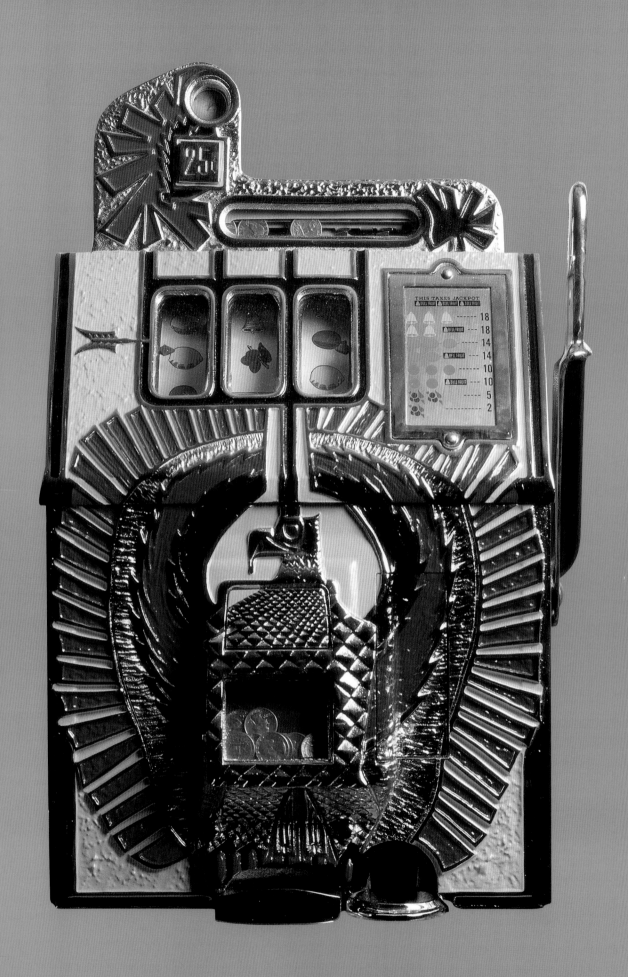

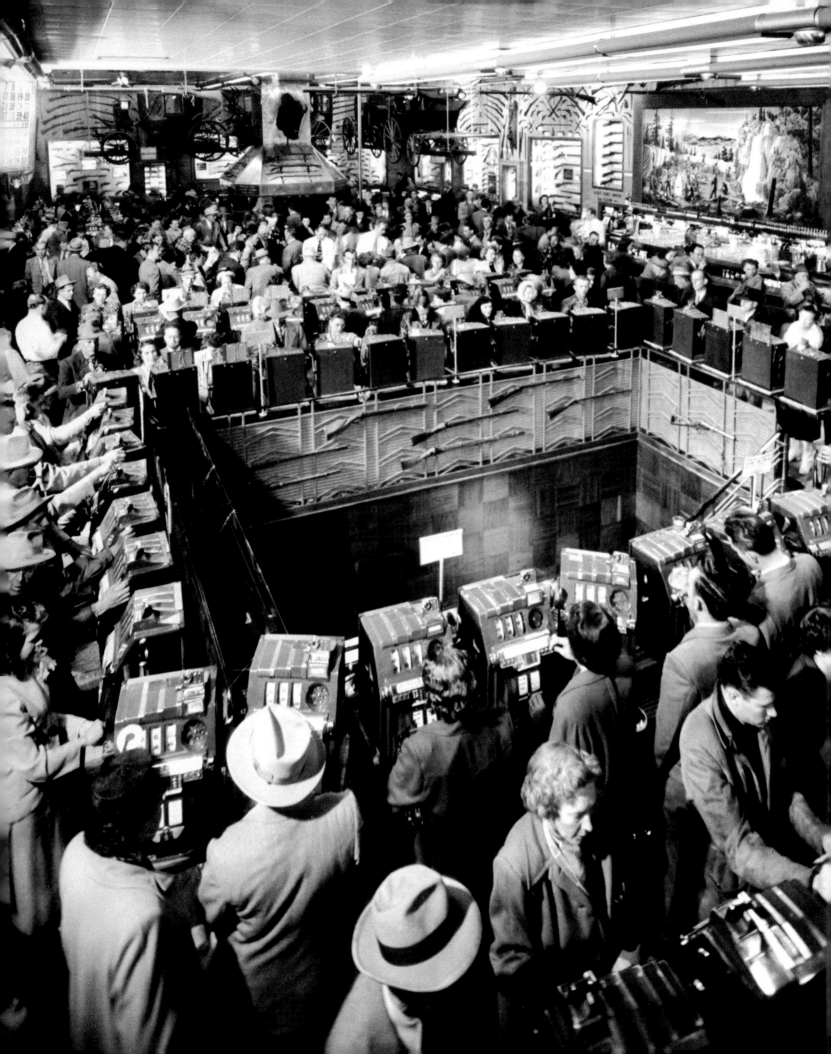

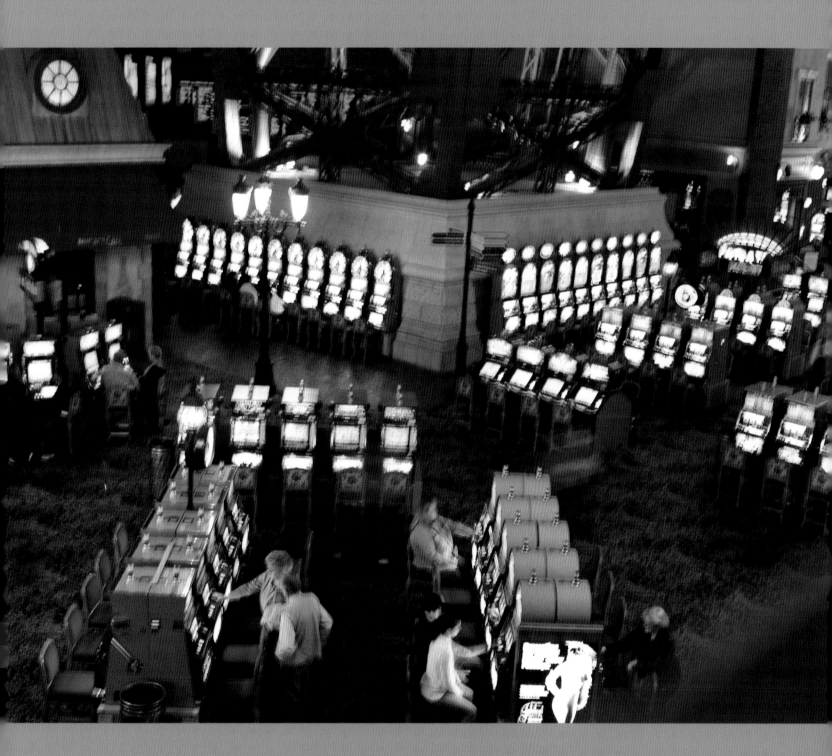

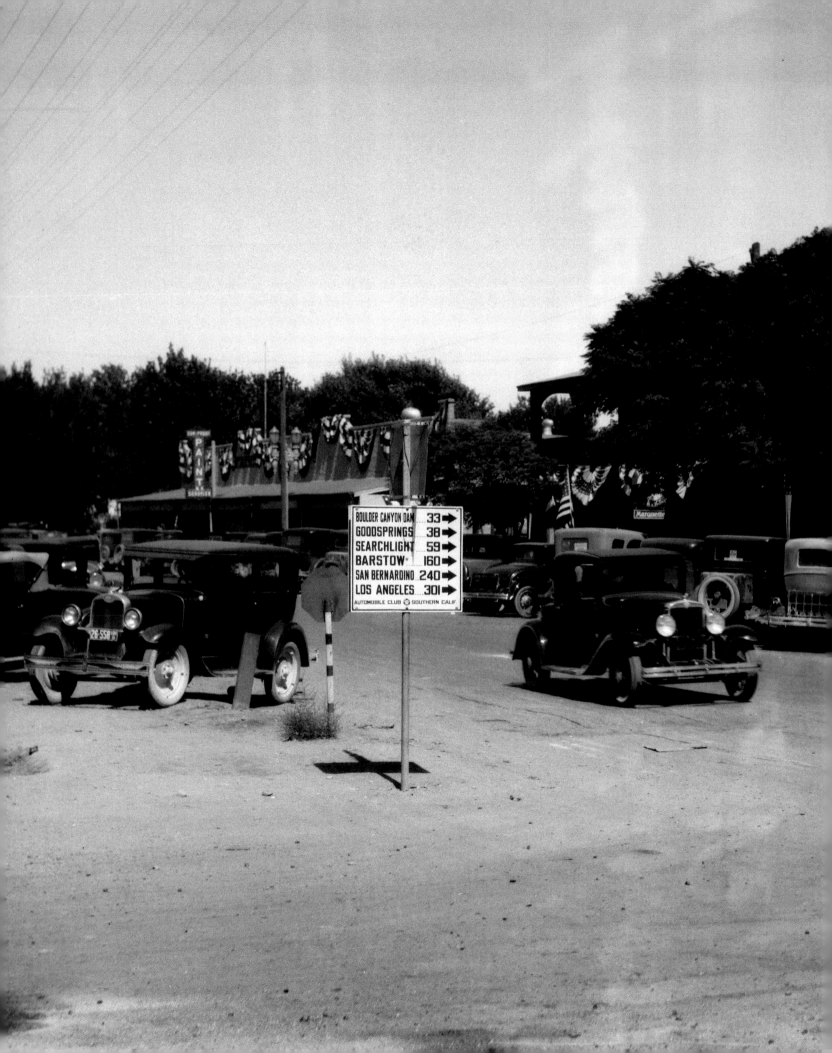

CHAPTER THREE
A FAR-FLUNG SUBURB OF L.A.

By the time President Franklin Roosevelt dedicated the nearly completed Boulder Dam, in the fall of 1935, Las Vegans were already bracing themselves for yet another bust. In the months to come, thousands of dam builders would collect their final paychecks and blow out of town, and the boisterous crowds that had made Fremont Street hum for half a decade would be little more than a memory.

Eager to offset the loss of the town's regular clientele, local boosters dreamed up a gimmick designed to make Las Vegas a permanent tourist destination. Imbuing the town's reputation for depravity with a tinge of nostalgia, they began to promote their sleepy desert outpost as the one and only place in the country where Americans could still experience the Old West. In 1935 the local Elks chapter launched "Helldorado Days," an annual festival featuring authentic Western events such as cattle roping, bronco riding, and a cowboy parade. Later a mock frontier town called Helldorado Village was cobbled together, complete with wooden sidewalks, hitching posts, and

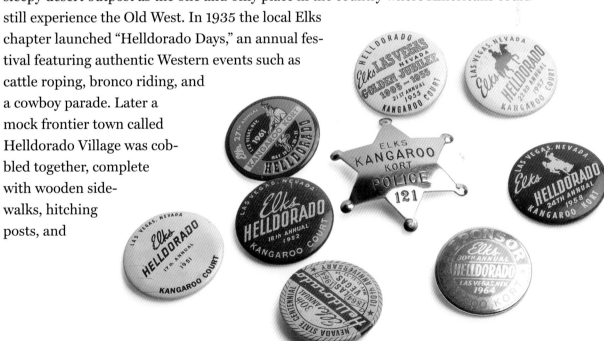

Opposite: An intersection at the southeast edge of town, 1930s.

Above: Buttons identified local sponsors of the Las Vegas Elks' annual Helldorado Kangeroo Kourt, a fund-raising event in which participants were "arrested" and placed in fake jail cells, with "bail" set at one dollar. Proceeds went to charity.

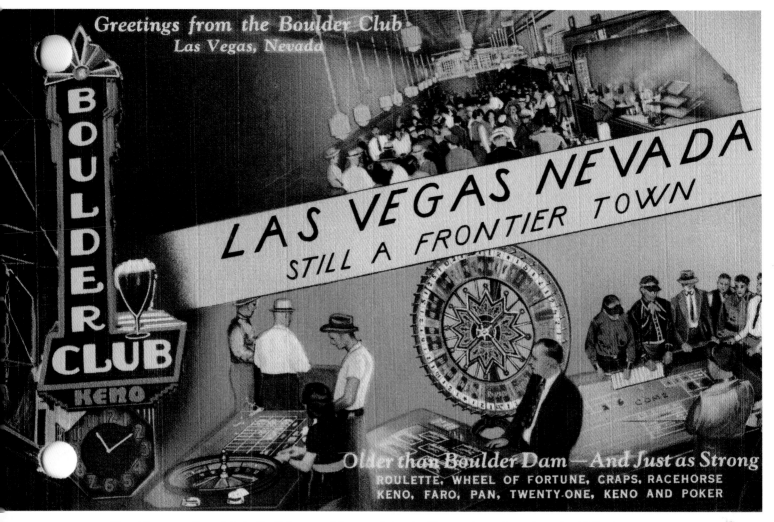

Illegal in every other state in the Union, gambling carried a significant stigma throughout the 1930s. Las Vegas's clubs and casinos tried to work around this with nostalgic references to the Old West.

watering troughs. Meanwhile, the clubs and hotels in town went wild with the Western motif, tacking wagon wheels to the walls, dressing bartenders in cowboy boots and ten-gallon hats, and blanketing the floors in sawdust.

But in the end it was not the Last Frontier pose that would turn Las Vegas into a place to go; it was the town's proximity to Los Angeles and its talent for making the most of any opportunity—that and a run of supernaturally good luck.

Las Vegas's winning streak began in 1937, when a New Deal–funded project completed the paving and widening of Highway 91, the lonely, two-lane road that ran southwest out of town to Los Angeles. Far more than a strip of concrete and tar, the newly improved highway was a promise of prosperity. Although it would be several more years before leisure motorists were willing to brave the seven- or eight-hour trip—during which the odds of the engine overheating somewhere in the middle of the

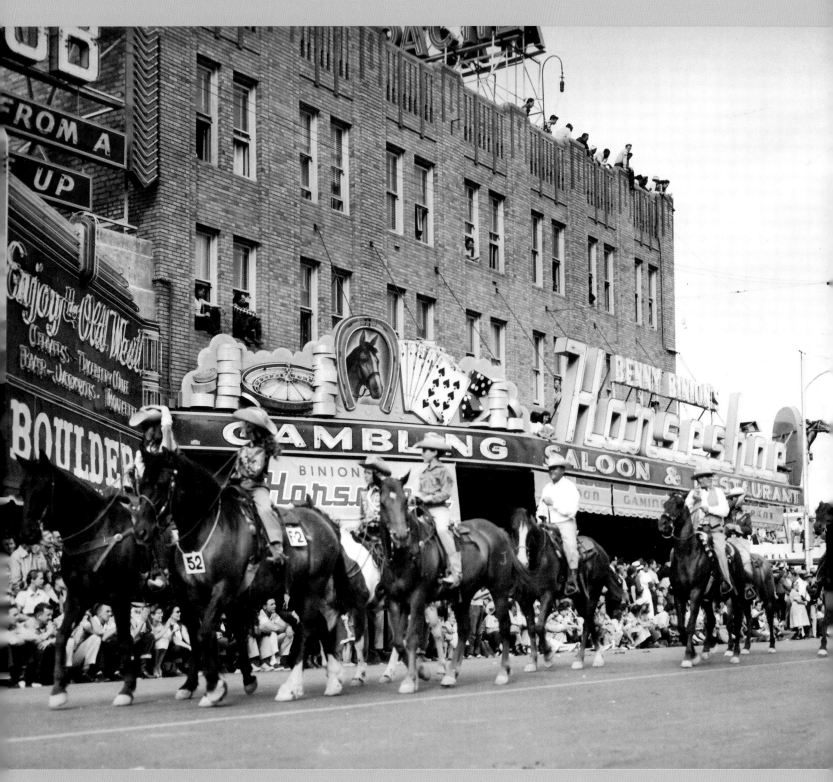

The annual Helldorado parade remained a popular local event well into the 1950s.

To Los Angeles
7 DAYS BY JACKASS
in 1837

1¾ HOURS BY PLANE
in 1937

Doesn't That Beat Hell-
dorado

Western Air Express
PHONE LAS VEGAS 800

Mohave were better than even—the more navigable highway would soon prove to be the town's primary conduit for growth, funneling in so many Southern Californians over the years to come that one observer would be moved to describe Las Vegas as "a far-flung suburb of L.A."

The cars came rattling across the desert the very next year, a veritable caravan of cardsharps, bookies, and dirty cops on the lam, all of them run out of Los Angeles by newly elected mayor Fletcher Bowron and his campaign-promised crackdown on vice. California's loss was Nevada's gain. Forced out of business and facing criminal prosecution, dozens of illegal Los Angeles casino operators hit the desert highway and headed for Las Vegas, the one sizable town in a three-hundred-mile radius where their dark trade could be plied in the open. As a writer once said of Monte Carlo, it was "a sunny place for shady people."

Leading the rogue migration was Captain Guy McAfee, a corrupt LAPD vice squad commander and husband of a notorious Hollywood madam. Before the attack of conscience in the City of Angels, McAfee had been a silent owner in several underground gambling parlors, an experience that had left him well versed in all aspects of casino management, from analyzing percentages to spotting cheats to maximizing the nightly hold. In Las Vegas, where the gambling operations were still run mainly by novices, such expertise was a valuable and welcome asset—the fugitive status of the expert in question notwithstanding. By late 1938 McAfee and his Los Angeles associates had already taken over much of the local casino business, greatly enhancing both its profitability and its image, and paving the way for other entrepreneurs of their ilk.

Opposite: Western Air Express introduced regular flights between Los Angeles and Salt Lake City in 1926 and operated an airfield ten miles northeast of Las Vegas until World War II.

Right: When a reform-minded mayor closed down Guy McAfee's gambling parlors in Los Angeles, McAfee brought his expertise to Las Vegas.

But the lucky inheritance of Southern California's most experienced gambling operators was only the beginning for Las Vegas. In mid-January 1939, before McAfee and the others had even got their enterprises off the ground, the town received an additional boost from yet another Angeleno, a prospective divorcée named Ria Langham—better known as Mrs. Clark Gable. Gossip columns around the country had been reporting on the imminent implosion of the Hollywood screen idol's marriage for months, and Langham's decision to wait out her legally mandated residency requirement in Las Vegas—rather than in Reno, the Nevada town best known for catering to divorcées—struck local boosters as a fact destined for a national dateline. Although Langham had hoped to keep a low profile while in town, she eventually caved in to the pleas of three reporters from the *Las Vegas Review-Journal* and agreed to cooperate with the local press on the condition that no stories be printed until after her divorce was final.

Over the next six weeks, while her soon-to-be ex-husband cavorted in Hollywood with screen siren Carole Lombard, Langham gamely played the gay divorcée for the *Review-Journal*'s cameras. She was photographed riding horseback in the desert and hosting glamorous parties at her rented home; dealing craps, roulette, and blackjack at the Apache Club; and cruising Lake Mead on a yacht. Meanwhile, the *Review-Journal*'s editor prepared a full-page, lavishly illustrated feature that took pains to highlight Las Vegas's gracious hospitality while simultaneously poking jabs at rival Reno. The story was later sent to eighty-five newspapers all over the country and actually printed in fifty. Captain McAfee, for his part, wisely capitalized on the free publicity and timed the grand opening of his Pair O' Dice Club to coincide with the Gables' final divorce decree in March.

Nevada's already scandalous reputation was greatly enhanced by its so-called quickie divorce, which enabled disgruntled couples to dissolve their unions in forty-two days flat.

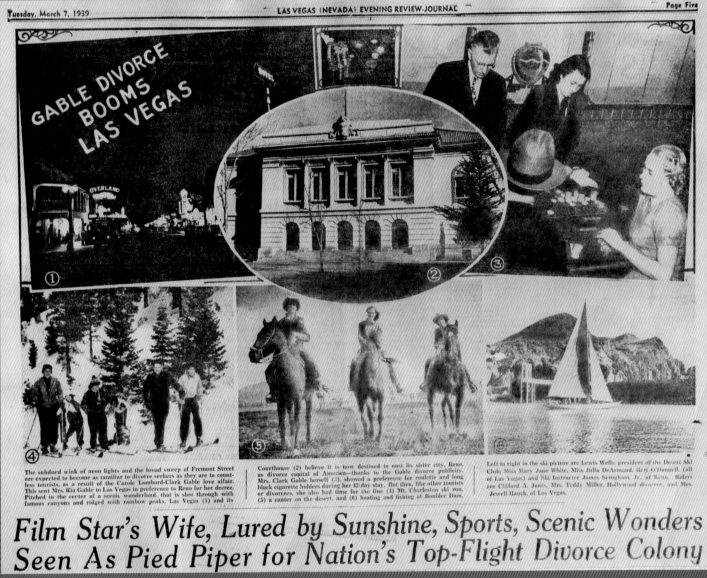

GABLE DIVORCE BOOMS LAS VEGAS

The subdued wink of neon lights and the broad sweep of Fremont Street are expected to become as familiar to divorce seekers as they are to countless tourists, as a result of the Carole Lombard-Clark Gable love affair. This sent Mrs. Ria Gable to Las Vegas in preference to Reno for her decree. Pitched in the center of a scenic wonderland, that is shot through with famous canyons and ridged with rainbow peaks, Las Vegas (1) and its

Courthouse (2) believe it is now destined to oust its sister city, Reno, as divorce capital of America—thanks to the Gable divorce publicity. Mrs. Clark Gable herself (3), showed a preference for roulette and long black cigarette holders during her 42-day stay. But then, like other tourists or divorcees, she also had time for the fine (4) Mt. Charleston ski run, (5) a canter on the desert, and (6) boating and fishing at Boulder Dam.

Left to right in the ski picture are Lewis Wells, president of the Desert Ski Club; Miss Mary Jane White, Miss Julia DeArmand, Bert O'Donnell, (all of Las Vegas) and Ski Instructor James Scrugham, Jr., of Reno. Riders are Clifford A. Jones, Mrs. Teddy Miller, Hollywood divorcee, and Mrs. Jewell Hauck, of Las Vegas.

Film Star's Wife, Lured by Sunshine, Sports, Scenic Wonders Seen As Pied Piper for Nation's Top-Flight Divorce Colony

The *Review-Journal*'s feature on the Gable divorce appeared in newspapers across the country. In acknowledgment of Langham's cooperation, the local junior chamber of commerce made the famous divorcée a lifetime member and presented her with the gift of a silver cigarette case.

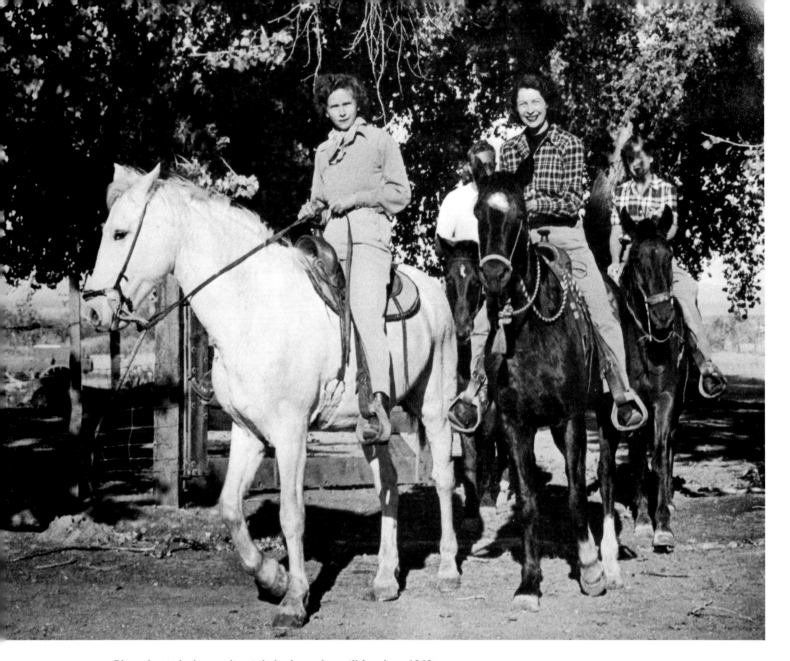

Disenchanted wives wait out their six weeks until freedom, 1940s.

Opposite: Thomas Hull's El Rancho Vegas, located just outside of town, on Highway 91, drew both motorists en route from Southern California and locals looking to escape the Fremont Street crowds.

Almost overnight Las Vegas became the number-one place in the country to dump a spouse. Celebrities, well-to-do industrialists, and middle-class housewives now rushed from California in droves, eager to put a rapid end to their marital misery. By the close of 1939, more than seven hundred marriages had been dissolved in Las Vegas, and Reno's hold on the title "divorce capital of the nation" seemed in danger of slipping away. "All the world began to show up," one Las Vegan remembered, "to get their own divorces where Ria and Clark got theirs." Most of them gambled a little while they

waited out their six weeks until freedom, and the word on Las Vegas spread. Before long, L.A.'s favorite spot to untie the knot would come to be seen as an ideal place for a weekend getaway.

Then, in early 1940, just as the Las Vegas quickie divorce had begun to catch on, California hotelman Thomas Hull selected the town as the site for the newest resort in his popular El Rancho chain. "For many years Las Vegas has bemoaned the absence of high type resort hotels and the wealthy class of people such would draw to us," one longtime resident enthused. "Now the ice is broken." To the puzzlement of many locals, however, Hull decided not to build downtown, near the train station, as common sense

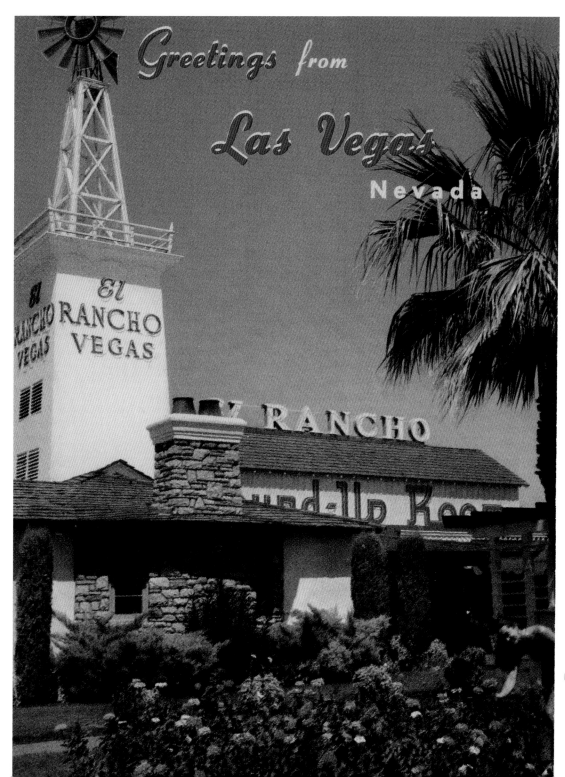

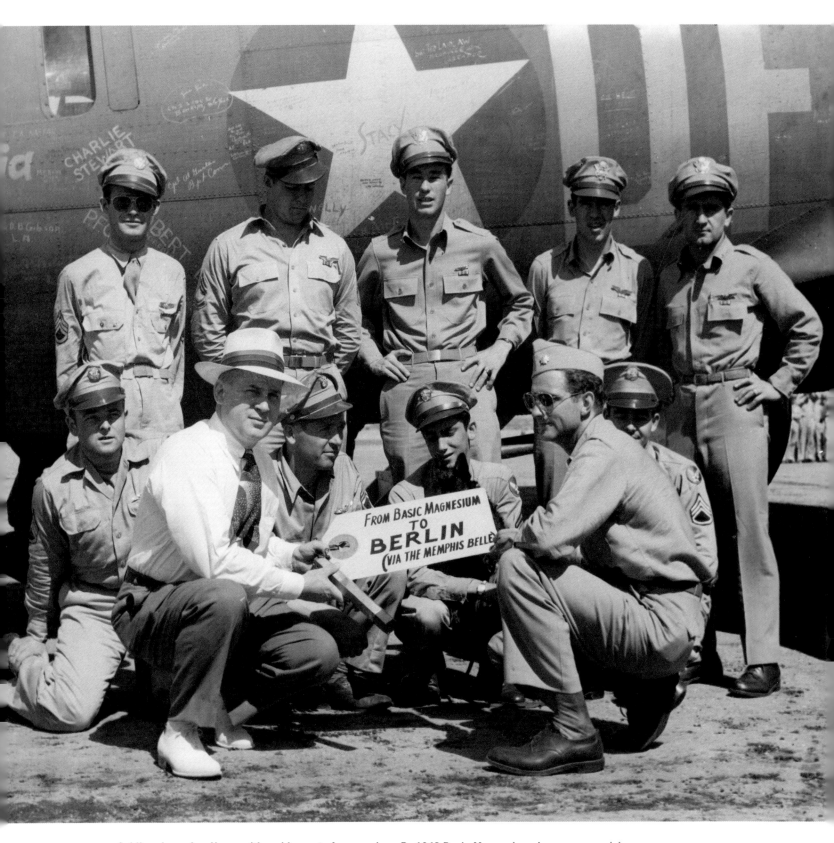

Soldiers leave Las Vegas with a shipment of magnesium. By 1943 Basic Magnesium, Inc., was supplying airplane and ordnance factories in Los Angeles with some five million pounds per day.

would have seemed to dictate. Instead, convinced that the popularity of train travel would soon be eclipsed by the automobile, he broke ground roughly three miles south of the center of town, on Highway 91, on a thirty-three-acre tract with plenty of room for parking. Situated a few feet south of the city limits, the site had the added advantage of being just beyond the reach of municipal tax collection.

A sixty-five-room, low-rise motor inn laid out in the old Spanish mission style, Hull's El Rancho Vegas would revolutionize the casino gambling experience in America. At a time when games of chance were played either on boats or else in ramshackle clubs or the cramped back parlors of small hotels, Hull made the visionary leap of putting a casino in the posh setting of a resort, surrounding it with a restaurant, several shops, a large swimming pool, lush gardens, and an elegant showroom that featured a chorus line of scantily clad dancers imported from Los Angeles. Done up in the town's now-traditional frontier theme and topped by an enormous neon windmill meant to attract passing drivers, the El Rancho was precisely the sort of establishment that local boosters had been hankering for—a full-fledged, full-service vacation destination. But deep down few thought the place would survive. The El Rancho was much too far from downtown to maintain any sort of steady patronage, skeptics reasoned, especially since nothing of consequence existed on the dusty road in between.

But the skeptics were wrong. By the time construction of the El Rancho was completed, in early 1941, providence had intervened once more, this time in the form of a massive influx of federal dollars. With the war in Europe escalating and Allied orders for planes and munitions pouring in, the U.S. government had already begun to dole out millions to build and staff key defense industries throughout the American Southwest. Las Vegas, with its relative isolation, ideal flying weather, and nearby deposits of minerals essential to the production of war matériel, was among the first to hit the federal jackpot. Just months after the El Rancho's opening, an Army Air Corps training base called the Las Vegas Gunnery School (later Nellis Air Force Base) opened eight

miles to the northeast of town, and construction began on Basic Magnesium, Inc., an enormous magnasite processing plant located fifteen miles to the southeast, on a 2,800-acre site just off the Boulder Highway. Over the next year, the two defense installations would lure some twelve thousand new residents, spawning the creation of a suburb near BMI called Henderson and more than doubling the total population of the valley.

A magnesium ashtray made by the employees of Basic Magnesium, Incorporated.

Suddenly the saloons and casinos in town were jammed to capacity. Though the army brass had insisted that Las Vegas regulate its infamous nightlife, demanding the shutdown of every bordello within a mile's radius of town and the closure of all drinking and gambling establishments between the hours of 2 and 10 a.m., the steady patronage of thousands of local soldiers and defense personnel more than justified the compromise. Better still, the number of out-of-town visitors was actually on the rise, as the defense boom boosted tourism in the far western states and preparations for war propelled thousands of impatient

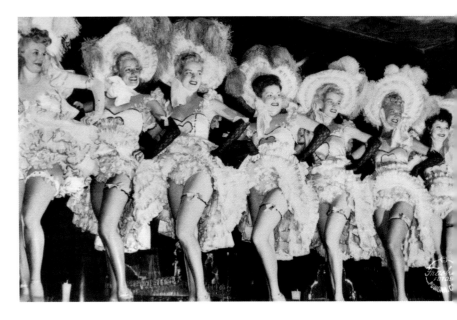

The chorus line at the Last Frontier, late 1940s.

couples across the California border and into Nevada, where they could tie the knot without waiting for the blood tests required back home.

At the El Rancho Vegas, business was soon so good that Hull added sixty new guest rooms, well ahead of his own expansion schedule. Within a year a competing resort had opened just down the road, an extravagant Western-themed complex called the Last Frontier that boasted a six-hundred-seat banquet facility, parking for nine hundred cars, and a mock frontier village filled with nine hundred tons of authentic western artifacts, including not only wagons and antique firearms but full-size mining trains and an actual mining camp jail. Neither gasoline rationing nor the general decline in travel during the war years kept people away. By 1945 Las Vegas was drawing tens of thousands of visitors annually, and some savvy entrepreneurs had begun to eye the town's up-and-coming new hot spot, Highway 91.

The Last Frontier Village included a wedding chapel (far right) called the Little Church of the West. Designed as an exact, half-size replica of a famous church built in Columbia, California, during the Gold Rush, it remains perhaps the most famous of all of Las Vegas's wedding chapels.

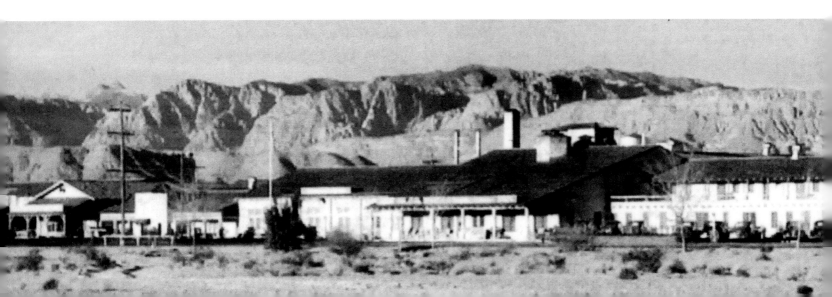

The Last Frontier inaugurated the Las Vegas tradition of elaborate theming with its painstaking re-creations. Its lobby was adorned with stuffed buffalo heads and Pony Express lanterns hanging from wagon wheels. In the guest rooms, cattle horns were mounted above every bed. But it was the Last Frontier Village (above), with its wooden sidewalks and hitching posts, that turned the resort into a major tourist attraction.

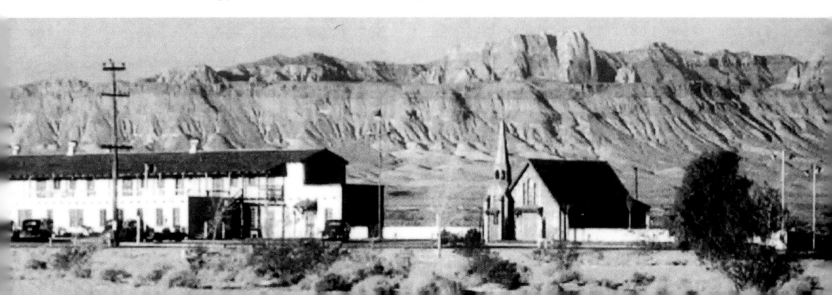

In the years to come, as new developments sprang out of the scrub, the property owners on Highway 91 would lodge a formal request with the city for a link to the municipal sewer system. Calculating the hard costs of building infrastructure rather than the potential benefits of collecting taxes, city officials flatly refused. Left no other choice the businessmen opted to create their own unincorporated township—essentially a sanitation district with the unlikely name of Paradise. But Captain McAfee had another appellation in mind. With a nod to Los Angeles, the city that had effectively kept Las Vegas from going the way of so many other specks on the map of Nevada, he dubbed the still mostly empty stretch of highway south of town "the Strip," in a kind of optimistic homage to Hollywood's famed Sunset Strip. He likely had no idea how prophetic the designation would turn out to be.

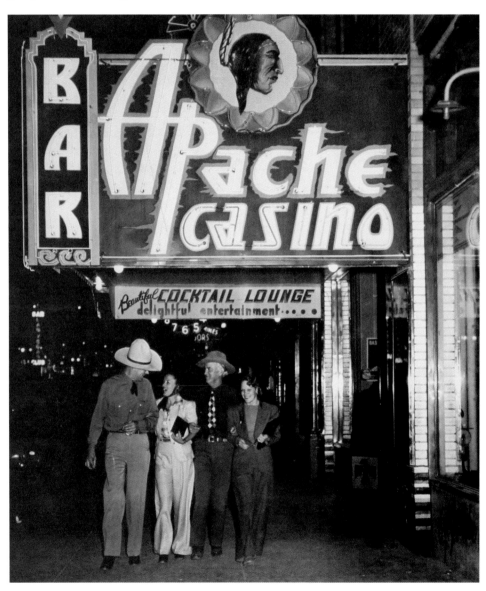

Revelers in downtown Las Vegas, where, as one observer put it, "every night is New Year's Eve."

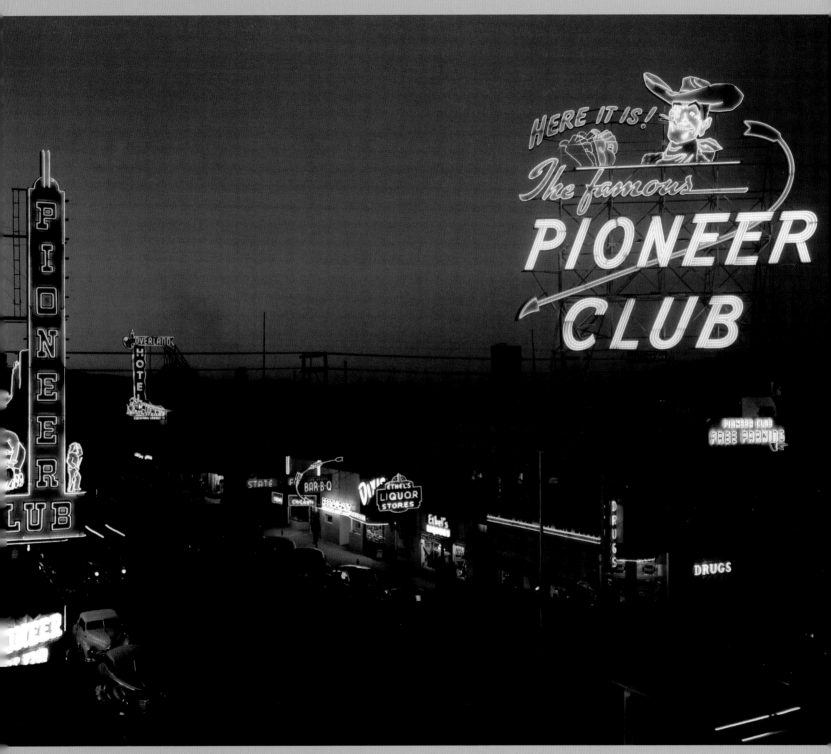

Following the trail blazed by Captain Guy McAfee and inspired by the wartime boom, Los Angeleno Tudor Scherer and his partners opened the Pioneer Club in downtown Las Vegas.

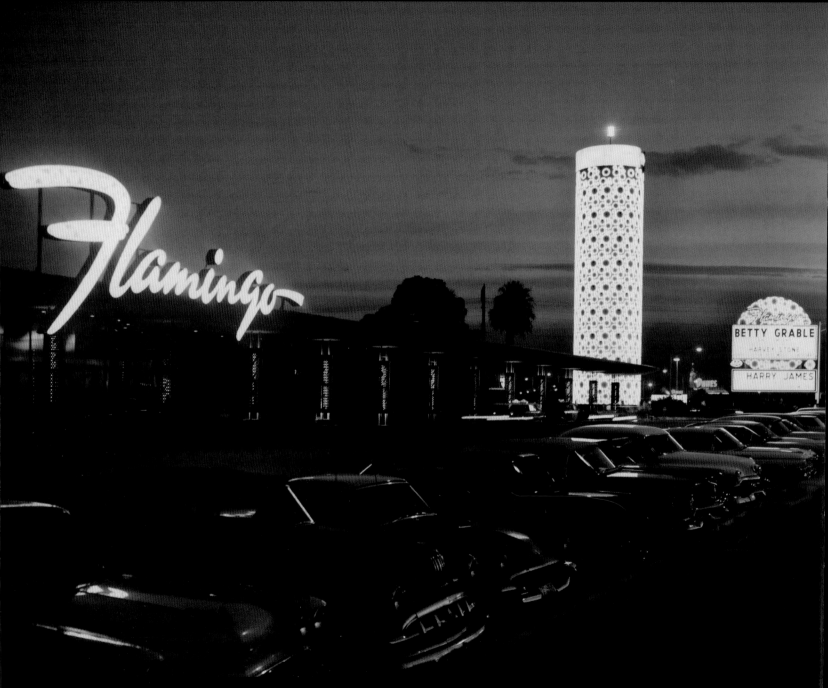

CHAPTER FOUR
THE FLAMINGO

Built by Benjamin "Bugsy" Siegel in the late 1940s, the Flamingo liberated Las Vegas from the Western motif. The eighty-foot-tall "Champagne Tower" was erected in 1953 and remained the tallest freestanding sign structure on the Strip for the rest of the decade.

By the mid-1940s, Las Vegas had staked its future on tourism. Fremont Street was already ablaze in neon, and the western-themed resorts on Highway 91 were doing a booming business. The town seemed to be on its way. But there was at least one local who thought Las Vegas was missing a bet. And in 1945, just as World War II came to a close, he vowed to transform the rowdy cowboy outpost into the Monte Carlo of the American West.

His name was Benjamin Siegel. On occasion people called him Bugsy, the moniker he had earned as a young tough on the streets of New York; but if they were smart, they never did so to his face. A notorious mobster and longtime associate of Meyer Lansky, the reputed boss of a loose underworld coalition known as the Syndicate, Siegel had spent the last twenty years overseeing illegal gambling, prostitution, bootlegging, and narcotics operations in dozens of cities all across the country. Now, at thirty-nine, he was far and away one of the most crooked entrepreneurs of his time.

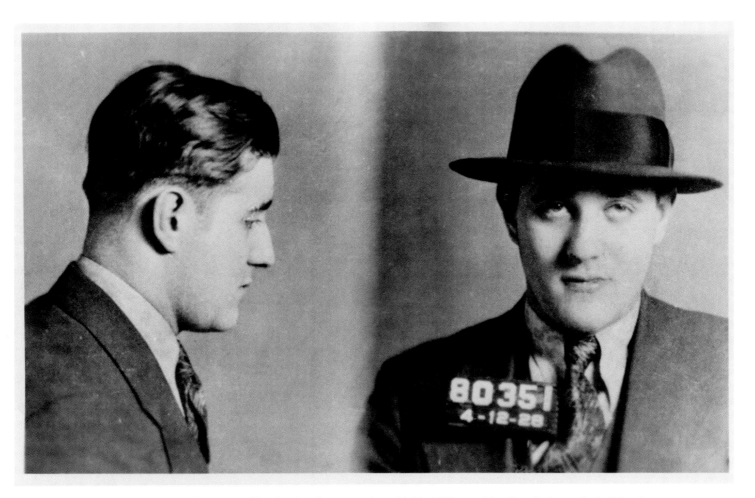

Mug shot of Benjamin Siegel, taken in connection with his 1928 arrest for disorderly conduct. At fourteen Siegel had headed up his own street gang, which carried out hits for some of New York's most notorious Prohibition-era bootleggers.

Meyer Lansky, shown here after a 1928 arrest for homicide, ran with Siegel as a kid on New York's Lower East Side. By the mid-1920s, he was in charge of a vast criminal organization known as the Syndicate.

Siegel (left) with his pal screen actor George Raft. If Raft could get parts playing gangsters, Siegel didn't see why he couldn't, too.

Opposite: U.S. marshals take Siegel (center) into custody in Los Angeles, where he was operating a book-making enterprise for the Syndicate. Run-ins with the law were fairly routine.

Moe Sedway (center) with associates Gus Greenbaum (left) and Benny Goffstein. Sedway accompanied Siegel to Las Vegas in 1941 and helped him put the screws to the local race-wire operator.

It was difficult to calculate how many had died at his hands. "He had gotten away with so many gangland executions," said one observer, "that he felt murder was legal, as long as it was done by him." In the bulging file the FBI eventually compiled on Siegel, one report noted simply that he "was insane along certain lines."

Siegel's true ambition was to be a film star. He had first gone out to Hollywood in the 1930s to run Los Angeles's half-a-million-dollar-a-day bookmaking enterprise for the Syndicate. In between collecting debts and roughing up the poor saps who could not make good on their markers, Siegel took acting classes and palled around with studio executives, starlets, and screen idol George Raft (who, ironically, was best known for his chilling portrayals of gangsters). But despite Siegel's constant prodding, his celebrity friends were reluctant to arrange a screen test. He just could not understand their hesitation.

Thwarted in his cinematic aspirations, Siegel focused instead on expanding the Syndicate's operations to Las Vegas. He made his first appearance in town back in 1941, shortly after Nevada became the only state in the Union to legalize racewire, a lucrative transmission system that relayed Thoroughbred race results to equestrians and offtrack bookies across the country. With assistance from Moe Sedway, a Lansky associate from Los Angeles, Siegel first undercut the local competition with ludicrously low prices; then he eliminated it entirely by poisoning the rival racewire operator, a luckless novice named James Ragan. Once the Syndicate's wire was the only game in town, Siegel jacked up his

prices and bullied the participating casinos into also paying a share of the book profits. The breathtaking ease with which the entire maneuver had been accomplished was not lost on him: wide-open Las Vegas, he told Lansky, was a town tailor-made for the mob.

Over the next several years, with the Syndicate's blessing, Siegel bought and sold interests in a half dozen local casinos before purchasing the downtown El Cortez outright, in 1945. With that deal, he and Lansky had masterminded a pattern of investment and profit sharing that would become the hallmark of the Las Vegas casino. The

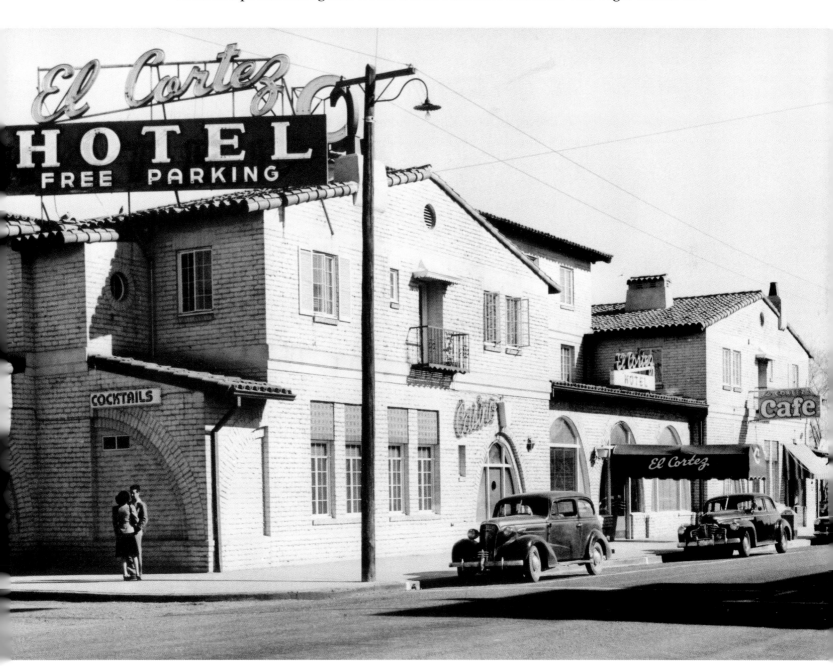

The El Cortez, on Fremont and Sixth streets, was downtown Las Vegas's first resort hotel. Siegel and other Syndicate investors took it over in 1945.

official owner was a front man. Behind him were the real owners—hidden, mobbed-up investors who got their share of the profits from cash skimmed off the top.

With a roster of fellow investors that read like a *Who's Who* of organized crime, Siegel now acquired an interest in a new development on the Strip, purchasing a two-thirds stake from the project's ambitious and indebted founder, Billy Wilkerson. The publisher of the *Hollywood Reporter* and owner of several swank clubs on the Sunset Strip, Wilkerson envisioned a resort hotel that, unlike the other establishments in Las Vegas, positively oozed glamour—carpeting, gourmet food, big-name entertainment, and an A-list celebrity clientele. Siegel's vision was both more extravagant and more blunt. As he put it to one reporter, his plan was to build "the goddamn biggest, fanciest gaming casino and hotel you bastards ever seen in your whole lives." He would call it the Flamingo.

Siegel's design plans called for a tropically themed resort of 105 lavishly appointed rooms; a restaurant and showroom; a health club; steam rooms; tennis courts; facilities for handball, squash, and badminton; stables for forty horses; a trapshooting range; a swimming pool; a nine-hole golf course; and assorted shops. Initial estimates

Billy Wilkerson (standing, center), the original founder of the Flamingo, chats with Siegel as he gets a shave and a manicure in Hollywood, 1936.

THE
FLAMINGO

LAS
VEGAS
NEVADA

MAIN
LOBBY

F4816

With its wall-to-wall carpeting, the Flamingo represented a quantum leap for Las Vegas design.

put the total cost for construction and related bribes at $1.5 million. Since the American banking establishment patently refused to invest in anything as tawdry as gambling, that sum would have to come almost entirely from the Syndicate—either out of Siegel's own pocket or from the wads of small bills that his mobster friends kept stashed in coffee cans and sock drawers and worn envelopes under the mattress.

Around town the shady details of the project's financing were widely known and largely ignored. "When [Siegel] started building the luxurious Flamingo," one local remembered, "Las Vegans applauded the move as that of one of the community's most farseeing and public-spirited citizens." So welcome was the mobster's money in perpetually hard-up Las Vegas that Nevada senator Pat McCarran reputedly accepted a substantial bribe to wangle the Flamingo a temporary exemption from the state's postwar building freeze. "We don't run for office," Siegel later told an associate looking to dabble in local government. "We own the politicians."

But once construction got under way, Siegel's budget proved no match for his opulent tastes. To the consternation of his Syndicate partners, he brought in out-of-state

The Flamingo rises up out of the desert. Construction costs estimated at $1.5 million eventually ballooned to $6 million.

plumbers and paid them triple overtime to install copper piping and individual sewer lines to each room. He made a lengthy excursion to the Middle East to stock up on exotic desert plants and blithely arranged to import a flock of live flamingos for the waterfall that was slated to grace the resort's entrance. Two of the birds withered and died in the desert heat before Siegel grudgingly canceled his order for a hundred more. "His guiding principle was class," said one observer. "At least, as conceived by a mobster."

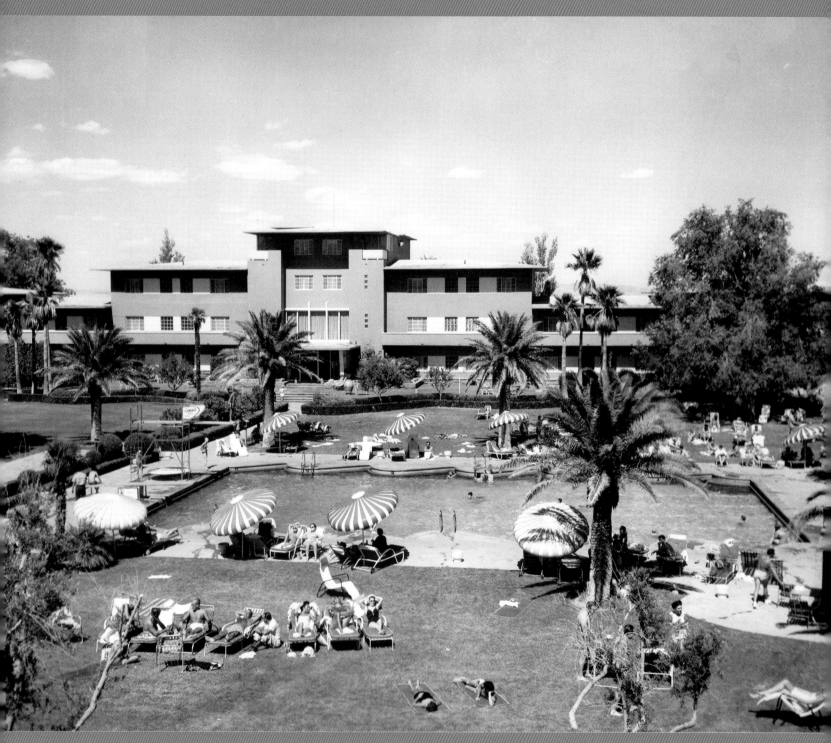

Lounging poolside at the Flamingo. The lavishly landscaped grounds featured Oriental date palms, rare Spanish cork trees, and acre upon acre of grass.

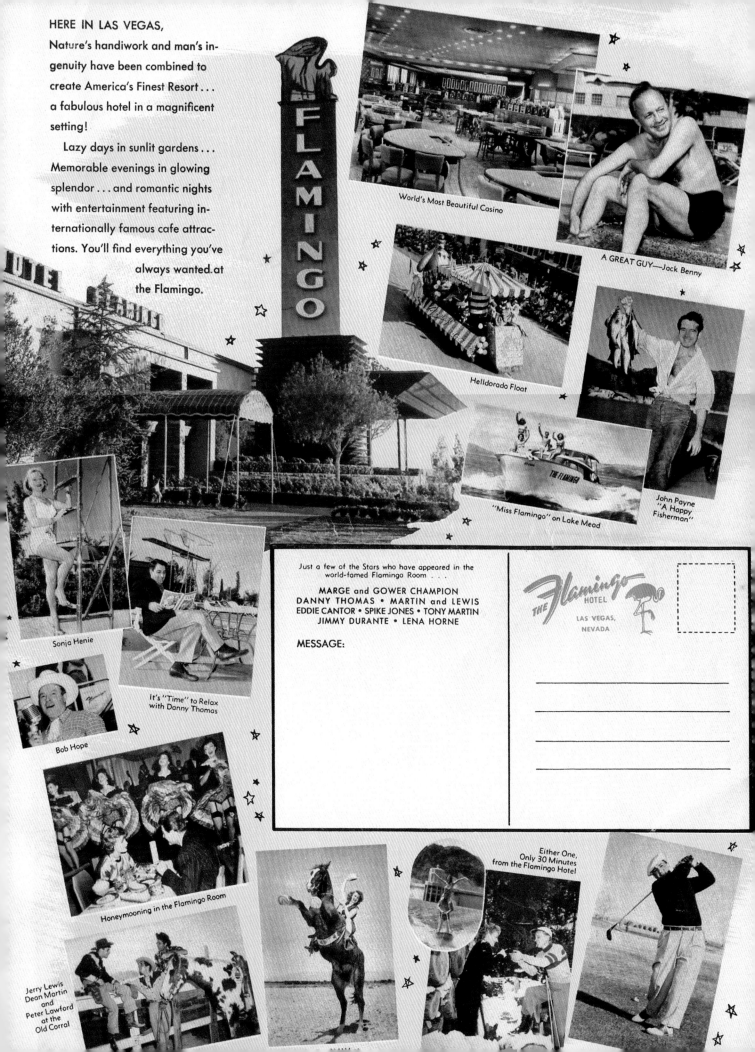

HERE IN LAS VEGAS,
Nature's handiwork and man's in-
genuity have been combined to
create America's Finest Resort...
a fabulous hotel in a magnificent
setting!

Lazy days in sunlit gardens...
Memorable evenings in glowing
splendor...and romantic nights
with entertainment featuring in-
ternationally famous cafe attrac-
tions. You'll find everything you've
always wanted.at
the Flamingo.

FLAMINGO

World's Most Beautiful Casino

A GREAT GUY—Jack Benny

Helldorado Float

John Payne
"A Happy
Fisherman"

"Miss Flamingo" on Lake Mead

Sonja Henie

It's "Time" to Relax
with Danny Thomas

Bob Hope

Honeymooning in the Flamingo Room

Just a few of the Stars who have appeared in the
world-famed Flamingo Room...

MARGE and GOWER CHAMPION
DANNY THOMAS • MARTIN and LEWIS
EDDIE CANTOR • SPIKE JONES • TONY MARTIN
JIMMY DURANTE • LENA HORNE

MESSAGE:

THE Flamingo HOTEL
LAS VEGAS,
NEVADA

Either One,
Only 30 Minutes
from the Flamingo Hotel!

Jerry Lewis
Dean Martin
and
Peter Lawford
at the
Old Corral

JIMMY **DURANTE**

XAVIER **COUGAT**

ROSEMARIE

TOMMY WONDER
THE TUNE TOPPERS

Premiere
GRAND OPENING
of Las Vegas' *newest*
$5,000000 Resort
Thursday and Friday, Dec. 26-27

Owned and Operated by
THE NEVADA PROJECTS CORP.

Casino The world's finest Casino, staffed
by an organization gathered from
the entire U.S. Special Chemin de
Fer gaming room. Craps, roulette, '21'.

Restaurant The Flamingo cuisine will be
the finest that money can buy and
brains can serve, prepared by a
kitchen crew gathered from all parts
of the world.

Cocktails A Cocktail Lounge unsur-
passed anywhere open 24 hours a
day. Music and entertainment by the
Tune Toppers. Your favorite drinks
made to perfection.

Pick Your Night for Either Gala Opening Thursday or Friday
Phone 1138 or Apply in Person
DRESS OPTIONAL

Reserve Now for the Big New Year's Eve Jamboree

Above: Turnout for the Flamingo's splashy opening
was somewhat lighter than Siegel had anticipated.

Right: Most of Hollywood's glitterati received
invitations to the Flamingo's opening.

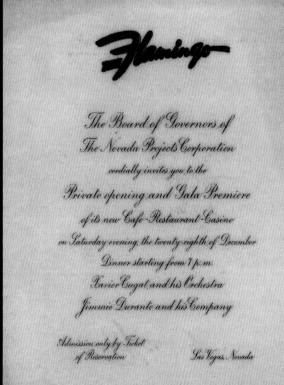

The Board of Governors of
The Nevada Projects Corporation
cordially invites you to the
Private opening and Gala Premiere
of its new Café-Restaurant-Casino
on Saturday evening, the twenty-eighth of December
Dinner starting from 7 p.m.
Xavier Cugat and his Orchestra
Jimmie Durante and his Company

*Admission only by Ticket
of Reservation*
Las Vegas, Nevada

Worse still, unbeknownst to either Siegel or his investors, the contractors on the project were robbing him blind, running a scam in which they delivered materials, accepted payment for them, and then carted them away to be delivered once more.

By the fall of 1946, Siegel had blown through the $1.5 million and had to head back East with his hat in hand. After a series of tense negotiations with various members of the Syndicate, he managed to scrape together another $1 million, which he supplemented with two loans and a mysterious investment from an unnamed corporation in Mormon Utah.

But it still wasn't enough. When the Flamingo opened on December 26, 1946, with what one writer described as "the gaudy opulence of a top hoodlum's funeral," the resort's seventy-eight guest rooms were still not finished. Half of Hollywood had been invited to the premiere, but the private planes Siegel had chartered were grounded by a steady rain in Los Angeles, and Jimmy Durante, the headliner in the Flamingo's lounge, wound up playing to a thinner crowd than Siegel had hoped for. By midnight the players in attendance had scooped up their rather substantial winnings and headed down the street to their rooms at the El Rancho Vegas and the Last Frontier.

Over the next two weeks, the Flamingo lost an astonishing $300,000, forcing Siegel to close down and go begging once more. But with the exception of Lansky, who loyally ponied up his share of the shortfall, the Syndicate's mood had soured. Some suspected Bugsy had been skimming.

By the time the Flamingo reopened, in March 1947, Siegel was desperate to turn a profit. This time, instead of leaving publicity to chance and word of mouth as he had on the first go-round, he hired an agent to hype the resort, a thirty-four-year-old attorney turned magazine publisher named Hank Greenspun. A recent transplant from Brooklyn, New York, Greenspun had spent much of the previous year putting out a glossy, pocket-size entertainment guide called *Las Vegas Life,* a semimonthly that he sold for a nickel. Now, in what he referred to as his "well-paid position" with Siegel, he also churned out a weekly gossip column for the *Review-Journal* called Flamingo Chatter, which dangled incentives like prize drawings to pique local interest in the casino. Within a month of its reopening, the house was showing a profit.

But Siegel just could not relax. He was into the Syndicate for roughly $6 million—enough, he knew, to make him expendable, even with long-standing friends like Lansky. His paranoia was so acute that he took to having the lock on his suite changed once a week.

The Syndicate did not keep him in suspense for long. That June, while on a weekend jaunt to Los Angeles, Siegel caught a bullet through the right eye. Minutes later Phoenix mobster Gus Greenbaum and two associates took over the Flamingo for the Syndicate.

Sensational coverage of Siegel's murder translated into reams of free publicity for Las Vegas.

End of the Trail for Siegel

Above picture shows death scene just after police arrived at palatial Beverly Hills apartment where Benjamin (Bugsy) Siegel was slain. Man at right is Allen Smiley who was sitting on the davenport with Siegel when the gangland lead came through a window.

Who Killed Siegel? What Was Motive?

Girl Friend Admits Tiff At Flamingo

PARIS, June 23 (UP) — Virginia Hill, in whose house Benjamin (Bugsy) Siegel was killed, said today she had quarreled with the west coast gang leader three weeks ago.

LOS ANGELES, June 23. (Special)—The picture of a typical gangland killing was being pieced together today by Beverly Hills police as they continued their probe of the slaying of Benjamin Siegel, "man - about - Hollywood," ranked as the nation's number one mobster who was killed Friday night as he sat reading a newspaper in the living room of a woman listed as Siegel's

Bookie Confab Held Here Last Tuesday

Los Angeles police today reportedly were seeking information on a supposed race track bookie conference which was held last Tuesday at the Flamingo hotel in which "big shots" of the wire syndicate

Gang Feud Now Believed Siegel Murder Motive

Police Told That Bookmaking Control Was Given to Bugsie in Las Vegas Conference

Reports emanating from Las Vegas, Nev., that control of the bookmaking racket in five Western States had been taken away from one group of gamblers by heads of an asserted nation-wide bookmaking syndicate and given, gling, Siegel was said to have been given control of the five States, including California, Oregon and Nevada. The group on the losing end of the transaction was said to have headquar-

Siegel Murder Ascribed to Gambling Racket Grab

Bugsie Given Control of Bookmaking Instead of Chicago Gang, Report Says

Continue from First Page

his henchmen accused him of a double cross."

Anderson said he hopes to receive from New York in the next day or two further infor-

was received from Las Vegas by Anderson that Siegel had "a clean slate" in the Nevada gambling town. Officers sent to Las Vegas reported that operators of other gambling clubs thought

Love Tangle Suspected as Siegel Murder Cause

Chicago Racketeer Believed to Have Hired Killers Because of Jealousy Over Miss Hill

Jealousy over the love of Virginia Hill was blamed yesterday for the murder of Benjamin (Bugsie) Siegel.

These rapid developments capped a day which began with a hushed, secret funeral service for Siegel, attended by only six

Mexico Narcotics Ring Hinted in Siegel Mystery

MEXICO CITY, June 28.— (UP)—Half a dozen big - time gangs, operating small, fast planes from secret airfields, will smuggle an estimated $66,000,000 worth of narcotics into the United States from Mexico this year, official quarters told the

SIEGEL HINTED $1,500,000 IN DEBT BEFORE MURDER

Benjamin (Bugsie) Siegel's debts just a week before his murder in Beverly Hills 12 days ago may have totaled a stagger-

no way linked to the murder and has not been questioned by any of the Attorney General's staff.

But disclosures made yesterday showed that Siegel's Sec

June 16, four days before Siegel was murdered in Beverly Hills. They were drawn on the Las Vegas office of the Bank of Ne-

RACE WIRE WAR HELD SIEGEL SLAYING MOTIVE

Statements that a dispute over race wire service was responsible for the killing of Benjamin (Bugsie) Siegel were made yesterday by Chief of Police C. H. Anderson of Beverly Hills and Walter H. Lentz, Chief Special

The statements from both officials followed a conference held in Anderson's office.

Siegel was killed in gangland fashion while seated in the living room of the Beverly Hills home of Virginia Hill, former dancer

By the next morning lurid stories about Siegel's past were plastered across front pages nationwide. "When this thing began to scream in the papers," one Las Vegan remembered, "people [in town] began finding out they'd probably gotten a little more than they'd bargained for."

Then again, for a place like Las Vegas, there was really no such thing as bad publicity. After all, as one observer noted, Ben Siegel had not founded the Las Vegas Strip. He did not invent the luxury resort-casino. The original concept for the Flamingo was not even his. But thanks to his grisly gangland execution, he had made all of them famous.

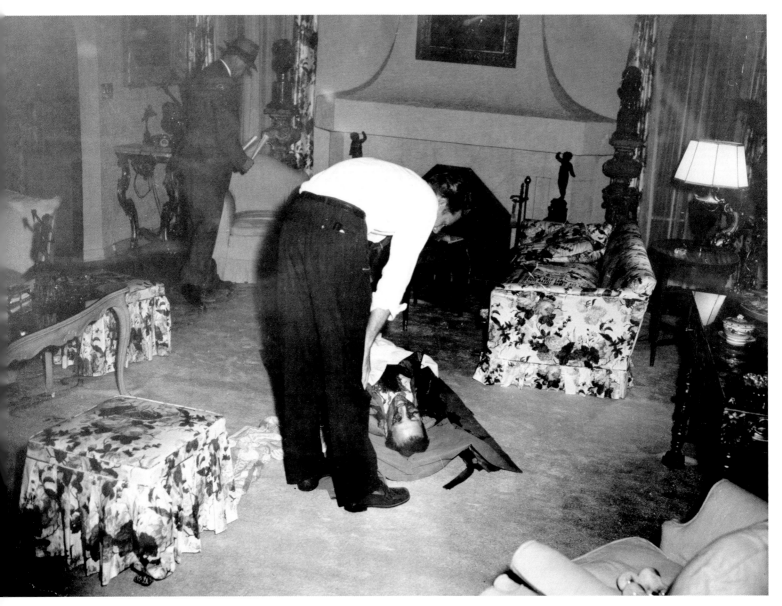

A detective bends over the body of Benjamin "Bugsy" Siegel, June 1947. Siegel had been sitting on the couch in his girlfriend's Beverly Hills home when nine shots were fired through the window. One shot entered through the back of his neck; another knocked his right eye clear across the room.

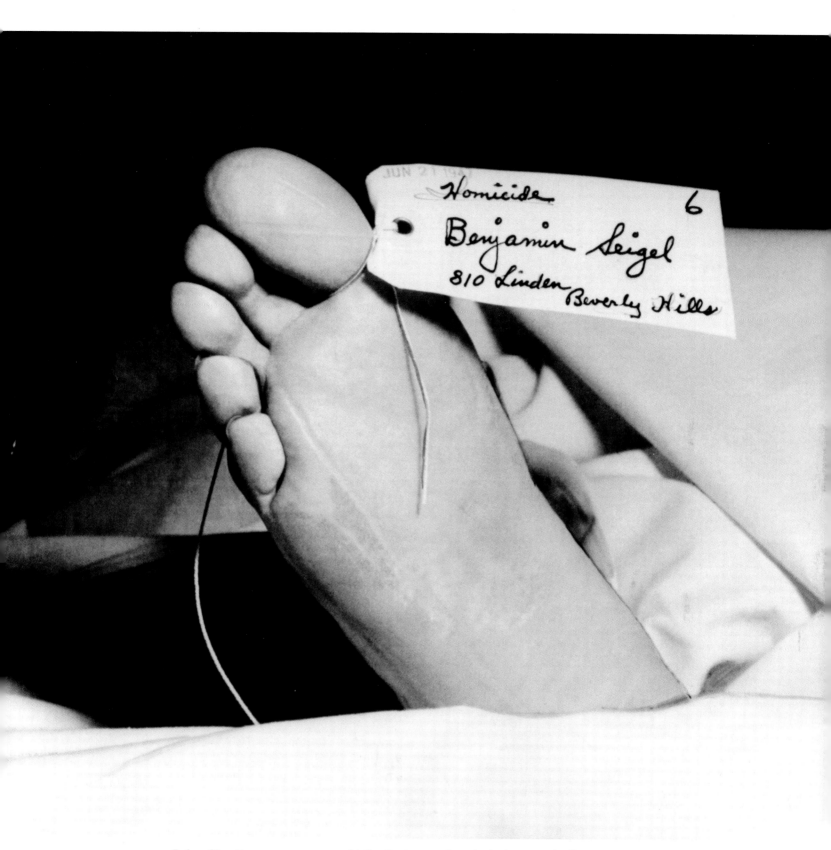

Before Siegel's corpse was even cold, Syndicate associates had taken over the Flamingo, "like generals," one reporter wrote, "mopping up after a coup."

LIGHTS
BY DAVE HICKEY

Fifteen years ago, on our first evening out as official residents of Las Vegas, my wife and I cruised down the Strip in a silver Ford pickup we had just driven from New Mexico. Like thousands before us we motored through the luminous neon twilight under lowering clouds. Classic rock blasted from the radio and blazed from neon marquees. Ray Charles was playing that night at the Desert Inn. Duran Duran was coming. Eric Burdon and War were ensconced at Arizona Charley's. Bobby Bare was out at Boulder Station, and so many more glitterati from the deck of pop trivia were scheduled that I immediately envisioned my new hometown as a kind of secular Lourdes, a purgatory of vestigial desire. Everything, it seemed, that anyone had ever loved, that they still loved even though it had fallen from fashion, landed here. The Moody Blues, Johnny Paycheck, Vicki Carr, Sam Butera. Then, thinking of myself, I surmised that anyone who had ever dreamed anything and who, without actually abandoning the dream, had fallen or jumped from grace probably landed here, as well.

At that moment all reverie stopped with a giant *ka-whack!* as a desert thunderstorm exploded around us, rattling the truck and jolting us in our seats. Rain crashed down in torrents, engulfing everything. Banners of light from the setting sun suddenly spangled through the plunging water. Colors bled on the windshield, and the Strip seethed like chemical fire. Lightning bolts crackled down the blue curve of the southern sky in jagged, mile-high trees, and then, as if to summon up the dead, another heart-stopping clap of thunder banged—magically synchronized with the opening chords of Pink Floyd playing "The Wall" on the radio—and the rain stopped. The lights sharpened to pinpoints. You could smell the ozone in the air, and it was over.

We just sat there at a stoplight shivering at the violence of the storm, at its apocalyptic theatricality, which was so blatant, so effective, and so, you know, *Vegas* that we weren't sure whether to laugh or cry. I could think only that, finally, after all those airports and all that highway, I was here—at the glimmering, glamorous, precipitous edge of cultural oblivion. Unfortunately I could not have been more wrong. My new secret place stayed secret for about an hour. We arrived in the middle of the boom that followed the opening and extravagant success of Steve Wynn's Mirage. The cranes were up. The lights were up, and the sites were being worked around the clock. Hundreds arrived daily from California, Mexico, and beyond to fill the jobs. For a person more attuned to the anxious chaos of New York and Los Angeles, the speed, scale, and exquisite smoothness of these endeavors were stunning and a little intimidating. You got the impression that the world was moving on quickly and no one had consulted you.

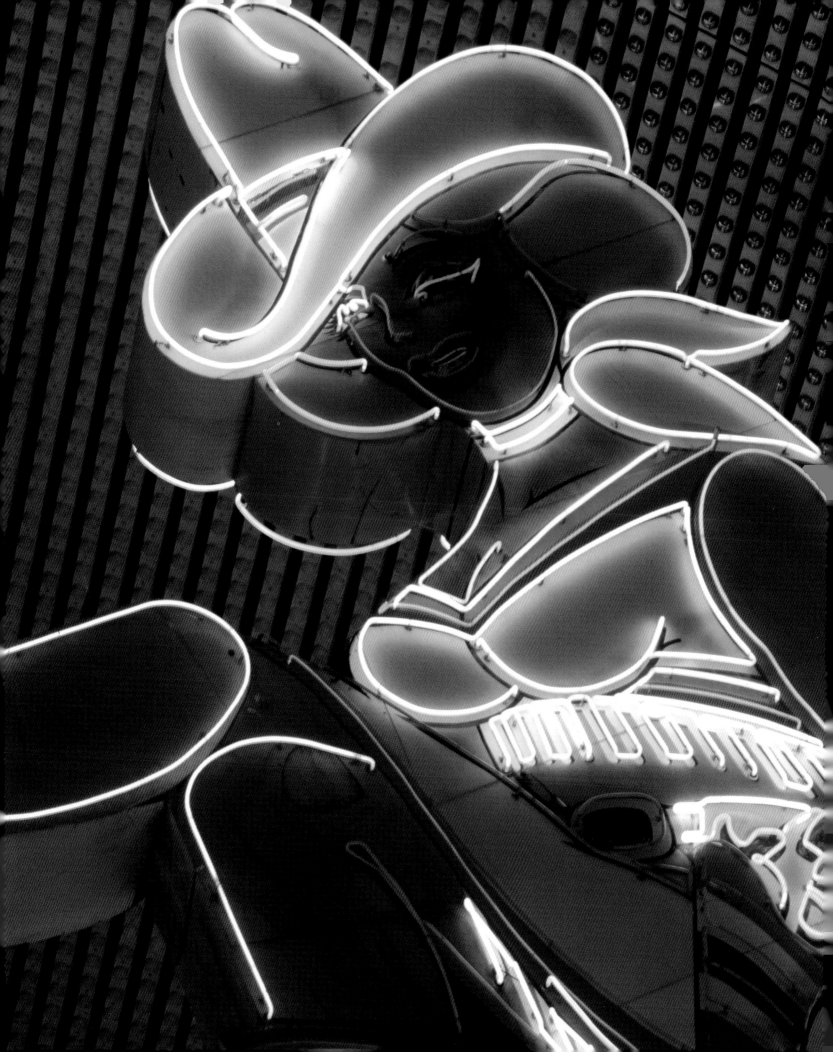

So I would ask people if it was like this all the time, and they would say no, that it was just a bubble. They assured me that it would plateau in about six months. Every year they said this, but it didn't plateau, and it hasn't. Crazy people were building a pyramid down at the bottom of the Strip. Two blocks north, the Eiffel Tower was going up, and all my sculpture students had jobs carving lions for extra cash for the Piazza San Marco two blocks farther north. People and money poured in, and every year, the citizens of Las Vegas, trained in the rhetoric of probability, accustomed to hedging their bets against disaster, shook their heads, looked at the floor, said it was just a bubble, and then put their money down anyway. They bet on the bubble, and nothing slowed down.

Then, suddenly, seemingly from out of nowhere, the cultural beau monde, from which I had fled, slipped in on my heels, sniffing the money. Monets and Picassos arrived aboard private jets. My wife found herself curating a multimillion-dollar art collection over on the Strip. Robert Rauschenberg and I strolled through the lobby of the Bellagio. As culturati on the ground, I ended up hosting a dinner at an ultrafine restaurant for directors of Asian museums. The Guggenheim was on its way with Rem Koolhaas at the architectural helm, and eventually, they all came from everywhere in the world—the journalists, critics, students, architects, scholars, writers, artists, and collectors—on their junkets. They all claimed to be interested in Las Vegas, and maybe 4 percent of them were. The rest shopped to alleviate their anxiety, because they were truly worried and concerned, and they still are. They don't really think of themselves as the Fun Police, of course, but they think we are getting away with something here, and maybe we are. They think it might be contagious, and maybe it is. They can't understand why this isn't happening in Connecticut, so they want to see our down cards, and they want to see them now. They have inquiring minds, and who better but the ardent media to conduct these inquiries?

This is the part that no one could have predicted: the feedback loop, the sheer oddness of awaking one morning to find Martin Scorsese's minions redesigning the front of your cherry-Vegas apartment building to look "more Vegas." Soon thereafter two of my students rushed up and informed me that Julia Roberts was playing my wife in a movie, and indeed she was. At least, Roberts was playing the curator of a multimillion-dollar art collection in a Strip casino, and there was but one of these. At this point the dam broke. The burgeoning allure of Las Vegas, the fear and loathing it inspired in the

learned and virtuous alike, occasioned an escalating onslaught of media surveillance that fed the frenzy it purported to investigate. The books, movies, documentaries, television dramas, reality shows, and poker tournaments poured out. Like a negative imprinted with multiple exposures, the fictions of Las Vegas blurred into new fictions about it, and a new rising spiral of escalating extravagance and intensive scrutiny began.

Since the onset of this latest boom, I have given some thought to the actual object of the scrutiny. A lot of it is pure titillation, of course, and some of it is genuine cultural interest, but there is another, larger, hovering, and more ominous question, I think, that goes unasked because we don't want it answered—because it would both reassure and disappoint us. To wit: is Sin City really full of sinners? Is Las Vegas really that cinematic "back-to-the-future" thug town? The answer, of course, is no. Las Vegas is a nice town full of interesting, gregarious people. As a place it is bland as a biscuit in the sunshine, dreamy and pastel at the edges of the day, and under the stars? Well, under the stars the town is transformed into the absolute, incarnate, dazzled heart of earthly promise, but even so, the ordinary laws, customs, and regulations of cosmopolitan society are genially in place and tolerantly enforced. Folks stop at stop signs and drive slow in the school zones and even the gamblers must work for their living.

Las Vegas does have the benison of its exceptionalities, however. As a twenty-four–seven town, it has its own smooth tempo. Someone is always off, someone is always on, so the demand on streets, stores, and services is efficiently distributed, and best of all, you need never be alone with your angels or with your demons. Also, since Vegas is the only town in America that does the job it does, its purported wickedness is extravagantly fueled by the overwhelming adjacency of purported virtue. Where other American cites are damned by the vices of the great men, Vegas is blessed by the virtues of its wicked founders, by Bugsy Siegel's visionary inspiration, by Moe Dalitz's civic pride, and by Frank Sinatra's social consciousness.

With forefathers like these, then, it is hardly surprising that Las Vegas is the only town in America that is not run from a country club—that survives without the benefit of Protestant cultural guidance and leadership. The city is run from the synagogue, the cathedral, the Mormon temple, the Culinary local, and the Strip, and such tastemakers as Las Vegas boasts don't sit on committees. They actually make taste. They don't

impose it. They don't defend it. And they happily discard it when it goes stale. As a consequence, glamour and generous spectacle are not illegal here or even frowned upon. You can gamble here and gawk and drink and dine and shop and dance and never stop, and the idea that you needn't stop and needn't even wait is an important part of the whole thing.

Moreover, the social consequences of this gambling, entertaining, and never stopping are just what you would think they are. Three shifts means more jobs per square foot in a town that survives on the promise of a fair game and the guarantee of quick friendly service. Thus, honesty, congeniality, and efficiency are marketable virtues here. They are held in reverence as positive social attributes, and nearly everyone, from your dentist to the guy at the 7-Eleven, aspires to them. This lightens the tone of daily life considerably. Casinos, after all, are not run by noir hipsters. They couldn't be. They are managed and run by quick people who are not predisposed to put their hand in the till, who want a job and a good salary and a decent life.

That said, however, Vegas is still about gambling, and gambling has its own cultural eccentricities. First and foremost, it breeds optimism and attracts it—not childlike, Pollyanna, people-are-great optimism, of course, but the serene confidence that whatever happens tomorrow, you can probably handicap it. This is crucial to the life of the town because one doesn't bet on yesterday or on metaphysical ideas. One bets on the future contingencies of the actual world, on the psychological tendencies of one's fellow citizens, and losing is an everyday happenstance, and since no one is going to stop you, losing everything is a very real option.

This reality, not surprisingly, breeds and attracts attentive, intelligent people who know that luck is a real entity that haunts the law of large numbers. These are not *cultured* people, necessarily, but they are bright, which is sometimes better, since Culture, big C, encodes its own repressions and blind spots. None of these people is empowered by a past beyond the money in his pockets. No graduate programs exist in Texas hold 'em or sports investing, so a high percentage of the population is bright, self-schooled, and largely self-invented. The nice lady in the flowered dress sitting next to you at the card table can probably project the statistical consequences of Kobe Bryant's sprained ankle through the point spreads of next week's games, and this ambient practical intelligence, I am happy to say, further simplifies daily life. Whining is kept to a minimum, and only a small percentage of the population is totally befuddled at the teller machine.

Finally, this being a public-television project, I feel that I should conclude with a cautionary observation, so how's this: if you live in a town that thrives on people's vices, you can't afford to have them, or you had better be able to afford them. This sounds okay, and it's a useful tip in theory. I've heard it before, but in practice it means nothing, because what are you doing in Las Vegas anyway, dummy? Were you drawn by the lure of desert gardening? More useful are my friend Speedy Newman's three rules for living

in Vegas. *No sissies. No dummies. Full accountability.* These really do help, but Speedy's too strict. He misses the rock and roll of it, so if you ask me, it's all about the lights. Their profligate ebullience, I think, goes a long way toward explaining everything, because these lights, these millions of gratuitous lights, don't light up government buildings, or monuments, or corporate headquarters, or famous heroes, or saints, or steeples. These lights sizzle and dazzle and smoke, and light *you* up. They are *for* you. They invest you with grace and embrace you with their shadowless illumination. So right in the middle of this wild desert town, surrounded by the black oblivion of hard, high desert, surrounded by the gloomy, sleeping ambience of dark America spreading away, there you are, in the middle of everything, glowing like a Renaissance saint.

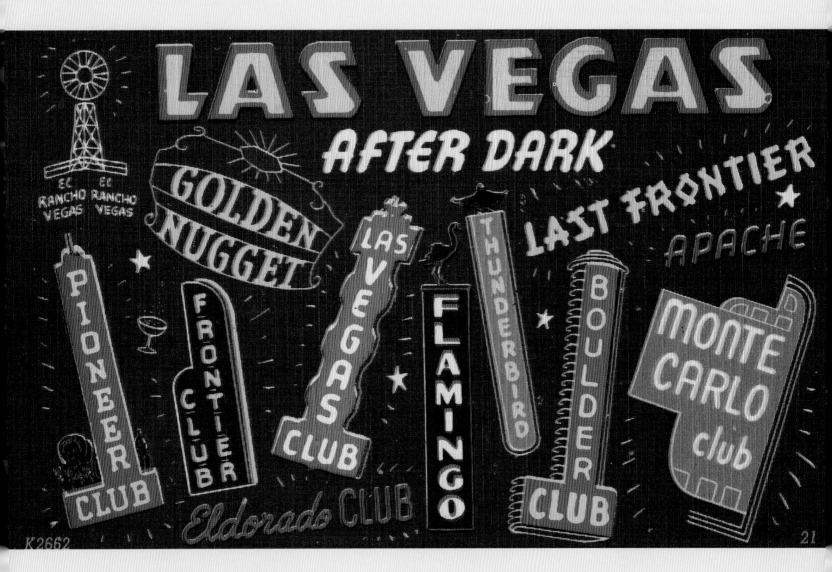

ACCORDING TO ASTRONAUTS, THE LIGHTS OF LAS VEGAS ARE VISIBLE FROM SPACE

Journalist Tom Wolfe once wrote that Las Vegas was the only city in the world without a skyline—just a "signline." "But such signs!" Wolfe sighed. "They tower. They revolve, they oscillate, they soar in shapes before which the existing vocabulary of art history is helpless." That was 1964. In the four decades since, Las Vegas's cityscape has been transformed by fantastical architecture—a massive bronze glass pyramid, a Disneyesque medieval castle, minutely detailed replicas of the Eiffel Tower and the Statue of Liberty. But it is still the phantasmagoria of blinking, jewel-toned, neon signs that

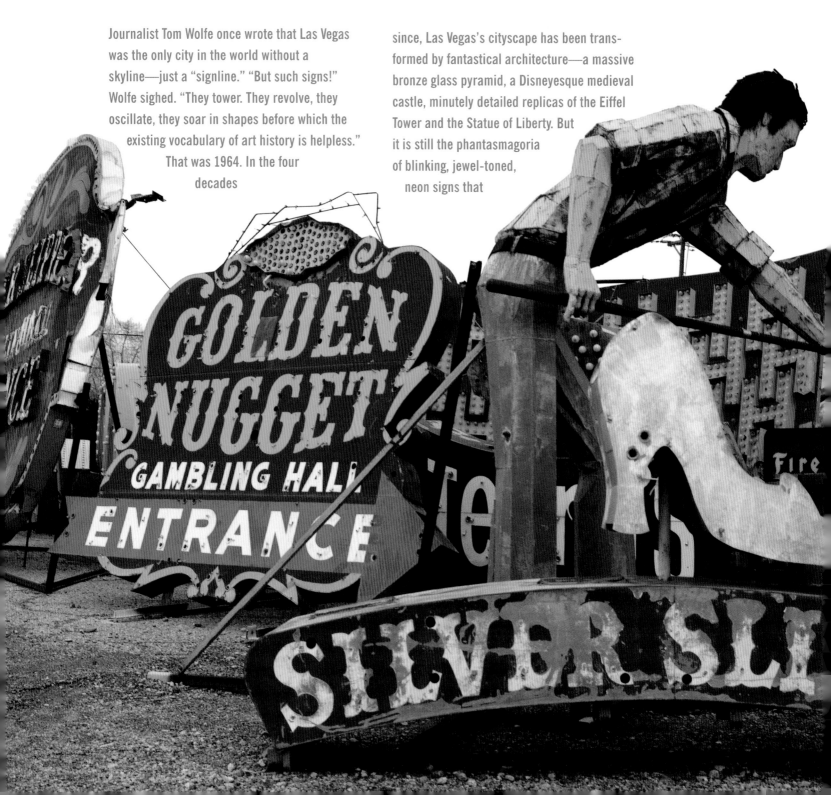

makes Las Vegas one of the most recognizable places on earth.

Introduced in the mid-1940s by a Utah-based lighting salesman named Thomas Young, neon signage instantly became a competitive sport among Las Vegas's hotel and casino operators. Availing themselves of the cheap electricity supplied by the Hoover Dam, they installed monumental neon marquees—some more than two hundred feet high—to hype their locations to passing motorists. By the 1960s it was not uncommon for a two-story building to be topped by a sixteen-story sign. On the Strip, even the

McDonald's was decked out in neon. Before long Young's company was doing more than 60 percent of its business in Las Vegas.

Today, illuminated by millions of bulbs and some fifteen thousand miles of tubing—enough to stretch from coast to coast approximately five times—Las Vegas boasts by far the highest concentration of neon anywhere in the world.

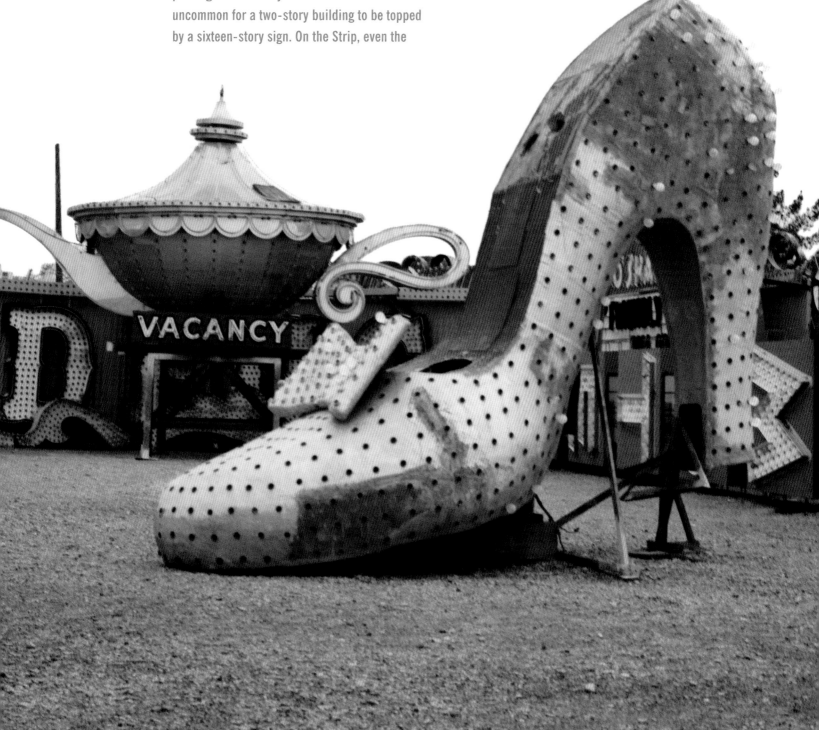

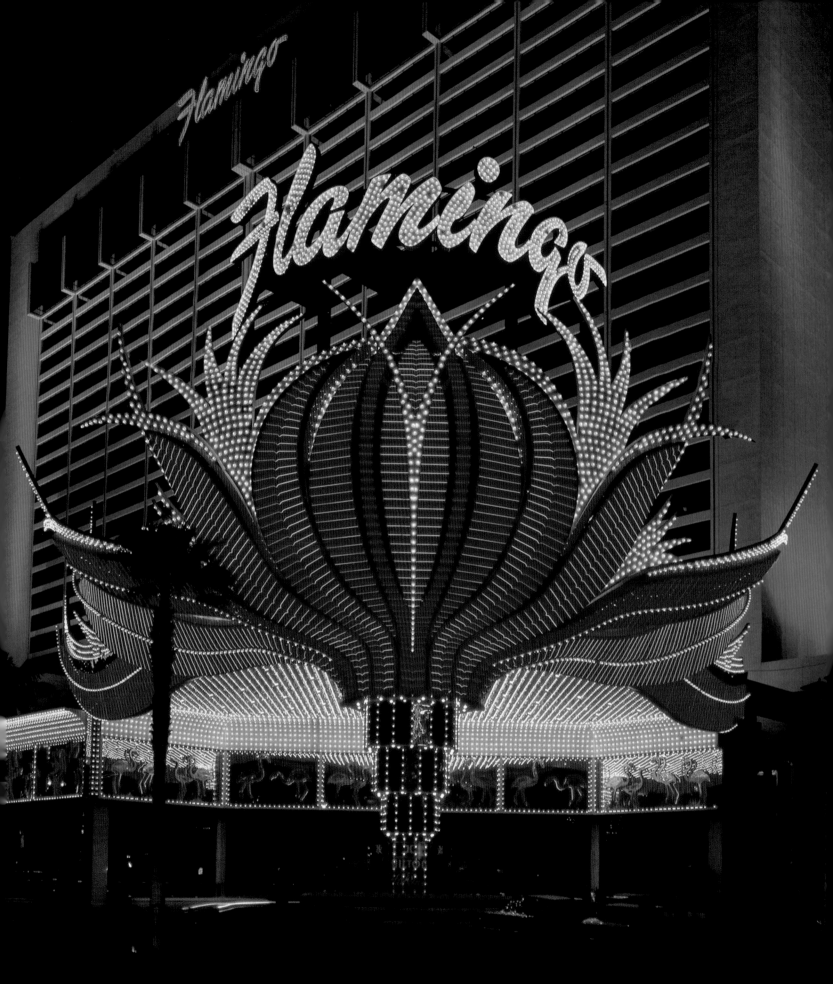

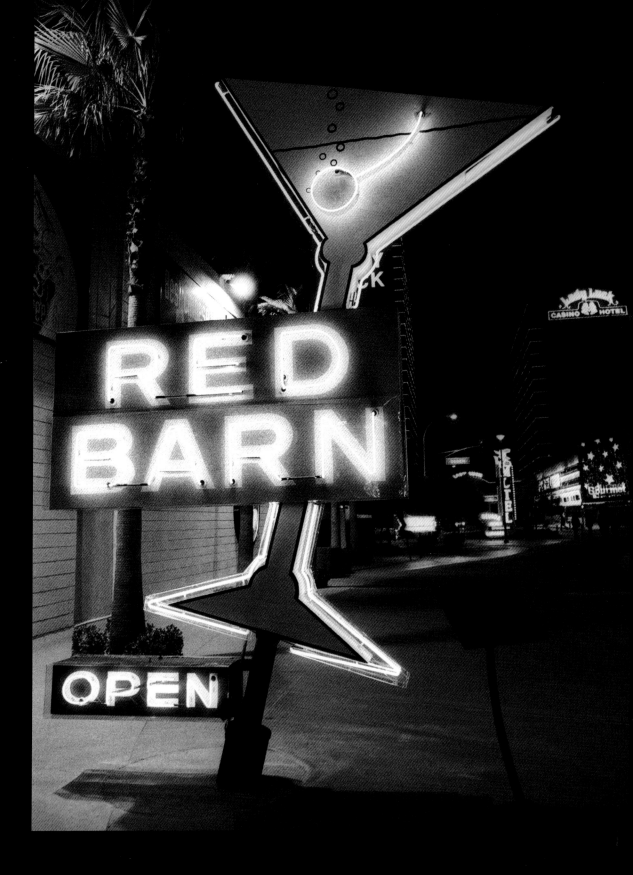

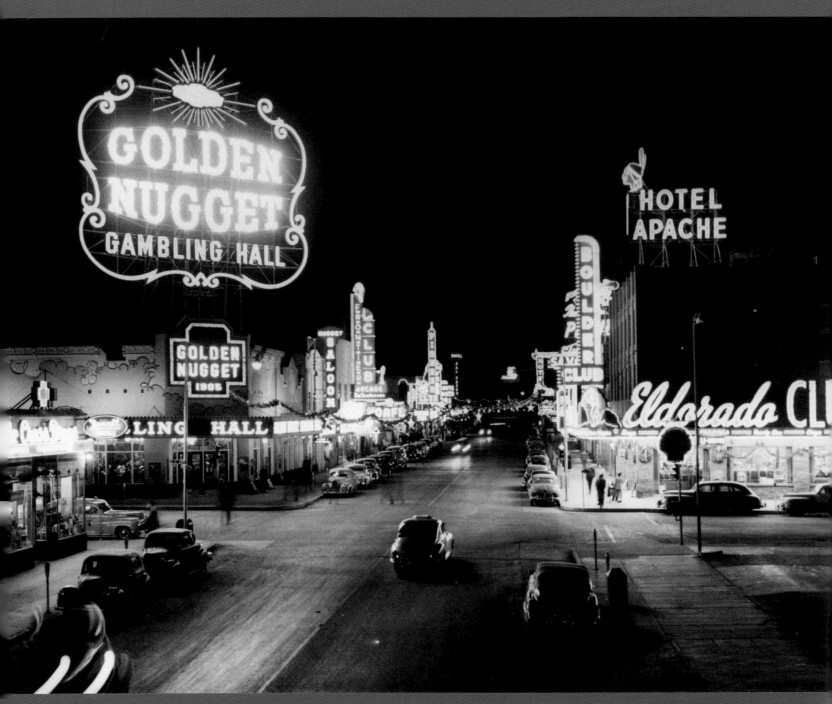

By the late 1940s the neon-emblazoned stretch of Fremont Street was known as Glitter Gulch. The Golden Nugget's one-hundred-foot-high neon sign, installed in 1948, justified the casino's claim to being "the brightest night spot in the world."

MOBSTER METROPOLIS

By the late 1940s Las Vegas was really beginning to catch on. The years since the onset of the Great Depression had been some of the leanest and most wearying in memory, and the nation's craving for fun was by now verging on desperate. Liberated from the restrictions and rationing of necessities such as gasoline and rubber that had so inhibited travel during the war years, and possessed of more disposable income and leisure time than at any other moment in history, Americans were hitting the road in record numbers, boosting visitation to national parks, ski resorts, and historic sites across the country, particularly in the American West. As ever Las Vegas was perfectly poised to capitalize on the national mood. Thanks to Carrier's new air-conditioning system, which effectively cooled large spaces even during the infernal months of prime summer vacation season, and a chamber of commerce that spent more money per capita on advertising than any American city of equal size, Las Vegas would figure ever more prominently in the array of possible destinations, drawing hundreds of thousands of visitors annually and some twenty thousand a weekend from L.A. alone.

As a fourth development, a $3 million, Native American–themed resort called the Thunderbird, took shape on the Strip, and Captain Guy McAfee's new, ultraluxe Golden Nugget Casino spurred a major revitalization effort on Fremont Street, the little town in the middle of the Mohave, the one with only four roads leading in and out—and none with a stoplight—suddenly began to look like a prime spot to cash in on the nation's postwar prosperity.

Pair of dice from the Thunderbird. A group game with extremely fast action, craps has long been one of the most popular games in Las Vegas.

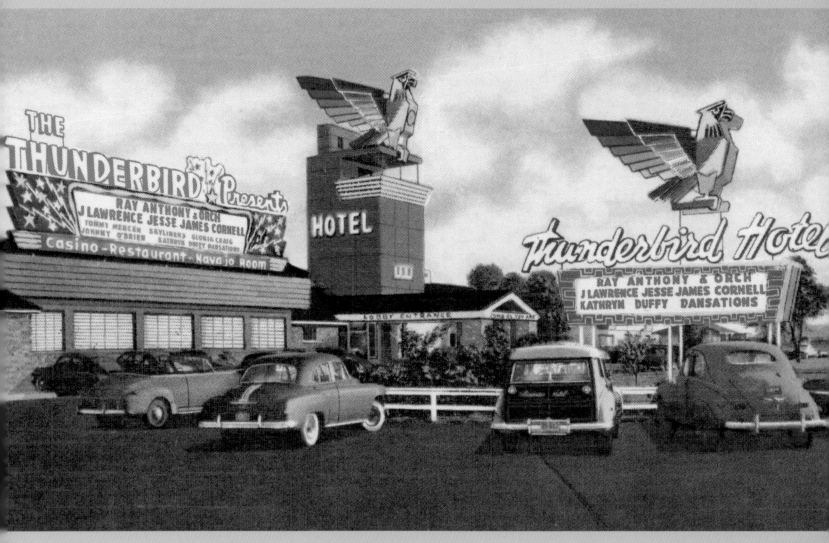

Built in 1948 and co-owned by Clifford Jones, then the lieutenant governor of Nevada, the Thunderbird was popular with local residents and prominent politicians from all over the state.

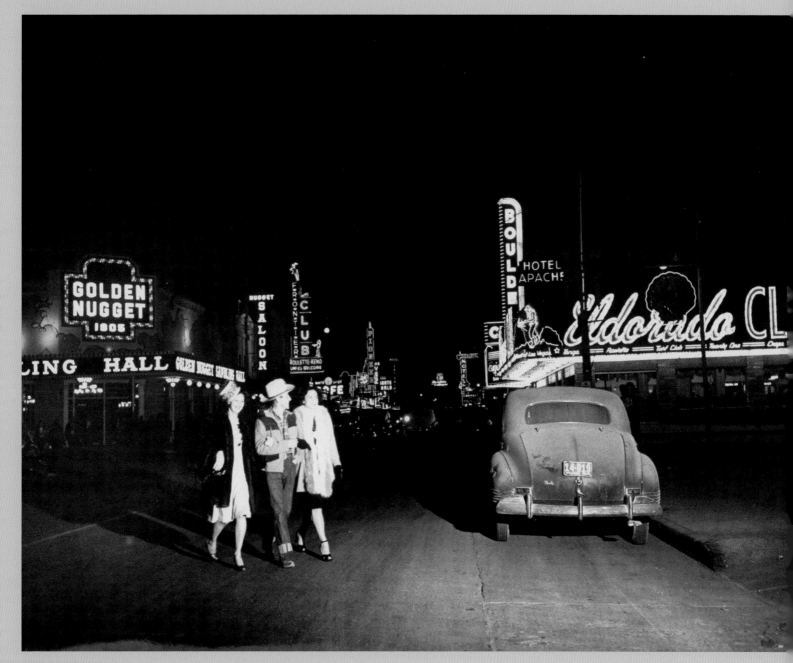

Four a.m. on Fremont Street, 1947. In Las Vegas the party never stopped.

GREETINGS FROM
NEVADA

No Retail
Sales Tax

No Corporation
Tax

No State
Income Tax

No
Inheritance
Tax

No
Thumb
Tax

THE
ONE
SOUND
STATE

Servicemen and defense personnel who had been stationed in the valley during the war now contemplated the long, frozen winters in the towns they had come from and decided to stay put. Returning combat veterans snapped up federal land outside of town, offered to them by the government at just $5 an acre. People from California, Utah, and Arizona came by the thousands: attorneys looking to be at the epicenter of the nation's alarming postwar divorce epidemic; architects, designers, and contractors lured by the prospect of frenzied resort and residential development; entrepreneurs eager to fill any available and obviously lucrative niche.

It was during these years that the national Culinary Union, sensing an opportunity to dramatically increase its membership, dispatched its business agent, Al Bramlet, to build up Las Vegas's Local 226. A tough-talking, charismatic ex-bartender from Arkansas, Bramlet would soon begin to recruit hotel workers throughout the country, reeling in carloads of aspiring maids, cooks, and bellhops with the promise of cheap land, almost nonexistent taxes, and a seemingly infinite supply of well-paying union hotel jobs.

And then there were the casino operators, men who would transform their lives of crime into legitimate business enterprises just by changing their address.

Benny Binion, a convicted bootlegger who had killed two men back in his home state of Texas, pulled into town in 1946. After more than a decade of running numbers and illegal craps games in Dallas, forty-two-year-old

Opposite: Nevada went to great lengths to encourage settlement.

Above: For the European-style casino game baccarat, special chips called cheques are used to place bets. A favorite with James Bond, baccarat is played almost exclusively by high rollers.

Binion had recently found himself on the losing side of a local gang war. With his friends and business partners checking out faster than the guests at a hot-sheet motel, he had packed his wife, five kids, and a suitcase full of cash into his Cadillac and headed straight for Las Vegas. Within five years he would be the proprietor of Binion's Horseshoe Casino, the only joint in Las Vegas that would accept any bet a player put on the table—no matter how high—and the first to ply the clientele with free booze. "If you wanna get rich," Binion liked to say, "make little people feel like big people."

Around the same time, in Reno, a local casino owner named Moe Dalitz got a tip about a business opportunity on the Strip. A small-time operator named Wilbur Clark was trying to get a posh new resort called the Desert Inn off the ground, but he had only about a quarter million in cash. Dalitz, the mobbed-up former kingpin of Cleve-

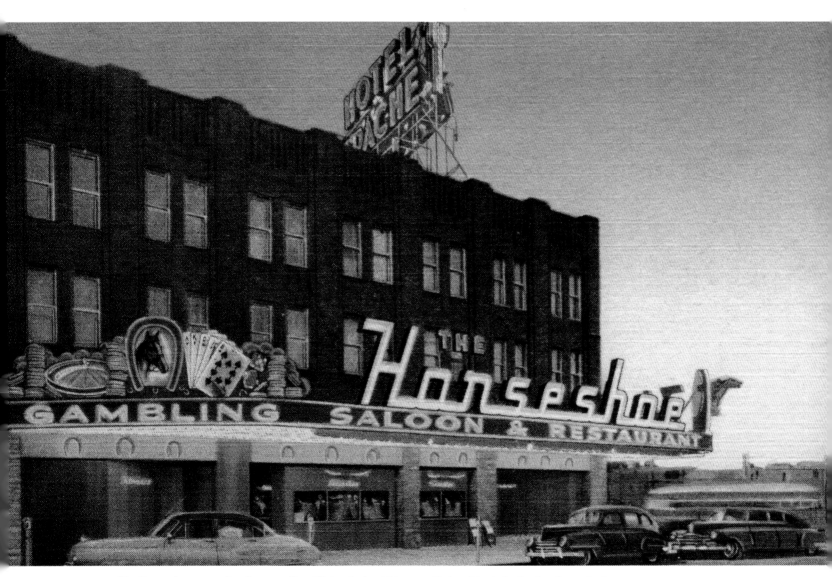

The Horseshoe was a family operation. Binion trained his sons, Ted and Jack, by having them deal every game in the house and work their way up through pit boss.

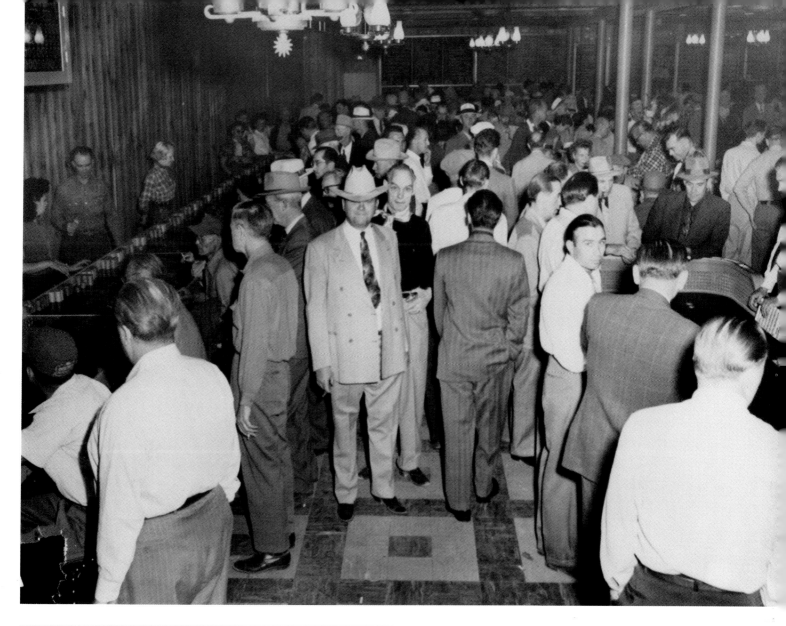

Above: Benny Binion (center, in cowboy hat) at the gala opening of his downtown Western Club, 1950. Dissatisfied with the size of the club, Binion would bail out after just one year and build the world-famous Horseshoe.

Left: Benny Binion, around the time he moved from Texas to Las Vegas.

land's bootleg-whiskey racket and part owner of several illegal casinos in Ohio and Kentucky, knew a golden opportunity when he saw one and shrewdly made a beeline for Las Vegas. After just one brief negotiation, he and his associates had acquired a 74 percent stake in Clark's dream.

Before long, gamblers, grifters, thugs, and small-time operators from all over the country were decamping to Las Vegas, eager to do business in the one state in America where they were in no danger of being rousted by the cops. Gambling convictions received elsewhere were routinely shrugged off in southern Nevada, if not actually regarded as evidence of valuable experience. "Vegas was like another planet," the late comedian Alan King recalled, "and all of a sudden all the things that were illegal all over the country became not only acceptable, it was what drove this town." By 1950, as one resident observed, Las Vegas was home "to more socially prominent hoodlums per square foot than any other community in the world."

As mob-connected individuals moved in on the local casino business, buying up controlling interests in existing joints and quietly bankrolling new ones, Las Vegas became an ideal front for organized crime. Behind nearly every shady operator in town was a plethora of even shadier, hidden owners whose investments were repaid with the undeclared—and, therefore, untaxed—earnings that were routinely skimmed off the top. "Three for us, one for the government, one for [Syndicate boss Meyer] Lansky" was the way one mobster's daughter recalled the revenue disbursement that was routinely performed in the counting rooms of casinos controlled by the mob.

Opposite: One-time bootlegger and reputed mobster Moe Dalitz was a key player in 1950s Las Vegas.

Above: A novelty roulette wheel ashtray from the Desert Inn.

A group of Las Vegas businessmen, including mobster Gus Greenbaum (second from left) and convicted murderer Benny Binion (third from right), meet with high-ranking clergy. In Las Vegas criminals could become city fathers.

For the most part authorities in Nevada were inclined to look the other way. After all, the reported income alone was staggering. Between 1945 and 1950, deposits in Las Vegas's two banks ballooned from $3.3 million to more than $30 million. "Las Vegas Strikes It Rich," *LIFE* magazine proclaimed, "[in] the biggest boom that has ever hit." With the state's take at 2 percent of all gambling revenues over $3,000, there wasn't much to be gained by asking too many questions about the men who ran the casinos.

But in 1950 those questions were beginning to be raised in Washington, D.C. That spring, Senator Estes Kefauver, the Honorable Democrat from Tennessee, launched a full-scale Senate investigation into the role of organized crime in interstate commerce. Over the next seventeen months, his committee would travel more than fifty-two thousand miles and take testimony from some eight hundred witnesses in fourteen American cities. Not surprisingly Las Vegas was a prime target. "Big time gambling is amoral," Kefauver declared. "I refer to the casino type of operation which is more often crooked than not. Gambling produces nothing and adds nothing to the economy or society of our nation."

A shameless political opportunist with a secret gambling habit that, according to one close friend, left him "constantly, vulnerably broke," Kefauver had hoped that a

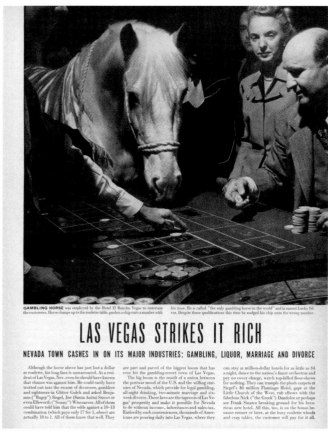

GAMBLING HORSE was employed by the Hotel El Rancho Vegas to entertain the customers. Horse clumps up to the roulette table, pushes a chip onto a number with his nose. He is called "the only gambling horse in the world" and is named Lucky Silver. Despite these qualifications this time he nudged his chip onto the wrong number.

LAS VEGAS STRIKES IT RICH

NEVADA TOWN CASHES IN ON ITS MAJOR INDUSTRIES: GAMBLING, LIQUOR, MARRIAGE AND DIVORCE

Although the horse above has just lost a dollar at roulette, his long face is unwarranted. As a resident of Las Vegas, Nev. even he should have known that chance was against him. He could easily have trotted out into the swarm of divorcees, gamblers and sightseers in Glitter Gulch and asked Benjamin ("Bugsy") Siegel, Joe (Santa Anita) Smoot or even Ellsworth ("Sonny") Wisecarver. All of them could have told him that the odds against a 10-13 combination (which pays only 17 for 1, above) are actually 18 to 1. All of them know that well. They

are part and parcel of the biggest boom that has ever hit the gambling-resort town of Las Vegas.

The big boom is the result of a union between the postwar mood of the U.S. and the willing statutes of Nevada, which provide for legal gambling, all-night drinking, two-minute marriage and six-week divorce. These laws are the taproots of Las Vegas' prosperity and make it possible for Nevada to do without income-, inheritance-and sales-tax. Enticed by such conveniences, thousands of Americans are pouring daily into Las Vegas, where they

can stay at million-dollar hotels for as little as $4 a night, dance to the nation's finest orchestras and pay no cover charge, watch top-billed floor-shows for nothing. They can trample the plush carpets at Siegel's $6 million Flamingo Hotel, gape at the Little Church of the West, rub elbows with the fabulous Nick ("the Greek") Dandolos or perhaps see Frank Sinatra breaking ground for his luxurious new hotel. All this, too, is on the house because sooner or later, at the busy roulette wheels and crap tables, the customer will pay for it all.

Above: Las Vegas hits the national radar in *LIFE*, May 1947.

Right: Advertisements emphasized Las Vegas's frontier heritage well into the 1950s.

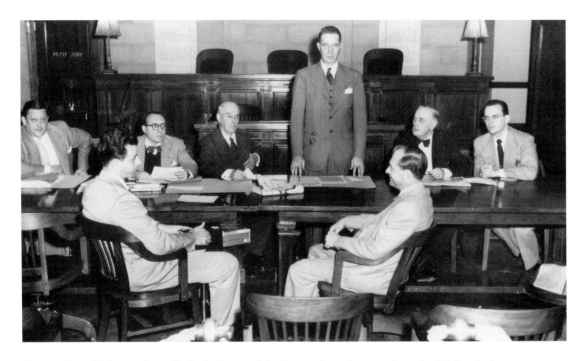

Senator Estes Kefauver (standing), chairman of the Senate Committee on Organized Crime in Interstate Commerce, opens hearings into Las Vegas's gambling enterprises, November 1950. The first witness, William J. Moore, executive director of the Last Frontier, is seated across from him, at right.

zealous attack on the underworld would curry favor with Democrats in the Bible Belt and earn him the party's presidential nomination in 1952. But by the time the senators arrived in Las Vegas on November 15, five months into their highly publicized probe, they had already exposed a web of political corruption so extensive that many on Capitol Hill believed it had cost the Democrats five seats in the recent midterm elections. "In Senate cloakrooms," said one acquaintance, Kefauver had all the appeal of "a skunk at a lawn party."

Las Vegans refused to give him even that much credit. "Privately my father and his friends joked that the [committee] would never shut them down," the daughter of one mobster recalled. "They had never had respect for politicians since they had made a career of bribing them." It was telling that Las Vegans saw fit to lay odds on the outcome of the hearings. Bookies later reported that almost no one had bet Kefauver would win.

The investigative proceedings, held at the federal courthouse in downtown Las Vegas, lasted the better part of a day, including a three-hour recess during which the senators dashed out to Black Canyon for a cursory tour of Hoover Dam. Testimony was taken from a half dozen witnesses, including Syndicate deputy Moe Sedway, who began by regaling the committee with a list of his many infirmities: three episodes of coronary thrombosis, chronic diarrhea, an ulcer, hemorrhoids, and abscess on his upper intestines. "I just got out of bed," he told Kefauver, "and I am loaded with drugs." Under

questioning Sedway eventually admitted to his role as a local representative for the Continental Press Service, a race-wire outfit allegedly controlled by the mob.

Later in the afternoon the committee heard from the Desert Inn's front man and host, Wilbur Clark, who conceded under oath that he had sold a controlling interest in his resort to Moe Dalitz in exchange for money to complete its construction. "Before you got into bed with crooks to finish this proposition, didn't you look into these birds at all?" Senator Charles Tobey of New Hampshire asked Clark, incredulous. "Not too much," Clark replied. "No, sir."

Dalitz himself was nowhere in evidence. As Hank Greenspun, now the publisher of the *Las Vegas Sun,* noted in his front-page column: "The top brass of the underworld suddenly remembered long-forgotten relatives in distant lands . . . They fled subpoenas like the black plague."

The day after the hearing, just before he departed for California, Kefauver held a closing press conference. He asserted that Nevada gambling had a "definite interstate character" but stopped short of leveling any actual charges. "Little New Light Is Shed on Casino Kingpins Here," a headline proclaimed the next evening in the *Las Vegas Review-Journal.* "The United States Senate's crime investigating committee blew into town yesterday like a desert whirlwind," the story began, "and after stirring up a lot of old dust, it vanished, leaving only the rustling among prominent local citizens as evidence that it had paid its much publicized visit here."

Nine months later Kefauver closed the books on his inquiry. Of the more than eleven thousand pages in his official Senate report, only four were devoted to Las Vegas—and those confined themselves primarily to stating what most locals had known all along. "The licensing system which is in effect in [Nevada]," the senators argued, "has not resulted in excluding the undesirables . . . but has merely served to give their activities a seeming cloak of respectability." As a corrective Kefauver proposed a 10 percent federal tax on wagering— enough, some claimed, to effectively

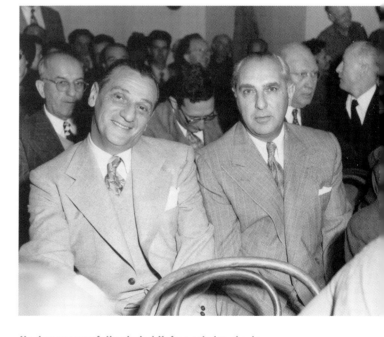

Having successfully eluded Kefauver's inquiry in Las Vegas, Moe Dalitz (left) finally showed up for questioning in Los Angeles. When Kefauver pressed him to admit that his Las Vegas investments had been financed with contraband liquor profits, the mobster cracked wise. "Well, Senator," he said, "if you people wouldn't have drunk it, I wouldn't have bootlegged it."

destroy the state's gambling industry. But thanks to Nevada senator Pat McCarran, the bill never made it out of committee.

Despite its failure to achieve anything of legislative consequence, the Senate inquiry had made Kefauver a national celebrity. He appeared on the cover of *Time* magazine in March 1951, and his book, *Crime in America,* became a best seller later that year. He even made an unsuccessful bid for the presidency, albeit without the backing of the Democratic Party. But his investigation had not come close to shaking the mob's hold on Las Vegas.

In the end, Kefauver's entire crusade wound up playing like an advertisement for America's unofficial mobster metropolis. As his Senate investigation and the publicity it generated forced the closure of underground bingo parlors and roulette dens all across the country, the concentration of gambling operators in Las Vegas only increased. As one new arrival put it: "I love that man Kefauver. When he drove me out of an illegal

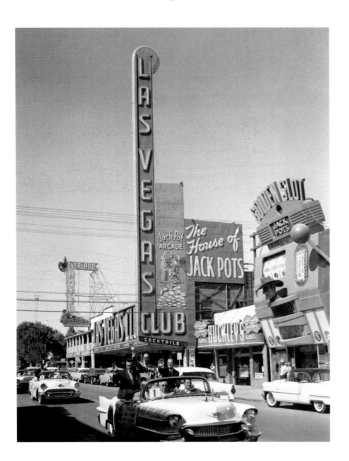

casino operation in Florida and into a legalized operation in Nevada, he made me a respectable, law-abiding citizen and a millionaire."

In another five years, amid continuing questions about hidden ownership interests in Las Vegas's gambling industry, state legislators would create a new regulatory body, the Nevada Gaming Commission, and pass a law requiring each and every casino operator to be licensed by the state. But like Kefauver's crusade, the move would have dramatic unintended consequences. Since the three-person commission was simply not equipped to investigate tens of thousands of stockholders, the law effectively barred investment by large, publicly held corporations and ensured that the mob would rule over Las Vegas casinos for years to come.

Kefauver (center) waves to passersby as he cruises Fremont Street during his campaign for Vice President, November 1956.

Opposite: Kefauver believed his investigation had uncovered evidence of "a government within a government," a criminal force with profits in excess of $20 billion a year and covert control of the politics and economies of several major cities and states coast to coast.

TIME

THE WEEKLY NEWSMAGAZINE

CRIME HUNTER KEFAUVER

Gamblers + Politicians = Corruption.

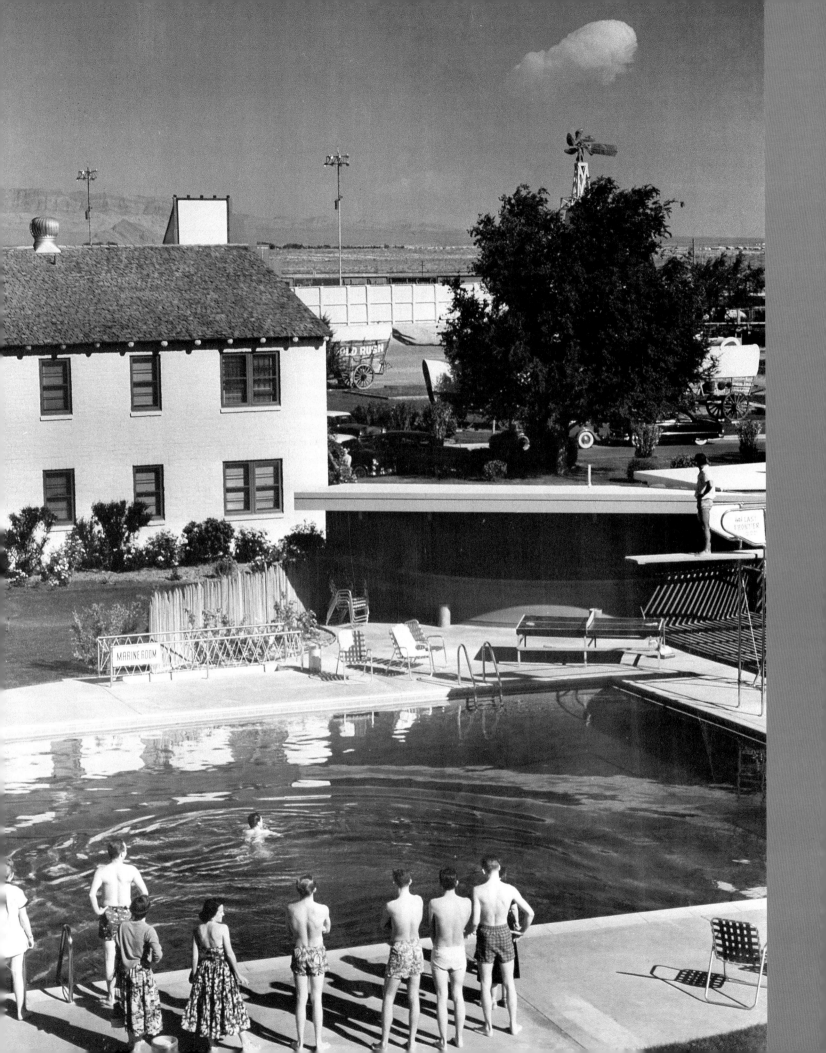

CHAPTER SIX
ATOMIC CITY, U.S.A.

Just before dawn on January 27, 1951, early rising Las Vegans saw a blinding white flash light up the sky. Minutes later, a whacking blast left a trail of broken glass from Fremont Street clear out to the Strip and shook a few dazed locals right out of their beds. The early edition of the *Review-Journal* summed up the mysterious event with this pithy headline: "Vegans Atomized." "Operation Ranger," the code name given to the Atomic Energy Commission's inaugural series of bomb tests at the first and only permanent nuclear proving facility on U.S. soil, had begun. Over the next twelve years, a total of 120 nuclear devices—an average of one every five weeks—would be detonated aboveground in the southern Nevada desert, just sixty-five miles from downtown Las Vegas.

The United States had already employed the atomic bomb as a weapon, in the spring of 1945, when the cities of Nagasaki and Hiroshima had been effectively vaporized in an effort to force a Japanese surrender and an end to World War II. But American scientists, hoping to perfect their grim creation, nevertheless had continued to gather information about its power and effect. Since 1946, tests had been conducted on the remote Pacific island of Eniwetok, in Bikini Atoll, some twenty-four hundred miles southwest of Hawaii and more than five thousand miles from AEC headquarters in Los Alamos, New Mexico. The site was inconvenient, logistically impractical, and quite costly for the AEC, but conventional wisdom held that only a national emergency could justify testing within the continental United States.

It was not until the Soviet Union detonated its first atomic weapon, in Siberia in 1949, and Communist forces invaded South Korea the following summer, that President Harry S. Truman had approved the establishment of the continental test site in southern Nevada, on 640 square miles of arid, unpopulated, federal land formerly used as the Bombing and Gunnery Range at Nellis Air Force Base. By the time the radiation reached Las Vegas, the nearest inhabited place, scientists had calculated it would be dissipated enough to cause no ill effects. As one AEC official noted later: "The population problem was almost zero." Las Vegans had been informed of the decision a couple

Guests of the Last Frontier watch a bomb blast poolside, May 1953. Photos like this one routinely appeared in newspapers across the country.

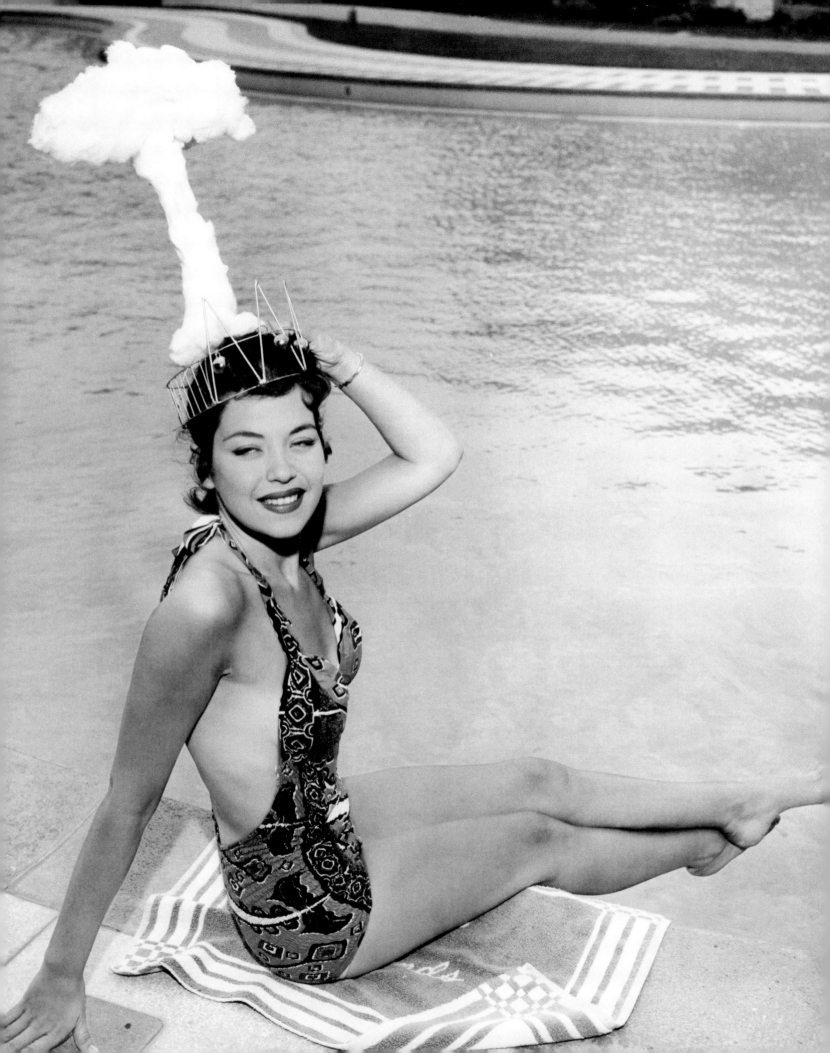

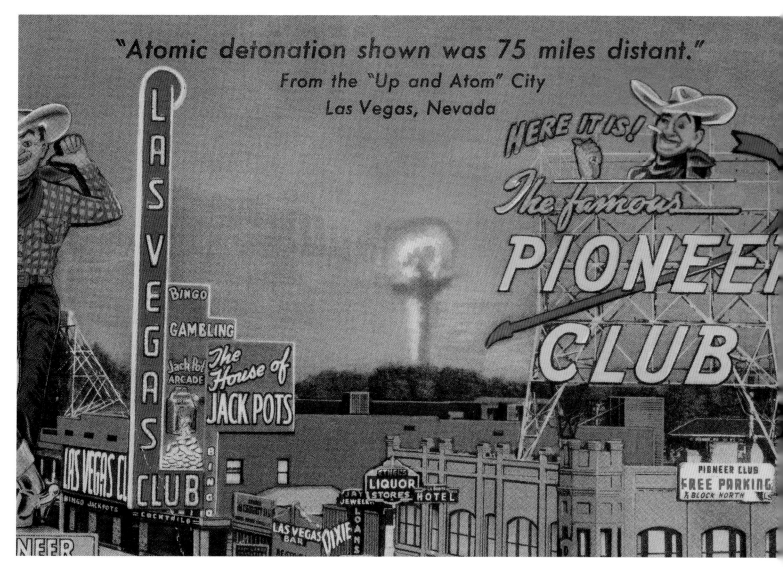

A postcard version of *LIFE* magazine's Picture of the Week, November 12, 1951, exploits the bomb as spectacle.

Opposite: Mushroom clouds were ubiquitous in Las Vegas in the 1950s, adorning everything from municipal reports to showgirls' headpieces.

of weeks before the first blast, amid firm assurances that the tests would pose no hazard. "The dangers of radiation pollution," one government scientist told a local audience, "have been unjustly overemphasized."

What little apprehension Las Vegans evinced revolved not so much around the potential exposure to radioactive fallout but the possibility that the bomb tests might scare tourists away. Around town much was made of an episode that had supposedly taken place at the local Sears, Roebuck, in which an elderly lady from Los Angeles had burst into the store one afternoon wanting two shirts in a hurry. She was just passing through, she explained to the salesman, and her husband was outside in the car with the motor running. She wanted the shirts to pass down to her grandsons, she said, "as heirlooms that had come from Las Vegas just before it was wiped off the face of the earth."

In the end, however, few residents objected to the bomb tests. Swept up in the great wave of anti-Communist hysteria that was then cresting over the nation and convinced that the security of the free world depended upon the development of atomic weapons, Las Vegans tended to regard their proximity to the test site as proof of their patriotism. And for a town that was most frequently described as "a whirlpool of vice," patriotism in the face of national peril was virtually synonymous with respectability. "We have glorified gambling, divorces, and doubtful pleasures to get our name before the rest of the country," Hank Greenspun opined in the *Sun*. "Now we can become a part of the most important

Above: A mushroom cloud dwarfs army observers during a joint Atomic Energy Commission–Department of Defense test series, 1951. Soldiers were purposely exposed to the tests to gauge the effects of radiation on human beings.

Opposite: The Nevada Proving Ground brought thousands of soldiers and defense workers into Las Vegas.

Above: The first atomic artillery shell ever to be fired explodes over Frenchman's Flat, 1953.

Right: Soldiers gape at a mushroom cloud, 1952. Moments earlier, at the time of detonation, they had occupied foxholes fewer than five miles from ground zero.

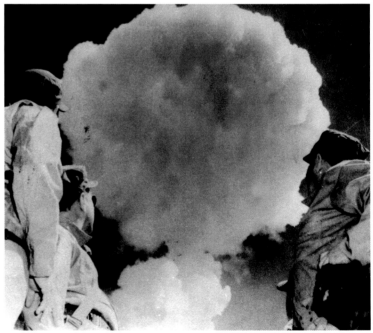

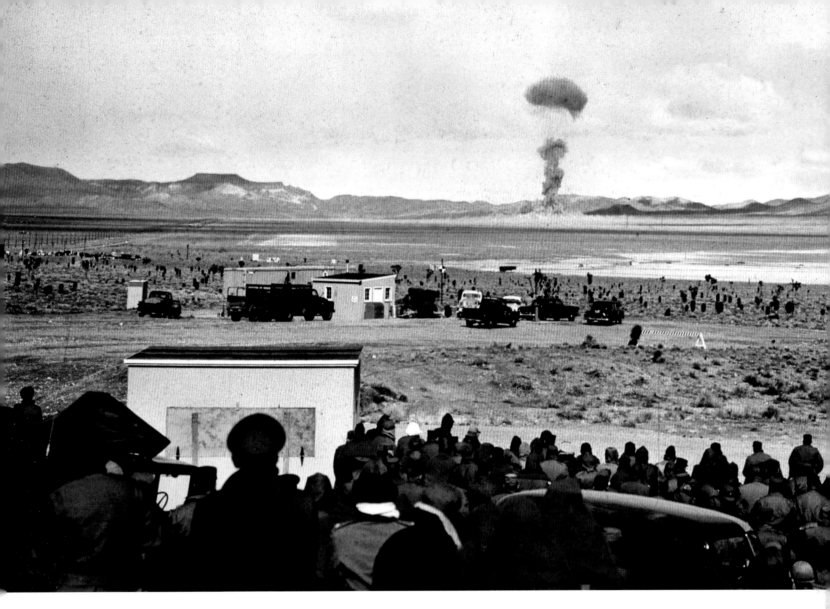

Military observers watch a mushroom cloud rise from the test blast called Met, a twenty-two-kiloton bomb exploded on Frenchman's Flat, April 1955.

work carried on by our country today. We have found a reason for our existence as a community."

Then, too, as the Hoover Dam and Nellis Air Force Base and Basic Magnesium, Inc., had already proved, an influx of federal cash was a powerful spur to growth. Over the course of the next decade, the test site would provide hundreds of steady, well-paying jobs and a total payroll of $176 million, a full two-thirds of which would eventually find its way into the local economy. And as a federally designated "critical defense area," the Las Vegas Valley now qualified for a mother lode of government assistance in the form of mortgage loans, school funding, and public work benefits.

But the real boon turned out to be the blasts themselves. At a moment when signs for Atomic Café and Atomic Motel were sprouting up on highways across the country,

when Boy Scouts were laboring to earn their "atomic energy" merit badges, and Hollywood was churning out films like *The Atomic City* and *The Atomic Kid,* Las Vegas now had the singular, if dubious, distinction of being the only city in America with a front-row seat at ground zero.

In the deft hands of Las Vegas's publicity machine, the specter of nuclear annihilation now became spectacle. Within days of the first test, the chamber of commerce had already printed up a series of press releases that promoted the blasts as just one more of the city's many dazzling attractions. In one a curvy blonde sported something called an Atomic Hairdo, the specialty of the Flamingo's beauty parlor. Another heralded the creation of the Atomic Cocktail, which consisted of a dash of sherry shaken with equal parts vodka, brandy, and champagne. Still another showed a woman in a bikini waving a Geiger counter as she tested the beard of a grizzled old prospector for radioactivity. "The angle was to get people to think the explosions wouldn't be anything more than a gag," one chamber official explained. To drive the point home, the chamber also churned out up-to-date shot calendars designed to help tourists schedule their trips and distributed road maps that highlighted the best vantage points around the test site.

Before long, the streets of Las Vegas were crowded with bomb tourists. They flocked to the "dawn bomb parties" at the casinos—drinking and singing sessions that began at midnight and ended with the sight of a flash—and jammed the Sky Room at the Desert Inn for its much-touted panoramic view of the surrounding desert and the mushroom clouds blooming over the proving ground. They rolled into town in old trucks and Airstream trailers and saw to it that dingy motels such as the Atomic View, which boasted "an unobstructed sight line to the bomb blast from the comfort of one's lounge chair," were chronically and perpetually over-

Top: Reporters, photographers, and others invited to watch the atomic blasts at the Nevada Test Site were provided with green, polarizing "Atomic flash" goggles. These were produced by Polaroid for "protection against excessive light and glare."

Bottom: An early "atomic" version of the special cereal-box prize.

Some of this radioactive matter spills out of the cloud near the explosion. Most of it is carried by the wind for many miles. Eventually it settles to earth. It is called fallout and continues to give off radioactivity until it decays.

RADIOACTIVITY IS NOTHING NEW

THE WHOLE WORLD IS RADIOACTIVE

But normal amounts of it are not dangerous. Only when radioactivity is present in large amounts does it become dangerous. Hydrogen bomb explosions create large amounts of radioactive fallout.

Fallout could settle anywhere. Winds could carry it to every part of the country.

Handbill issued by the Office of Civil Defense and Mobilization, and distributed to residents living in proximity to the Nevada test site. The pamphlet was designed to reassure area residents that the bomb tests would be "carried out under controlled conditions."

booked. On test days the road to Mount Charleston, a forty-two-hundred-foot vantage southeast of the proving ground, was typically thronged with cars. "Bumper to bumper, just like a ball game," noted an attendant at one gas station on the route. Some intrepid tourists actually hiked out to the site, packing motel-provided "atomic box lunches" and hoping to get as close to ground zero as the government's security restrictions would allow.

For a time even the locals seemed persuaded by the hype. In Las Vegas's residential neighborhoods, alarms rang before dawn and families gathered on their front lawns to watch the blinding flashes that reportedly could be seen from as far away as Montana. "Good bangs," recalled one Las Vegas native, "and so pretty coming at sunrise as they did." The iconic mushroom cloud became the town's most popular insignia, appearing on the covers of the local high school's yearbook and the telephone directory and even as the county's official seal.

But by the third round of tests, Las Vegans were already jaded. "Time was when a nuclear detonation took place, people knew about it," complained *Review-Journal* columnist Joe McClain. "But the good old days of Operation Ranger have passed. The scientists, to speak loosely, seem to have a little more control on the old fireball . . . Yesterday afternoon we had several calls wondering when 'the A-bomb was going off.' The people were real sore when they learned it already had been detonated. We think it might be good for the town's spirit if the scientists would send a few effects down Vegas way. Just to keep people happy."

Las Vegas's unbridled enthusiasm for the bomb did not go unnoticed. The *New Yorker, National Geographic, LIFE,* and the *New York Times Magazine* all ran stories about Atomic City, U.S.A., generating more column inches of free publicity for the local marriage, divorce, and gambling businesses than even the most loyal town boosters could have hoped for. "We're in the throes of acute prosperity," a hotel owner told journalist Daniel Lang of the *New Yorker* in 1952. "Before the proving ground, people just heard that this was a wide-open town. Now that we're next door to the atom bomb, they really believe it."

Top: Survival Pak, a provision kit designed for use in nuclear fallout shelters, contained water, food, and first-aid equipment.

Bottom: A "space-age" version of the toy cap gun, the Atomic Disintegrator was a favorite among American boys in the 1950s.

At the AEC's invitation dozens of journalists from all over the country regularly trooped out to the test site to photograph and report on the blasts. Perched some ten miles from ground zero atop a small hill that became known as News Nob and outfitted with dark glasses to shield their eyes from the initial blinding flash, they scribbled vivid dispatches that told of choking dust clouds and glowing orange balls in the desert sky. They applauded the triumph of American science and the success of the testing program. And, to a man, they parroted the government line that the tests were 100 percent safe.

Meanwhile some nearby residents noticed that their housepets bristled when petted and their horses' food went untouched. By decade's end, there were small, isolated pockets of protest: a petition circulated by seventy-five residents of the Tonopah area, eighty-five miles southwest of the test site, and complaints from local ranchers that their livestock were suffering beta particle burns. But it would be another several years before the Limited Test Ban put an end to the atmospheric detonations and more than a decade before the evidence of the tests' harmful effects truly came to light.

In the early 1950s any misgiving Las Vegans harbored about the bombs were still easily brushed aside. The town was growing. Tourism was booming. And every time a radioactive cloud bloomed over the desert, Las Vegas made the news.

Top: Geiger counters like the one above were commonly used at the test site to measure residual radiation levels postblast.

Bottom: Binion's Horseshoe promotes the atomic bomb with a postcard.

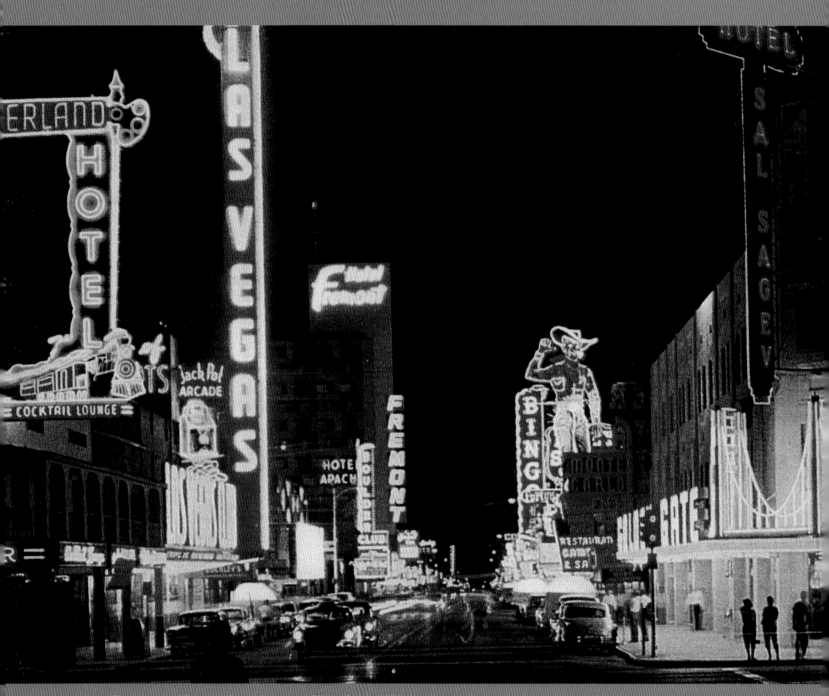

The stretch of Fremont Street known as Glitter Gulch, 1956. No other main drag in America was quite like it.

CHAPTER SEVEN

THE HEART OF THIS UNSPIRITUAL MECCA

At night the town was visible from a distance of more than fifty miles, an eerie, unnatural beacon in the pitch-dark desert that by 1955 lured an estimated eight million visitors a year—more than the Washington Monument, Mount Rushmore, Yellowstone National Park, and the Grand Canyon combined. Arriving either on one of the dozens of daily flights that now operated out of McCarran Airport or, more commonly, by car, they came from as nearby as Southern California and as far away as Kansas, bent on indulging in the illicit pleasures denied them back home. If queried

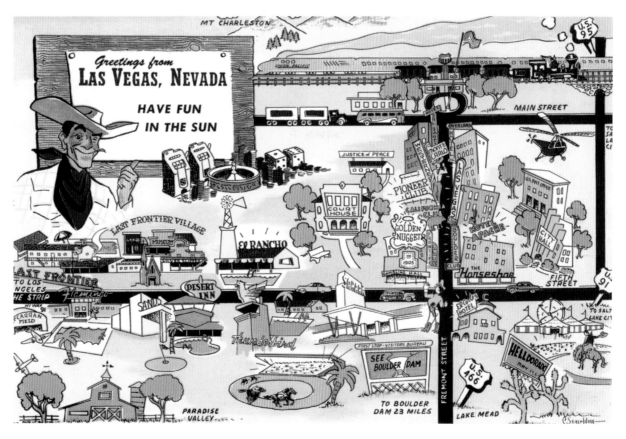

A 1955 postcard sketches the contours of the popular tourist mecca.

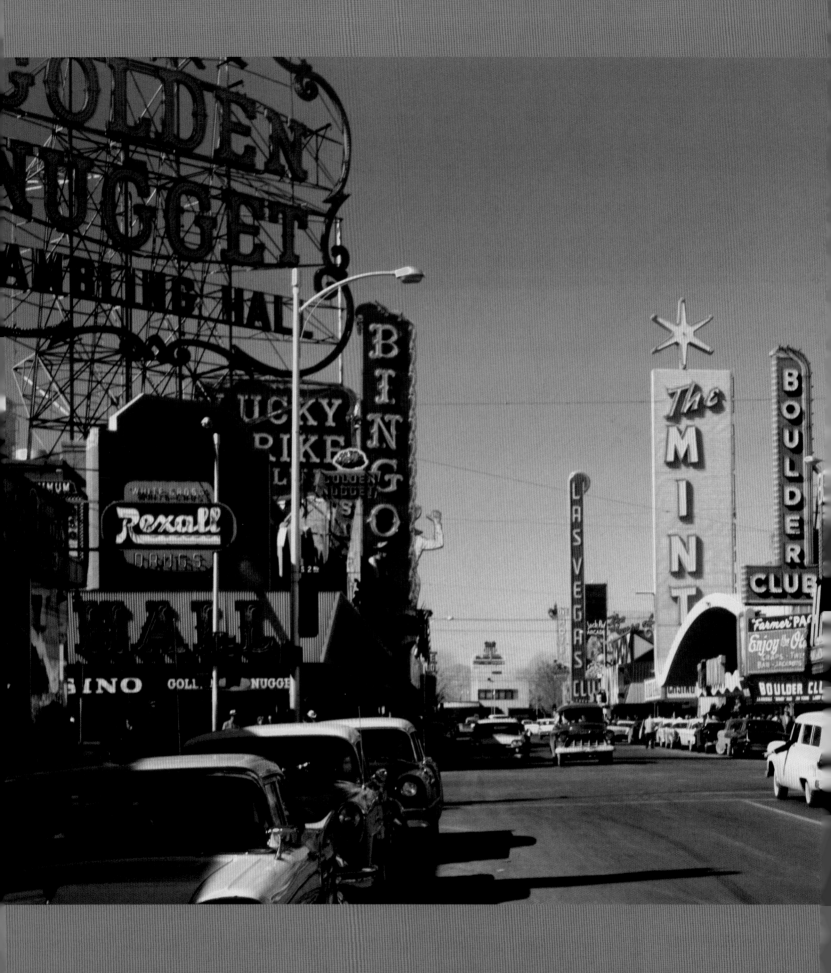

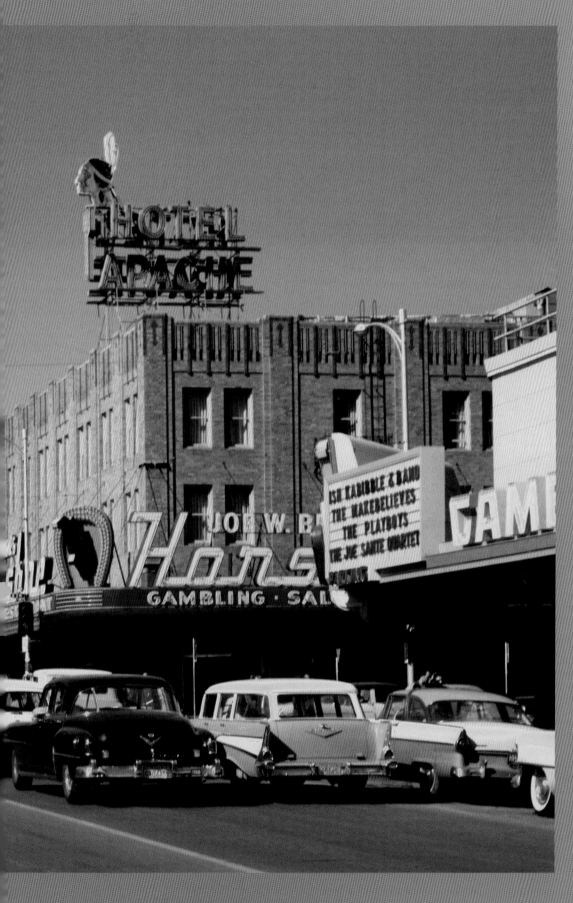

Glitter Gulch lost some of its allure when the sun rose. As *New York Times* journalist Wallace Turner would later put it, "In the bright desert sunlight of midmorning, [it] looks like a debauched chorus girl with a hangover."

publicly many likely would have conceded that the place was as worthy as ever of moral condemnation—a vulgar, garish sink of iniquity peopled primarily by rogues and thugs. But whatever aspersions were cast upon the town around office watercoolers in Topeka and Dubuque, its blithe and entirely legal wantonness had begun to exert an irresistible pull. In an era of stifling conservatism and sterile conformity, Las Vegas now looked to more and more Americans like an ideal escape. As one journalist put it: "The visitor . . . finds himself whisked as if by rocketflight from the world of reality into a sun-baked

Las Vegas gamblers bet on the horses.

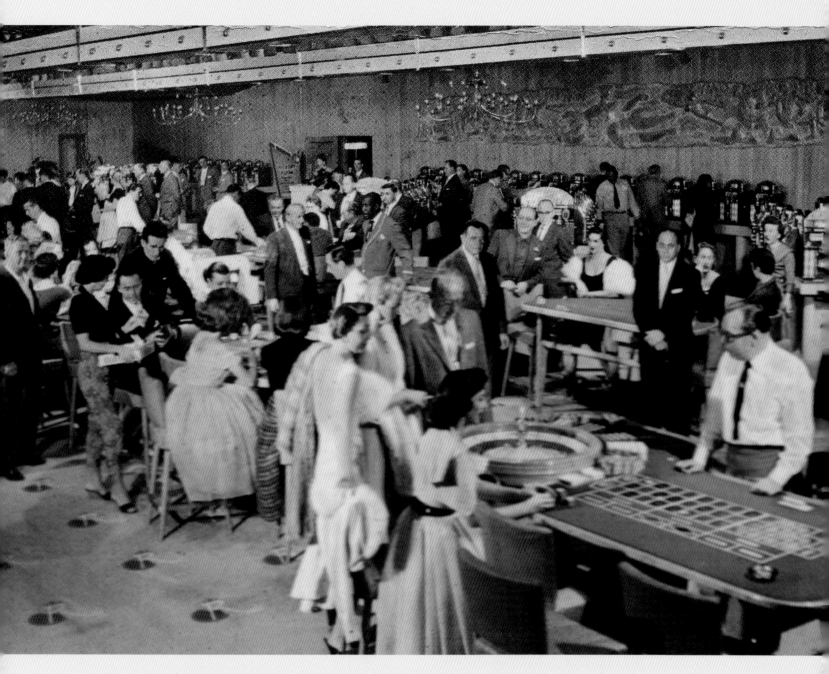

In the 1950s Las Vegas was chic, and gamblers dressed up to throw their money away.

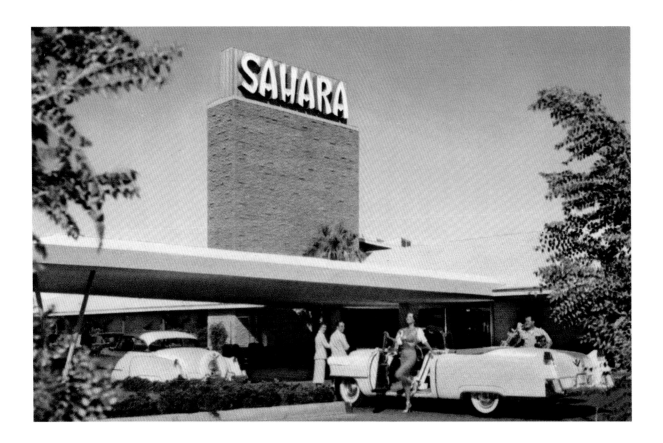

neo-Klondike, as the Klondike might be depicted in a Hollywood musical with palm trees substituted for snow."

As in the past, the tourists flocked by the thousands to the neon-emblazoned stretch of Fremont Street known as Glitter Gulch, where a half dozen gaudy gambling halls offered round-the-clock risk straight up—no fancy atmospherics, no distractions, just a multitude of games designed to part players from their money. In joints like Binion's Horseshoe, the Golden Nugget, and the Pioneer Club, the clink of silver dollars was constant, and sport-shirted vacationers circulated restlessly among grizzled cardsharps and local hustlers hoping to make a score, while cocktail waitresses in fishnet stockings picked their way through the crowds, doling out liquid courage to anyone who seemed in need of an inducement to play.

But even as Glitter Gulch continued to pack them in, Las Vegas's center of gravity was shifting. "If the visitor can bring himself back to earth," suggested journalist Gladwin Hill in the *New York Times Magazine*, "he can discern that Fremont Street . . . is a fairly humdrum small-town main-drag." Increasingly, the real draw in Las Vegas was the Strip. There, along the once-desolate two-mile expanse of Highway 91, Hill noted, "the traveler plunges into a never-never land of exotic architecture, extravagant vegetation, flamboyant signery, and frenetic diversion . . . [that is] the heart of this unspiritual Mecca."

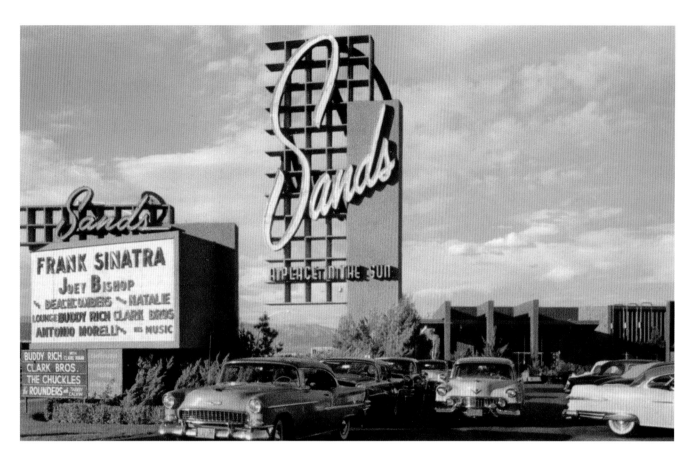

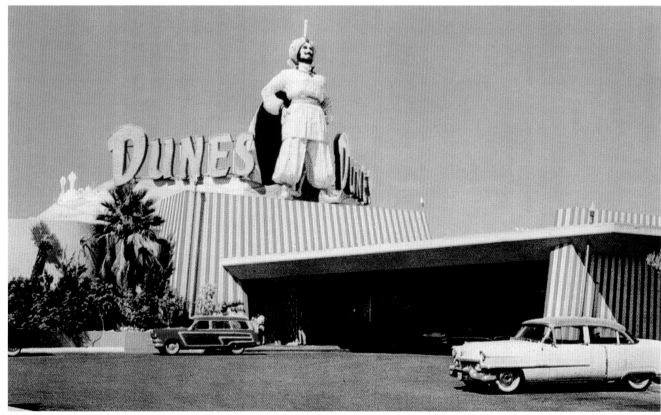

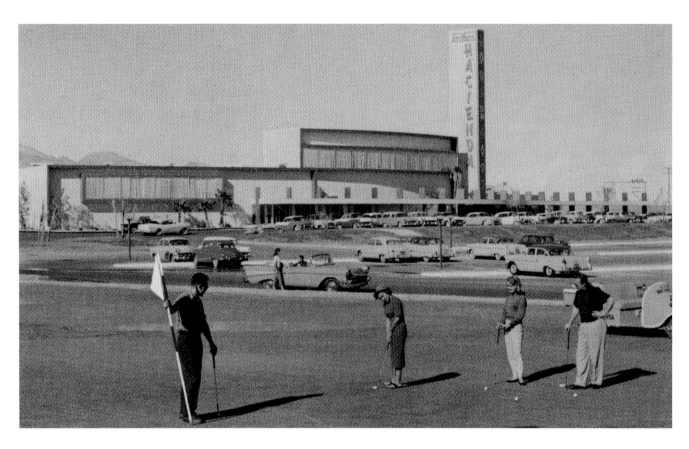

Inspired by the spectacular profits that had been reaped in the years immediately after the war, various mob-affiliated interests had rushed to stake their own claims on the Strip. By 1954 the pioneer resorts—the El Rancho Vegas, Last Frontier, Flamingo, Thunderbird, and Desert Inn—had been joined by two new establishments: the 276-room Sahara, an architectural homage to an imaginary North Africa adorned with outsize plaster camels and a one-hundred-foot neon sign; and the sprawling Sands, with its posh nightclub, the Copa Room, and its floating craps tables in the pool. In 1955 came the New Frontier, a modern annex to the Last Frontier, which swapped the once-ubiquitous western motif for a sleek, space-age design; the eleven-story Mediterranean-themed Riviera, the Strip's first high-rise hotel; and the 194-room Dunes, which boasted a ninety-foot swimming pool and three-story-high sultan standing guard out

front. The deluxe, $15 million Tropicana soon followed, with its sixty-foot tulip-shaped fountain and enough air-conditioning to cool one thousand homes in Death Valley; along with the 1,032-room Stardust, which was not only the largest hotel in the world at the time but also the site of the two largest casinos in the state and the largest electric marquee on the planet: 216 feet long, 27 feet high, and composed of more than 6 miles of wiring, 7,100 feet of neon tubing, and eleven thousand lamps.

With competition among the resorts at a fever pitch, and each employing its own full-time publicist, the Las Vegas Strip became a household name almost overnight. The Dunes doled out some $56,000 a year to keep an enormous neon sign atop New York City's Capitol Theatre; beneath the words "Dunes" and "Las Vegas" was a giant roulette wheel that spun and stopped of its own accord, reportedly prompting unusual traffic jams and occasional wagering activities in the immediate area. The Sahara, meanwhile, commissioned the construction of a gargantuan replica of the resort's "Garden of Allah" swimming pool at the busy intersection of Sunset and Doheny in Los Angeles. Not only was the pool actually filled with water, but eight bathing beauties were paid to leap and cavort around in it for eight hours a day. The stunt cost $30,000 and resulted in an estimated $1 million worth of free publicity.

Occasionally the plays for national attention bordered on the bizarre. At one point, in the interests of what a bemused reporter called "a nationwide demand for Las Vegas whoop-de-do," the New Frontier installed a glass-enclosed observation chamber at the

bottom of its swimming pool, ostensibly so that guests could watch swimmers frolic while tossing back a Gibson or a martini. The inevitable photos that appeared in hometown papers everywhere were accompanied by a caption that read: "Where else in all the world but Las Vegas could Mr. and Mrs. Joe Doakes of Wichita, Kansas, enjoy cocktails underwater?" One publicist even toyed with the idea of filling the Flamingo's pool with Jell-O, before a desperate maintenance engineer put a stop

to the stunt. "It's sometimes debatable in Las Vegas whether pools are constructed for swimming or for publicity purposes," one writer quipped. "[But] Las Vegas has learned in the space of a few short years how to get its picture on the nation's front pages every day without benefit of gambling or atomic explosions, though both help."

What the Strip resorts were after was volume: high rollers and serious gamblers would always be welcome, but operators knew that the real profits in the casino business would come from maximizing the number of small-time $1 and $2 bettors, other-

wise known as suckers, tinhorns, and grinds. To lure them in, the Strip offered something found nowhere else in America: a luxury vacation at a middle-class price. Each year throughout the 1950s, millions of what English playwright Noël Coward called "the most ordinary people" descended on the Strip, eager to avail themselves of the posh accommodations, eternally green golf courses, and famously lavish midnight buffets—suppers described by one satisfied diner as "unrestricted vistas of Eastern lobster in aspic, terrines of Strasbourg foie gras, Shrimp Louis, cold birds, and all the delicatessen of the Super-Reuben's." In the evenings they wandered through the casinos, rubbing elbows with the Hollywood elite and shouting to one another over the din of clanging slot machines and rumba music, their eyes peeled for mobsters. The criminal element, after all, was part of the

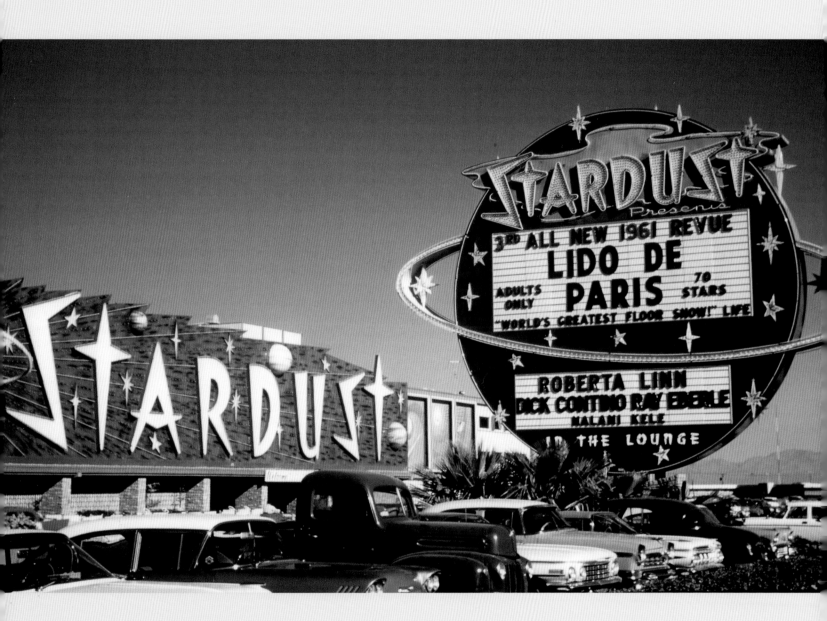

place's appeal, a flesh-and-blood reminder that buttoned-down mainstream America, with its starter ranches and Tupperware parties, thankfully had been left far, far behind.

Twice nightly, guests were invited into the elegant showrooms, where for the price of a cup of coffee—the least expensive item on the menu—they could catch the sort of live performance that rarely, if ever, made it to Main Street, U.S.A. Over the course of the

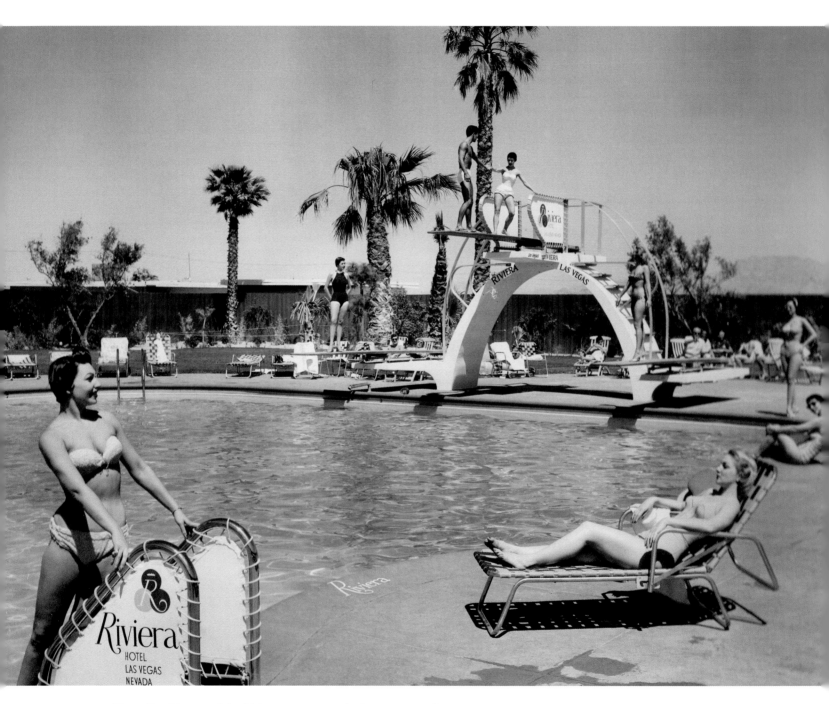

Views like this one, of the Riviera, were a standard component of Las Vegas's advertising.

The pool area at the Sahara was known as the Garden of Allah. When the resort opened, in 1952, its pool was the largest in Las Vegas, a distinction that lasted all of two weeks.

decade, virtually every popular entertainer in America made an appearance on the Strip, their usual shows invariably retooled a bit to include a leggy, suggestively clad chorus line. Singers Bing Crosby, Perry Como, Rosemary Clooney, Andy Williams, Ella Fitzgerald, Nat King Cole, and Frank Sinatra all headlined at one time or another at one of the Strip resorts, as did comedians Jimmy Durante, Dean Martin and Jerry Lewis, Abbott and Costello, Milton Berle, and Red Skelton. There were also the unclassifiable, all-around showmen like Sammy Davis Jr. and Liberace; the performances by legendary orchestras and big bands; the extravagant magic shows and cabaret acts and musical revues. As one visiting reporter put it: "The wayfarer arriving in Las Vegas during any given week has a wider choice of top-banana talent than the average New Yorker." The parade of stars was so relentless that, as early as 1953, the entertainment

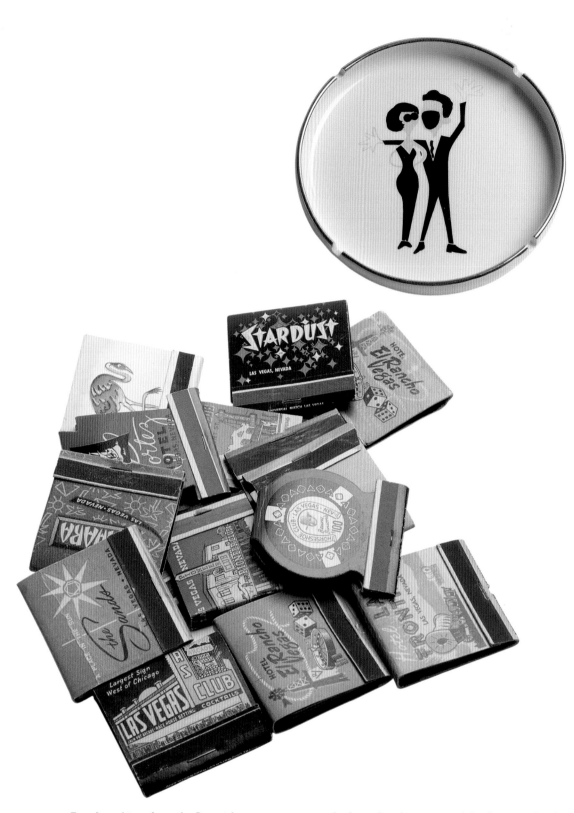

Top: An ashtray from the Desert Inn commemorates the legendary lounge act of the first couple of jazz, Louis Prima and Keely Smith. When the couple divorced in 1960, Smith refused to fulfill her contract with the Desert Inn.

Bottom: A selection of matchbooks from some of Las Vegas's most popular destinations.

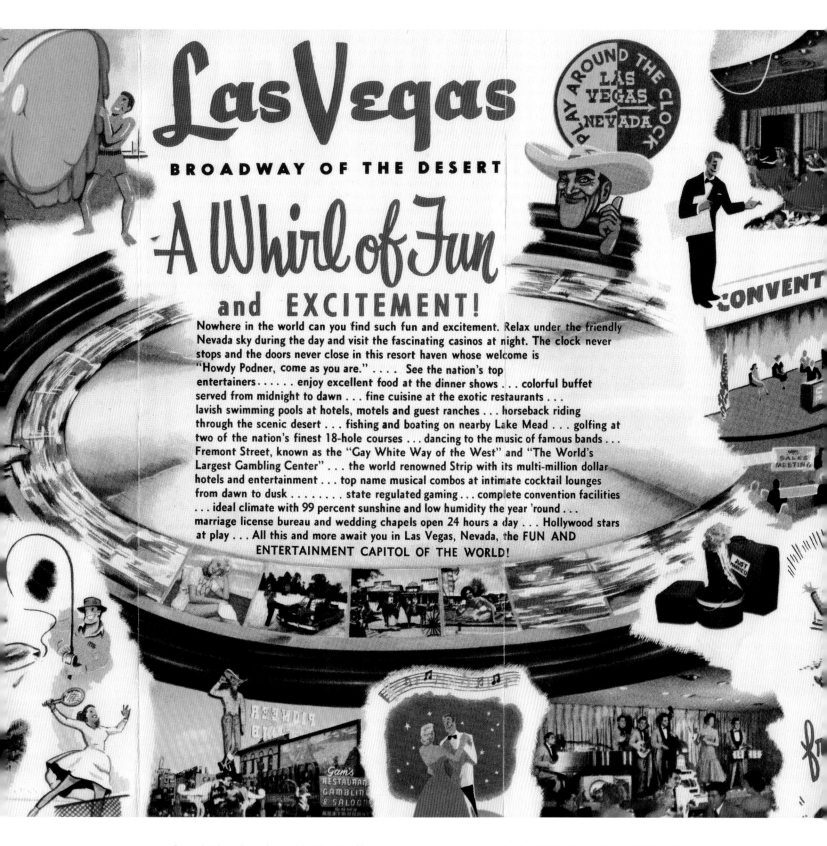

Las Vegas

BROADWAY OF THE DESERT

A Whirl of Fun and EXCITEMENT!

PLAY AROUND THE CLOCK
LAS VEGAS NEVADA

Nowhere in the world can you find such fun and excitement. Relax under the friendly Nevada sky during the day and visit the fascinating casinos at night. The clock never stops and the doors never close in this resort haven whose welcome is "Howdy Podner, come as you are." See the nation's top entertainers enjoy excellent food at the dinner shows . . . colorful buffet served from midnight to dawn . . . fine cuisine at the exotic restaurants . . . lavish swimming pools at hotels, motels and guest ranches . . . horseback riding through the scenic desert . . . fishing and boating on nearby Lake Mead . . . golfing at two of the nation's finest 18-hole courses . . . dancing to the music of famous bands . . . Fremont Street, known as the "Gay White Way of the West" and "The World's Largest Gambling Center" . . . the world renowned Strip with its multi-million dollar hotels and entertainment . . . top name musical combos at intimate cocktail lounges from dawn to dusk state regulated gaming . . . complete convention facilities . . . ideal climate with 99 percent sunshine and low humidity the year 'round . . . marriage license bureau and wedding chapels open 24 hours a day . . . Hollywood stars at play . . . All this and more await you in Las Vegas, Nevada, the FUN AND ENTERTAINMENT CAPITOL OF THE WORLD!

A tourist brochure issued by the Las Vegas chamber of commerce in the 1950s. As early as 1947 Las Vegas had been praised for its successful efforts "to sell relaxation."

industry's newspaper, *Variety*, had found it necessary to station a full-time correspondent in Las Vegas.

Nowhere else in America, not even New York, were performers paid so well—as much as $50,000 dollars for a one-week stand. The celebrities gladly returned the favor, plugging their Vegas gigs every time they appeared on television and generating frenzied press coverage of the self-proclaimed "Entertainment Capital" of the nation. Eventually, as the competition in town mounted and the price of star-studded productions soared, some casinos began to rely more heavily on titillation to bring the crowds in. With each passing month, costumes in local revues grew skimpier, until finally, in

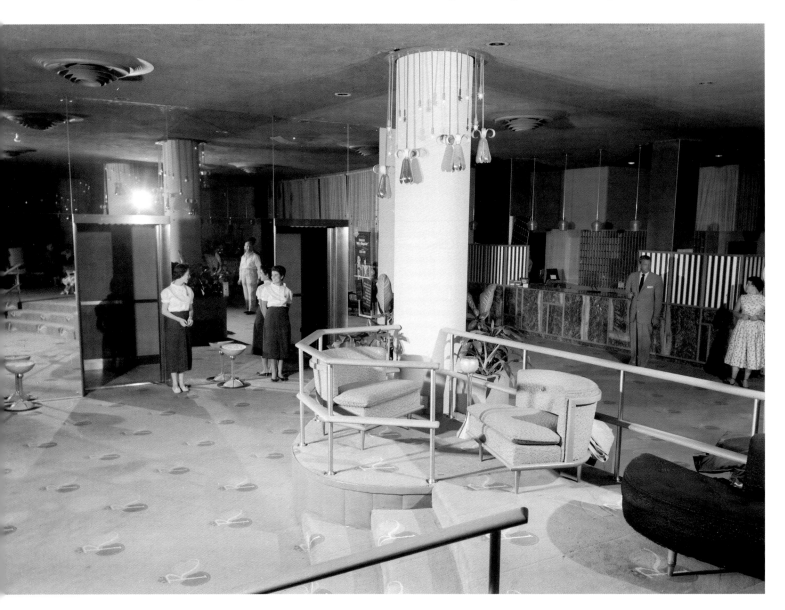

Opened in 1955, the Riviera was the Strip's seventh resort. Apart from its height—at nine stories, it towered above its neighbors—the Riviera's main claim to fame was its headliner, Liberace, who was reportedly paid $50,000 a week. The hotel went bankrupt inside of a month and was immediately taken over by the Syndicate.

The New Frontier, which opened in 1955, boasted an outer-space design motif that included three-dimensional amethyst murals depicting the twelve signs of the zodiac, a cocktail lounge called Cloud Nine, and a showroom called Venus.

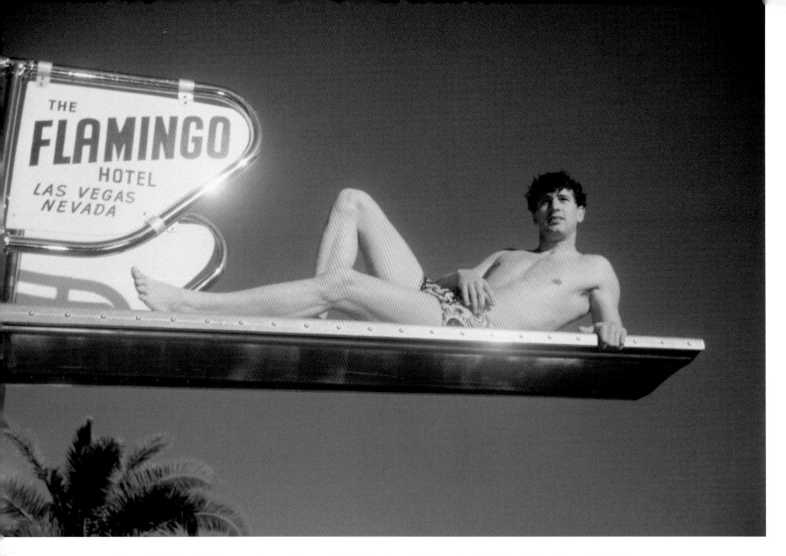

Screen idol Rock Hudson soaks up the sun at the Flamingo. Hollywood celebrities helped to establish Las Vegas's reputation as a glamorous weekend getaway.

1957, the dancers at the Dunes appeared on stage topless. "Pretty girls sell," a veteran of the Las Vegas publicity business explained to a journalist. "You need to do something to get people's attention."

But in the end, the entertainment was never more than a sidelight—"a smart business hype," noted *LIFE* magazine, "[that] brings gambling patrons in." Actress Tallulah Bankhead put the matter more baldly: "Dahling," she once said to a reporter, "we're just the highest-paid shills in history."

It was, after all, the gambling that kept people coming—and kept them coming back. In the Strip casinos, thoughtfully devoid of both windows and clocks, there was never any telling night from day. Truth was, no one much cared. Hopeful players swarmed in at all hours, ready to spend their last dollar on the chance that this time they might beat the odds and walk away a winner. The pace never seemed to slow. "Even now, in the pre-Christmas slump," Noël Coward marveled in 1958, ". . . there are masses of

Opposite: Silver-screen swimmer Esther Williams catches a glittering downpour at the Sahara, 1954.

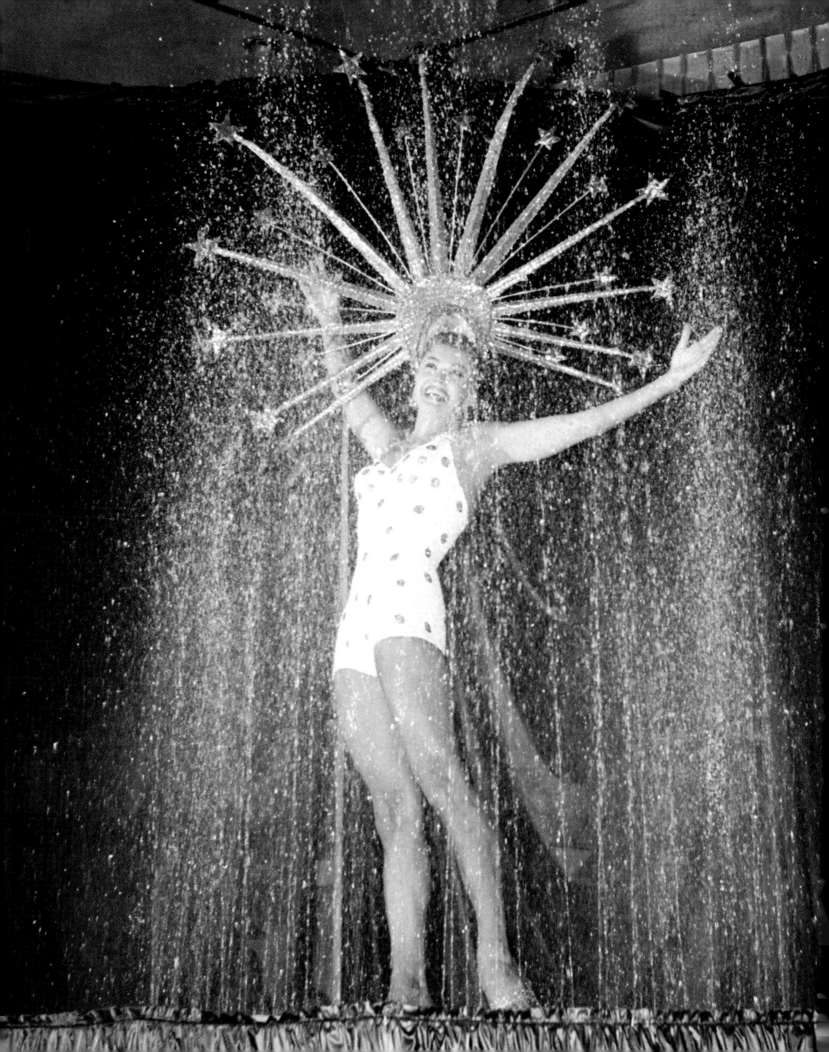

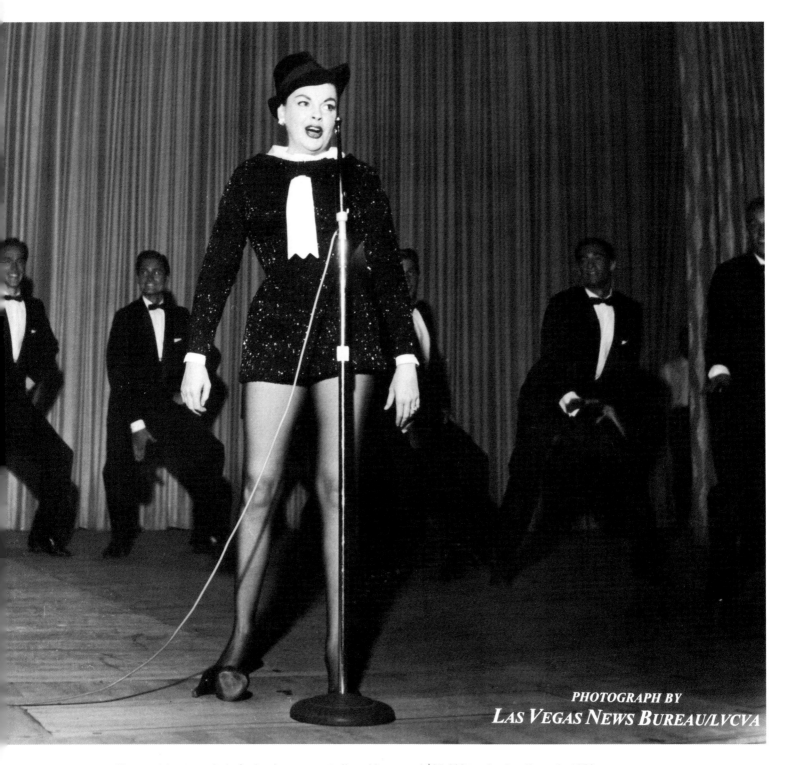

Singer and actress Judy Garland was reportedly paid a record $55,000 to play Las Vegas in 1956.

Opposite: Screen siren Mae West winds up her act at the Sahara, surrounded by the self-proclaimed "Strongest Men in the World," among them Dick Dubois, "Mr. America of 1954." The bit would likely never have flown on Broadway.

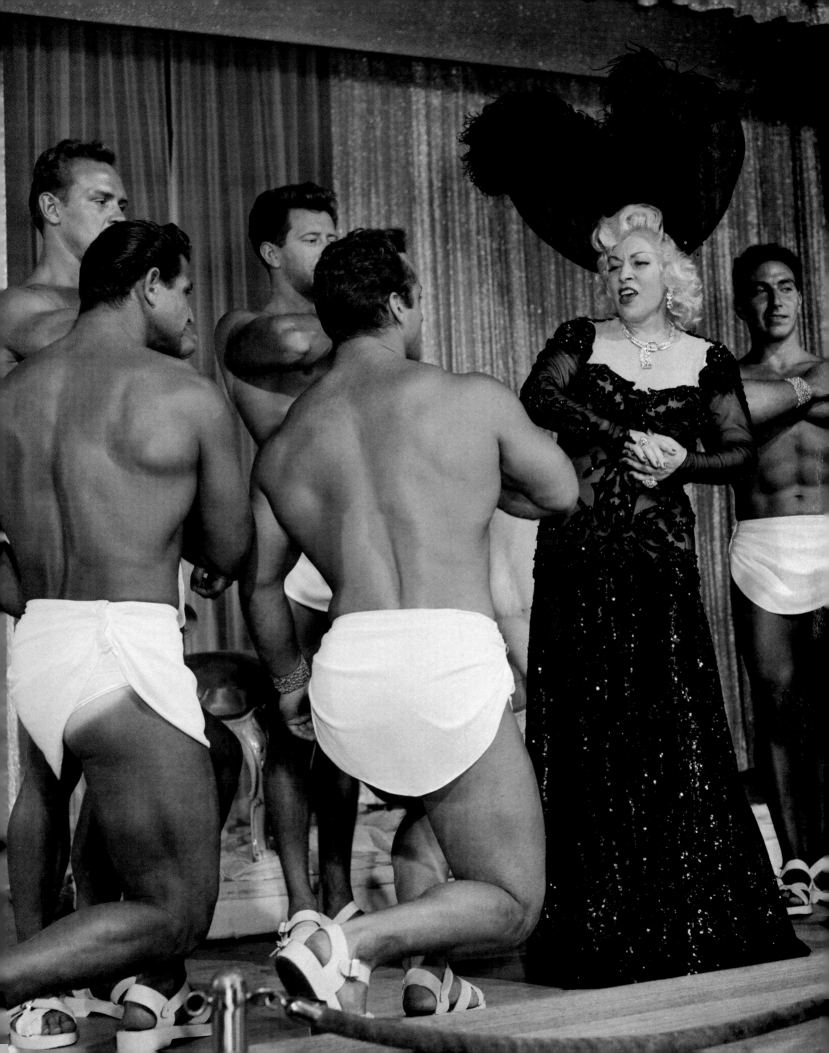

earnest morons flinging their money down the drain . . . There are lots of pretty women about but I think on the whole, sex takes a comparatively back seat. Every instinct and desire is concentrated on money."

Casino owners calculated that few of their guests spent more than four hours out of every twenty-four in their rooms. Fewer still ever ventured off the Strip. "One in a thousand visitors may know other aspects of the community," an L.A.-based reporter surmised, "the rest would, in fact, be surprised that Las Vegas has other faces." If the Strip was not quite synonymous with Las Vegas in the American mind by decade's end, it had at least come to represent its essence: a hyperkinetic fantasy playground for the adult id, miles away from the staid, middle-class suburbs and a world apart, a singular place now known to the country as Sin City.

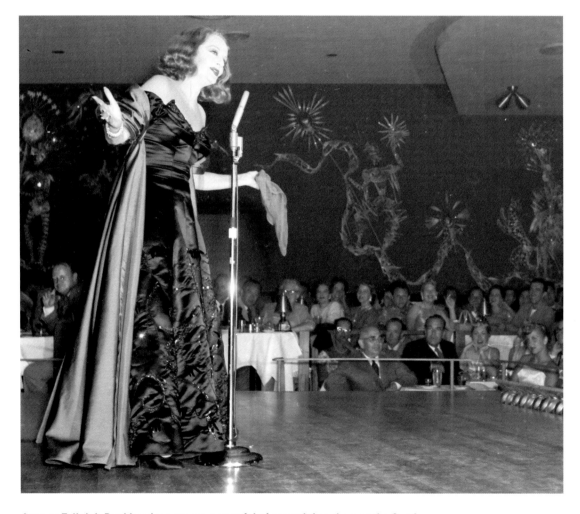

Actress Tallulah Bankhead warms up a roomful of potential suckers at the Sands.

Overleaf: The lavish stage shows of the 1950s, with their troupes of chorus girls in outlandish headdresses, actually created an entertainment subgenre known as the Las Vegas–style revue.

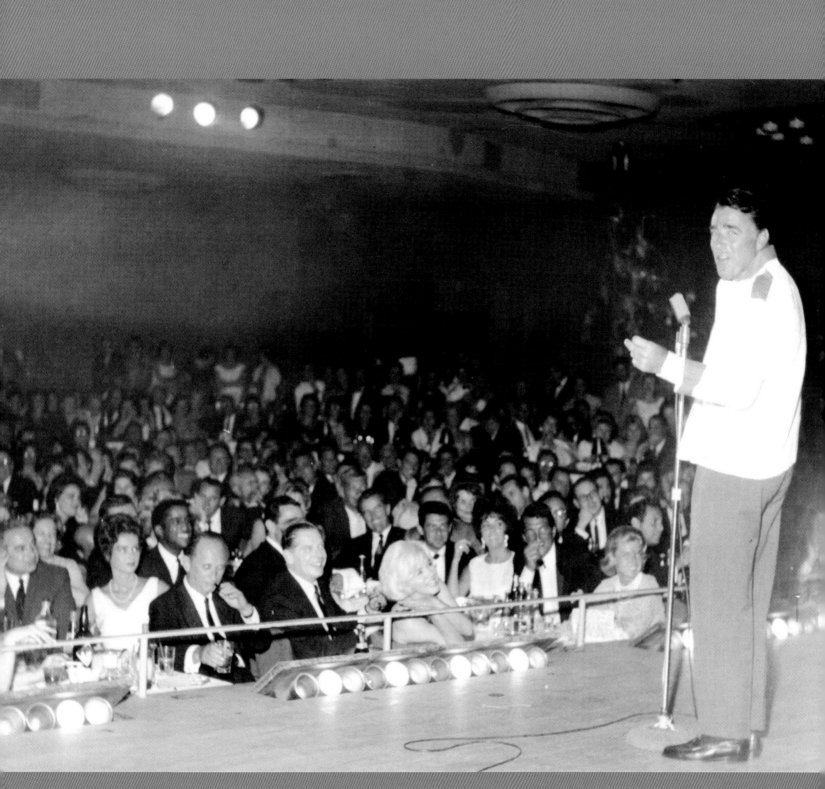

The stars come out to see Peter Lawford perform at the Sands, circa 1960. Seated front and center are Sammy Davis Jr., Milton Berle, Marilyn Monroe, Eddie Fisher, Elizabeth Taylor, and Dean and Jeannie Martin.

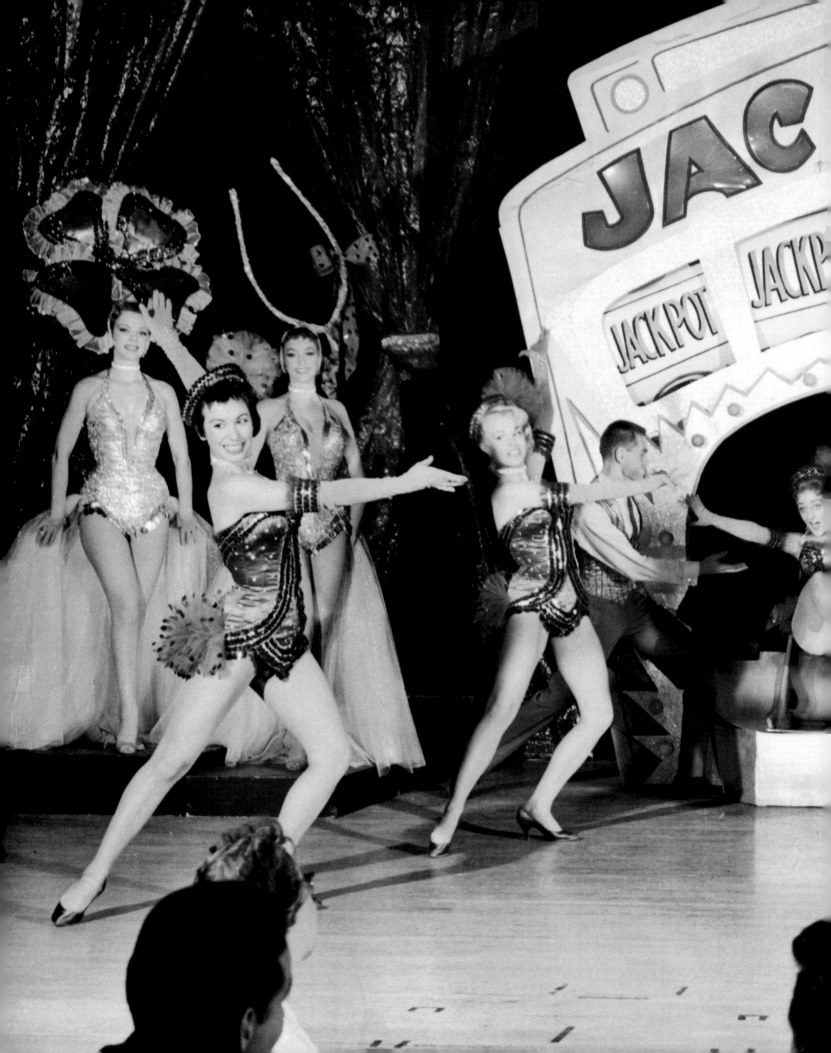

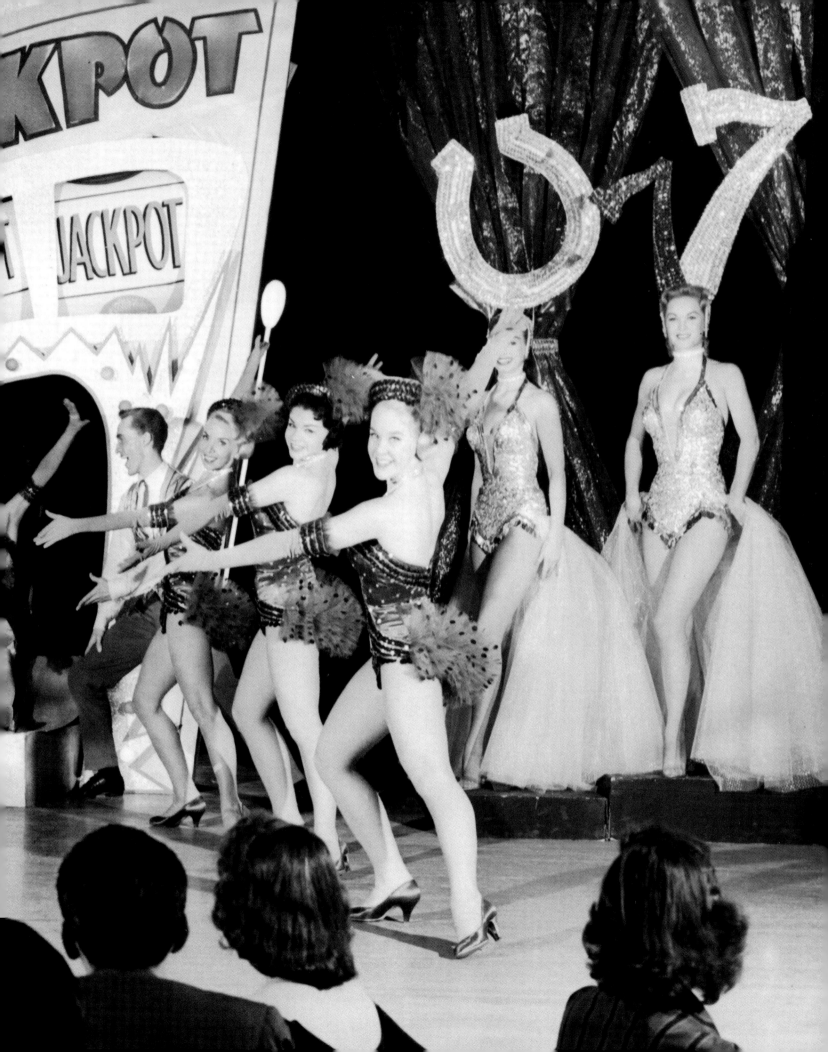

THE RAT PACK

BY MAX RUDIN

In 1960, an unlikely group of entertainers, all loosely gathered around Sinatra, had been in Las Vegas to shoot a movie and do two nightclub shows each evening, spending most of the hours in between at all-night parties. Billed, with intentional swagger, as "the Summit" (a reference to the coming conference of Eisenhower, de Gaulle, and Khrushchev), their act took off like a rocket, its momentum carrying them beyond the three-week club date into movie and record and business deals, reprises in Miami, Atlantic City, and Palm Springs—power and influence unusual even for movie stars.

On stage and off, the Rat Pack "swung" in every sense of the term, sending up the square world with a bravado that took mainstream the rebellious poses of rock and roll and predicted the sexual revolution we now associate with a different generation and a slightly later period. The Rat Pack announced that a new generation was laying claim to American tradition and to the right to define American Cool: one black, one Jew, two Italians, and one feckless Hollywoodized Brit, three of them second-generation immigrants, four raised during the Depression in ethnic city neighborhoods. Successful, self-assured, casual, occasionally vulgar, they were sign and symptom of what the war had done to the American WASP class system. The Rat Pack were more than entertainers, and the Summit was more than a stage act. It was a giddy version of multiethnic American democracy in which class was replaced by "class."

No one understood how fragile it was. The brassy music, the camaraderie, the power, sex, and sharp male stylishness—it all depended on a potentially explosive mix of elements held together for a moment in a high-wire drama: Hollywood, Washington, D.C., and the Las Vegas underworld; white and black; sophistication and vulgarity; rebellion and tuxedoed respect for tradition, especially the Tin Pan Alley and theater song tradition that with the Rat Pack had its last run at the hit parade.

Sinatra and Martin and the Rat Pack instead exuded machismo and danger, a style lent authority by their known associations with powerful and violent men. Postwar Americans had learned to take their popular culture spiked with a touch of risk, and Sinatra had molded his adult image on the sensitive tough guys portrayed in the movies by Humphrey Bogart.

Bogart in fact is central to Rat Pack history. In 1949 Sinatra had moved his family from L.A.'s Toluca Lake to Holmby Hills, just blocks from Bogart's house, and the Hollywood rookie was inducted into a group of the film star's drinking buddies. The story goes that when Bogart's wife, Lauren Bacall, saw the drunken crew all together in the casino, she told them, "You look like a goddamn rat pack."

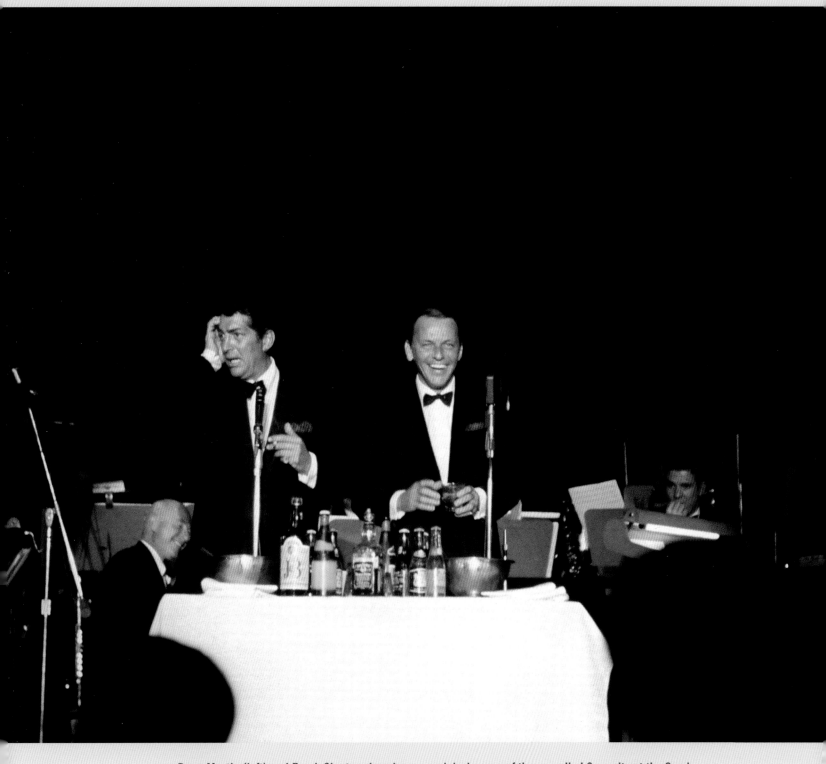

Dean Martin (left) and Frank Sinatra clowning around during one of the so-called Summits at the Sands, 1961. The Summit epitomized Las Vegas at its most hip.

Sinatra liked having people around him, and after Bogart died in 1957, he assembled his own court. Some had been beneficiaries of Frank's patronage. Joey Bishop, who grew up Joseph Gottlieb in South Philadelphia, the son of a bicycle repairman, was known as the Frown Prince of Comedy for his world-weary style. He had knocked around the burlesque and nightclub circuit for years when Sinatra spotted him in New York in 1952 and saw that he was booked on the same bill with him. Sammy Davis Jr. was another. Singing with the Dorsey band in 1941, Frank had befriended the aspiring dancer, then part of the Will Mastin Trio; they reconnected after Sammy was discharged from the army, and Frank helped the trio get work. In 1946 he insisted that New York's Capitol Theater book the Mastins as his opening act at $1,250 a week, a sum that stunned Sammy's partners.

Dean Martin had come up as a singer very much in Sinatra's mold. In September 1943 reviewers touted a new act at New York's tony Riombamba Club: "In Sinatra's singing spot is a chap . . . who sounds like him, uses the same arrangements of the same songs and almost looks like him." They didn't meet until June 1948, after Martin had teamed up with Jerry Lewis, and the first impression didn't impress. "The dago's lousy," Sinatra said, "but the little Jew is great." By the early fifties, though, the fellow Capitol recording artists had grown close, and they sealed their friendship in 1958 on the set of *Some Came Running*, which also featured the future Rat Packette Shirley MacLaine.

In January 1959 Sinatra joined Martin for the first time on the stage of the Sands, setting the tone and format for the Rat Pack shows. *Variety* reported: "Martin, a heavyweight who appeals to both distaffers and their gaming escorts, sparks casino activity even if he doesn't double as stage performer and blackjack dealer—which he usually does. First-nighters got an extra added attraction—Frank Sinatra joined his Great & Good friend onstage, and the pair put on one of the best shows ever seen at the Sands."

It was a good thing, for the Sands, for Las Vegas, for the people whose money built all those modernistic hotels. Earlier that month Fidel Castro had marched into Havana and seized casinos that earned the mob millions annually. The pressure was now on Las Vegas, where the mob—with financing courtesy of the Teamsters Central States Pension Fund—had in the course of the 1950s invested in such new hotels as the Fremont and the Dunes. The Sands was the classiest, and it offered incentives to hold on to top talent. In 1958 Sinatra's percentage in the hotel and casino was raised from two to nine points, and Dean Martin was sold a point. With Davis and Bishop already signed to long-term contracts, the Sands was the de facto home of the Rat Pack well before the Summit.

The fifth member of the Pack, suave, London-born Peter Lawford, was an actor and entertainer who had landed a contract with MGM when he was twenty but never broke into serious leading roles. By the late fifties he wasn't doing much, but he had other assets: His wife was Jack Kennedy's sister Pat. Sinatra clearly relished the Kennedy connection; his Rat Pack nickname for Peter was Brother-in-Lawford.

The Sands entertainment director agreed to a format for the Summit that fitted its improvisatory informality. For two shows each evening, at least one, perhaps two or three or four, sometimes all five entertainers, would appear on the Copa Room's stage. The Sands would have its own gathering of top men. Although February was traditionally a slow month, the hotel received eighteen thousand reservation requests for its two hundred rooms. Word traveled fast about the Summit's wildness—hijinks partially scripted and anchored by the emcee, Bishop, whom Sinatra called "the hub of the big wheel." Between star turns by Martin, Davis, and Sinatra, and dance numbers with Davis and Lawford, they wandered off to the wings, parodied each other, did impressions, and poured drinks from a bar cart they rolled onstage.

They performed together, drank together, hung out together, and the press couldn't get enough of them. At first they were called the Clan, over heavy protests. Sinatra said, "It's just a bunch of millionaires with common interests who get together to have a little fun." Bishop frowned: "Clan, Clan, Clan! I'm sick and tired of hearing things about the Clan. Just because a few of us guys get together once a week with sheets over our heads . . ." Sammy Davis, straight-faced: "Would I belong to an organization known as the Clan?"

It was the sixties, and the resonance of *clan* was finally too disturbing given the growing awareness of the civil rights movement, so reporters reverted to the older name, and it stuck.

Nineteen sixty-one was the peak for the Rat Pack. Their pal was in the White House, Sammy got married, and Sinatra and Martin were buying their own casino. They inspired a book and a television roundtable hosted by David Susskind. It was also the year Sinatra formed his own record company, Reprise, and brought the Pack over to it. In February, one month after Kennedy's Inauguration, the first five albums were released, including Davis's *The Wham of Sam* and *Ring-a-Ding-Ding!*, a great Sinatra record that captured the spirit of the era. The Rat Pack had their own argot: It was good to be *Charlie* or *chicky baby*, very bad to be a *Harvey*, and *clyde* was an all-purpose word, as in "Pass the clyde." *Ring-a-ding-ding* was another Rat Pack phrase, which Sinatra first used in the 1961 song "Ring-a-Ding-Ding!" It was the sound, as

Shawn Levy notes in his well-researched [1998] book *Rat Pack Confidential,* of coins falling into the lap, of telephones bringing new offers of business or sex. It was the sound of brash self-confidence, of power, of the Rat Pack calling the shots, collecting the jackpot, of America reveling in its good fortune, its booming economy, and its sexy new world hegemony.

The music, in which bells and chimes follow through on the ringing-and-dinging theme, provides the era's ideal soundtrack. The brassy arrangements carry forward the full-throttled power, boldness, and insouciant humor of Sinatra's late-fifties and early-sixties *Come Dance/Swing/Fly With Me* albums, but there's a new jazzy informality and casualness in the singing: Sinatra had recently been on the road with the Red Norvo combo, and the small-group experience lent a new looseness to his sense of timing. Big and luxurious but light and flexible and spacious, the effect is of driving an expensive car down a highway with one hand on the wheel, Sinatra nudging it along with punched-out consonants and perfect syncopations ("Lets! sss . . . fall in-*love*").

The combination of power with casual comfort, the stylish looseness, carried over to the Rat Pack's act, which with its improvisations and combination of solo and ensemble work had analogs to jazz performance. They were swingers; like the Las Vegas club sound they helped invent, they combined a hip-sophisticated urban polish with the new informality of suburban living.

The Rat Pack is remembered for their style, their irreverent humor, their boozy and fleshy private lives, and their leader's occasional thuggish arrogance. But in their time they meant something else too, something that had everything to do with the expectations and aspirations of their audience. The key was ethnicity and the special role it played in postwar America.

The Rat Pack show, unlike pre-war entertainment, featured—even flaunted—race and ethnicity. Bishop, dressed as a Jewish waiter, warns the two Italians to watch out "because I got my own group, the Matzia." The night JFK showed up ringside, Dean picked Sammy up in his arms and held him out to the candidate: "Here. This award just came for you from the National Association for the Advancement of Colored People." Sammy: "I'm colored, Jewish, and Puerto Rican. When I move into a neighborhood, I wipe it out."

The act worked because each of them projected a different attitude toward aspiration and its success: Frank was the embodiment of slum kid become American classic; the others were foils. Dean, with what *Variety* called his "somebody wrote this song so I might as well sing it" attitude, suggested to the audience that the whole American success thing was a racket. Joey warded off envy with classic Jewish self-

deprecating irony. Sammy, with his heartbreakingly perfect accent, turned every number into a drama of aspiration, giving everything to win over the audience, to have it accept and love him despite his race; the message was about overcoming odds. And Peter was the ultimate foil; he stood for the elegant but desiccated Anglophilic WASP culture whose day was over. The Rat Pack projected the giddy, disorienting flight to American success: the guys on the block, coming up the hard way, ethnic jokes and attitudes; a future of complete assimilation, wealth, swinging fun, and acceptance.

Like the Pony Express and the cattle drives, the Rat Pack's legend seems all out of proportion to their fairly skimpy history. In 1960 there was the Vegas Summit, a Miami Summit at the Fontainebleau, a TV special featuring the much-ballyhooed first post-army appearance of Elvis Presley, and the premiere of their first movie, *Ocean's 11*. That

 summer they sang the national anthem to open the Democratic National Convention in Los Angeles, and afterward they campaigned for Jack Kennedy. By 1962 Lawford was out, and a reduced Pack played Atlantic City and the mob-owned Villa Venice near Chicago. A second movie, *Sergeants Three*, opened. In 1963 came more shows at the Sands and the movie *Four for Texas*. In 1964 came the musical comedy-cum-gangster picture *Robin and the Seven Hoods*. That was pretty much it, except for a somewhat staid 1965 benefit for Father Dismas Clark's halfway house for ex-cons, caught in a recently rediscovered kinescope, and a final 1966 "mini-summit" at the Sands.

There's irony in the fact that the Rat Pack, like the cocktail and the cigar, has lately been taken up as an emblem of a new political incorrectness. The drinking, the smoking, the swinging insouciance seem like a vacation from the economic and political pressures of nineties America. But there is more to the Rat Pack than adolescent swagger, more even than the sharp-edged dash of their masculine style, though they had plenty of both. For a few short years America's greatest entertainers kidded and sang their way through our last cultural consensus.

LAS VEGAS ISSUES ROUGHLY 120,000 MARRIAGE LICENSES A YEAR, MAKING IT THE WORLD'S WEDDING CAPITAL

In late 1963 an epic scandal rocked Las Vegas. According to the *Sun*, which broke the story, local ministers had begun to perform weddings *full time*, an act that amounted to brazen flouting of state licensing regulations. In years past, a minister had been able to obtain a lifetime license simply by proving that he had a congregation. But as the *Sun* now explained, it turned out that many ministers, once having got the license, summarily left said congregation in the lurch, opting instead for a career as a so-called Marrying Sam, which

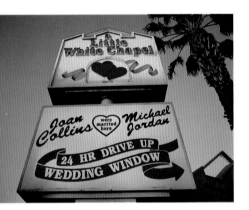

paid well, sometimes by the minute, and often included an ancillary share of the package wedding concessions—such as choirs, bridesmaids, flowers, and refreshments—that were offered by many of the twenty-four-hour wedding chapels in town. To cope with the rogue officiants, the county Ministerial Association petitioned the state legislature to put marriers on a yearly license basis,

so they would have to prove annually that they still ministered to an actual flock. One witness who appeared before the legislature "cited an

amusing incident," the *Sun* reported, "in which a would-be minister, not yet a resident, attempted to obtain a certificate to perform marriages [in order] to finance his own divorce."

Weddings have been a money-making proposition in Las Vegas since the early 1940s, when the windup to World War II first began to prompt frenzied nuptials across the nation. As the only state in the Union that required neither a blood test nor a waiting period, just a license and some cash, Nevada drew impatient couples by the thousands, and Las Vegas did its best to capitalize on the rush, installing a marriage bureau in the Union Pacific depot on the eve of Pearl Harbor.

Before long a string of full-service wedding chapels had sprouted up on the northernmost end of the Strip, and the number of marriages performed in the city had exceeded divorces by a factor of six to one.

By August 26, 1965—the last day, by presidential order, that a young man could improve his draft status by taking a wife—the local industry was operating efficiently enough to conduct 171 marriages in a single three-hour period, with a lone justice of the peace, the indefatigable James A. Brennan, performing no fewer than 67 of them. "I got it down from five to three minutes," Brennan reportedly later said. "I could've married them *en masse*, but they're people, not cattle. People expect more when they get married." Today Las Vegas handles nearly that number of weddings, some 150 on average, every single day of the year, with the predictable spikes in business on Valentine's Day and New Year's Eve. "I've done more weddings here in eight months," says one minister, "than I did in thirty-eight years working at parishes in New Hampshire, Maine, and Illinois. Getting married in Vegas is like going to Niagara Falls for a honeymoon. It's just the thing to do."

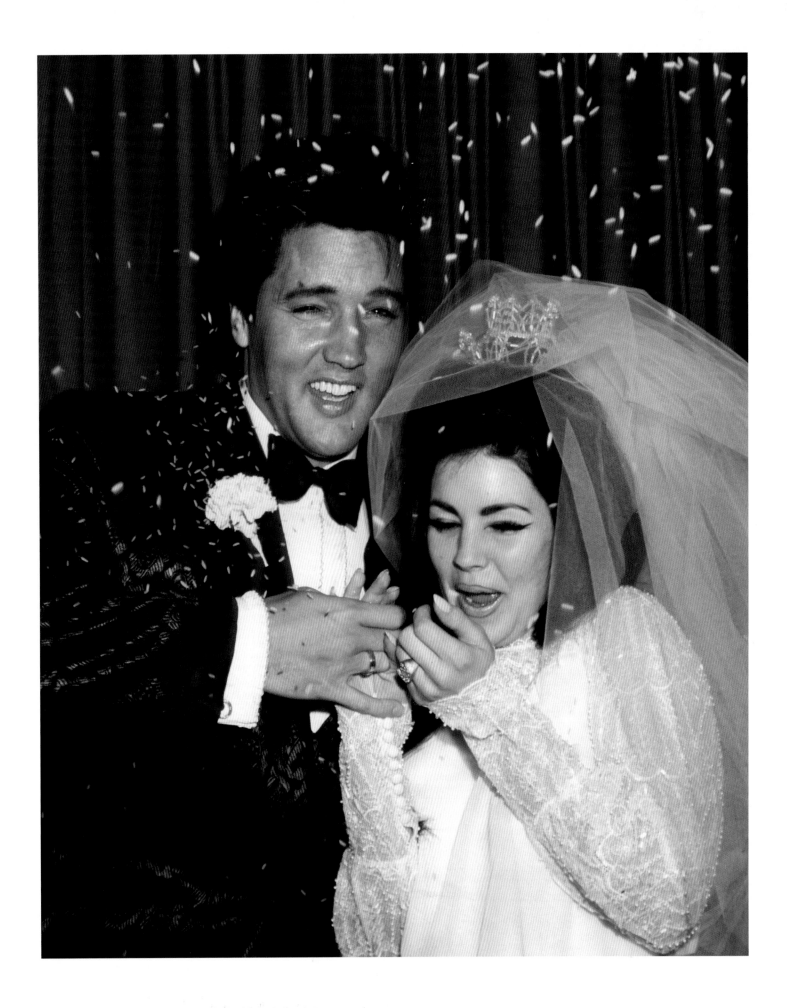

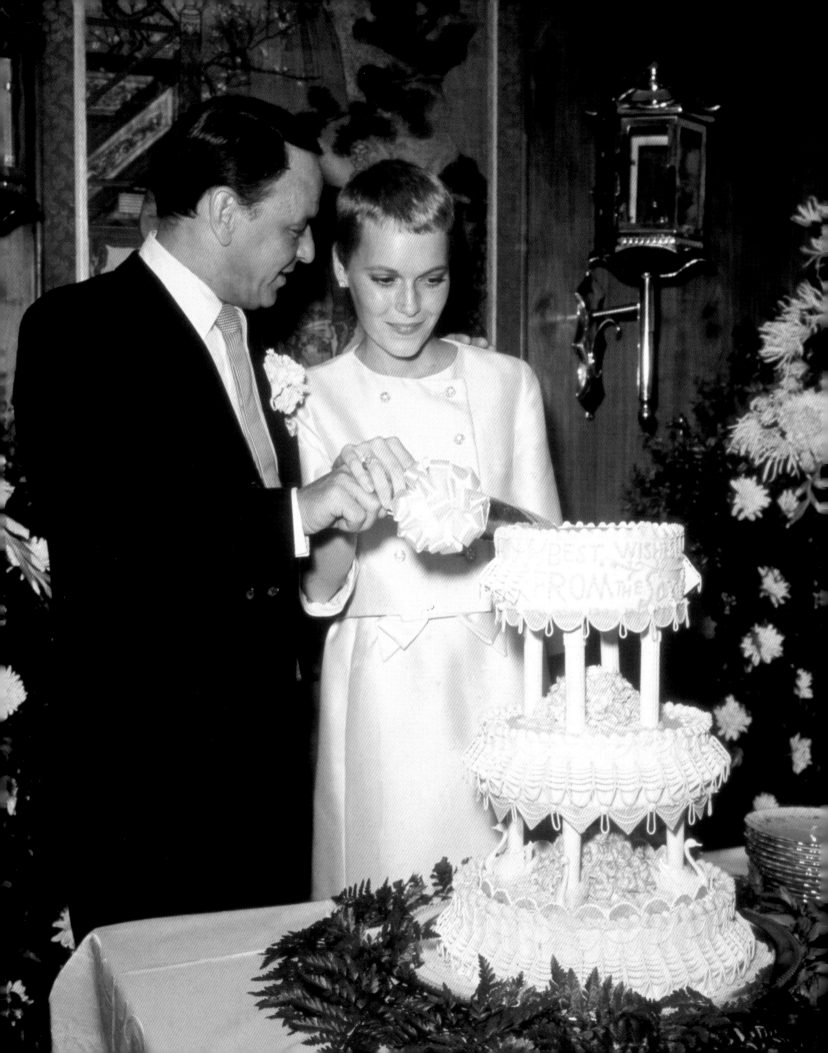

A Special Memory
Wedding Chapel
DRIVE UP WEDDING MENU

Ala Carte

1. APPETIZER............................ $ 25.00
 Wedding Music
 Ceremony

2. BREAKFAST........................... $ 55.00
 Wedding Music
 Ceremony
 Rose Presentation
 Commemorative Photo
 3 Post Cards

3. LUNCH.................................. $ 79.00
 Wedding Music
 Ceremony
 Rose Presentation
 Commemorative Photo
 2 T-Shirts

4. DINNER................................ $ 139.00
 Wedding Music
 Ceremony
 Rose Presentation
 Commemorative Photo
 2 T-Shirts
 Novelty License Plate
 Certificate Holder
 Just Married Car Kit
 NewlyWed Sign

5. DESSERT......................... INCLUDED
 Kisses
 Hugs
 Congratulations

1. T-SHIRTS: (1)........................... $ 15.00
 (2)........................... $ 25.00
 XXL & XXXL ADDITIONAL................... $ 3.00
2. NOVELTY LICENSE PLATE................... $ 9.00
3. CAR DECORATING KIT....................... $ 35.00
4. NEWLYWEDS ON BOARD SIGN............... $ 4.00
5. COMMEMORATIVE DRIVE-UP PHOTO.... $ 15.00
6. PHOTO PACKAGES:
 (9)4X6.................. $ 69.00
 OR
 (14)4X6............... $ 99.00
7. SINGLE ROSE PRESENTATION................. $ 20.00
8. A SPECIAL MEMORY GARTER................ $ 8.00
9. CHAMPAGNE FLUTES........................... $ 25.00
10. CHAMPAGNE (NON-ALC.)...................... $ 10.00
11. COMMEMORATIVE CERTIFICATE.......... $ 10.00
12. VIDEO OF CEREMONY......................... $ 49.00
13. 3 POSTCARDS.................................. $ 1.00
14. WEDDING RING................................ $ 39.00
15. DELUXE LICENSE HOLDER.................. $ 20.00
16. SOUVENIR MUGS............................... $ 6.00
17. BUMPER STICKER............................. $ 2.00
NOT INCLUDED: TAX
 M & H PHOTO PKGS.

GRATUITY FOR YOUR SERVER.......$25 & UP
MAJOR CREDIT CARDS ACCEPTED

THE COLOR THAT MATTERED MOST

Beyond what one visitor called the "fabulous, extraordinary madhouse" of the hypnotic Strip, Las Vegas was exploding, its $200 million-a-year tourist take and booming defense industry drawing new residents at an average rate of some 350 a month. Over the course of the 1950s, the city's population tripled, reaching nearly 65,000 by decade's end. Meanwhile the suburban communities of Henderson and North Las Vegas would continue to swell, putting the total metropolitan tally in 1960 at more than 127,000 people.

That city, the residential one, was all but invisible to the millions who flocked to Las Vegas each year. The average tourist never even glimpsed the neighborhoods where the newcomers lived or the schools their children attended or the markets where they shopped. Visitors likely had no idea that Sin City claimed more houses of worship per capita than any other city of equal size or that the community had to make do with a single high school or that growth had so taxed the antiquated water distribution systems that sewage effluent was being used to keep the golf courses green.

And certainly almost no one who passed through had ever been to the so-called Westside, the run-down neighborhood across the railroad tracks from Fremont Street that had served as Las Vegas's very first town site back in 1904. Now a squalid "ragtown" roughly ten blocks square, without sewage lines or even paved streets, the Westside was essentially hidden from the rest of the city, obscured by a wall of blocks and mortar that locals called the cement curtain. By 1955 it was home to some fifteen thousand African Americans—fully 10 percent of the city's population— who lived there under Jim Crow restrictions as rigid as those found anywhere in the Deep South.

African Americans had begun settling in Las Vegas back in the early 1900s, but their numbers had remained relatively small until World War II, when wartime labor shortages had prompted Basic Magnesium, Inc., to bring in scores of black workers from a

During the construction of Basic Magnesium, Inc., housing in the Henderson area was in short supply and strictly segregated. Morgan's Court was one of the few establishments open to African Americans.

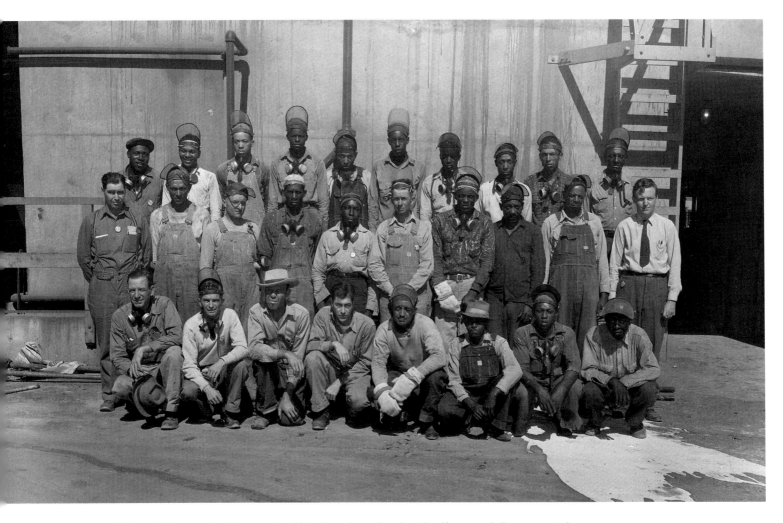

Although BMI recruited thousands of black workers, the plant itself was racially segregated.

handful of dying textile towns in Arkansas and Louisiana. Between 1941 and 1944 the county's black population jumped from 178 to well over 3,000, provoking the first concerted effort in Las Vegas's history to implement universal segregation. Racial discrimination, which in the 1930s had been sporadic and ad hoc, now hardened into official policy. Restrictive clauses were added to property deeds, limiting the sale of housing or land to "members of the Caucasian race," and black-owned businesses on Fremont Street were refused the right to renew their commercial licenses unless they relocated to the Westside. Local shops, restaurants, clubs, and casinos, meanwhile, increasingly barred African Americans from their establishments, ostensibly in deference to the preferences of white tourists, many of them southerners transplanted to Southern California. By war's end there was not a casino in Glitter Gulch or on the Strip that would accept a bet from a black patron, nor a hotel that would rent a room to a black guest, and the few seedy saloons that did admit a mixed clientele routinely charged blacks twice as much for a drink as they did whites.

No doubt some white Las Vegans had imagined that when the war ended, the black defense workers would leave town. But the phenomenal postwar tourist boom had dashed those hopes altogether. As new hotels sprang up out of the desert and the demand for labor soared, African Americans began moving to Las Vegas by the thousands. "Come on out here," a newcomer from Tallulah, Louisiana, wrote her family and friends, "they're giving money away." It mattered little that the available positions in Las Vegas's hotels and casinos were the lowliest and least visible, known in local parlance as "back-of-the-house" jobs. To southern blacks, especially, staring down a lifetime of backbreaking labor in the cotton fields, the prospect of pushing brooms and washing dishes seemed a considerable improvement. As one recent transplant put it in a letter home: "[It's] eight dollars a day and working in the shade."

At once confined and united by Jim Crow, Las Vegas's growing African American population created a distinct and entirely separate community on the Westside, with its own churches and grade schools, barbers and clothing stores, restaurants and night-clubs. From time to time various members of the community organized to challenge segregation and twice managed to get an NAACP-sponsored civil rights bill before the Nevada legislature. But the bill was killed in committee on both occasions. "We Negroes in Las Vegas are not at all satisfied with conditions in our city. And we are doing all we can to bring about some change in them," local NAACP spokesman

An African American family poses for a photo in Carver Park, a 324-unit housing facility to the east of Boulder Highway. Carver Park was built in 1943 specifically to house black BMI workers.

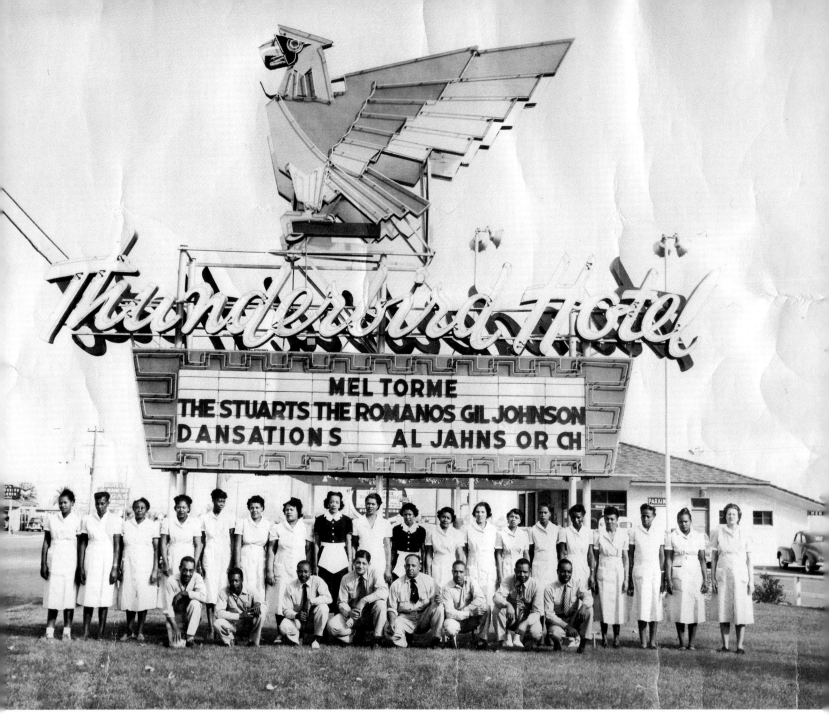

Thunderbird staff members, about 1950. By the middle of the decade, African Americans held most of the "back-of-the-house" jobs on the Strip.

Woodrow Wilson told *Ebony* magazine in 1954. "We realize, though, that we are up against heavy odds in this fight and that it will take a long time to gain victory."

In an era of pervasive Jim Crow, the discrimination practiced in Las Vegas was fairly unremarkable—the place was not much better, perhaps, than other cities in America, but it was certainly no worse. What made its racial dynamic unique in the 1950s was that the city owed its cachet as a resort destination, at least in part, to the African

American entertainers who regularly headlined in the showrooms on the Strip. Internationally known and wildly popular, black stars could be counted on to deliver what Las Vegas valued most: packed houses and fawning press. Without names such as Nat King Cole, Lena Horne, and Sammy Davis Jr. emblazoned on the Strip marquees, the city's reputation as the "capital of entertainment" would quickly have faded away.

The hypocrisy of refusing black headliners admission as guests and patrons may have escaped the Strip owners and operators, but it was not lost on the entertainers themselves. "In Vegas, for twenty minutes, our skin had no color," Sammy Davis Jr. later recalled. "Then, the second we stepped off the stage, we were colored again . . . The other acts could gamble or sit in the lounge and have a drink, but we had to leave through the kitchen with the garbage . . . What they said was that they didn't want to offend the Texans. Black and white people just don't gamble together, dig?" African American performers were also routinely denied rooms in the resorts where they played and were instead forced to stay on the Westside, where dingy rooming-house accommodations went for as much as $15 a night—50 percent more than the

Top: The New Town Tavern, on the corner of F and Jackson streets, was black owned, black operated, and frequented by Westside residents.

Bottom: Dr. James McMillan (clapping, left) looks on as Dr. Charles West presents an award to local NAACP leader Woodrow Wilson (right), 1958. With the arrival of professional blacks like McMillan and West in the mid-1950s, the civil rights movement in Las Vegas took off.

Legendary crooner Nat King Cole performs in the Copa Room at the Sands. In 1955, in response to Cole's protests, the Sands became the first Strip resort to welcome their black headliners as guests.

Lena Horne belts one out at the Sands. In the late forties Horne demanded to be put up at the Flamingo. The management gave her a cabana out by the pool and reportedly instructed housekeeping to burn the sheets instead of simply washing them.

Opposite: Sammy Davis Jr. dazzles in the Copa Room at the Sands Hotel. When the curtain came down, Davis Jr. remembered, black entertainers had to "leave through the kitchen with the garbage."

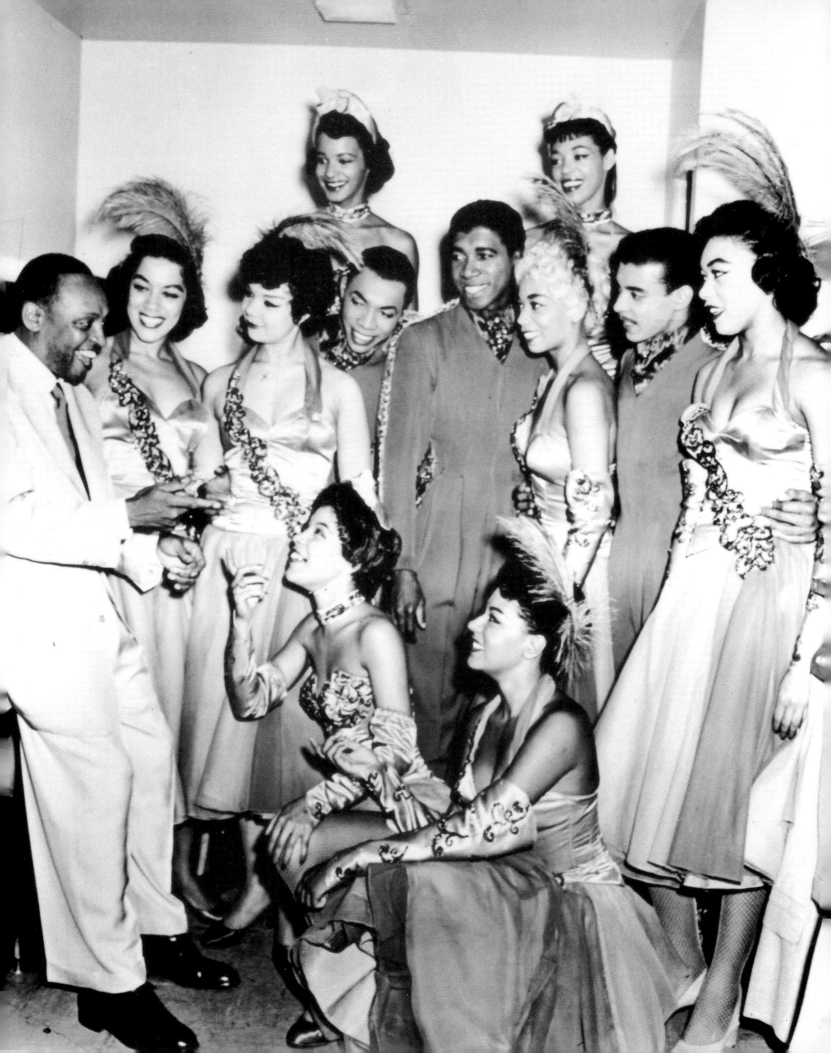

going rate for a room on the Strip. "Of course you resented it," dancer Harold Nicholas remembered. "There was a bad feeling that it would put inside you . . . but you had to go on . . . And I guess we weren't about to get in the street and start yelling and fighting and carrying on."

In a city keyed to the subtleties of customer demand, it was only a matter of time before savvy entrepreneurs recognized a market to be exploited. By May 1955 a group of investors had opened the city's first integrated casino-hotel, the Moulin Rouge, on the southern border of the Westside. A $3.5 million resort with mahogany walls, a swimming pool, and a luxurious showroom, the Moulin Rouge consciously set out to best the Strip hotels by adding a third nightly show. Throngs of celebrities, black and white, turned out for the grand opening, an event so splashy that it landed the Moulin Rouge on the cover of *LIFE* magazine. Overnight, the place became the hottest after-hours spot in town.

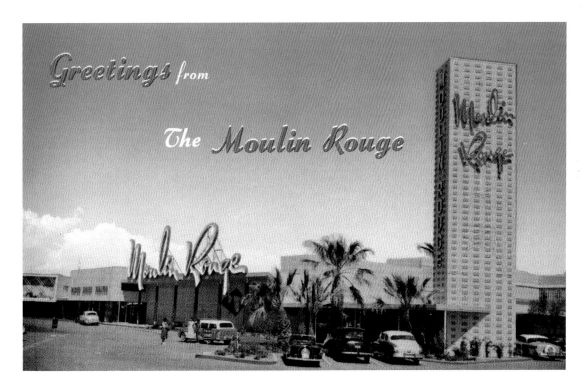

When it opened in 1955, the Moulin Rouge was the only integrated casino-hotel in Las Vegas.

Opposite: Jazz musician Lionel Hampton (in white suit) chats backstage with the Moulin Rouge dancers, 1955. The place drew nearly every major African American celebrity of the day.

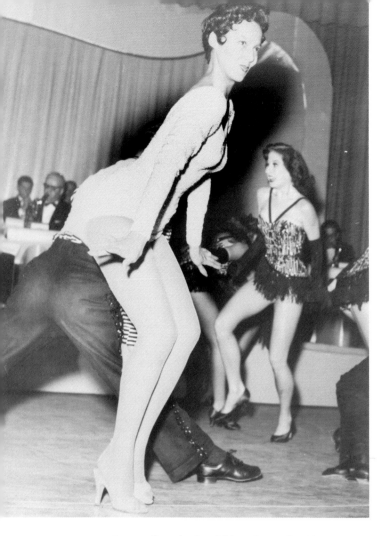

Actress Dorothy Dandridge plays a Las Vegas showroom, 1955. Once, after Dandridge had gone for a swim at a Strip resort, the management reportedly drained the pool.

Even after the Strip was desegregated in 1960, black Las Vegans continued to frequent clubs such as Carver House (above), on the Westside.

Entertainers would finish their last performance and then dash across town for the late-night jam session at the Moulin Rouge, the Strip showroom crowds trailing in their wake. "At night, honey, it was good," recalled master of ceremonies Bob Bailey. "I think we hit at two [a.m.], and we were over at three or three thirty—from that time until eight or nine you couldn't move. You couldn't move. And Harry Belafonte might be on the stage singing . . . Louie Armstrong used to come in and blow all the time. It was the only hotel [where] the musicians could get together and jam."

By the time poor management forced the Moulin Rouge into bankruptcy, in December 1955, just seven months after it had opened, Las Vegas's color barrier had begun to erode. Unwilling to return to the rooming houses on the Westside, and emboldened by events in Montgomery, Alabama, where Dr. Martin Luther King had just launched a bus boycott in protest of segregation, African American entertainers in Las Vegas now went on the offensive, demanding rooms in the hotels where they played and refusing to perform unless black people were allowed in the audience. Gradually the Jim Crow policies softened. If the Moulin Rouge had not persuaded local hotel and casino owners that integration might actually be good for business, it was at least beginning to dawn on some of them that discriminating against the star attraction was potentially disastrous.

Then, in early 1960, as student sit-ins sparked racial violence in communities

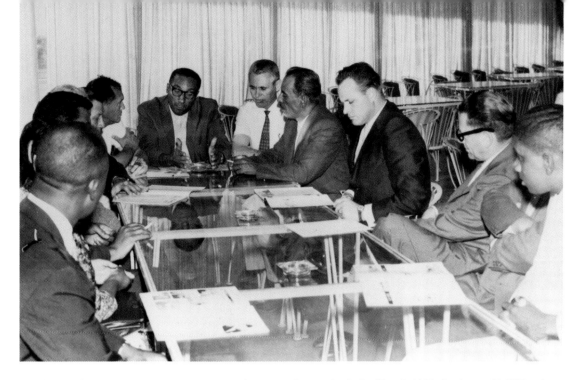

Las Vegans hammer out an agreement to end segregation on the Strip, March 1960. Dr. James McMillan is seated at the head of the table, with *Las Vegas Sun* publisher Hank Greenspun on his right.

throughout the South, the president of Las Vegas's NAACP chapter, Dr. James McMillan, ratcheted up the pressure, threatening Mayor Oran Gragson with a massive protest if the city's public accommodations were not desegregated within thirty days. The prospect of thousands of African Americans marching through the streets—and of the national news coverage they were bound to receive—hastened what was already all but inevitable. On March 25, the day before the planned march, at the now-closed Moulin Rouge, McMillan and other members of the local NAACP met with Mayor Gragson and Nevada governor Grant Sawyer. In a matter of hours, with *Las Vegas Sun* publisher Hank Greenspun acting as mediator, the group hammered out an agreement to immediately desegregate every hotel, restaurant, bar, casino, and showroom in town. The passage of the national Civil Rights Act was still more than four bloody years away.

It would be another decade before Las Vegas was fully desegregated, before African Americans could hold any of the more lucrative casino positions or make their homes beyond the boundaries of the Westside. But the Moulin Rouge agreement, as it would come to be known, had underscored an irreducible truth about the economics of life in a gambling resort. The color that mattered most in Las Vegas was not black or white, but green.

LAS VEGAS, NEV. "WORLD'S NEWEST CONVENTION CAPITAL"

In the late 1950s, convinced that gambling alone could never fully support the city's resort industry, Las Vegans built a convention center to rival similar facilities in New York, Chicago, and Atlantic City. By the mid-1960s conventioneers represented a significant proportion of the city's annual tourist tally.

Opposite: With slot machines strategically situated just steps from the tarmac at McCarran Airport, Las Vegas attempts to wring every last nickel out of its visitors.

THE CAPITAL OF SIN, GIN, AND DIN

By the close of the 1950s, Las Vegas had become a national phenomenon, its licentious excess the subject of countless features in national magazines and hometown newspapers; its name invoked often and fondly by the glamorous luminaries who inhabited the precincts of television's late-night variety shows; its gaudy, glittering cityscape the backdrop for a handful of Hollywood features. But although there could scarcely have been an adult in the country who had not at least heard of Las Vegas,

almost no one residing east of the Ozarks had ever been there. Throughout its heyday in the fifties, Sin City had remained a regional tourist destination, with as many as three-quarters of its visitors hailing from California alone. But in September 1960, United Airlines introduced direct jetliner service to Las Vegas's McCarran Airport, slashing travel time from the East Coast from nine hours to four and a half and instantly making Sin City accessible to millions of Americans who otherwise would never have made the trip.

Briefcase-toting convention-goers from the East and Midwest, who once had gathered in Boston or Chicago or Miami, now headed instead for the recently completed Las Vegas Convention Center, a sprawling $4.5 million facility built expressly to boost weekday visitation and draw national organizations into the orbit of the town's ubiquitous tables and slots. Dressed in sport coats and ties, and often traveling in packs, the conventioneers jammed airport terminals alongside throngs of boisterous gamblers and golfers and fun seekers, many of them lured to what one Los Angeles journalist called "the capital of sin, gin and din" by wildly affordable travel promotions. Typical was the package at the Hacienda: for $188—less than half the price of a brand-new color television—guests were entitled to round-trip airfare on one of the hotel's eight private jets, a double room for five nights, four meals, temporary membership in the hotel's golf club, and free champagne every evening served by waitresses in not-quite-transparent baby-doll nightgowns. "It's as though you walk through a veil," one hotel operator said of the Las Vegas experience, "you become a nonconformist. You enter an adult fairyland where a dollar is not a dollar and five dollars is a chip." By the end of 1960, the annual tourist tally had topped ten million, an increase of more than two million people in just one year.

Las Vegas had to scramble to accommodate the stampede. With the annual number of airline passengers expected to exceed three million by the mid-1960s, construction of a spacious, modern terminal on Paradise Road, just to the east of the existing airport, soon got under way, and on the Strip, resort owners feverishly began laying plans for a spate of elaborate expansion projects.

Opposite: Efforts to promote Las Vegas tourism in the 1960s included irresistibly priced holiday packages like the Flamingo's, which promised a fun-filled weekend getaway for roughly the cost of a transistor radio.

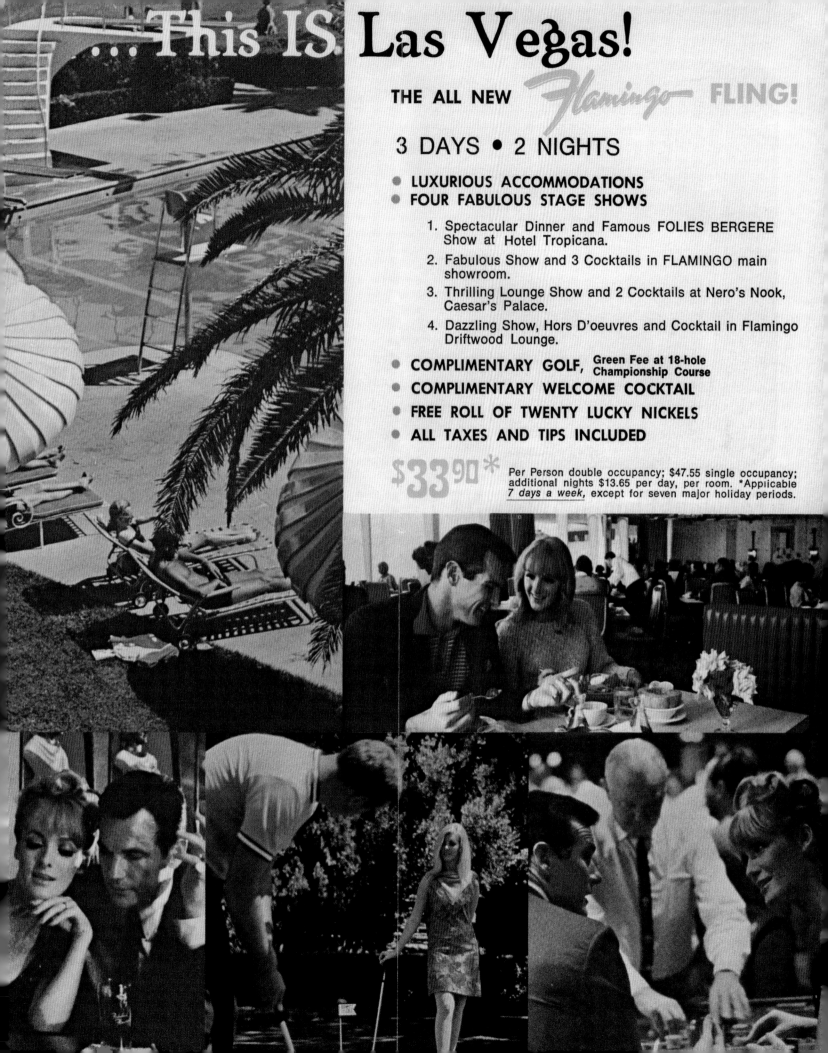

...This IS Las Vegas!

THE ALL NEW *Flamingo* FLING!

3 DAYS • 2 NIGHTS

- LUXURIOUS ACCOMMODATIONS
- FOUR FABULOUS STAGE SHOWS

 1. Spectacular Dinner and Famous FOLIES BERGERE Show at Hotel Tropicana.
 2. Fabulous Show and 3 Cocktails in FLAMINGO main showroom.
 3. Thrilling Lounge Show and 2 Cocktails at Nero's Nook, Caesar's Palace.
 4. Dazzling Show, Hors D'oeuvres and Cocktail in Flamingo Driftwood Lounge.

- COMPLIMENTARY GOLF, Green Fee at 18-hole Championship Course
- COMPLIMENTARY WELCOME COCKTAIL
- FREE ROLL OF TWENTY LUCKY NICKELS
- ALL TAXES AND TIPS INCLUDED

$33.90* Per Person double occupancy; $47.55 single occupancy; additional nights $13.65 per day, per room. *Applicable *7 days a week,* except for seven major holiday periods.

Building on the Strip had become a costly proposition. Frontage that two decades earlier had been nearly worthless now sold for more than $1,500 a foot, and fierce competition had raised the bar on luxury, turning resort development into a frenzied game of one-upmanship. The sort of cash investments that had financed the construction boom of the 1950s, with mobsters dipping into the coffee cans in their kitchen cupboards for a couple of wads of C-notes, were simply no longer sufficient, and American banks remained frustratingly steadfast in their refusal to get mixed up with gambling. "Conservative lending institutions are not interested in Las Vegas because of its image," noted one casino entrepreneur. "Most won't even write insurance here." Anxious to capitalize on the surging popularity of the resort they had effectively built, the operators on the Strip turned to the only source of capital readily available to them: the pension funds of the Teamsters Union, a national labor organization that in 1960 was positively notorious for its reputed ties to organized crime.

The Teamsters president, Jimmy Hoffa, had made one of the first investments in Las Vegas back in the late 1950s, at the urging of his longtime associate Moe Dalitz, the former bootlegger and known mobster who now ran the Desert Inn. Unlike most of his mob-connected colleagues—who confined their operations either to legal gambling in Nevada or underground ventures run by criminal organizations like the Syndicate or the Five Families or Murder Inc.—Dalitz had always dabbled in the mainstream as well, maintaining financial interests in a host of legitimate enterprises, including the Michigan Industrial Laundry Company, the Chicago & Rock Island Railroad, and Cleveland's Liberty Ice Cream. After setting up shop in Las Vegas, he had teamed with two local entrepreneurs, Irwin Molasky and Merv Adelson, to found the Paradise Development Company, a firm dedicated to promoting commercial and residential construction in the town's growing suburbs. Their inaugural project had been a one-hundred-bed, for-profit medical facility called Sunrise Hospital, which

Opposite: Jay Sarno (standing, left) receives a delivery of marble statues during construction of the Teamsters-financed Caesars Palace, 1965. Sarno believed that a gambling resort should not merely be a hotel with gaming tables but a fully articulated fantasy environment. Nonetheless, gambling remained at the center of the experience, and Sarno purposely laid out the resort like a wheel with the casino as the hub, to ensure that a guest had to walk past the "action" to get anywhere.

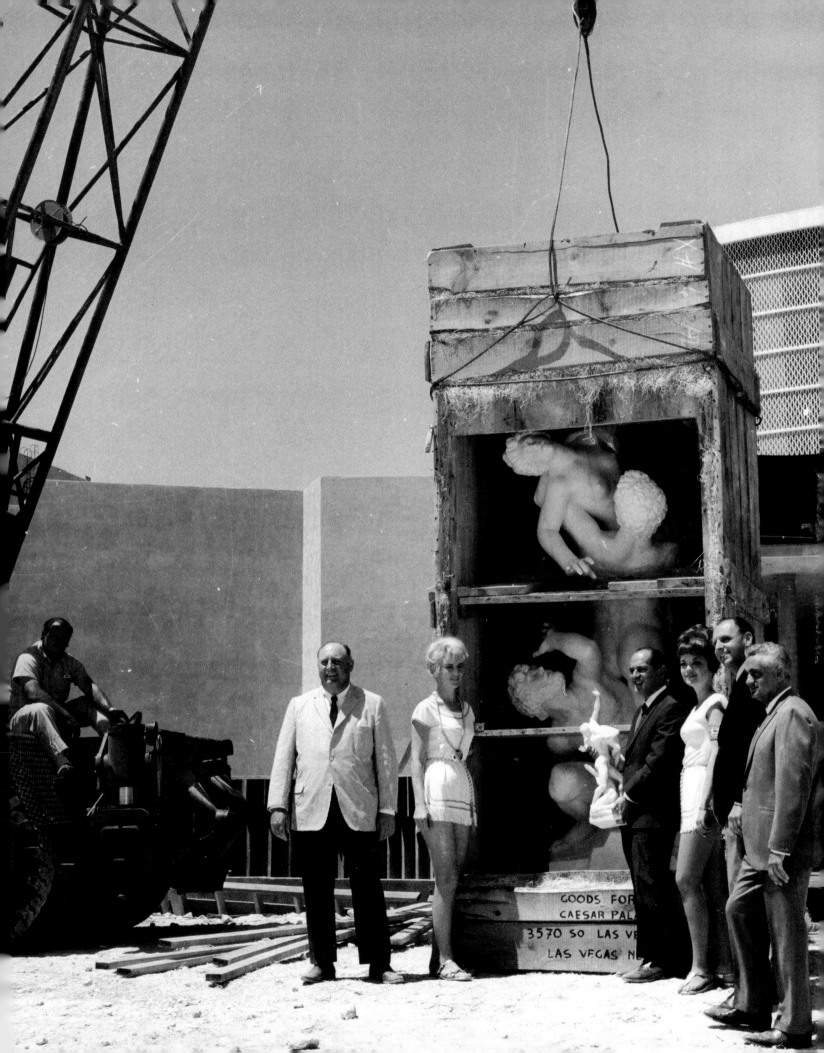

GOODS FOR
CAESAR PALA
3570 SO LAS VE
LAS VEGAS N

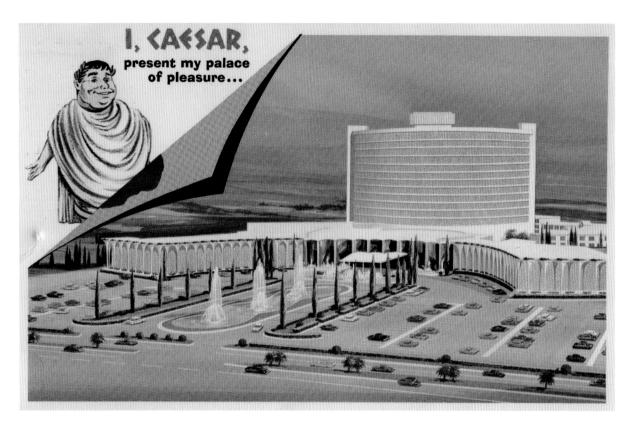

A postcard from Caesars Palace, late 1960s. After careful consideration Sarno reportedly dropped the possessive apostrophe in "Caesar's" as a way of conveying to guests that the hotel belonged not to a single Caesar but to anyone who wanted to live like a Roman emperor for a couple of days.

Dalitz convinced Hoffa to fund. "If Moe told them to make the loan," said one observer of the Teamsters Pension Funds, "they made the loan." Drawing on the pooled retirement savings of nearly two hundred thousand union members, Hoffa floated a $1 million loan to Dalitz and then ensured his facility's success by instituting a new union health plan that required members to seek treatment either at Sunrise or at the dismal Clark County Hospital.

Now, with the spike in visitation fueling an urgent need for new resort development, Hoffa diverted his largesse to hotel and casino projects, funneling the multimillion-dollar Teamsters' loans through the president of Las Vegas's Valley National Bank, an influential local Mormon named E. Parry Thomas. "I've got to see that the community stays healthy," Thomas once explained, when queried about the pension fund loans. "I'll take dollars from the devil himself if it's legal, and I don't mean anything disparaging towards the Teamsters by that." Over the course of the 1960s, the Teamsters Pension Funds would finance expansions at a half dozen Las Vegas resorts, including the Desert Inn, the Stardust, and the Dunes, eventually adding more than five thousand new hotel rooms and creating a skyline of pastel high-rises that one journalist compared to the

"minarets of Mecca." "It was like coming on some mystery city in the wilderness," said a visitor of the drive in from the south, "like some eighth wonder of the world you never expected to see out here. It just showed up."

Soon, on a thirty-four-acre plot across from the Flamingo, a newcomer named Jay Sarno—the designer, builder, and operator of the award-winning Cabana Motel chain—broke ground for the Strip's most flamboyant resort yet, a luxurious Greco-Roman–themed hotel and casino called Caesars Palace. Constructed from hundreds of tons of Italian marble and stone and adorned with imported cypress trees and classic Romanesque fountains and statuary, the lavish complex would ultimately carry a $19 million price tag—a record even for the extravagant Strip and an absolute impossibility without the Teamsters. As a *Wall Street Journal* reporter once put it: "Without the Teamsters, there might not even *be* a Las Vegas."

There was nothing explicitly illegal about the loans Hoffa made in Las Vegas. Although it was unusual for pension funds to be so heavily invested in real estate, it was by no means unlawful. But for the U.S. attorney general, Robert F. Kennedy, the

The overall design of Caesars Palace reflected Sarno's conviction that oval shapes promoted relaxation.

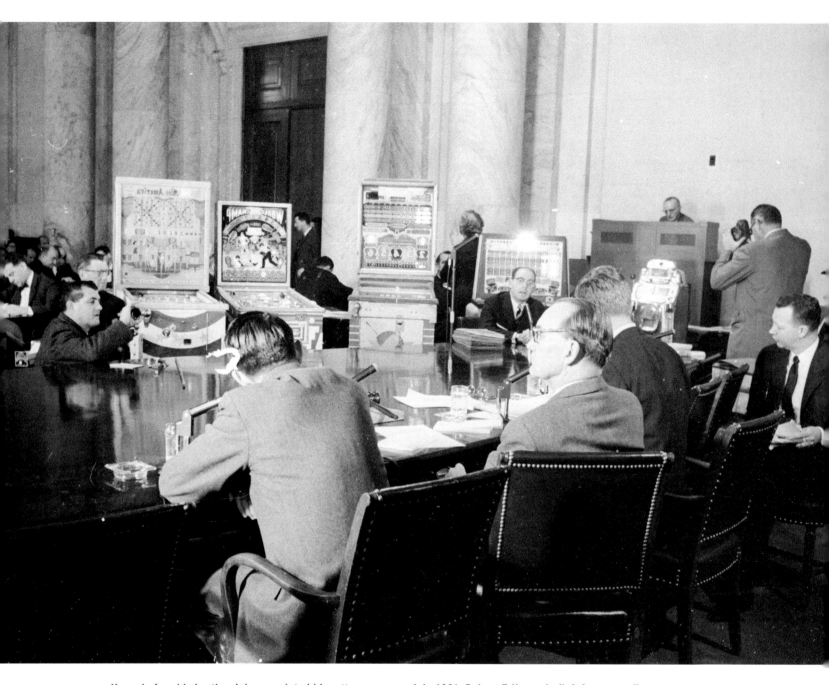

Years before his brother John appointed him attorney general, in 1961, Robert F. Kennedy (left foreground) had served as chief counsel for a full-scale Senate investigation of American labor rackets, which had been headed by Senator John L. McClellan (second from left). Here, in the Senate Caucus Room, the commission opens an inquiry into jukeboxes, pinball, and slot machines.

reputed links between American labor unions and alleged underworld figures like Moe Dalitz were, nonetheless, of prime concern. Back in 1956 Kennedy had served as chief counsel to a highly publicized Senate investigation of labor corruption and had watched all but a few of the country's most audacious racketeers get away. Now, on the heels of his brother John's election to the presidency and his own appointment as chief of the U.S. Justice Department, he was determined to collar those who had so far eluded the government's grasp. Topping his "hit list" were Jimmy Hoffa and dozens of alleged mobsters with interests in Las Vegas.

By early 1961 the FBI had launched a secret operation, designed to refute the claim (made often and vehemently by the Nevada Gaming Control Board) that the state's gambling industry was entirely free of criminal influence. Posing as telephone repairmen, federal agents infiltrated a handful of Las Vegas casinos, including the Sands, the Stardust, and the Desert Inn, and installed dozens of patently illegal wiretaps. The goal was to expose the notorious "skim"—the undocumented millions that were routinely pocketed in the casino counting rooms and distributed among hidden investors. Over the next year and a half, with field agents eavesdropping around the clock, a steady stream of incriminating evidence spilled forth from the bugged casinos, their managers blithely prattling on about the merits of various skimming methods, the dispersal of the so-called dividends, and the offshore accounts where illegal profits were stashed.

No one in town was the wiser until early September 1963, when the FBI leaked wiretap material to a *Chicago Sun-Times* reporter, arousing suspicion on the Strip. One by one the bugs were discovered. "Nevada," one justice attorney remembered, "went ballistic." Casino lawyers filed a flurry of lawsuits. Grand jury investigations were convened. But in the end—because the wiretap material had been illegally obtained—none of the evidence was admissible in court.

For Las Vegas the real impact of the operation would be felt in the barrage of negative publicity unleashed by the FBI revelations. Throughout the fall of 1963, newspapers across the country ran story after story about the not-so-mysterious disappearance of casino profits—estimated to be at least $10 million annually. *New York Times* correspondent Wallace Turner not only churned out a series of articles about what he called "the new force in American life" but also began work on a book entitled *Gamblers' Money,* in which he devoted an entire chapter to Moe Dalitz. Even the family-friendly *Saturday Evening Post* ran a story entitled "How Wicked Is Las Vegas?"

The scandal was so intense that not even the shocking assassination of President Kennedy in late November nudged it off the national radar. Instead in December Americans were treated to *The Green Felt Jungle,* a book-length exposé of Las Vegas that claimed to "blast the lid off the fabulous entertainment capital of the world and lay bare a corrupt jungle of inequity." Coauthored by *Las Vegas Sun* reporter Ed Reid and fellow journalist Ovid Demaris, *The Green Felt Jungle* became a runaway best seller overnight, turning Las Vegas's "open secret" into a national preoccupation. "Ask anyone even remotely connected with the gambling casinos who the proprietors of any one of

Moe Dalitz arrives at the Las Vegas courthouse to give testimony in a state probe into casino tax evasion, 1966. By the mid-1960s even traditionally hands-off Nevada authorities were cracking down on the Strip operators.

Circus Circus, Jay Sarno's second Teamsters-financed project, opened in 1968. A casino without a hotel, the place featured live elephants and orangutans roaming the casino floor, and acrobats and trapeze artists soaring overhead. As novelist Hunter S. Thompson once said of the frenetic and rather bizarre scene, it was "what the whole hep world would be doing on Saturday night if the Nazis won the war."

them are—supposedly a matter of public record," wrote journalist Gladwin Hill in his review of the book for the *New York Times*. "The interrogatee will be afflicted with a glaze in the eyes and the same vagueness displayed by Russians when one asks penetrating questions about Khrushchev. It just isn't healthy to be quoted as bandying the names of the business's 'wheels'; too many of them have been uncomfortably connected with homicide."

In response to the smear campaign, *Sun* publisher and longtime Las Vegas booster Hank Greenspun leaped to the defense of his adopted city, denouncing *The Green Felt Jungle* on national television and vigorously denying the claim that Las Vegas was a mob-dominated town. But the effort to paint Sin City as just another normal American community was growing ever more absurd. In the years to come, the government would only turn up the heat on organized crime. Dalitz eventually would be indicted on federal tax evasion charges, and Las Vegas patron Jimmy Hoffa would find himself convicted of jury tampering and headed for a federal penitentiary. By 1966 Las Vegas's national reputation would be charred almost beyond recognition.

To many longtime residents, men like Moe Dalitz may well have seemed beneficent city fathers: not only had they transformed Las Vegas into the gambling center of the Western world, they also had spearheaded countless projects, like Sunrise Hospital, that gave the place the feel of a genuine community. But whatever allegiance locals felt they owed the mobsters, there was little doubt that in the face of relentless government scrutiny and reputation-killing publicity, "the boys," as they were known, were also fast becoming a dangerous liability.

Opposite: Keeping tabs on the players at the Mint, in downtown Las Vegas, in the mid-1960s. Casino security now depends less on the catwalk and more on the surveillance camera—or the so-called "eye in the sky."

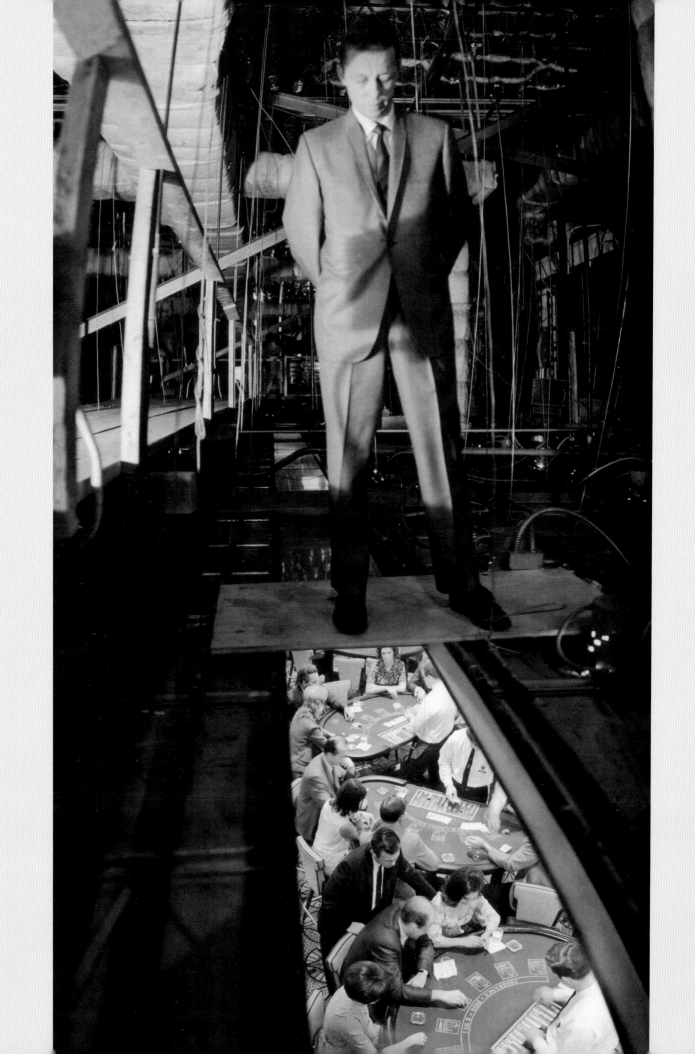

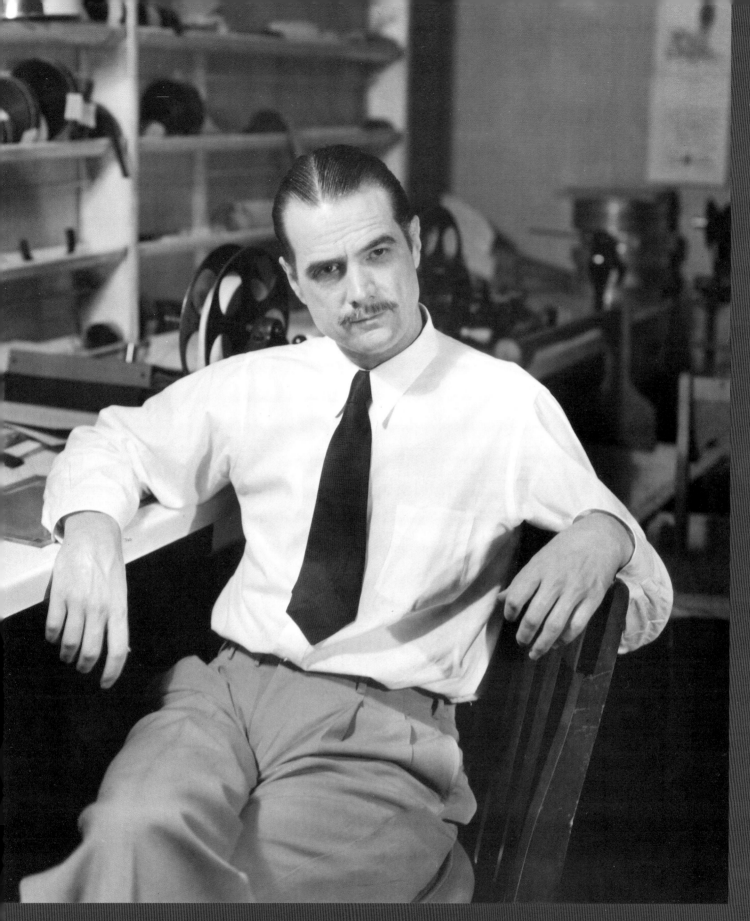

Howard Hughes spent four years cloistered in a penthouse suite at the Desert Inn, playing a highly publicized game of Monopoly with Las Vegas's prime real estate. "You're wondering why I don't have a drink in my hand?" Frank Sinatra asked a Dunes audience one night during Hughes's residence in town. "Well, Howard Hughes bought it."

CHAPTER TEN
THAT BILLION-DOLLAR BABY

In the wee hours of Thanksgiving morning 1966, two private Pullman cars pulled into a desolate crossing in North Las Vegas and rattled to a stop. From the trailing car, laid out on a litter and attended by a fawning retinue like some pampered Siamese prince, emerged the legendary billionaire recluse Howard Robard Hughes—by far one of the wealthiest men in the entire world. Arrangements for his arrival had been made well in advance: once loaded into a waiting van, he was rushed to the Desert Inn, where his old acquaintance Hank Greenspun had secured the entire eighth and ninth floors for his private use.

Hughes was not the man he used to be. Gone was all trace of the youth who had parlayed a family fortune into an industrial empire, the dashing rake whose exploits had provided fodder for countless gossip columns, the record-breaking pilot who had once been honored with a hero's ticker-tape parade. All of it had been blotted out in an

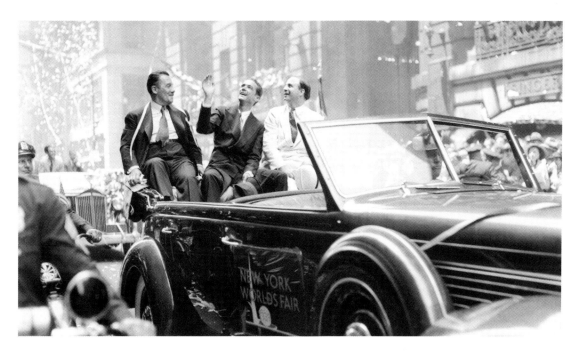

Record-breaking aviator Howard Hughes (center, waving) is honored with a ticker-tape parade in lower Manhattan, July 1938.

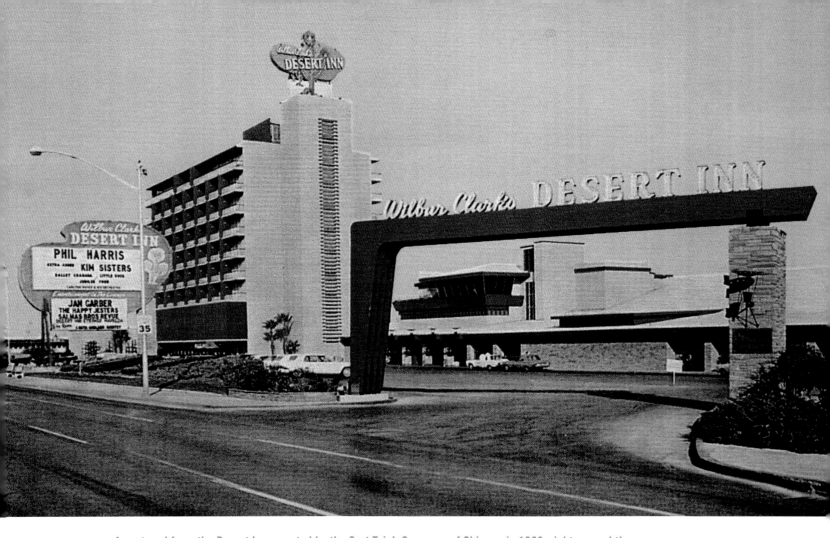

A postcard from the Desert Inn, created by the Curt Teich Company of Chicago in 1966, right around the time that Hughes arrived in Las Vegas. The high-rise hotel tower was built in the early 1960s with Teamsters Pension Fund money.

instant in 1946, when the near-fatal crash of a plane he was piloting left him with several herniated spinal disks, chronic and often mind-bending back pain, and an all-consuming dependence on narcotics.

Approaching sixty-one, and hard on the heels of a spectacular mental breakdown, Hughes now looked every bit the wraith—gaunt, colorless even to his lips, and sporting the long, stringy hair and spiraling fingernails of a Hindu holy man. Haunted by an inordinate dread of germs and obsessed with his own bodily functions, he spent day after day indoors, windows taped against airborne contaminants and heavy curtains drawn, lolling naked and usually unwashed in a white leather chair, his mind careening between rationality and full-blown dementia. Apart from a phalanx of beefy Mormon caretakers, his attorneys, and his security chief—a former FBI agent named Robert Maheu—Hughes had had virtually no contact with the outside world in three full years. Maheu, in fact, had never even met his employer and reportedly received his orders via interminable, rambling memos scrawled on sheets of yellow legal paper.

A year before his arrival at the Desert Inn, in one of his more lucid moments, Hughes had sold his controlling interest in Trans World Airlines for more than $546 million—the biggest check ever to have been made out to a single individual. Determined to avoid what he considered a fleecing at the hands of the California Tax Board, he elected to decamp to Las Vegas, where neither the state nor the city would levy unnecessary fines on his wealth and where he had long dreamed of expanding his domain. Now, having secreted himself away in the 250-square-foot bedroom of the Desert Inn penthouse, his addled brain fairly reeled with the possibilities for acquisition. Indeed, it might have been said that his money was burning a hole in his pocket—had Hughes actually been in the habit of wearing pants.

His first purchase opportunity came rather sooner than anticipated. As the weeks passed, and Hughes and his gaggle of pious Mormons showed no signs of moving on, let alone gambling, Desert Inn co-owner Moe Dalitz began to make noises about evicting them. The Christmas-to-New Year's stretch was high season in Las Vegas, Dalitz explained, and the suites on the eighth and ninth floors were choice bait for snaring high rollers. Disinclined to relocate just then, Hughes instead offered to buy the place.

His bid could not have come at a better time. Although Las Vegas's annual tourist tally was holding steady, and the Cold War defense boom had boosted employment at both Nellis Air Force Base and the test site, the economic momentum that had propelled the city through the 1950s and early 1960s had begun to stall. Only a couple of major developments were on the wire now: Jay Sarno's newest venture, Circus Circus, a tented extravaganza featuring live elephants and orangutans and trapeze acts that sailed over the casino floor; and Las Vegas's first retail shopping center, the Boulevard Mall. But

Las Vegas Sun publisher Hank Greenspun saw Hughes as a kind of "fairy godfather" for the city, and regularly championed the billionaire in his column.

both were Teamster financed, and with all the charges of corruption surrounding the union, that kind of cash did not come cheap. Hughes was precisely what Las Vegas needed: a well-respected, corporate entrepreneur with more liquid capital than almost any other human being on the planet and the power to single-handedly redeem the city from the stigma of organized crime. That he was also mad as a hatter merely made him a more obvious mark.

Las Vegans seized the opportunity. Negotiating primarily through Greenspun, Maheu, and Hughes's Washington attorney, Ed Morgan, Dalitz now cut a deal that gave Hughes a fifty-five-year lease on the Desert Inn in exchange for $6.2 million in cash and the assumption of another $7 million in outstanding loans. Before the ink on the agreement was even dry, Greenspun had rolled out the official welcome mat, championing the hermit billionaire in the *Sun* as the city's "fairy godfather." "[Mr. Hughes's] self effacement and humility entitles him to a little private space here on his own earth," Greenspun gushed in his front-page column. "We hope he finds it in Nevada." The *Sun* publisher would later receive a half-million-dollar, prepaid advertising contract and a $4 million loan at just 3 percent interest from none other than Hughes Properties.

In Nevada's capital, meanwhile, Governor Paul Laxalt was busily manipulating state gambling regulations to secure Hughes a casino operator's license. Acutely aware of the public relations value in swapping a mobster for one of the most successful businessmen in the world, Laxalt urged the Gaming Control Board to approve Hughes's application, in spite of the fact that he had failed to appear in person, had declined to submit to a financial background check, and had refused to be photographed or fingerprinted as required by Nevada law. "So far as they know," one critic groused, "that could be Bonzo the Chimp in there pulling the switches."

The members of the control board were not overly concerned. As the board chairman explained: "Hughes's life and background are well known . . . and he is considered highly qualified." On April Fools' Day 1967, by unanimous vote, Howard Robard Hughes became the registered owner of the Desert Inn.

But like a shrimp cocktail to a starving man, the transaction only whetted his appetite. "I have decided this once and for all," he wrote in one of his infamous memos. "I want to acquire even more hotels and to build this operation to be the greatest thing in the U.S. . . . I want to make Las Vegas as trustworthy and respectable as the New York Stock Exchange." Cloistered round the clock in his makeshift headquarters at the Desert Inn, Hughes now began to collect Las Vegas hotels and casinos as if they were snow globes or stamps: the Frontier, the Sands, and the Castaways; the massive, unfinished, $17 million Landmark; and across from the Desert Inn, a small, bare-bones casino called the Silver Slipper, whose revolving, mirrored, marquee-topper reportedly disturbed his sleep. He would also buy thousands of acres of undeveloped land, a hundred residential lots at the Desert Inn Country Club, 80 percent of the silver reserves in

The Desert Inn and its most famous guest. Despite the fact that Hughes never once ventured outside his room during his four-year stay—and almost never allowed anyone in, including the hotel maids—the national press nevertheless did its best to keep track of his doings.

two Nevada counties, Alamo Airways, the North Las Vegas Airport, and local CBS affiliate KLAS-TV—largely because the station's owner, Hank Greenspun, had refused to honor his demands to broadcast more late-night western and airplane movies.

In just one calendar year, Hughes spent some $65 million in Las Vegas—an average of more than $178,000 dollars a day—all, quite literally, without ever leaving his room. As ABC noted in its televised report on the opening of the Landmark Hotel: "Despite Hughes' reputation for shelling out without stepping out, many of his guests are still hoping for even a glimpse of their elusive host. But they won't find that billion dollar baby in this five and ten cent store." By the close of the decade, the invisible billionaire was the single largest landowner and employer in the state. As an economic engine for Nevada, one reporter noted, Hughes "was bigger than the Comstock Lode."

Then in 1968, in the midst of negotiations for the purchase of the Dunes, Hughes made a bid to acquire the Stardust—and there, his crazed buying spree hit a snag. Arguing that the tycoon's ownership interests in the Las Vegas gambling industry were veering dangerously close to a monopoly, President Lyndon Johnson's Justice Department brought suit against Hughes to block the pending sales. "It is contrary to our basic concept," a Justice official explained, "to permit one individual or one firm to control one-fifth of the economic activities of a city of 250,000."

WHY IS HOWARD HUGHES BUYING UP LAS VEGAS?

Once upon a time, there was a billionaire who was content to make unknown girls famous in the movies and set world aviation records. Then he became a missile maker, important to the nation's defense. Now, at the age of 62, he's taking over America's gambling capital.

THE MARIMBA PLAYER at the Tropicana, a big hotel-gambling casino on the Las Vegas Strip, currently gets only a polite laugh from Folies Bergère audiences when he jokes in mock anguish: "Thirty years in show business, and now I'm out of it. Howard Hughes just bought my marimba!" This is not too funny to most listeners. Odds are they heard a similar joke at one of a half dozen other Las Vegas night spots in the past few days. Anyway, it just might be true.

Billionaire Hughes, one of the world's richest men, has long owned about 27,000 acres of cheaply bought desert on the outskirts west of town—which makes him the largest private landowner in Clark County. But in recent months, he has won a commanding position in the gambling capital by committing over $115 million to buy control of three-quarters of a mile of the neon-splashed Strip (including the famous casino hotels, the Desert Inn, Sands and Frontier), the entire North Las Vegas airport plus 1,300 adjoining acres of valuable land, a CBS-affiliated television station, a showplace ranch, an airplane charter service, more Strip land, etc. etc. His aides confirm that he's not yet finished buying and still has millions of dollars worth of options out that may soon be picked up.

In the process of spending all this money, Hughes has become the town's leading citizen, a position achieved without making a single PTA speech, appearing at a solitary Chamber of Commerce dinner or shaking a lone hand. He apparently didn't even show up in person to close one of the big deals, delegating the chore to a few tight-mouthed lawyers and business types he had shipped in to Nevada.

"I don't believe Howard Hughes exists," suggests a cynical gambler who deals 21 in one of the casinos. "Name one person—just one—who can prove he's seen Hughes in the past year," he challenges.

In the last 15 years or so, not too many people *have* seen "The Man," as some Las Vegans call him. These days, he hides out, perhaps, in a $325,000 rented house not far from the Strip, or maybe on his 518-acre desert ranch, bought recently for $625,000 from the late Vera Krupp, ex-wife of the German industrialist.

His aides claim that Hughes lives on the ninth floor of the Desert Inn, where he has taken over all five deluxe suites. The draperies remain tightly drawn at every window. Telephone calls to Hughes are shunted to a special operator, and the messages

are handled by a Hughesman. A visitor immediately discovers that there is no button in the elevator for the ninth floor; you need an escort with a special elevator key to get up there.

"I haven't seen him since I became manager," confesses Walter Fitzpatrick, who was named managing director of the hotel by Hughes.

Not even the Nevada Gaming Control Board, the state's powerful monitor of gambling activities, can swear that Hughes exists. When Frank H. Johnson, now board chairman, showed up at the ninth-floor suite last March to pick up Hughes's application to operate a gambling casino, he didn't get to look over the applicant. A lawyer emerged from behind a closed door with a power of attorney authorizing him to act in Hughes's behalf. The long application forms were scantily filled out in places. A favorite answer to a number of questions was: "not available."

About all that I could glean from one probing questionnaire I saw was that Hughes is still married to former movie actress Jean Peters, his wife of ten years, that he has been married once before, that he is six feet two inches tall, weighs a scarecrow 150 pounds, has brown eyes, black hair, has just turned 62, and that his So-
continued

BY JACK STAR
LOOK SENIOR EDITOR

LOOK 1-23-68 **69**

In Las Vegas Hank Greenspun leaped to Hughes's defense, hailing him in the *Sun* as "a modest, self-effacing person . . . [who] has never throughout his career displayed any tendencies of control or monopoly." What Greenspun did not say was that the erratic billionaire's "tendencies" were almost beside the point. The money behind the casino investments belonged to Hughes, to be sure, but it was not at all certain that he had been the one actually pulling the purse strings. And although he nominally controlled as much as one-third of the revenue generated on the Strip, the truth was that

Hughes reportedly bought the Castaways, a Polynesian-themed resort across the street from the Sands, because of the land underneath. Stretching from the northernmost border of Caesars Palace all the way to the end of a very long block, the plot was slated to be the site of Sands West, an enormous resort city that Hughes planned one day to build. The parcel is now occupied by the Mirage and Treasure Island.

The Landmark Hotel was mired in debt when Hughes purchased the property. Altogether he assumed almost $9 million in Teamsters Union loans and about $5.6 million in other debts, as well as paying the original owners nearly $2.5 million. His object was simply to establish his presence across the street from the massive, fifteen-hundred-room International Hotel, which his rival, casino entrepreneur Kirk Kirkorian, had recently begun to build.

he was routinely being swindled out of millions of dollars in the counting rooms of his own casinos.

Since no one in the Hughes organization had any idea how to run a casino—as one aide openly admitted, "none of us knew snake eyes from box cars"—Hughes's right-hand man Maheu had kept most of the mobbed-up middle managers in place. Under their direction the skim had continued just as before, only now Hughes was being defrauded every bit as much as the IRS. According to later estimates, some $50 million had been drained from the Hughes-owned joints in fewer than four years. In casino parlance the scheme was known as "cleaning out the sucker."

The extent of the plunder would finally be made clear to Hughes late in the summer of 1970, in a specially prepared financial report that revealed losses of $6.8 million in the first six months of the year alone. Convinced of Maheu's treacherous complicity in the bilking, Hughes signed over his power of attorney to more trustworthy associates and froze Maheu out of the organization altogether. But his love affair with Sin City was over. Stymied by the Justice Department's antitrust suit and hemorrhaging cash, Hughes abandoned Las Vegas on Thanksgiving 1970, four years to the day after his

By 1968, much of the Strip was owned by Howard Hughes, including the Sands and the Frontier. His bid to buy the Stardust brought on charges of monopoly.

arrival, his aides spiriting him away from the Desert Inn in the dead of night without even so much as a good-bye.

In four years few, if any, Las Vegans had actually laid eyes on Hughes, so he would not exactly be missed. He had built nothing and, therefore, left behind no enduring monuments to his name. But by sinking legitimate capital into an enterprise long regarded as the exclusive domain of organized crime, he had changed Las Vegas forever. As Governor Laxalt later put it to reporters: "Hughes had added a degree of credibility to the state that it would have taken years of advertising to secure." Sin City was about to clean up its act.

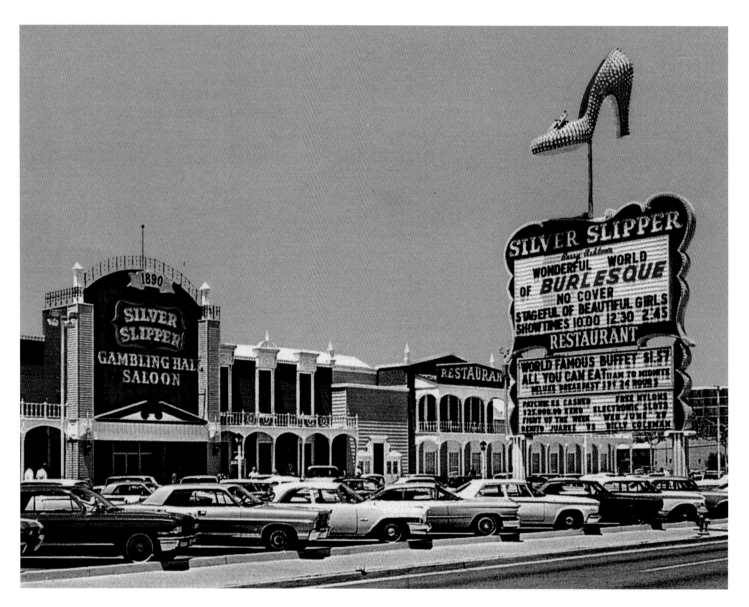

As the casino at Last Frontier Village, the Silver Slipper retained the raw, bawdy flavor of the Old West. Hughes reportedly bought the place because the revolving sequined shoe that topped the marquee was visible—and quite distracting—from his Desert Inn penthouse across the street.

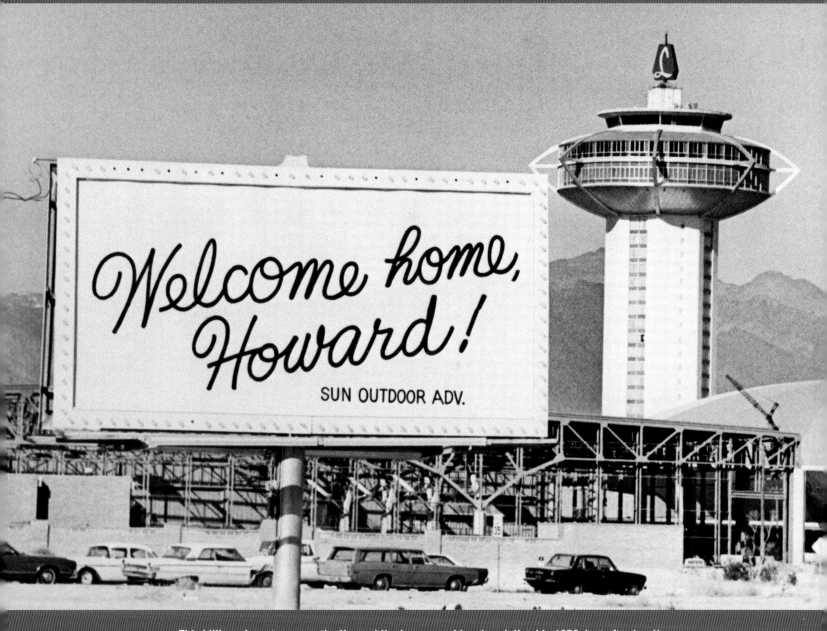

This billboard went up near the Howard Hughes–owned Landmark Hotel in 1972, just after Las Vegans received the news that the eccentric billionaire had left his residence in the Bahamas. Apparently local boosters assumed he was heading back to Sin City.

THE JUICE

BY MARC COOPER

One hot Los Angeles summer eve in the mid-seventies, my mother, Minnie, restless with the flickering TV and the rising room temperature in her small house, and with my father away on a business trip, made a snap decision. My newlywed wife and I should join her that night in an impromptu run to Vegas.

Within an hour, the air-conditioning at full bore, I was captaining her boatlike, decade-old, white El Dorado through the pitch darkness of the Mojave Desert. As if on autopilot I effortlessly steered an inalterable course toward the atomiclike glow that beckoned from the Vegas Strip just across the California border.

By midnight, our few bags still in the car, we were bunkered into the smoky Stardust Casino, occupying the first- and third-base positions at a $5 blackjack table just off the raucous stage of the lounge. My wife had taken her $10 allowance to the roulette wheel. In my early twenties and struggling economically, I allotted myself a mere $40 limit.

A half hour into the play, I was busted out. But with three Cuba libres already consumed, I was feeling flush. My mother, down about $150 and clicking her last few chips on the table, was equally lit up—not so much by a similar amount of booze but by that electric buzz that jumps off the green felt, crackles through your body, and touches off the sort of low-grade Vegas fever that alters time, judgment, and reason. She was running purely on "the Juice."

Sitting there in a floral polyester jumpsuit, her black roots showing through her thinning bleached hair, erratically waving a brown Sherman cigarette, she motioned over to the sharply suited pit boss and loudly said, "Sweetie, I'm Mrs. Sam Cooper. Bring me a five thousand dollar marker, wouldya?"

This was a moment my mother most certainly had long waited to act out. In those few seconds it took to make the request, she was no longer just Minnie the local PTA president. Or Minnie who spent her mornings anonymously watching *The Price Is Right* and her afternoons cruising discount stores. Or Minnie whose most entrusted tasks were to dutifully retrieve the dry cleaning and pick up my little sister from school.

No. In the casino half light, outlined by the bluish gray haze, against the clanging score of the slot machines, she was, for an instant, Minnie the Player. She was hungrily wringing the maximum return out of our $200 stake, living out, if ever so briefly, that ultimate Vegas fantasy bestowed by the odd democracy of the tables. That there was no way we could pay back that marker or even less of a chance that we would be given it in the first place was something only we knew. But what a glorious moment it was just asking for it.

I was equally susceptible to such reverie, having experienced it as a young child in the fifties whenever my parents would regularly tote me on their weekend Vegas forays.

Each time we would roll down the long Baker Stretch into Nevada, they would ritualistically stop in that first ramshackle gas-station casino right on the state line, forty miles short of Vegas. There they would stand before a single row of primitive slot machines. The whir and the clatter of the spinning reels of oranges, plums, and cherries, the *kerplunk* of the heavy silver dollars into the open slots, the *clang* of the coins spitting into the metal retainers, the snap back of the machine handle were all unmistakable signals to me that we had not only crossed the California border but that we had as much as departed from America and all of its smothering Puritan proprieties.

Hoping to hit it big at the Dunes, 1967.

These were no longer just my parents but rather some sort of exotic species: gamblers. And they were gambling in the only place on the continent where you could do it without going to jail. As long as you had one more silver dollar to play, one more stack of chips, or until your credit line ran dry, you were whoever you wanted to be.

So that night at the Stardust, when my mother demanded the marker, who knew who she really was—or was not?

The pit boss surely didn't know, as he obsequiously scribbled down her name and address and solicitously told us he'd be right back with an answer. For all he knew, Minnie Cooper might be Meyer Lansky's first cousin. Her husband, Sam Cooper, might be another Sam Giancana.

In reality Mr. Cooper, my father, was but a barely middle-class suburban steel salesman who had to rank near the bottom of the Vegas food chain, if at all. Yes, he had an account at the Stardust, where he sometimes lodged a client for a day or two—a form of legalized bribery paid for by his employers. Such low-level spending would register but a ripple compared to the splash made by the Whales, the free-spending high rollers on whom the casinos were willing to lavish much more than a few markers.

This was, however, of little concern to my mother or to me. The point wasn't in getting the five grand in chips—just asking for them was enough. The Juice is rarely, if ever, about the money itself.

Frankly I also relished those few sweet minutes, waiting for the floor supervisor's return, basking in the reverent glances of the other players nursing their anemic stacks of chips and—I hoped—wondering who we were.

My mother, who had to be anticipating a negative answer, no doubt planned to make a face-saving but short stink, probably saying they had made some sort of clerical error. And then we would retreat from the table with a disdainful huff. No thought was given by either of us to what we would do if the marker was actually issued, nor did we know, or care, that at that period in history, the Stardust was being run for the mob by Frank "Lefty" Rosenthal and that street enforcement was left to the psychopathic Tony "the Ant" Spilotro (the legendary duo immortalized on the screen two decades later by Robert De Niro and Joe Pesci in Martin Scorsese's *Casino*).

In a way, asking for the chips was just one more bet, albeit a very long shot. That's the Juice: the breathtaking moment when all rides on the snap of a card, the flop of a hand, the click-drop of the steel ball, the lazy tumble of a die, or the discreet nod of a floor boss. It's the delicious sipping, or the lusty gulping, of that heady casino cocktail of greed, risk, fear, and guilt that transports us far from the humdrum.

But what guilt? What's wrong, anyway, with the casino odds? I much prefer battling the meager half-percent edge the house maintains in a fair game of blackjack than

delving into the uncertain seas of high tech or small caps. Playing the craps pass line at near 50–50 odds seems more alluring than sussing out semiconductors, telecoms, and certainly dot-coms. I'm oblivious to margin calls, and I abhor options. I don't go short or long. And while I am bored by the blue chips, I always have a hankering for those lush, purple, $500 chips.

In the casino, moreover, there is no pretense of *investment*. There is only *risk*. Mercifully no overpaid cable TV touts are vowing that this might finally be the Year of Red. Or Black. With the house advantage built into the game, there's no need to dupe the player, no need to call in Arthur Andersen to cook the books. Everyone knows that the luck of the draw or the spin of the wheel is serendipitous—all you need is the nerve to ride it out. No guesswork needed for the odds or payouts. A natural blackjack pays 3–2. A yo-eleven returns 16–1. A straight-up number on the wheel pays 35–1. Red or black—even money, of course, whatever year it is.

Was my mother asking for the five grand in chips that night, with no way to back up a loss, really that reckless? Compared to what? As *Fortune* magazine recently revealed, of the forty thousand stock recommendations made by 213 brokerages during the year 2000, the *most* recommended stock declined 31 percent in value. And— yes—the *least* recommended stock went up a whopping 49 percent. Why not stake it, then, on a double-down soft eighteen against the dealer's six?

Thirty years later, every day, thousands and, ultimately, millions of ordinary Americans make that same devil's bargain with Vegas that my mother and I did in the dank confines of the Stardust. If their lives are to be ever more dominated by distant corporate employers and indifferent HMOs, when it's an all-out crapshoot if they'll get downsized or outsourced, when it's a steep bet that their medical coverage won't be curtailed or that college tuition will require the sale of the family home, when the authority you appeal to is increasingly a soulless, digitally created voice on the other end of the line—then, why not bet it all on Vegas?

Detached and suspended in the Eternal Now of Vegas for a day or two or maybe three, removed from the numbing routine of daily obligations, transfixed by the notion that the undulating girl on your lap might really desire you or that the craps dealer really wants to be your pal or that the whims of the draw or the spin of the wheel might drop two months' salary into your pockets, the 9-to-5 alienation and powerlessness that often defines our lives quickly evaporates.

In the only city where all the bare-knuckle rules are publicly posted and mutually agreed upon, where the house advantage is openly flaunted, average Americans may not really expect to win, but at least they can buy into some fleeting recognition, some transitory respect.

Such was my mother's $5,000 ploy that night. Just as she was getting ready to noisily withdraw from the table, ready to protest that it had taken too long to get an answer from the house, the pit boss came striding our way. To our shock he set down a fully loaded rack of black $100 chips in front of my mother and asked her to sign a slip that she had far too much dignity to read before initialing.

Apparently the trickle of penny-ante business my father had regularly sent the Stardust was enough to grant us the credit.

The rest I can remember only in fleeting, disjointed images. I took half the chips, and we boldly raised our bets to $25 or more. The Bacardi kept going down, and so did our stacks of chips. I played on entranced, half numb.

At about 3 a.m. my mother pulled me away for a break from the table and told me to go wash my face and to recover my bearings and concentration. As I came out of the bathroom, she put both hands on my shoulders and quite sternly told me that we were down $3,000 and that we had to return to the table and win it all back or otherwise . . . what?

My head pounding and my hands trembling, my throat parched, we played through dawn and into the morning. A nonsmoker, I burned anyway through a pack of Marlboros. I have no recollection of any strategy or plan or of any expert playing. (Indeed, I knew very little then of the game to which I now claim some expertise.) I do remember playing every hand with as much skill and logic as I could muster—but it couldn't have been much. Only ten years later, after my mother's death, did I learn that the blackjack "method" she had taught me was terribly flawed.

More than anything, good luck alone must have saved us that night. Sometime before noon, my wife asleep in one of the cocktail lounge chairs, my mother and I had somehow fought and scratched our way out of the hole—except for our original $200 stake. Proudly stacking up the $5,000 in chips we now had, she bought back the marker from another pit boss as nonchalantly as buying a couple of tangerines.

After quietly putting aside enough money in her wallet to pay for the gas to get us home, she tipped him our last $20 and asked him to remember her, as she'd be back soon. The pit boss quickly pocketed the double sawbuck and told her to make sure and ask for him the next time we passed by.

Out the casino doors, through the piercing sunlight, we trudged back to the aging white Caddy, rolled up the windows, turned on the motor and the air-conditioning, pushed the seats back, and let the rush of cool air and the engine vibrations lull us into a foggy sleep right there in the parking lot.

Over the years I have sometimes wondered what would have happened if we had defaulted on the marker. We were probably insignificant enough to have elicited no more than a small-claims suit. Now safely insulated by time and circumstance, the more thrilling fantasy is that Spilotro would have noticed and given us a middle-of-the-night ultimatum.

My mother was never willing to speculate or even speak about what she would have done if we had lost. But she often told me that of the hundreds of nights she spent in Vegas over the course of her life, that was the best one ever, the one time she most deeply imbibed the Juice.

Las Vegas May Be the Only City in the World Where Buildings are Not Presumed to Be Permanent

In 1972 a controversial book called modern-day architects on the carpet both for their lack of receptivity to the tastes and values of "common" people and for their pretentious, knee-jerk disdain for so-called urban sprawl. As much insight could be gained from the symbolism of the parking lot at the A&P, the authors argued, as from that of more overtly "heroic" architectural structures like the Roman Coliseum and the palace at Versailles. The book is called *Learning from Las Vegas*, and it hails the city's architecture for illuminating, by its contrasting vitality, the "deadness that results from too great a preoccupation with tastefulness and total design."

Long before the Strip's most recent overhaul, the singular aesthetic of Las Vegas's cityscape—a seemingly chaotic jumble of baroque modern forms, flashing neon, and immense roadside advertisements—drew rapt attention and, at times, breathless praise. As author Tom Wolfe argued in 1964, Las Vegas was then "one of the few architecturally unified cities of the world—the style was Late American Rich—and . . . no enterprise was too small, too pedestrian, too solemn for The Look. The Supersonic Carwash, the Mercury-Jetaway, Gas Vegas Village . . . the Palm Mortuary, the Orbit Inn, the Desert Moon, the Blue-Onion Drive-in—on it went, like Wildwood, New Jersey, entering Heaven." Late American Rich it was, indeed; and whatever epithets were heaped upon the city's style back then—it was garish, critics complained, visually "noisy,"

just plain ugly—there was, in the end, no disputing that essential Americanness. Oriented to the highway, to the speedy convenience culture of the constantly mobile, and driven by the primary commercial imperative to compete ("Our sign is bigger than your sign!"), Las Vegas's aesthetic expressed like no other city's the lifestyle of mid-century, mainstream America.

As numerous travel guidebooks note, Las Vegas's skyline today is composed almost entirely of buildings cribbed from the skylines of other cities. Elsewhere hotels are built in proximity to major attractions; here the hotels *are* the attractions. Outsize and unabashedly artificial, the Strip resorts put design firmly and unself-consciously in service of human desire and offer environments that answer the modern-day demand for comfort and convenience, entertainment and experience. In so doing they have created what art critic Dave Hickey has called "the only indigenous visual culture on the North American continent . . . where there is everything to see and not a single pretentious object demanding to be scrutinized."

The Statue of Liberty, the Empire State Building, and the Chrysler Building, among other New York landmarks, contribute to Las Vegas's surreal cityscape.

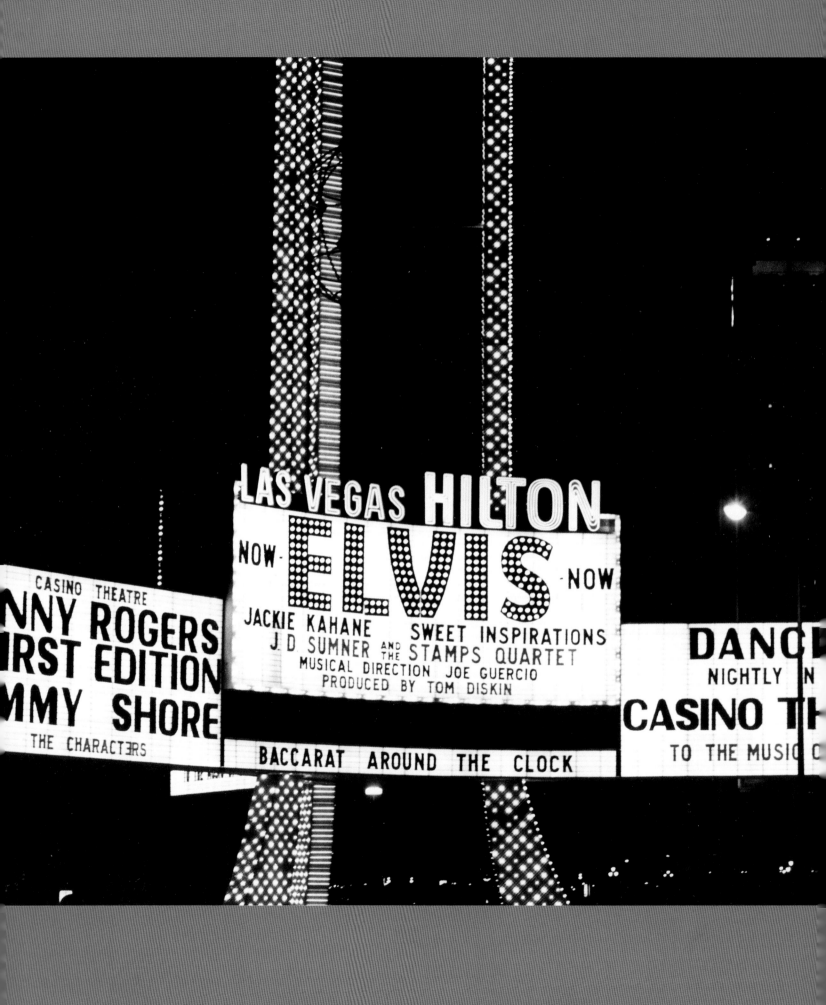

CHAPTER ELEVEN
SINGED CITY

On April 15, 1972, a raucous crowd gathered across the street from Caesars Palace, on the southeast corner of the Strip and Flamingo Road, to watch a piece of Las Vegas history go up in smoke. That morning the cursed Bonanza Hotel, a struggling sawdust joint that had changed hands three times in just five years, was slated to be blown to smithereens. With sex symbol Raquel Welch on hand to detonate the first explosive charge, reporters and news cameramen had turned out in droves, but the high-profile demolition was only part of the story. Equally newsworthy was the fact that the destruction of the Bonanza would make way for what was to be the largest hotel in the free world, a twenty-six-story, Hollywood-themed resort called the MGM Grand.

Using the so-called fast-track method, which allowed architects to revise the blueprints even as construction progressed, the MGM Grand would be completed in record-shattering time: 2,100 deluxe guest rooms, five gourmet restaurants, a 2,200-seat jai-alai court, the world's largest casino, and the third-largest shopping mall in the state, all built in just nineteen months—a shorter spell, by several weeks, than the average gestation period of an African elephant. According to the MGM Grand's publicists, some five thousand North Carolina trees had been sacrificed to produce a total of thirty-two thousand pieces of furniture for the resort, and the 125,000 square yards of carpeting that covered the complex's floors was enough to stretch all the way from Las Vegas to Garden Grove, California.

At a cool $120 million, the resort's price tag was more than six times what had been spent on the Teamster-financed Caesars Palace roughly a half decade before. In post-Hughes Las Vegas, even pension fund money had become chump change. The colossal bankroll behind the MGM Grand belonged to Kirk Kirkorian, a former airline entrepreneur who had funneled the proceeds from the sale of his wildly profitable charter service into investments in Las Vegas, snapping up the famed Flamingo in 1968 and launching a new, $80 million, fifteen-hundred-room Strip resort called the International in 1969. To finance the MGM he then made a landmark transaction, selling both

Kirk Kirkorian's International was the site of Elvis Presley's legendary comeback. Between the time the hotel opened, in 1969, and his death, in 1977, the King played the two-thousand-seat theater exclusively, logging a total of some 837 shows.

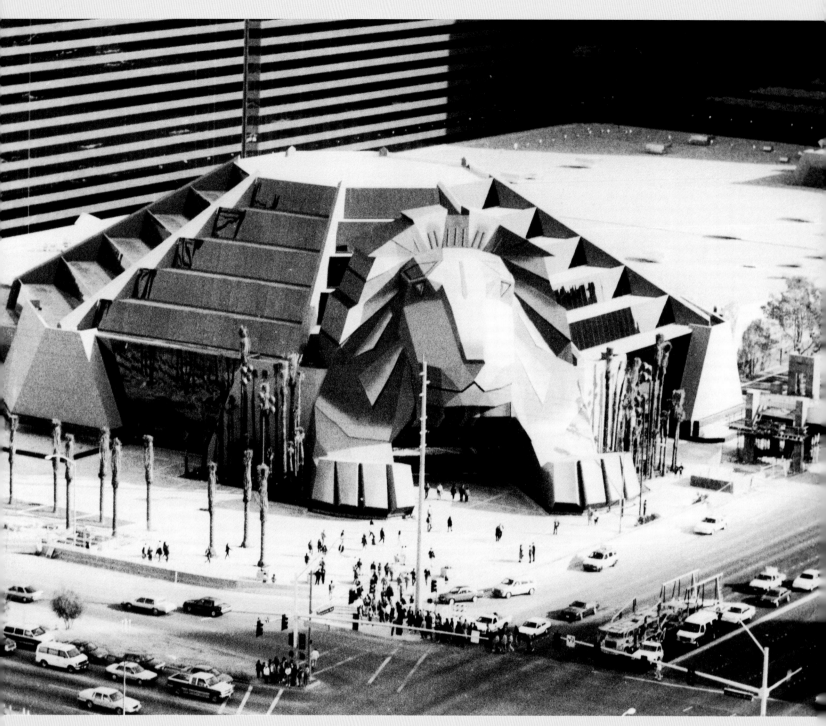

MGM Grand on opening day.

properties to the Hilton Hotel Corporation, the first publicly held company ever to assume ownership of a Nevada casino.

Legitimate financiers had been eyeing Nevada's gambling industry ever since Howard Hughes had first alighted on the Strip, in 1966. At a moment when the primly conservative values of postwar America were folding faster than a poker player with a busted hand, when neckties were going the way of corsets, and nice kids from the suburbs were preaching free love, the old puritanical condemnation of gambling suddenly seemed almost quaint. In 1967, mindful of the enormous profits that so far had been left to gangsters to reap, Hilton Hotel chain owners Baron and Conrad Hilton and several of their colleagues pressured Nevada lawmakers into passing the Corporate Gaming Act, a monumental revision of casino ownership regulations that lifted the implied ban on corporations by eliminating the required background check for every investor. Now, for the first time since 1955, only major operators had to submit to an investigation at the hands of the Nevada Gaming Control Board, and the way was clear for large, publicly held companies to cash in on the casino business.

By 1976 nearly half of the annual gross revenue earned by the 163-hotel

Former airline entrepreneur Kirk Kirkorian pauses for a photo during the construction of his International Hotel, 1969. Situated on eighty-two acres, a few blocks east of the Strip and next to the Convention Center, the International was the largest hotel in the country when it opened.

Hilton chain came from its two Las Vegas properties alone, and rival multinationals Holiday Inn and Sheraton were jockeying for their share of the city's lucrative market. Wall Street had at last come to Sodom and Gomorrah.

With corporate capital at its disposal, Las Vegas no longer had any reason to put up with the mob—or its questionable business practices. When Syndicate soldiers Frank "Lefty" Rosenthal and Tony "the Ant" Spilotro instituted an old-style skimming opera-

Conrad Hilton of the Hilton Hotel Corporation shows off a model of a new hotel, 1954. With help from his brother Baron and several other colleagues, Hilton later convinced the Nevada legislature to allow large, publicly held corporations to own casinos in the state. The Hiltons made their first Las Vegas investments in the early 1970s, when they bought the International and the Flamingo from Kirk Kirkorian.

tion at the Stardust in the mid-1970s, Nevada authorities were confident enough of alternative cash to call a spade a spade. Arguing that Rosenthal had been a gambler since his youth—a characteristic once considered essential for a casino operator—the Gaming Control Board summarily denied the reputed mobster a license and then ran a sting on the Stardust's counting room. Struggling for traction as the city shifted allegiances, Rosenthal and Spilotro resorted to violence and intimidation—crude street tactics that only sullied Las Vegas's national reputation and strengthened its resolve to be rid of the mob. By 1980, "the boys" would mostly be gone from the scene, replaced by business school graduates with calculators.

The transition to corporate ownership would prove particularly rocky for the 30,000 members of Las Vegas's Culinary Union—the maids, bellhops, dishwashers, and cooks who

together formed the backbone of the resort industry. Now more than four decades old, the Culinary had so far enjoyed overwhelmingly cordial relations with the city's hotel and casino owners, who depended on the union to supply them with a steady, reliable workforce. Led by General Secretary Al Bramlet, who had been negotiating with the resorts since the late 1940s, Local 226 by now had become a labor organization with genuine clout.

But as corporations gained dominion over the casino business and the mob made its last-ditch stand, the union began to feel the squeeze. On one side was the explosive, at times savage, Spilotro and his gang of burly minions, who tried to bully Bramlet into

Frank "Lefty" Rosenthal (seated in chair, left) with Donn Arden, producer of the topless revue Lido de Paris, and a bevy of dancers from the Stardust. In between stints as a TV talk-show host and a newspaper columnist, Rosenthal was allegedly a front man for the Chicago mob. In the mid-1970s the Nevada Gaming Commission denied him a license to operate the Stardust and eventually nominated him for inclusion in the notorious "black book," the commission's list of individuals banned from licensed gaming properties throughout the state.

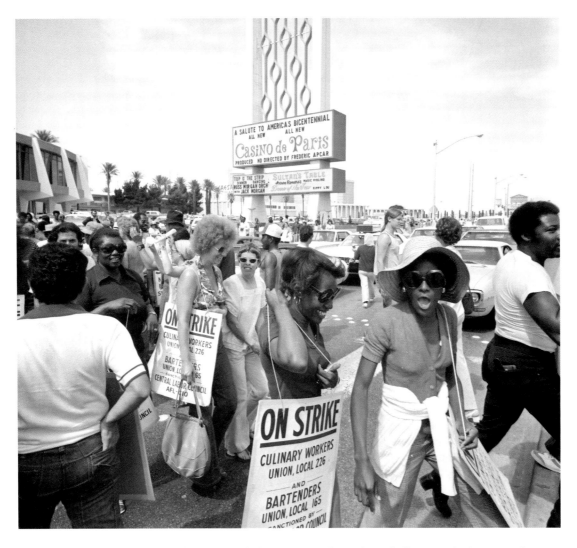

Corporate investment in the Las Vegas resort industry mounted a serious challenge to the long-standing power of the Culinary Union, and labor strikes became a fairly common occurrence.

enrolling the local in a mob-run dental plan. On the other was a covey of white-collar corporate managers—sober, calculating, and obsessed with the bottom line. No longer were food and entertainment considered loss leaders for the real business of the casino. Every sector of the hotel's operation was expected to show a profit, and when it didn't, labor-intensive service work was the most obvious place to slash costs.

As the decade wore on, the Culinary struggled mightily to hold its ground. In 1976, Union members held the first major citywide strike since local railroad employees had walked more than a half century before. The action lasted sixteen days, at which point management grudgingly caved to the union's demands for a wage increase and a "no lock-out" clause. But the Culinary had won a Pyrrhic victory. In retaliation for the heavy financial losses incurred during the strike, hundreds of Strip employees were laid off. The chasm between management and labor widened.

Meanwhile Spilotro's lean on the Culinary turned violent. For his refusal to cooperate, Bramlet took a beating one night in a bar, narrowly escaping with only a couple of broken ribs. Then, in 1977, the union leader turned up dead, his naked body discovered by hikers in the desert thirty miles southwest of town, his hand jutting up out of a shallow grave. With Bramlet gone the Culinary unraveled. Over the next several years, under the leadership of Bramlet's successor, Ben Schmoutey, a lackluster negotiator with reputed ties to Spilotro, union members were forced to swallow a contract with a no-strike provision, and the first explicitly nonunion hotel, the Imperial Palace, opened on the Strip. Crippled by inept leadership and internal strife, the local eventually lost more than 30 percent of its membership.

Returning visitors immediately discerned a difference in the new, increasingly corporate Las Vegas: the service, once impeccable and world class, was now notably subpar, if not downright surly. Worse still, the buzzing energy of the place seemed strangely muted. America's most freewheeling city had become suddenly stodgy. Glitzy had given way to bland. The onetime paragon of nightclub cool, Las Vegas had now become the last plateau on the downward slope to cultural obscurity, a magnet for every cheesy mainstream act and washed-up has-been to have ever taken center stage. A single fact encapsulated the trend: as one local has noted, the corporate geniuses who had scrubbed away the taint of organized crime were also the ones to build the new towers at the Flamingo—the towers that cast the pool in deep shade all day long.

The one thing Las Vegas still had going for it was its singularity. However dowdy or sleazy or tame the place may have seemed to visitors now, it remained the one big city in America, outside of the comparatively rinky-dink confines of Reno anyway, where a person could legally sit down at a blackjack table and throw his life savings away. But in the 1970s even that avowedly dubious distinction

EXCLUSION LIST IDENTIFICATION RECORD

NAME/ALIASES					AKA:	Tony Pasquale Spilotro Pasquale Peter Spilotro "The Ant"		
Anthony John Spilotro								
SEX	RACE	HT	WT	HAIR	EYES	BUILD	OTHER CHARACTERISTICS	
M	Cauc	65½"	160	Brn	Blu	Stocky		
DATE OF BIRTH		PLACE OF BIRTH		FBI			CII	
May 19, 1938		Chicago, Ill.		860 142 B			3 319 488	
LAST KNOWN ADDRESS								
4675 Balfour, Las Vegas, Nevada								
DATE LAST UPDATE		OTHER INFO						
		Business: Gold Rush Ltd. (Jewelry Store) 228 W. Sahara, Las Vegas						
PLACED ON LIST		COMMISSION'S FINAL DECISION					PHOTO DATE	
Dec. 2, 1978		December 2, 1978					March 3, 1974	

Anthony "the Ant" Spilotro was among those included in Nevada's infamous "Black Book," the official list of persons barred from the premises of every casino in the state.

disappeared. In 1976, as a nationwide recession slowed tourism across the country, the revenue-hungry state of New Jersey voted to legalize gaming in its down-at-the-heels seaside resort of Atlantic City. A little over a year later, Resorts International, the first legal, non-Nevada casino in the United States, opened its doors to business so brisk that customers had to wait in line for a seat at a twenty-one table. With its proximity to the densely populated urban centers of the eastern seaboard, and some thirty-seven million people living less than a single gas tank away, Atlantic City easily won out against the four-and-a-half-hour airplane ride into the heart of the Mohave. By the end of the decade, the New Jersey resort's eleven casinos would be drawing nearly thirty million visitors a year—more than twice as many as Las Vegas. As one Resorts International patron put it: "I saw more people betting more money [there] than I'd ever seen in my life. It made Caesars Palace on New Year's Eve look like it was closed for lunch."

Competition mired Las Vegas in what could only be called a civic identity crisis. By 1980 visitation was down for the first time in nearly half a century, and the city

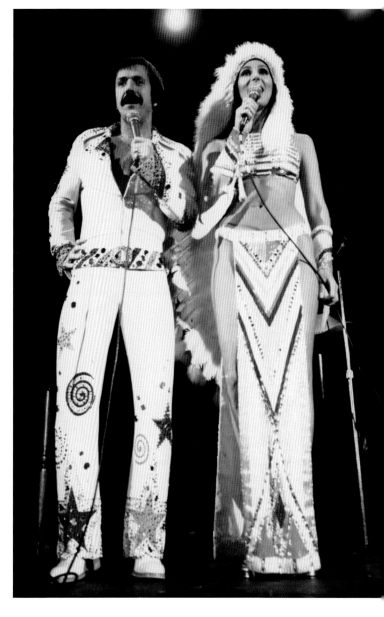

With its heavy emphasis on kitsch and glitz, Sonny and Cher's stage show found a natural home in 1970s Las Vegas.

was desperate for a break. But the losing streak only continued. That November a disastrous blaze at Kirk Kirkorian's seven-year-old MGM Grand killed eighty-five people and injured some seven hundred others. Investigators later blamed the fire on electrical equipment that had not been properly grounded, which in turn had caused the wiring to overheat and burn. Three months later the Las Vegas Hilton—formerly Kirkorian's International—also went up in flames, cutting short the lives of eight hotel guests. In California a joke began to make the rounds in which the "sin" (of "Sin City") had been replaced with the word "singed."

Opposite: Elvis and his decidedly middle-aged pelvis made their legendary comeback at Las Vegas's International.

Meanwhile a series of global economic catastrophes conspired to cut into casino profits even further. Devaluation of the peso kept Mexican high rollers away. The 1982 collapse of the Hong Kong stock exchange knocked out dozens of prime customers from Asia. Plunging oil prices ruined many Texans and Arabs who otherwise would have dropped tens, if not hundreds, of thousands on the tables over the course of a single weekend. In the end Las Vegas casino owners were left with millions in uncollectible markers. Six local establishments folded, and the Riviera filed for bankruptcy protection under Chapter 11.

The last straw came in 1983, when, citing heavy revenue losses, TWA canceled its nonstop service between Las Vegas and New York. In the grand scheme of things, it was arguably a minor blow. With a total metropolitan population of more than 450,000 people and an annual tourist tally that still topped 10 million, Las Vegas was in no danger of disappearing, like so many other specks on the map of Nevada. But it was tempting, nonetheless, to conclude that its spectacular rise had at last reached a sort of natural limit. Like an aging showgirl, a little tawdry and well past her prime, Sin City seemed an unlikely candidate for a second act.

Those who were inclined to count the city out, however, didn't know a thing about Las Vegas.

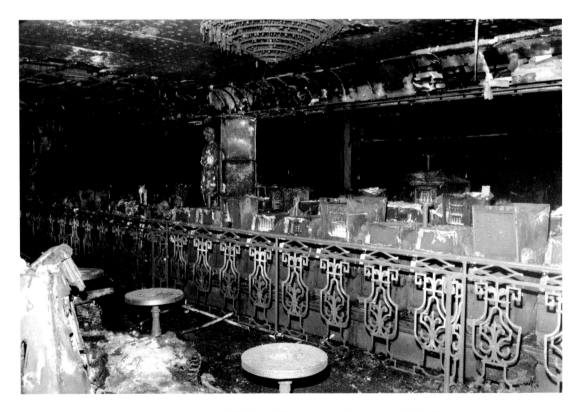

The fire that swept through Las Vegas's MGM Grand Hotel in late November 1980 left the casino charred beyond recognition and claimed the lives of eighty-five guests.

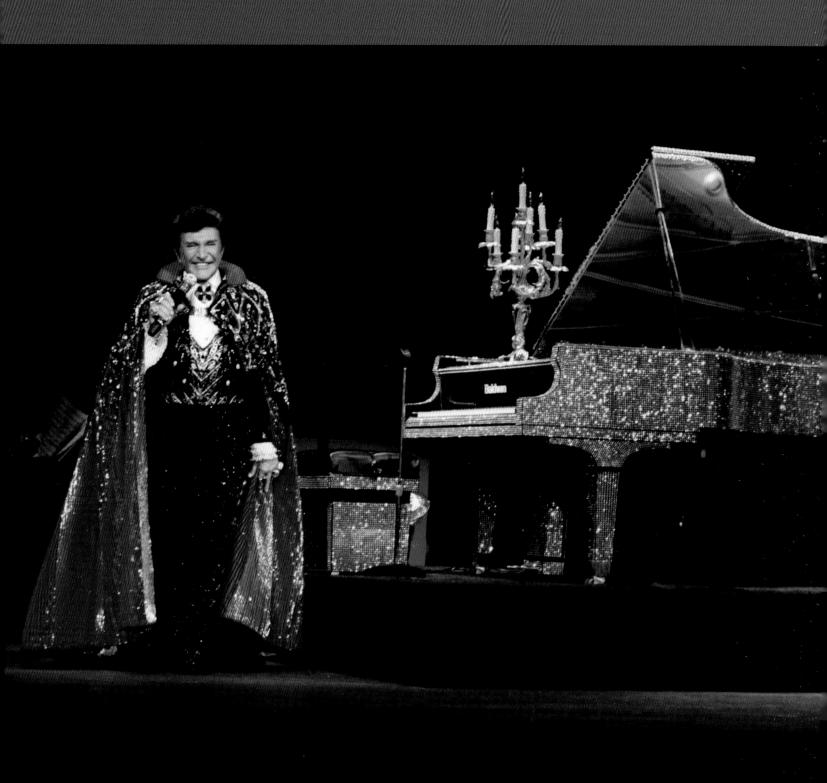

Liberace, king of Las Vegas kitsch. He found the glittering excess of Las Vegas so congenial that he chose
the town as the location for the Liberace Museum. Among the objets d'art in the collection is the "World's
Largest Rhinestone," 115,000 karats and 50.6 pounds of pure lead glass.

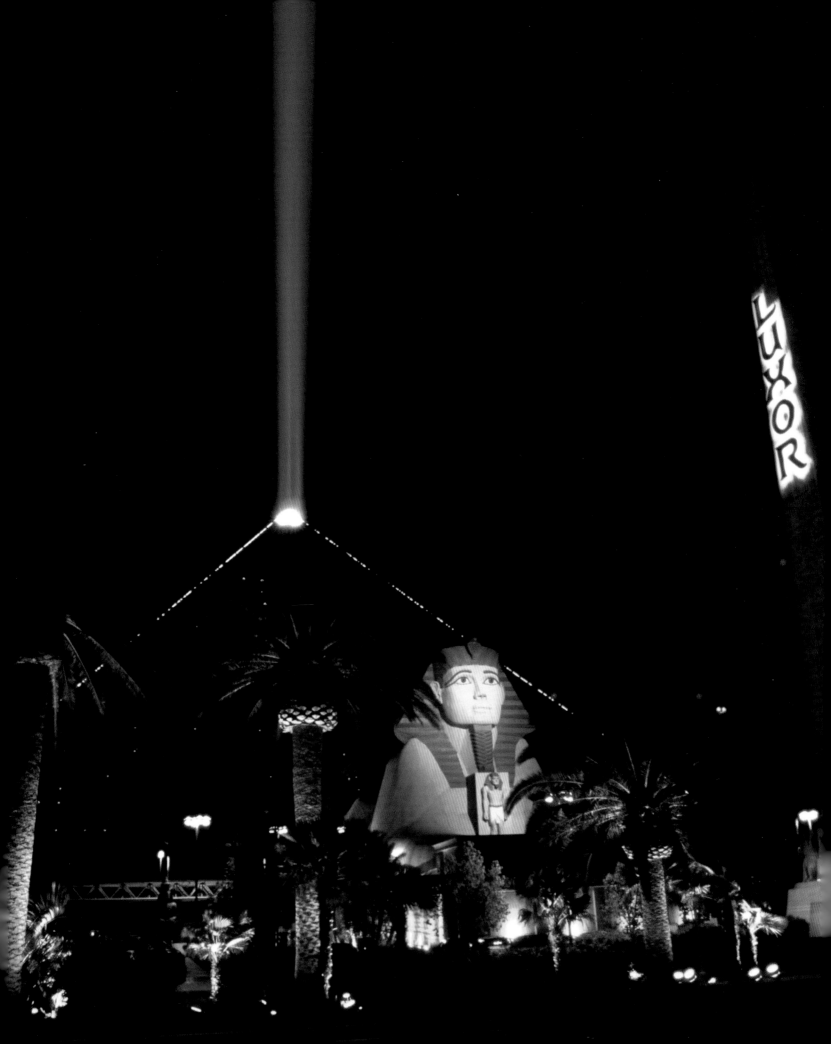

THE MOST VISITED PLACE ON EARTH

I n 1988, on a 102-acre plot next to Caesars Palace, construction began on a three-thousand-plus-room luxury resort called the Mirage, the first major resort to be built on the Strip since the MGM Grand more than sixteen years before.

The project was the brainchild of an audacious forty-five-year-old casino entrepreneur named Steve Wynn. The eldest child of an East Coast bingo operator and lifelong, unreconstructed gambler, Wynn was practically bound by lineage to wind up in Vegas sooner or later. He received his first neon immersion in 1952, at the tender age of ten, when his father opened a bingo parlor in a dingy room above the Silver Slipper. "I looked at the pit bosses [in the casino]," Wynn remembered, "and the cocktail waitresses who were all very beautiful, and I said to myself, what a hell of a business! I was intrigued by a business that offered the glamour of the movies and the stability of a bank."

Bingo, it turned out, was somewhat less stable. Within six weeks the parlor went bust, and the elder Wynn efficiently gambled away the minuscule profit he had managed to turn. Father and son were forced to scrape their way back home. "One thing my father's gambling did," Wynn later said, "was to show me . . . that if you want make money in a casino . . . the best way is to own one."

In 1967, shortly after his father's death, Wynn, now twenty-five, moved to Las Vegas to do just that, sinking the $45,000 profit from sale of the family's bingo operation into a 3 percent stake in the Frontier Hotel. When Howard Hughes bought the Frontier four months later, Wynn finagled a loan from influential Mormon banker E. Parry Thomas and parlayed it into ownership of a wholesale liquor distribution business called Best Brands and the purchase of a sliver of Hughes-owned property next to the Caesars Palace parking lot, reputed to be the only piece of land the eccentric tycoon ever sold. When Caesars heard that Wynn was planning to build a small casino on the spot, they offered him $2.25 million. The sale put Wynn $750,000 in the black—enough to finance a controlling interest in the downtown Golden Nugget Casino. He

Opposite: The forty-billion-candlepower spotlight that shoots up through the top of the Luxor is the most powerful beam of light in the world.

Casino entrepreneur Steve Wynn and actress Barbara Feldman shoot craps at Wynn's downtown Golden Nugget during the filming of an episode of the 1970s TV show *Switch*. Wynn's knack for promotion helped to resuscitate the Nugget and established Wynn as gambling's new wunderkind.

had been in town fewer than five years. Then, in a matter of a few *months,* he turned that fading downtown landmark around, pink-slipping 150 crooked employees, refurbishing the threadbare casino, and laying plans for a new, four-star, high-rise hotel tower. At a time when big-name celebrities appeared exclusively on the Strip, Wynn eventually managed to sign Frank Sinatra to forty performances downtown and then, to the consternation of his competitors, convinced the legendary crooner to star in what turned out to be a highly effective national advertising campaign for the now-glittering Golden Nugget.

But it was Wynn's next move that really captured attention. In the late 1970s, while putting together financing for a second Golden Nugget, in Atlantic City, Wynn called

Wayne Newton, a.k.a. "the King of the Strip," began performing in Las Vegas in 1959, at the age of fifteen. Since then, he has played the Strip almost exclusively, averaging some thirty weeks each year.

upon his cousin's college roommate, Michael Milken, a junk-bond specialist with the Wall Street firm of Drexel Burnham Lambert. Milken grasped the potential in gaming right off. "I'd take money managers and pension fund people into the casinos and show them that it wasn't a gambling business," Milken later said. "It was a business that was built on the laws of probability and statistics." The $160 million in highly leveraged bonds that Milken ultimately conjured for Wynn's project represented a quantum leap in casino financing, a breathtaking gamble that, if it paid off, promised to change the game forever. Within a year of its opening, the Nugget was the most profitable casino in Atlantic City, despite the fact that it was also by far the smallest. By the time Wynn sold out to Bally's in 1985 for roughly double the place's estimated value and three times his initial outlay, his financial high-wire act had earned him a reputation as gambling's new wunderkind.

Backed by a staggering $535 million in junk-bond financing and another $100 million from the sale of the Atlantic City Nugget, Wynn planned to reprise the performance in Las Vegas, albeit with a significant—and to local ears, fairly mysterious—twist.

Siegfried (right) and Roy introduced their unique specialty act to Las Vegas in 1971. Ten years later, after playing countless sold-out houses at the Mirage, they were household names.

"They don't need another casino in Las Vegas," Wynn told one writer. "But they sure as hell could use a major attraction." The Mirage, he promised, would be to Las Vegas what Disneyland was to Anaheim. With no real concept of what Wynn was up to, Las Vegans fixated on what had always mattered most in their town: money. The bottom line was that in order for Wynn to cover his overhead, he would need the Mirage casino to take in $1 million a day. Even preternaturally optimistic Las Vegans had to shake their heads; most believed it simply could not be done. As one experienced casino executive put it, "Wynn's borrowed up to his eyeballs."

But the skeptics had never in their wildest imaginings conceived of anything quite like the Mirage. With three separate wings, twenty-nine stories, and a total of three million square feet, the Mirage was the largest resort casino ever constructed on the face of the earth. At more than twice the size of the nearby Bally's (formerly the MGM Grand), Wynn's colossus literally dwarfed its competition. And unlike its predecessors on the Strip, with their kitschy evocations of Marrakech or Rome, the Mirage offered no tribute to a mythic era or locale—only an exuberant, almost manic, celebration of sheer, stupefying spectacle.

On the ground floor alone, Wynn and his builders installed an ecologically authentic tropical rain forest sheltered by a nine-story-high atrium and a fifty-seven-foot-long, twenty-thousand-gallon marine tank, dramatically situated just behind the reception desk and stocked with pygmy sharks, stingrays, and triggerfish. Out front, meanwhile,

The volcano at the Mirage, a fifty-four-foot, man-made mountain that erupts every thirty minutes after dark, complete with hissing steam, leaping flames, and fake lava. The spectacle routinely halts pedestrian traffic on the Strip.

surrounded by one thousand imported palm trees, stood a fifty-four-foot, man-made volcano that spewed steam and flames into the night sky for three minutes every half hour and routinely stopped pedestrians dead in their tracks. But the showstopper was the resort's headline act: a pair of flamboyant German illusionists named Siegfried and Roy and their hand-raised pack of rare, royal white tigers performing a twice-nightly, belief-defying extravaganza that not only kept the house sold out for literally years to come but also helped to rehabilitate Las Vegas's midcentury reputation as "the capital of entertainment."

Added to the luxurious guest rooms, the five-star restaurants, and the high-end shops—all of which had been intentionally designed as profit centers—Wynn's jaw-dropping flourishes soon made the Mirage the most financially successful resort casino in the world. Approximately 100,000 people were expected to show up for the grand opening; 200,000 actually came. Inside of a few weeks, the resort surpassed the Hoover Dam as the leading tourist attraction in the state. The state-of-the-art casino alone did a booming business: within the first six weeks of operation, some 400 people had already bet a million or more on a single visit. But for the vast majority of the Mirage's patrons, gambling was no longer the focal point of the Las Vegas experience. "We're in the entertainment and recreational business now," Wynn later said. "Although I love casinos! I'm just saying if you go and interview [the customers], that's what's going on out there . . . 'Don't tell me you've got slot machines, Mr. Wynn. I'm not that excited. What is there to *do* besides gaming?'"

Wynn's timing was perfect. The seismic revolution in American values that had begun in the sixties was by now almost complete. As *Time* magazine noted in a 1994 cover story, with shock jocks such as Howard Stern dominating the radio waves and the Hooters restaurant chain infiltrating malls across America, formerly forbidden pursuits had been recast as good, clean fun. "Deviancy really has been defined down," the piece proclaimed, "[and] America has become Las Vegasized." Any residual stigma that still clung to gambling soon dropped away. By 1994 there were lotteries in thirty-seven states in the Union, legal casinos in twenty-three, and nearly the same percentage of the gross national product was being spent on gambling as on groceries. What was more, thanks to the wild proliferation of ATM machines and a credit card blitz so aggressive that even college students with no demonstrable income qualified, the availability of cash (or lack thereof) no longer even factored into the entertainment equation. Americans were primed as never before for recreation Mirage-style.

Inspired by the stunning profitability of Wynn's business model, ever opportunistic and fantastically malleable Las Vegas now reinvented itself once more, this time as the nation's premier entertainment destination. Between 1990 and 1999, in a series of carefully orchestrated implosions, some of Las Vegas's most iconic landmarks—the Dunes,

As its scheduled demolition neared, the legendary Dunes said its good-byes.

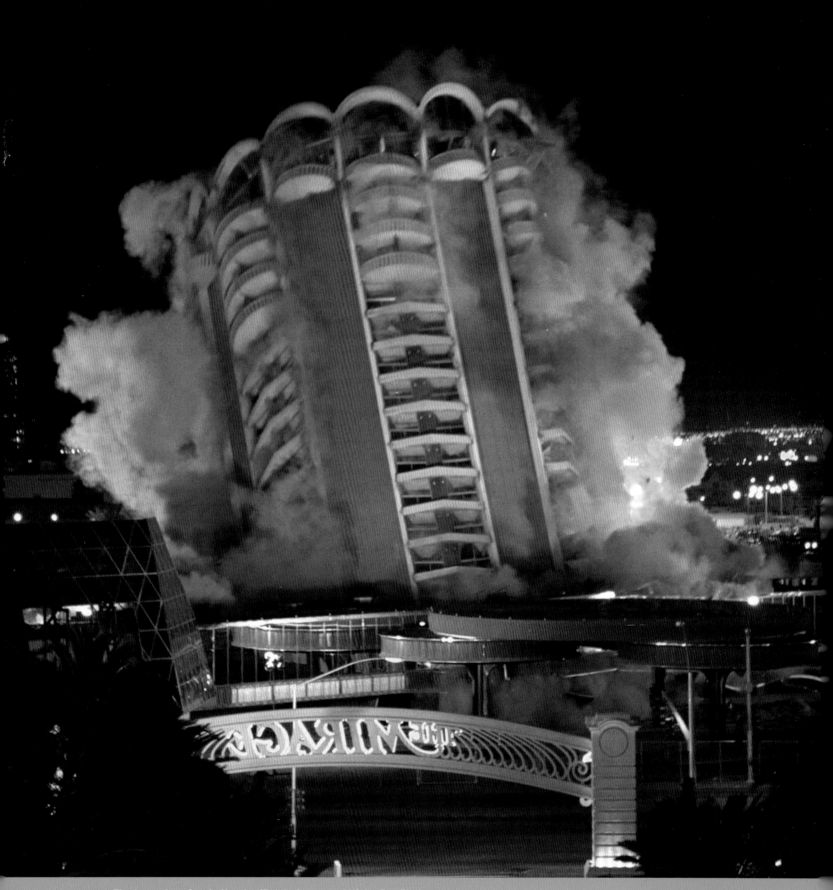

The legendary Sands Hotel, official playground of the Rat Pack, was demolished in 1996 to make way for the $1.2 billion Venetian, a convention-entertainment-shopping-resort complex designed to resemble the floating Italian city of Venice—piazzas, canals, and all.

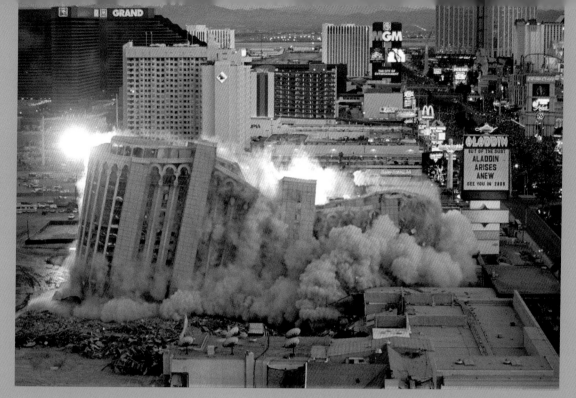

The thirty-two-year-old Aladdin Hotel and Casino comes tumbling down, April 1998. Inside of a few seconds, the fifteen-story resort was reduced to a forty-foot pile of rubble.

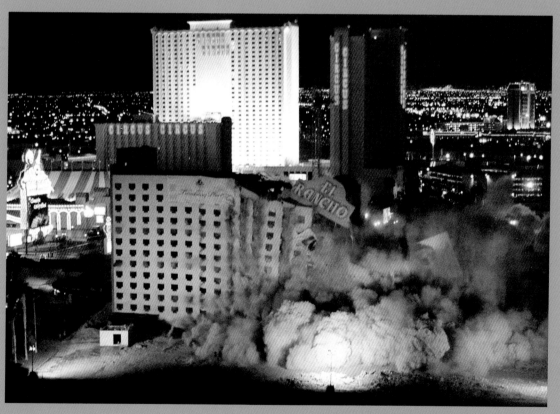

The thirteen-story El Rancho Hotel and Casino goes the way of many of Las Vegas's historic buildings, October 2000.

Excalibur's turrets and towers, an architectural echo of Disneyland.

the Hacienda, the Sands—were demolished, and in their places a dozen brand-new behemoth resorts sprang up out of the desert, like the outsize LEGO creations of an unnaturally large child.

They materialized almost overnight, one after another, each catering to a highly specific market and niche: the four-thousand-room Excalibur, outfitted with cartoonish turrets, towers, and spires and featuring a Knights of the Round Table–type theme designed to appeal to a blue-collar, kid-toting crowd; the slightly more upscale, pyramid-shaped Luxor, home to the world's largest atrium and a forty-billion-candlepower spotlight that astronauts say is clearly visible from space; the pirate-themed Treasure Island, where an elaborate maritime drama is performed six times nightly on a sixty-

Opposite: Equipped with a jumbo-tron, the man-made bay fronting Treasure Island is the backdrop for the resort's newest entertainment attraction, "The Sirens of TI," a sexy maritime-themed production that is performed six times nightly.

five-foot-deep, man-made lagoon fronting the hotel; and the new MGM Grand, a 5,009-room hotel-casino-entertainment complex that on a busy day boasts a total population larger than all but a handful of towns in the entire state of Nevada. These were followed by dazzlingly elaborate homages to New York City; Paris, France; the Italian resort town of Lake Como; and the floating city of Venice—all within walking distance of what was fast becoming perhaps the most famous volcano since Mount Vesuvius.

The new Las Vegas appealed in a way that the old, mob-run Sin City never had. By 1999 the annual tourist count had topped thirty-seven million people, and Las Vegas had eclipsed Mecca as the single most visited city on the planet. For the first time in history, visitors came as much for the sights, the shows, and the shopping as they did for the casino games. During the 1990s nongambling revenue actually exceeded the casino take, with tourists leaving behind some $8 billion a year at the tables and slots and more than $10 billion elsewhere in town. Almost overnight, it seemed, the city that had been defined by its deviance for nearly a century had become decidedly mainstream, an ebullient, unapologetic monument to the essential desires—freedom, pleasure, money— that now made the nation tick. "Las Vegas exists because it is a perfect reflection of America," Wynn once told *Time* magazine. "You say 'Las Vegas' in Osaka or Johannes-burg, anywhere in the world, and people smile, they understand. It represents all the things people in every city in America like. Here they can get it in one gulp."

The Forum Shops at Caesar's Palace, with almost 200 shops and restaurants, is the most profitable shopping venue in the country.

Opposite: France meets the United States at Paris, Las Vegas.

Overleaf: A typical tableau from Donn Arden's Jubilee (at Bally's), a classic Las Vegas–style revue.

RAINFALL IN LAS VEGAS AVERAGES FEWER THAN FOUR INCHES A YEAR

As statistics go, this one seems particularly coun-terintuitive, but in the year 2000, Las Vegas residents led the nation in water consumption, running through, on average, nearly four hundred gallons per person per day. A bird's-eye view of the ever-expanding metropolis reveals a mosaic of emerald lawns and blue swimming pools and massive sparkling lakes—a landscape that at first glance looks more like the Midwest than it does the Mojave. Students of the city invariably attribute these rather confounding facts to the preponderance of newcomers and their overweening desire to re-create the environments they left behind. But the extent to which Las Vegas neither looks nor acts like the desert also points to one of the more perverse dimensions of its

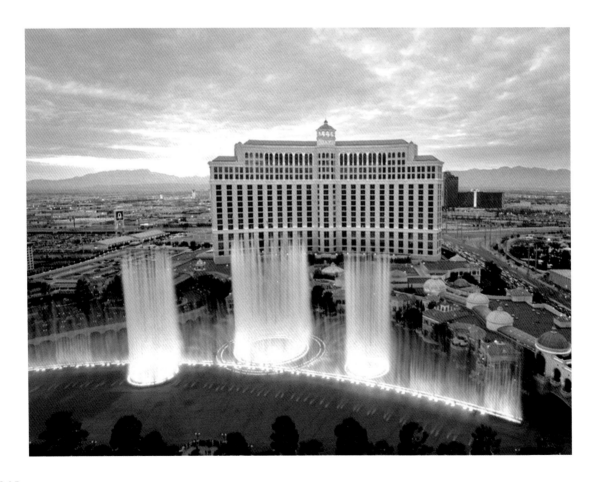

civic identity: despite all environmental and climatological evidence to the contrary, the city stubbornly continues to think of itself as an oasis.

In the beginning, of course, the place *was* an oasis, and it was the presence of water—the ample, if not exactly abundant, supply from its springs and artesian wells—that first put Las Vegas on the map. But the natural bounty, such as it was, could never have sustained the city's rampant, explosive growth, much

less kept the place green. As the population doubled and doubled and doubled again, Las Vegas bet the farm on the transformative power of technology and effectively willed the very idea of scarcity away, covering it over with a dazzling illusion of plenty.

By the 1990s artful water display had become a competitive sport, with Strip resorts incorporating extravagant design elements that obscured any immediate perception of the surrounding desert: Treasure Island's 65-foot-deep Buchaneer Bay; the Venetian's 1,200-foot miniature replica of Venice's Grand Canal; and the Bellagio's 8.5-acre man-made lake and $30 million fountain, a fantastical display comprised of more than one thousand "dancing" jets, each capable of shooting water some 240 feet into the air. In the residential neighborhoods, meanwhile, water worship gave rise to communities with preposterous names like Crystal Cove and Desert Shore, the Lakes and Coral Cay, as well as dozens of recre-

ational and aesthetic "water features" (otherwise known as ponds and lakes), and more than thirty eighteen-hole golf courses, each as green as the table felts in the casinos.

No one disputes that water use in this largely man-made oasis of a million and a half people is profligate, but few predict disaster for the desert city. While most observers agree that water remains the primary hedge on Las Vegas's growth, they also concede that, as long as American society continues to do business as it does now, little possibility exists that the city will ever actually run dry. As the late historian Marc Reisner once observed, in the West water flows uphill to money; and at this point, anyway, Las Vegas is practically minting the stuff. "I think in Las Vegas there is still that feeling of kind of surreal triumph over the elements," says writer David Thomson. "'Damn those elements,' you know, 'we can beat them.' It's this amazing sort of mixture of optimism and recklessness."

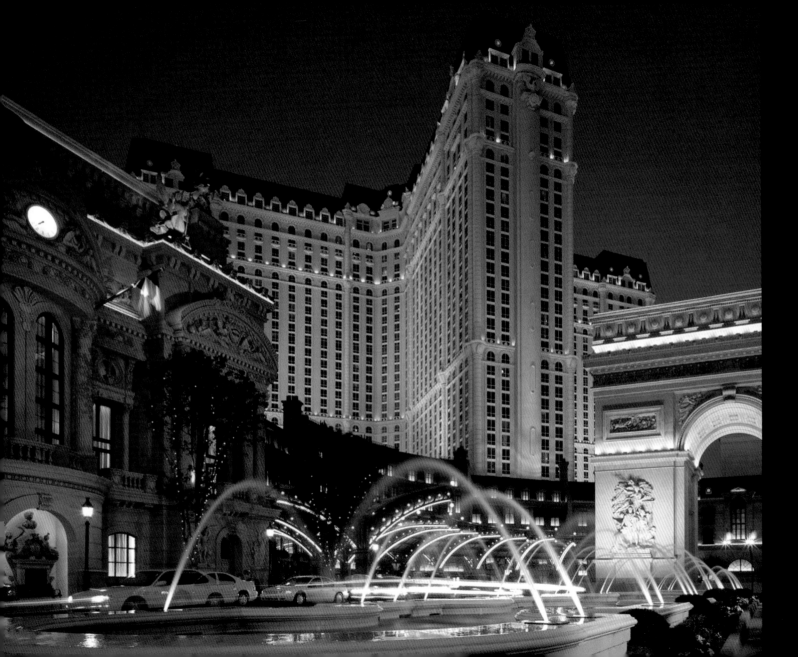

By the close of the twentieth century, the Las Vegas Valley epitomized the all-American phenomenon of "suburban sprawl."

CHAPTER THIRTEEN
ALL-AMERICAN CITY

By the dawn of the twenty-first century, Las Vegas was home to twenty of the twenty-three largest hotels in the world and a dozen immense resort complexes that had not even existed a decade before. What that meant, above all else, was *jobs*—thousands upon thousands upon thousands of them. From ground breaking to grand opening and beyond, every new resort employed a veritable army of contractors, construction workers, plumbers, electricians, painters, upholsterers, and craftsmen. With each of the more than sixty thousand new hotel rooms in town came openings for maids, bellhops, desk clerks, bartenders, cocktail waitresses, cooks, casino dealers, valets, lounge singers, and musicians. Before the first of the Strip leviathans, the Mirage and the Excalibur, could even open their doors, they had to assemble staffs that together totaled some eight thousand new employees.

In Las Vegas this was no mean feat. In a city with no hinterland and enviably low rates of unemployment, finding eight thousand available workers was about as likely as spotting a nun at the slots. For the first time in more than a decade, the Culinary Union, with its long history of recruiting labor for the hotels, had something corporate management wanted. Wielding true bargaining power for the first time since the mid-1970s, the union local cut historic deals with both hotels, agreeing to deliver a reliable workforce in exchange for significant wage increases and benefits for its membership. In the process the Culinary asserted itself as a full and necessary partner in Las Vegas's corporate entertainment enterprise.

With the resurgence of the Culinary Union, the new Las Vegas became the last bastion of the American Dream. Combined with low housing prices and almost nonexistent taxes, the city's heavily unionized economy and high wages promised America's unskilled workers something few other places in the country still could: a shot at a middle-class life. As globalization dismembered the national manufacturing sector, and the economy skidded into recession, thousands of downsized, outsourced, or otherwise excised steelworkers and meat packers and textile machine operators suddenly converged on Las Vegas—"a prolonged wave of new Oakies," journalist Marc Cooper called

Denying the desert on one of Las Vegas's many man-made lakes.

them—filling the fleabag weekly motels in town to capacity and thronging the white construction-site trailers that served as temporary hiring offices on the Strip. In a moment of blue-collar crisis, the one-time allure of the Nevada desert was turned on its head: now on the cutting edge of the postindustrial economy, Las Vegas ceased to be a refuge from a mainstream American life and instead became the last, best place in the country to find it.

As newcomers poured in, residential construction began to gobble up empty desert for miles in every direction. Operating on the premise that, as one real-estate tycoon put it, "every new hotel room meant a job, a paycheck, a house, and a mortgage," optimistic developers snapped up huge tracts of land and conjured entire instant suburbs where not long before had been nothing but scrub and sand. Following the model of Green Valley, a self-contained, master-planned community to the southeast of the city that *Las Vegas Sun* publisher Hank Greenspun had founded back in the mid-1970s, the new developments were designed, quite like the new resorts on the Strip, to appeal to specific income levels and demographics and to cater to every conceivable need.

The largest and ultimately most exclusive of these communities was Summerlin, built on a thirty-six-square-mile tract owned by Howard Hughes Properties and named for the billionaire's mother-in-law. Located on the western rim of the valley and some twelve miles from downtown Las Vegas, Summerlin was conceived as a constellation of thirty distinct "villages" (Hills Village, Trails Village, Canyons Village, and so on) and

Opposite: Construction of the new Strip resorts, like Mandalay Bay, put thousands of people to work.

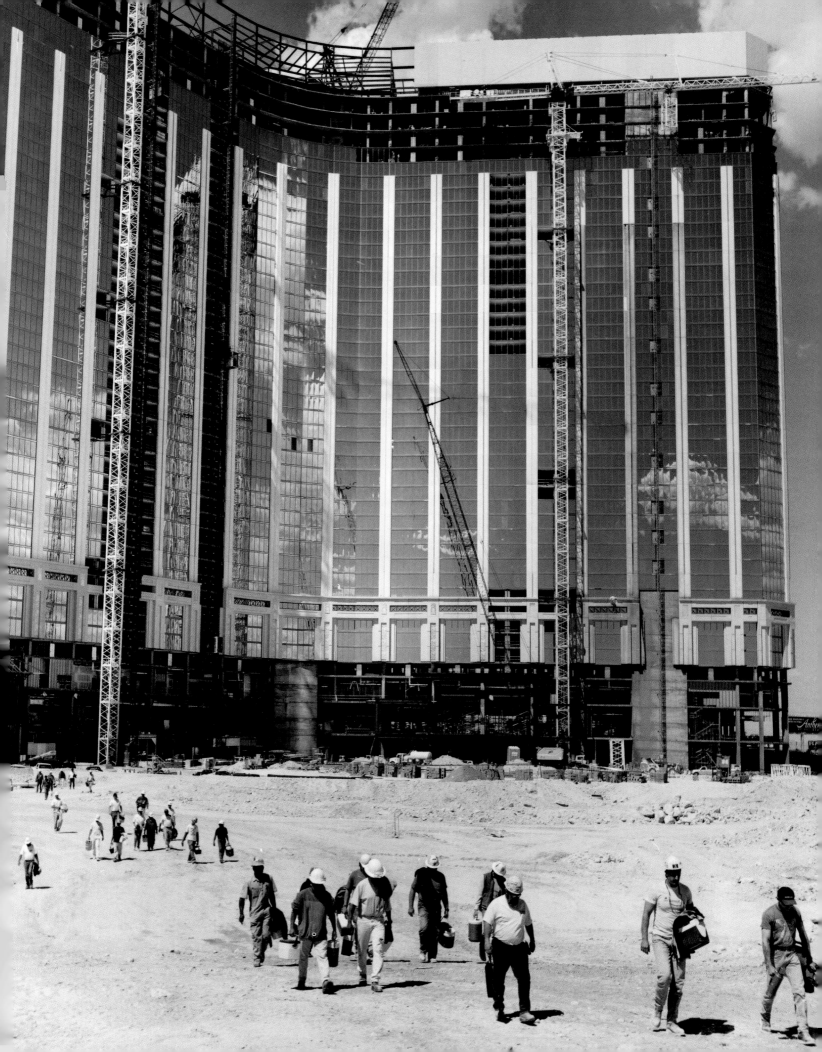

was slated to be constructed in three phases over more than two decades, in partnership with the Del Webb corporation, a longtime Nevada casino owner. Sparklingly clean, lavishly landscaped, and mostly gated, the Summerlin communities offered a range of housing options, from so-called starter homes to million-dollar mansions, and amenities such as golf courses, jogging trails, and a performing arts center, all intended to suggest the homey innocence of a mythic suburban America. As Marc Cooper notes, Summerlin—with its baseball diamonds, parks, libraries, schools, churches, and carefully zoned shopping districts—promised residents complete insulation from the wanton excess of Las Vegas, even as the billion-dollar profits from that excess fueled the economy that ultimately paid their mortgages.

The formula was replicated again and again, one meticulously plotted, picture-postcard community after another, throughout the 1990s. Already by the middle of the decade, between sixty and one hundred new streets were being named every single month, and a new map of the metropolitan area was good for just about as long as a quart of milk. So frenzied was the construction that locals began to joke that the state bird, in reality the mountain bluebird, surely ought to have been the (construction) crane. Before long the Las Vegas Valley was blanketed in brand-new, desert-hued stucco subdivisions, and real estate development began to rival tourism and gaming as a primary economic engine for southern Nevada.

Lower-priced than comparable housing elsewhere and aggressively advertised, the niche-market developments beckoned newcomers in droves. Sun City Summerlin, a

Desert dwelling Las Vegas–style.

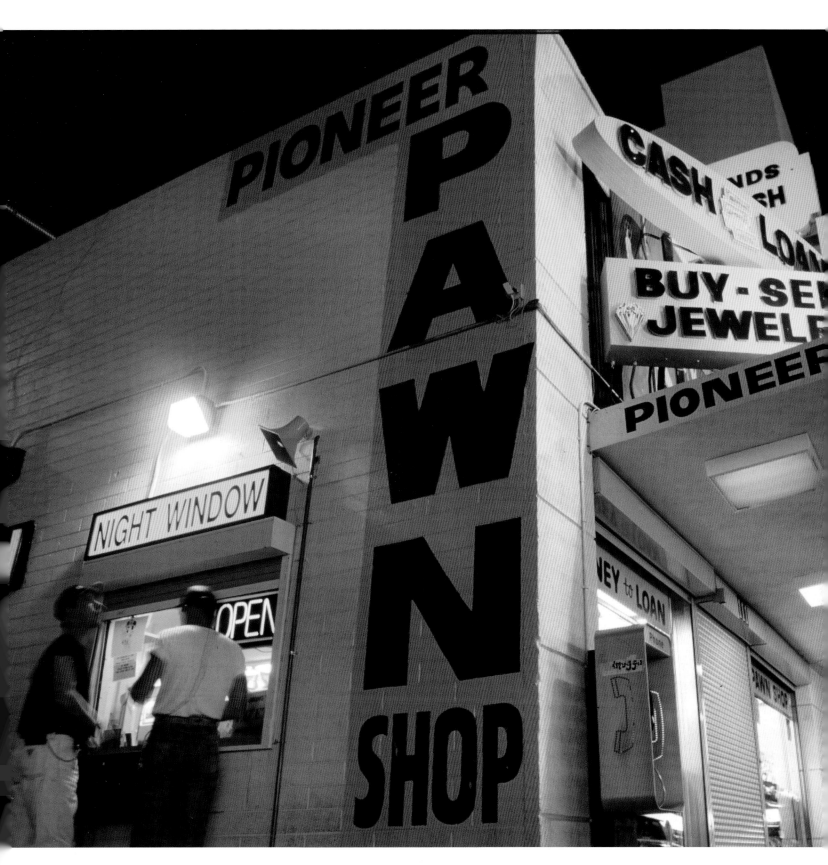

A popular antidote to losing streaks and ATM withdrawal limits.

The innovative theatrical experience Blue Man Group at the Luxor.

retirement village modeled on a master-planned, age-segregated community Del Webb had previously built in Arizona, for example, targeted the ever-increasing legions of American elderly and almost instantly established Las Vegas as a viable alternative to graying cities such as Phoenix and Fort Lauderdale. Lured by low taxes, warm weather, and the proximity of twenty-four-hour entertainment, hordes of retirees packed up and moved to Las Vegas—prompting, in turn, the rapid-fire construction of Sun City McDonald Ranch to the southeast of the city and Sun City Anthem in Henderson. By the year 2000, almost 25 percent of the population in southern Nevada was over sixty-five years old.

In the development offices of gated communities such as the Lakes, Capriana at Smoke Ranch, Desert Shores, and Via Romantica, meanwhile, middle- and upper-middle-class singles and families snapped up homes before they were even built, at times waiting a year or more to actually lay claim to their property. Mainly college-educated, white-collar professionals, these newcomers were often only tangentially dependent on the city's tourist trade for their livelihoods, if at all. Having accurately discerned in Las Vegas's boom an ever-expanding market for their skills and services,

Opposite: In the faux-pastoral surroundings of Summerlin, it is actually quite possible to forget that the Las Vegas Strip is just down the hill.

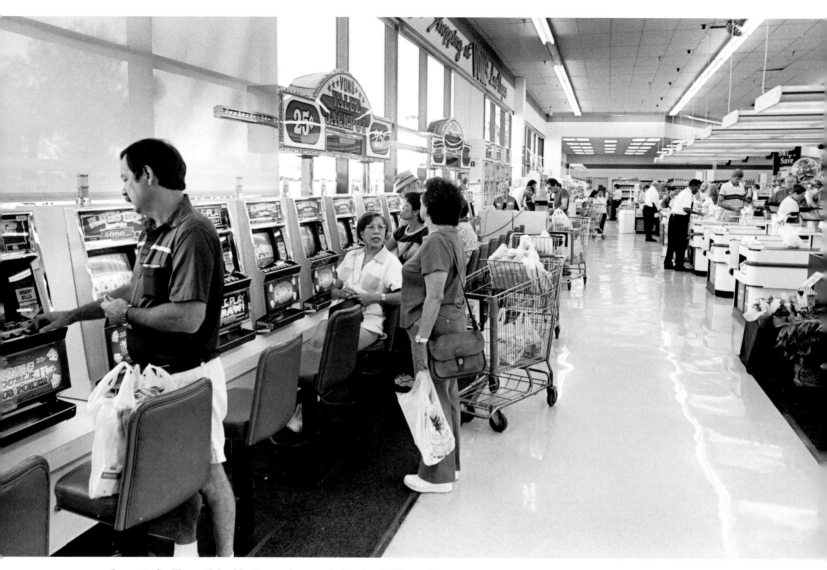

A quart of milk, a stick of butter, and a couple hands of video poker.

many simply regarded the move to the Nevada desert as a chance to do better than they could elsewhere. As one young physician told historian Hal Rothman, "I can make more money here in a month than in six in California."

Growth begat more of the same, as rampant construction and the influx of affluent residents sparked an insatiable demand for manual and low-skill labor. Hundreds of thousands of immigrants, mainly Spanish-speaking and undocumented workers from Mexico, El Salvador, Guatemala, and Los Angeles, poured into Las Vegas, more than doubling the city's Latino population in just one decade. Mirroring patterns that had shaped Latino immigration in the Southwest and elsewhere since the 1970s, these newcomers usually filled jobs on the lowest socioeconomic rung, building houses, tending gardens, and washing dishes and floors. Such low-level positions were widely

understood to be occupational dead ends, but for many they were, nevertheless, an improvement over the crushing poverty they had left behind. More important, they represented a foothold for the next generation. By 1998, 35 percent of Las Vegas's kindergarteners bore Spanish surnames.

As the 1990s wore on, Las Vegas began to look more and more like the rest of America. Once disproportionately populated by Jews and Mormons and overwhelmingly white, the city now counted among its residents not only people from Mexico and Central America but also immigrants from all over the world, including the Philippines, Russia, and China. Whereas the local educational level had traditionally been below the national average, Las Vegas boasted enough college graduates by 2002 to slightly surpass it. And in a society where, by 2025, Americans over the age of sixty-five were projected to outnumber teenagers two to one, Las Vegas, with its enormous and fast-growing elderly population, proved increasingly typical.

Predictably, as the population soared, the latter-day land of milk and honey began to show signs of strain. Studies conducted in the 1990s showed that Las Vegas had among the highest number of suicides, high-school dropouts, and automobile accidents in the nation. It also ranked near the top in abortions, teen pregnancies, births to unmarried mothers, alcoholism, drug addiction, and personal bankruptcy. While some critics regarded such dismal statistics as the inevitable spawn of an economy rooted in immorality, they were just as easily explained by the sheer transience of the community. "There are so many people bringing their own pathologies of various kinds," explains Hal Rothman. "People don't move here because their life is going wonderfully somewhere else, they often move here because something went wrong somewhere else and they're trying to resuscitate themselves. When you see high rates of high-school dropouts here, it's because high-school dropouts here can make seventy thousand dollars a year parking cars or getting a union job of some kind or another. People used to do that in Indiana, and in Michigan, and in other industrial states, but those jobs don't exist anymore. So now they do it in Las Vegas."

With a net gain of as many as five or six thousand new residents a month, and a notoriously regressive tax structure that gave municipal and state government precious few resources to draw upon, it is little wonder that public services were likewise adversely affected by growth. Streets, sewers, even sidewalks were increasingly paid for, and therefore owned, by the corporations that did business in Las Vegas. There were never enough parks or libraries or schools. For the first time in the city's history, measures had to be taken to ensure an adequate water supply, and air pollution was so bad that Las Vegas ranked among the most smog-afflicted metropolitan areas in the country. "These are high-class problems," insists Mandalay Bay Resort Group chief Glenn Schaeffer. "We've been the country's boomtown in terms of job creation, housing starts, new retail starts. We've kept the title most of the last ten or fifteen years. What you're

going to get with that sudden growth is traffic congestion and freeways that don't get built quite fast enough and new schools that have to be opened. But that happened in greater L.A. in the nineteen fifties and sixties and I saw it when I worked in Phoenix in the late seventies. The most important thing is job creation. So compared to most other cities of any scale in the United States, Las Vegas has been the best news going."

In the end that promise of a job and a better life trumped all. At the start of the 1980s, the total population of the Las Vegas metropolitan area barely topped 480,000, a number reached over more than seven decades of unbridled growth. By 1999 that number had nearly quadrupled, making Las Vegas, hands down, the fastest-growing city in the United States and by far the largest American city founded in the twentieth century. "Las Vegas is a world-class destination. This is the place. And so everybody takes their best shot here," Steve Wynn says. "Las Vegas is a place where the great American promise has been kept, where the great American promise is alive and well. We are not the only city like that, but we are certainly part of that tradition; and, like everything else in Las Vegas, here it is perhaps more exaggerated. We make billionaires out of people who believe."

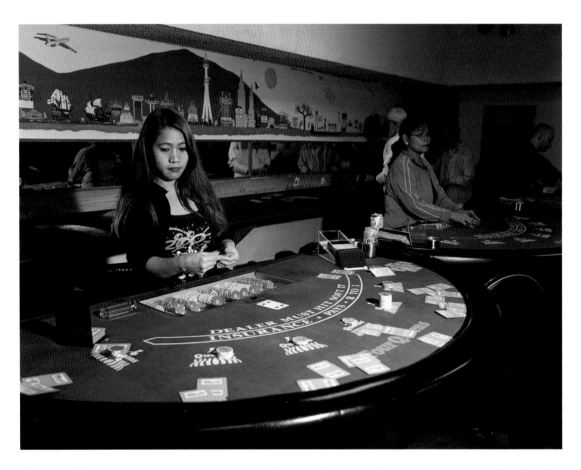

Opposite: Although there are more pedestrians on the Strip these days than at any other time in Las Vegas's history, there is nevertheless no shortage of cars.

LAS VEGAS, CITY OF THE FUTURE

T he night before we interviewed him for our documentary film *Las Vegas*, Steve Wynn stayed out late. Given that he is, quite possibly, the city's most celebrated mogul, one might be tempted to imagine that he attended some swishy social event—a charity ball, say, or the red-carpet premiere of a new show on the Strip. But that night Steve Wynn was working. At 2:30 in the morning, he and his wife, Elaine, stood at a construction site on the north end of Las Vegas Boulevard and watched as a demolition crew blew up the very last piece of what was arguably the most beloved remaining monument to old-style Vegas cool, the famed Desert Inn.

Not much of a crowd was in attendance, perhaps because Las Vegas has made such a habit of imploding landmarks over the past decade and a half that the novelty has long since worn off. But it was a historic event, nonetheless. After all, nearly half a century of Las Vegas's past had been played out between the walls of the legendary Strip resort. Founded by a starry-eyed, small-time gambler with a cash-flow problem and brought to life by a mobster with well-honed entrepreneurial instincts, the Desert Inn harkened back to a time when Las Vegas was synonymous with escape—not only for the drifters and grifters of midcentury America, but for any Mr. and Mrs. Main Street U.S.A. who craved the town's potent promise of release.

It had been here, in the Desert Inn's Sky Room, that crowds of "bomb-tourists" had pressed against the windows for a glimpse at a mushroom cloud blooming over the desert. It was here, in a ninth-floor penthouse suite, that Howard Hughes had cloistered himself for four long years while he played his own private game of Monopoly with Las Vegas's prime real estate. It was in this place, and none other, that the original Strip atmosphere of class and luxury had been so well preserved that the dealers wore tuxedos and bow ties well into the 1990s, long after "dressing down" had become the law of the land.

Now, in a matter of seconds, and marked only by the rumble of wave after wave of explosive charge, the final remnant of the Desert Inn and all of its implied history had been destroyed to make way for (what else?) Las Vegas's Next Big Thing—a $2 billion resort called Wynn Las Vegas, which was set to open just in time for the one hundredth anniversary of the city's founding.

But for the relative lack of fanfare (attributable, perhaps, to Wynn's avowed distaste for "blowing things up"), the moment was quintessential Las Vegas. In this city—where the significance of a building, regardless of its provenance, lies primarily in its economic utility, where the pace of change is so frenetic that history always seems just over one's shoulder—the future has always taken precedence over the past. Certainly no other city in the United States, by the very audacity and sheer artificiality of its existence, so forcefully screams "forward!" It may seem a particularly cavalier civic philosophy, the sort of blatant disregard for "heritage" that makes the doyennes of historic preservation elsewhere cringe and then cluck with knowing disapproval, but it is precisely this preoccupation with the future—and the inherent optimism, opportunism, and vision such a preoccupation demands—that has given Las Vegas its seemingly unstoppable momentum. When a city grows up where it has no business being, when practically everything that happens seems to do so through some mysterious alchemy of luck and accident, the restless, and at times reckless, pursuit of the Next Big Thing is perhaps the ultimate survival skill.

Faith in the future is also, at least in part, what has made Las Vegas at once an utterly unique American city and, in some ways, the most American city in the country. Freed from the constraints imposed by too great a reverence for what has gone before, Las Vegas has managed to develop into a full-fledged metropolis with no civic traditions outside of the wholly American imperative to reinvent, no entrenched social hierarchies, and no currency more valuable than currency itself. It is an almost weirdly democratic place, where the ideals of American individualism—"be who you are and do what you want"—translate into the reality of daily life just often enough to actually mean something.

For many years Las Vegas's penchant for prescience put it ahead of the rest of the country. By now, of course, America has caught up, to the point where Britney Spears's spur-of-the-moment Vegas nuptials strike a far less risqué note than do her concert performances in St. Louis or St. Paul. But Las Vegas's continued refusal to take up the burdensome yoke of history, legacy, and collective memory ensures that it remains a liberated zone, a place where we are free to shuffle off not only the shackles of our quotidian present, but of our past as well. "What happens in Vegas stays in Vegas," the marketing people tell us, and we believe them, at least in part because we know that what has already happened here has little significance. What matters in Las Vegas is the thing that happens next. And if history is any guide, it's going to be BIG.

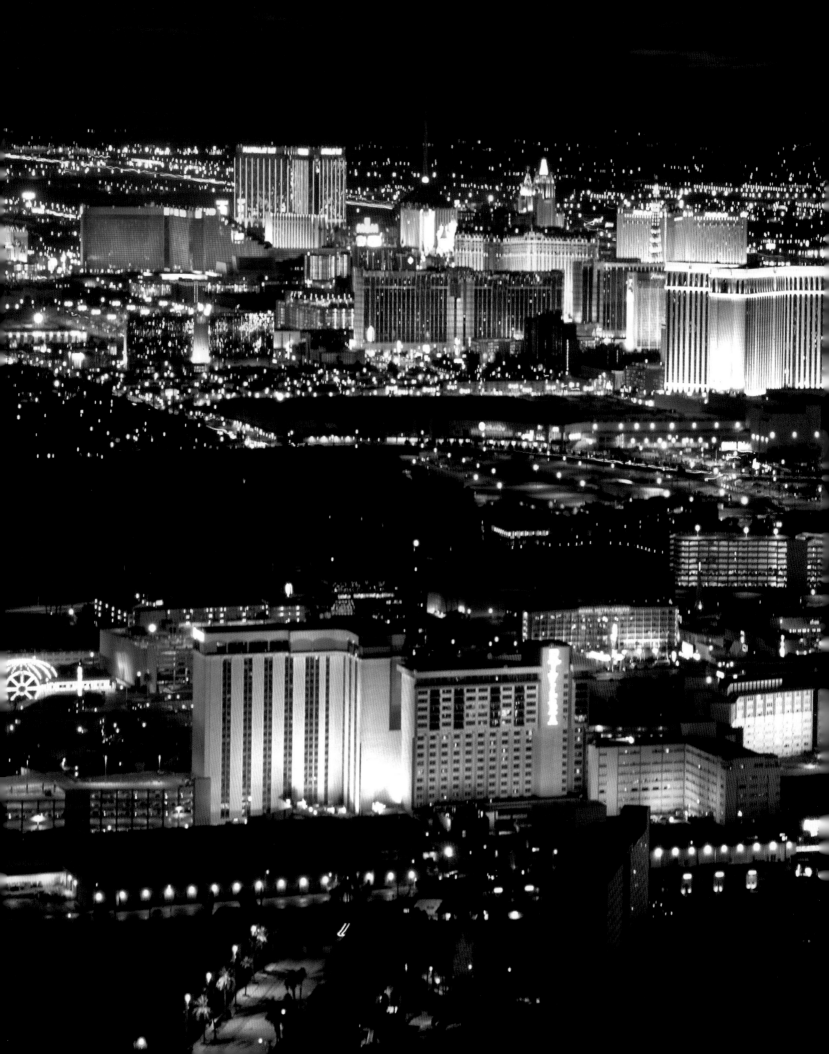

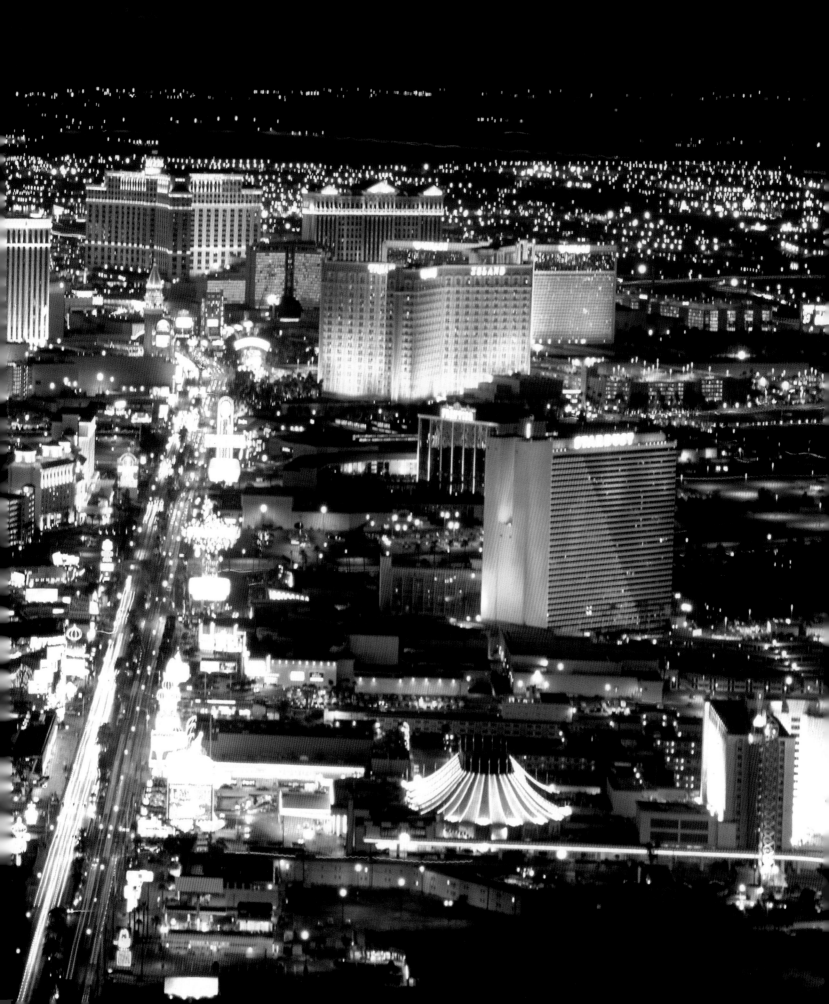

Cooper, Marc. *The Last Honest Place in America: Paradise and Perdition in the New Las Vegas.* New York: Nation Books, 2004.

Denton, Sally, and Roger Morris. *The Money and the Power: The Making of Las Vegas and Its Hold on America, 1947–2000.* New York: Alfred A. Knopf, 2001.

Findley, John M. *People of Chance: Gambling in American Society from Jamestown to Las Vegas.* New York: Oxford University Press, 1986.

Hickey, Dave. *Air Guitar: Essays on Art and Democracy.* Los Angeles: Art Issues Press, 1997.

McManus, James. *Positively Fifth Street.* New York: Picador, 2004.

Moehring, Eugene. *Resort City in the Sunbelt.* Reno: University of Nevada Press, 1989.

Rothman, Hal. *Neon Metropolis: How Las Vegas Started the Twenty-First Century.* New York: Routledge Press, 2002.

Stevens, Joseph E. *Hoover Dam: An American Adventure.* Norman: University of Oklahoma Press, 1988.

Thomson, David. *In Nevada: The Land, the People, God, and Chance.* New York: Vintage Books, 1999.

Titus, A. Constandina. *Bombs in the Backyard: Atomic Testing and American Politics.* Reno: University of Nevada Press, 1986.

Tronnes, Mike, ed. *Literary Las Vegas: The Best Writing about America's Most Fabulous City.* New York: Henry Holt, 1995.

Venturi, Robert, Denise Scott Brown, and Steven Izenour. *Learning from Las Vegas,* rev. ed. Cambridge, MA: MIT Press, 1977.

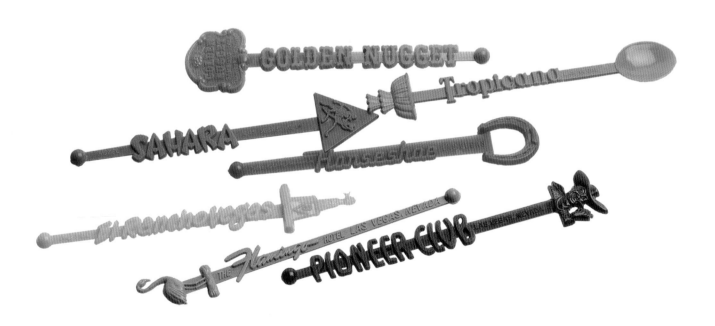

SOURCES

11 "the kind of bill most frequently introduced," Barbara and Myrick Land, *A Short History of Las Vegas* (Reno: University of Nevada Press, 1999), 40; "If you took away the whiskers," ibid.

13 "purchasing votes like eggs," ibid., 38.

15 "Get into line early," ibid., 40; "The auction was a nice clever scheme," Deke Castleman, *Las Vegas* (Fodor's Travel Publications, 2001), 40.

23 "In Nevada, the lawyer, the editor," Sally Denton and Roger Morris, *The Money and the Power: The Making of Las Vegas and Its Hold on America, 1947–2000* (New York: Alfred A. Knopf, 2001), 39; "People in . . . northern Nevada would have been very happy," Land, 47.

27 "That's when the excitement was," ibid., 49.

29 "The present time will be looked back upon," Joseph E. Stevens, *Hoover Dam: An American Adventure* (Norman: University of Oklahoma Press, 1988), 50.

34 "Everyone was coming," Land, 60; "Some of those tinhorn cops," ibid., 84.

48 "The sound is fascinating," Noël Coward, "The Noël Coward Diaries: 'Nescafé Society,'" reprinted in Mike Tronnes, ed., *Literary Las Vegas: The Best Writing About America's Most Fabulous City* (New York: Henry Holt and Company, 1995), 212.

49 "to keep the women busy," A. J. Liebling, "Action in the Desert," *The New Yorker* (May 13, 1950).

62 "All the world began to show up," Eugene Moehring, *Resort City in the Sunbelt* (Reno: University of Nevada Press, 1989), 30.

63 "For many years Las Vegas has bemoaned," ibid., 44.

68 "every night is New Year's Eve," ibid., 21.

74 "He had gotten away with so many gangland executions," Robert Laxalt, *Nevada: A History* (Reno: University of Nevada Press, 1977), 102; "was insane along certain lines," Denton and Morris, 50.

75 "With that deal," Hal Rothman, *Neon Metropolis: How Las Vegas*

Started the Twenty-first Century (New York: Routledge Press, 2002), 12.

76 "the goddamn biggest, fanciest gaming casino," Ralph Pearl, *Las Vegas Is My Beat* (New York: Lyle Stewart, 1973), 26.

77 "When [Siegel] started building the luxurious Flamingo," Oscar Lewis, *Sagebrush Casinos: The Story of Legal Gambling in Nevada* (New York: Doubleday, 1953), 198; "We don't run for office," Denton and Morris, 54.

78 "His guiding principle was class," ibid.

82 "the gaudy opulence," Pearl, 29.

84 "When this thing began to scream," Denton and Morris, 57; "Ben Siegel had not founded," Robert Lacey, *Little Man: Meyer Lansky and the Gangster Life* (Boston: Little, Brown, 1991), quoted in Jack E. Sheehan, ed., *The Players: The Men Who Made Las Vegas* (Reno: University of Nevada Press, 1977), 189.

85 "like generals, mopping up," Denton and Morris, 58.

92 "But such signs!" Tom Wolfe, "Las Vegas (What?) Las Vegas (Can't Hear You! Too Noisy!) Las Vegas!!!!," reprinted in Tronnes, 5.

104 "If you wanna get rich," Sheehan, 63.

107 "Vegas was like another planet," Land, 103; "to more socially prominent hoodlums," Ed Reid and Ovid Demaris, *The Green Felt Jungle* (New York: Trident Press, 1963), 184; "Three for us," Susan Berman, *Lady Las Vegas: The Inside Story Behind America's Neon Oasis* (New York: A&E Network and TV Books, 1996), 93.

108 "Las Vegas Strikes It Rich," *LIFE* (June 7, 1949); "Big time gambling is amoral," Jefferson Graham, *Vegas: Live and In Person* (New York: Cross River Press, 1989), 26; "constantly, vulnerably broke," Denton and Morris, 79.

110 "In Senate cloakrooms," ibid., 105; "Privately my father and his friends joked," Berman, 104; "I just got out of bed," Denton and Morris, 110.

111 "Before you got into bed," ibid.; "The top brass of the underworld," Hank Greenspun, "Where I Stand," *Las Vegas Sun*

(August 14, 1963); "Little New Light Is Shed on Casino Kingpins Here," *Las Vegas Review-Journal* (November 16, 1950); "The licensing system," Denton and Morris, 114; "Well, Senator," Sheehan, 37.

112 "I love that man Kefauver," Graham, 26.

115 "The population problem was almost zero," Denton and Morris, 138.

119 "The dangers of radiation pollution," ibid., 141; "as heirlooms that had come from Las Vegas," Daniel Lang, "Blackjack and Flashes," *New Yorker* (September 17, 1952); reprinted in Tronnes, 29; "We have glorified gambling," Greenspun.

122 "The angle was to get people to think," Lang, 28; "an unobstructed sight line to the bomb blast," Denton and Morris, 40.

124 "Bumper to bumper, just like a ball game," Lang, 34; "Good bangs and so pretty," ibid., 37; "Time was when a nuclear detonation took place," ibid.; "We're in the throes of acute prosperity," ibid., 38.

129 "In the bright desert sunlight," Wallace Turner, "Las Vegas: Trickery at Casinos Goes On Despite Close Scrutiny," *New York Times* (November 19, 1963), 1.

130 "The visitor . . . finds himself whisked," Gladwin Hill, "Klondike in the Desert," *New York Times Magazine* (June 7, 1953), 14.

132 "If the visitor can bring himself back to earth," ibid.

135 "a nationwide demand for Las Vegas whoop-de-do," Katharine Best and Katharine Hillyer, "Fanciful Press Agentry," from *Las Vegas: Playtown U.S.A.* (David McKay and Company, 1955); reprinted in Tronnes, 122.

136 "Where else in all the world but Las Vegas," ibid., 122; "It's sometimes debatable in Las Vegas," ibid.; "[But] Las Vegas has learned in the space of a few short years," ibid., 119; "the most ordinary people," John M. Findley, *People of Chance: Gambling in American Society from Jamestown to Las Vegas* (New York: Oxford University Press, 1986), 151; "unrestricted vistas

of Eastern lobster," *Holiday* (December 1952).

139 "The wayfarer arriving in Las Vegas," Hill, 14.

141 "to sell relaxation," Moehring, 67.

144 "pretty girls sell," *LIFE* (June 21, 1954); "a smart business hype," "Gamblers' Gala," *LIFE* (February 16, 1953); "Dahling, we're just the highest-paid shills in history," "Las Vegas: 'It Just Couldn't Happen,'" *Time* (November 23, 1953), 30; "Even now, in the pre-Christmas slump," Coward, reprinted in Tronnes, 211–12.

148 "One in a thousand visitors may know other aspects," Gladwin Hill, "Las Vegas Is More than the 'Strip,'" *New York Times Magazine* (March 16, 1953).

159 "I got it down from five to three minutes," Joan Didion, "Marrying Absurd," *Saturday Evening Post* (December 16, 1967), reprinted in Tronnes, 171; "I've done more weddings here in eight months," Graham, 195–96.

165 "fabulous, extraordinary madhouse" Coward, reprinted in Tronnes, 211.

167 "Come on out here," Rothman, 129; "[It's] eight dollars a day," ibid.; "We Negroes in Las Vegas are not at all satisfied," James Goodrich, "Negroes Can't Win in Las Vegas," *Ebony* (March 1954).

169 "In Vegas, for twenty minutes, our skin had no color," Land, 145.

173 "Of course you resented it," Faith Fancher and William J. Drummond, "Jim Crow for Black Performers," transcript of *All Things Considered*, a production of KNPR-FM, Las Vegas (July 4, 1991), reprinted in Tronnes, 307.

174 "At night, honey, it was good," Elizabeth Nelson Patrick, "The Black Experience in Southern Nevada," Donated Tapes Collection, Special Collections Department, James R. Dickenson Library, University of Nevada, Las Vegas.

178 "the capital of sin, gin, and din," Peter Wyden, "How Wicked Is Las Vegas?" *Saturday Evening Post;* reprinted in Dick Taylor and Pat Howell, *Las*

Vegas: City of Sin (San Antonio: The Naylor Company, 1963), 17; **"It's as though you walk through a veil,"** ibid., 22.

180 **"Conservative lending institutions are not interested,"** Graham, 53.

182 **"If Moe told them to make the loan,"** Denton and Morris, 232; **"I've got to see that the community stays healthy,"** Graham, 43.

183 **"minarets of Mecca,"** Denton and Morris, 226; **"It was like coming on some mystery city,"** ibid.; **"Without the Teamsters,"** ibid., 227.

185 **"Nevada . . . went ballistic,"** ibid., 249.

186 **"Ask anyone even remotely connected with the gambling casinos,"** Gladwin Hill, "Go West Young Hood," *New York Times* (December 8, 1963).

187 **"what the whole hep world,"** Rothman, 44.

190 **"You're wondering why I don't have a drink,"** Graham, 48.

194 **"[Mr. Hughes's] self effacement and humility,"** Denton and Morris, 273; **"So far as they know,"** ibid., 274; **"Hughes's life and background are well known,"** Sheehan, 142; **"I have decided this once and for all,"** ibid., 132, 141.

196 **"Despite Hughes' reputation for shelling out,"** ABC News, no date; **"was bigger than the Comstock Lode,"** Russell Nielsen for UPI (September 26, 1967); **"It is contrary to our basic concept,"** Denton and Morris, 281; **"a modest, self-effacing person,"** ibid.

199 **"none of us knew snake eyes from box cars,"** Sheehan, 147.

200 **"Hughes had added a degree of credibility,"** Graham, 49.

209 **"deadness that results from too great a preoccupation,"** Robert Venturi, Denise Scott Brown, and Steven Izenour, *Learning from Las Vegas*, revised edition (Cambridge, MA: MIT Press, 1977), 53; **"one of the few architecturally unified cities,"** Wolfe, reprinted in Tronnes, 9; **"the only indigenous visual culture"** Dave Hickey, *Air Guitar* (Los Angeles: Art Issues Press, 1997), 23.

217 **But as corporations gained dominion,** foregoing account of Culinary Union Local 226's decline drawn from Rothman, 73–78.

219 **the corporate geniuses,** ibid., 45.

221 **"I saw more people betting more money,"** Graham, 64.

225 **"I looked at the pit bosses,"** Graham, 88; **"One thing my father's gambling did,"** Land, 170.

227 **"I'd take money managers and pension fund people,"** Marc Cooper, *The Last Honest Place in America: Paradise and Perdition in the New Las Vegas* (New York: Nation Books, 2004), 62.

228 **"They don't need another casino in Las Vegas,"** Graham, 89; **"Wynn's borrowed up to his eyeballs,"** Land, 176.

230 **"Deviancy really has been defined down,"** Kurt Anderson, "Las Vegas, U.S.A.," *Time* (January 10, 1994), 51, 44; **"We're in the entertainment and recreational business now,"** Sheehan, 173.

237 **"Las Vegas exists because it is a perfect reflection,"** Anderson, 44.

241 **"I think in Las Vegas there is still that feeling,"** Insignia Films' interview with David Thomson, 2004.

245 **"a prolonged wave of new Oakies,"** Cooper, 63.

246 **"every new hotel room meant a job,"** Rothman, 263.

252 **"I can make more money here in a month,"** ibid., 139.

253 **"There are so many people bringing their own pathologies,"** Insignia Films' interview with Hal Rothman, 2004; **"These are high-class problems,"** Insignia Films' interview with Glenn Schaeffer, 2004.

254 **"Las Vegas is a world-class destination,"** Insignia Films' interview with Steve Wynn, 2004.

ACKNOWLEDGMENTS

Like so many creative endeavors, the making of a documentary film and the publication of a companion book like this one are fundamentally collaborative ventures. On *Las Vegas,* we have had the good fortune of working closely with a talented team of professionals whose contributions had a profound effect on our portrait of the city, both on the screen and on the printed page. We are glad to have this chance to express our gratitude and to acknowledge the importance of their work.

There would not have been a book if there had not been first a film, and there would not have been a film were it not for the efforts of certain key individuals who recognized the project's importance early enough to help get it off the ground: Mark Samels, the executive producer of the PBS series *American Experience,* who backed the project from the outset and offered invaluable creative input throughout; the Honorable Oscar Goodman, mayor of Las Vegas and chairman of the city's Centennial Commission, who embraced the idea of a new and thoughtful look at the city he governs with quintessential local panache; Don Snyder, a member of both the centennial board and the board of the Las Vegas Convention and Visitor's Authority (LVCVA), who stepped in and championed this project in his own inimitable style—quietly, effectively, and with nothing but the good of the city at heart; Rossi Ralenkotter, the president and CEO of the LVCVA, who tirelessly helped to introduce our film series to the Las Vegas community and enlist LVCVA as a sponsor; and Carol Harter, the president of the University of Nevada–Las Vegas, who made a critically important early commitment to this film that reflected her deep and abiding investment in the future of the Las Vegas community. At Insignia Films, series producer Amanda Pollak marshaled support for this undertaking and then saw it through with focus and intensity that would have made a high-stakes poker player proud. She is miraculous. And were it not for Coordinating Producer Cornelia Calder and her rigorous, tireless, meticulous research, there would quite simply be neither a film nor a book at all.

While there is certainly no shortage of appropriate superlatives to describe the rest of the Insignia Films team—passionate, committed, remarkable, gifted—we have, in the interest of space, elected simply to list them all here, confident that they know we know it could not have been done without them. Our deepest gratitude goes to Field Producer Jeff Dupre; Production Coordinator Ben Ostrower; Researcher Martha Corcoran; Production Associate Lindsey Megrue; Editors Michael Levine and Sari Gilman; Composer Joel Goodman; Editorial Assistants Niharika Desai and Judd Blaise; Sound Editors Marlena Grzaslewicz, Ira Speigel, Mariuz Glabinski; Cinematographers Andy Young and Buddy Squires; Sound Recordist John Zecca; Grips Jim Wise and John Dwyer; and the Board of Directors of Insignia Films—Daniel Esty, John Sughrue, and Robert A. Wilson.

To make a film about a city is to become at once an invader and a supplicant there: one is constantly hoping to bend the rules, begging favors, imposing on local goodwill.

It should go without saying, therefore, that were it not for the cooperation of certain Las Vegans, our project would have stalled at the gate. Our profound appreciation goes to Terry Jicinsky and Jim Gans at LVCVA, Stacy Allsbrook and Teresita Ponticello at the Centennial Commission, Stephanie Boixo, Elena Perez, and Cheryl Russo in Mayor Goodman's office, and Schyler Richards and Earnest Phillips II at UNLV.

Thanks also to the major casinos in Las Vegas and their talented PR staffs, especially Wendy Mosca and Alicia Malone at MGM Mirage; Stacey Solovey at Caesars Entertainment; Scott Voeller and Gordon Absher at Mandalay Bay; Lisa Keim at Tropicana; Lisa Johnson and Ryan Brooks at the Venetian; Joe Hasson at Green Valley Ranch; Alissa Kelly and Melissa Fox at the Hard Rock; Staci Columbo, Tina Rogo, and Gina Lateef at Station Casinos; Lisa Sanders at Boyd Gaming; Jim Seagrave and Terry Lovern at the Stardust; and Tom Mikovits at Coast Casinos.

We owe a particular debt of gratitude to the panel of advisers who shared their extensive knowledge of Las Vegas with us and guided the development of the series from its conception. Marc Cooper, Michael Green, Eugene Moehring, and Hal Rothman read through early drafts of our scripts and spent an entire Sunday locked up with us in a windowless conference room, correcting our errors, omissions, and misconceptions with patience and astonishing good humor. We are particularly grateful to Hal Rothman for his work on Las Vegas' Culinary Local 226 which informed our treatment both in the film and in this book. Our longtime collaborator Geoffrey C. Ward once again served as our senior creative adviser, offering us his immensely valuable insights and guidance during the editing phase of the film.

Our thanks as well to the wonderful staff at *American Experience,* including the unfailingly good-natured Susan Mottau, the series' coordinating producer; Series Editor Sharon Grimberg; director of new media Maria Daniels; Series Manager James Dunford; Project Administrator Nancy Farrell, and Production Assistant Vanessa Ruiz —Red Sox fans one and all! We are also indebted to the marketing team at WGBH who helped launch the series with such style, including Betsy Groban, Managing Director, WGBH Enterprises, Susan Trabucchi, Marketing Manager, Deborah Fagone, National Sponsorship Director, Suzanne Wallen, Senior Project Manager, Foundation Development, and Danielle Klainberg, Director, Foundation Development.

The Las Vegas series would never have made it to the screen without the generous support of *American Experience* series underwriters, and we are pleased to acknowledge their contribution to the project here: The Alfred P. Sloan Foundation, Liberty Mutual, The Scotts Company, The Corporation for Public Broadcasting, and PBS. Our critical production funding for the series came from two pillars of the Las Vegas community—UNLV and LVCVA.

Once the Las Vegas film series was under way, it seemed only natural to produce a book that found room for some of the marvelous material that inevitably would be

sacrificed to the exigencies of the broadcast clock. We wanted this volume to reflect the spirit and character of the city of Las Vegas—accessible, unpretentious, and unabashedly bold. So we set out to create a book that did history the way Las Vegas does fun: fast, furious, and always unexpected. The following people helped us do just that.

Peter Kaufman of Intelligent Television is more than a cutting-edge agent, he is also an old-fashioned impresario who understands the value not only of a creative partnership but also, and perhaps more importantly, of a dry martini. Once again, he helped find us the perfect publisher for the sort of book we had in mind, the indomitable Jill Cohen and her team at Bulfinch Press. Our editor Karyn Gerhard coordinated what was, without question, the most harrowing production schedule in the history of publishing without once losing her infectious energy and enthusiasm. The volume's clean and elegant look is due to the immense talents of our designer, Miko McGinty, and we are grateful both for her sophisticated aesthetic and for her collaborative approach. The stunning quality of the book is due to the top-notch production staff at Bulfinch, led by Production Coordinator Alyn Evans. Many of the little-known or never-before-seen photographs of Las Vegas in the book were discovered by the indefatigable research duo of Cornelia Calder and Martha Corcoran, with vital assistance from Peter Michel, Su Kim Chung, Claytee White, and David Schwartz at UNLV Special Collections, and Karen Silveroli at the LVCVA. The wonderful three-dimensional objects appear thanks to whirlwind coordinating by Eve Morgenstern and the elegant photography of Jim McGuane.

Finally, our eternal thanks to Anne Cleves Symmes and Leland Gantt, who always show up when the chips are down.

Stephen Ives and Michelle Ferrari
New York City, 2005

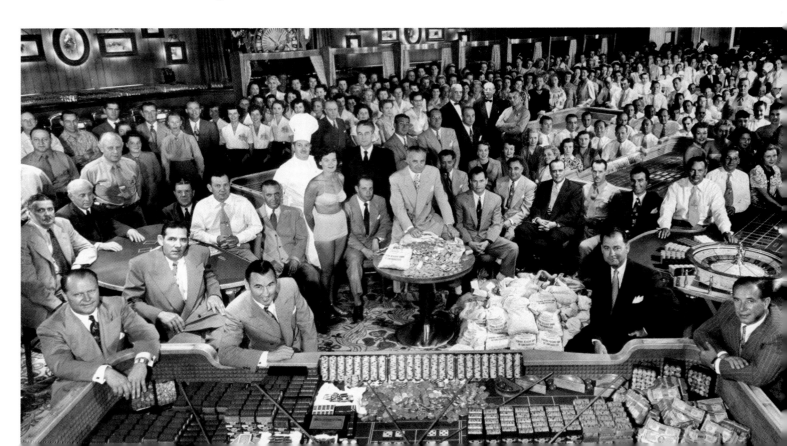

The Max Rudin essay is excerpted from "Fly Me to the Moon: Reflections on the Rat Pack," which appeared in *American Heritage* magazine, December 1998.

Bulfinch Press

Time Warner Book Group
1271 Avenue of the Americas, New York, NY 10020
Visit our Web site at www.bulfinchpress.com

First Edition: October 2005

Ferrari, Michelle.
 Las Vegas : an irreverent history / Michelle Ferrari and Stephen Ives.— 1st ed.
 p. cm.
 Includes index.
 ISBN 0-8212-5714-5
 1. Las Vegas (Nev.)—History. I. Ives, Stephen. II. Title.
F849.L35F47 2005
979.3'135—dc22 2005002336

Design by Miko McGinty

PRINTED IN SINGAPORE